MAKING CLASSICAL ART
PROCESS & PRACTICE

MAKING CLASSICAL ART

PROCESS & PRACTICE

EDITED BY ROGER LING

TEMPUS

First published 2000

PUBLISHED IN THE UNITED KINGDOM BY:

Tempus Publishing Ltd
The Mill, Brimscombe Port
Stroud, Gloucestershire GL5 2QG

PUBLISHED IN THE UNITED STATES OF AMERICA BY:

Arcadia Publishing Inc.
A division of Tempus Publishing Inc.
2 Cumberland Street
Charleston, SC 29401
1-888-313-2665

Tempus books are available in France, Germany and Belgium
from the following addresses:

Tempus Publishing Group	Tempus Publishing Group	Tempus Publishing Group
21 Avenue de la République	Gustav-Adolf-Straße 3	Place de L'Alma 4/5
37300 Joué-lès-Tours	99084 Erfurt	1200 Brussels
FRANCE	GERMANY	BELGIUM

British Library Cataloguing in Publication Data.
A catalogue record for this book is available from the British Library.

ISBN 0 7524 1499 2

Typesetting and origination by Tempus Publishing.
PRINTED AND BOUND IN GREAT BRITAIN

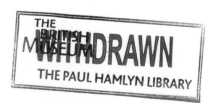

Contents

The contributors

Nicholas Durnan, stone conservator, Compton Durville, Somerset, UK

Karl Galinsky, professor of classics, University of Texas at Austin, USA

Seán Hemingway, assistant curator, Department of Greek and Roman Art, Metropolitan Museum of Art, New York, USA

Priscilla Henderson, independent researcher, Griffith, Australia

Peter J. Holliday, professor of art, State University of California, Long Beach, USA

Janet Huskinson, senior lecturer in classical studies, Open University, UK

Diana E.E. Kleiner, professor of classics and history of art, Yale University, USA

Lesley A. Ling, senior lecturer in history, Manchester Metropolitan University, UK

Roger Ling, professor of classical art and archaeology, University of Manchester, UK

John Prag, keeper of archaeology, Manchester Museum, UK

Brian A. Sparkes, emeritus professor of classical archaeology, University of Southampton, UK

Acknowledgements

This book has emerged out of a much more wide-ranging collection of essays, assembled by a different editor and covering the whole of western art, which never reached the publication stage; some of the essays written for that earlier volume appear here in a revised and updated form, while others have been extensively rewritten, and still others have been newly commissioned. The editor is deeply indebted to Alison Yarrington for her work on the original volume, to Phillip Lindley for inspiring the initiative to produce a more narrowly focused volume on a single period, and to all the contributors whose essays are printed here.

A special debt is owed to the various museums, institutions and individuals acknowledged in the captions for providing illustrations and giving permission for publication. Additional thanks are due to Leo Biek (London), Michael Donderer (Erlangen), Ricky Grossman (New Haven), Ian Jenkins (London), Susan Matheson (New Haven), Hélène Morlier (Paris), Olga Palagia (Athens), R.R.R. Smith (Oxford), Antonio Varone (Pompeii) and Susan Walker (London). Professor Sparkes wishes to thank the following individuals for help: Lucilla Burn (London), Jacklyn Burns (Los Angeles), Ursula Kästner (Berlin), Charles Kline (Philadelphia), Joan Mertens (New York), Howell Perkins (Richmond), Jemima Scott-Holland (London), Marion True (Los Angeles) and Michael Vickers (Oxford).

Final thanks are due to Lesley Ling for her assistance with a number of editorial chores.

General bibliography on classical art

General

Boardman, J. (ed) (1993) *The Oxford History of Classical Art*, Oxford: University Press.

Elsner, J. (1998) *Imperial Rome and Christian Triumph*, Oxford: University Press.

Osborne, R. (1998) *Archaic and Classical Greek Art*, Oxford: University Press.

Pollitt, J.J. (1986) *Art in the Hellenistic Age*, Cambridge: University Press.

Ramage, N.H., and Ramage, A. (1991) *The Cambridge Illustrated History of Roman Art*, Cambridge: University Press; 2nd edn (1995) *Roman Art*, London: Laurence King.

Robertson, C.M. (1975) *A History of Greek Art*, Cambridge: University Press.

Robertson, C.M. (1981) *A Shorter History of Greek Art*, Cambridge: University Press.

Spivey, N.J. (1997) *Greek Art*, London: Thames and Hudson.

Strong, D.E. (1988) *Roman Art*, 2nd edition, Harmondsworth: Penguin (Pelican History of Art).

Sculpture

Stewart, A. (1990) *Greek Sculpture. An Exploration*, New Haven and London: Yale University Press.

Kleiner. D.E.E. (1992) *Roman Sculpture*, New Haven and London: Yale University Press.

Painting

Ling, R. (1991) *Roman Painting*, Cambridge: University Press.

Sources: primary

Pausanias, *Description of Greece*, edited and translated by W.H.S. Jones, 1918-35, Cambridge, Mass: Harvard University Press (Loeb Classical Library).

Pliny, *Natural History* 34-6, edited and translated by H. Rackham and D.E. Eichholz, 1952 and 1962, Cambridge, Mass: Harvard University Press (Loeb Classical Library).

Vitruvius, *De Architectura*, translated by M.H. Morgan, 1914, Cambridge, Mass: Harvard University Press.

Sources: collections

Pollitt, J.J. (1965) *The Art of Greece 1400-31 BC: Sources and Documents*, Englewood Cliffs, NJ: Prentice-Hall.

Pollitt, J.J. (1966) *The Art of Rome c753 BC-337 AD: Sources and Documents*, Englewood Cliffs, NJ: Prentice-Hall (reprinted Cambridge, University Press, 1983).

Further, more specific, bibliography is given at the end of the individual chapters.

The illustrations

Text figures

Colour plates

Introduction

The artistic production of the Greeks and Romans is fundamental to the subsequent history of western art. Some periods and some movements have turned their faces against it, but the achievements of what we call 'classical antiquity' are an essential part of our artistic heritage and can hardly be ignored. It is to the Greeks and Romans that we owe many of the artistic principles that have been taken for granted, at least since the Renaissance — the naturalistic representation of the human body, the ability to draw or paint an illusion of reality on a flat surface, the privileging of nudity in depictions of the human figure, truly individualistic portraiture, the prizing and collection of art for its own sake. None of these had been fully developed in earlier civilizations, and the emergence of all of them together during the last few centuries BC gives the classical age a unique importance.

It is not only principles but also media and techniques that western art has inherited from the Greeks and Romans. It was in the classical period that standard media, such as large-scale stone sculpture, hollow-cast bronze statuary, fresco painting, mosaic floor-and-wall-decoration, and metal-engraving, were brought to maturity. Here some of the groundwork had been laid by earlier civilizations. Stone carving was already a major art form in ancient Egypt, for example, while the Minoans and the Myceneans had painted in fresco. But the crucial steps in the forging of the European tradition of art technology took place in Greco-Roman times. And certain techniques, notably the lost-wax method of bronze casting, were new creations of the period.

Greek art emerged in the first half of the first millennium BC after the collapse of the Bronze Age civilizations of the Minoans and Myceneans. Its first phase, the **geometric** period, occupying what is to us largely a dark age, was characterized by the production of painted pottery and bronze or terracotta figurines which put the emphasis on simplified structures and abstract patterns. During the eighth and seventh centuries BC, however, the development of trading relations with the East led to a phase of **orientalizing** art, in which human figures, vegetal forms, and particularly animals, many borrowed from the East and now rendered in a more flowing (if still conventional) manner, became the favoured motifs. The late seventh and sixth centuries saw a wave of influence from Egypt, from where the Greeks imported the concept of monumentality, and especially the idea of large-scale stone sculptures of the human figure. This marked the beginning of the great age of Greek art. Starting with stereotypes based on Egyptian sculpture, the artists of the **archaic** period (*c*700-480 BC) evolved the first truly naturalistic representations of the human form. The reasons for this dramatic development will never be fully comprehended. Artists may have been inspired partly by seeing athletes competing in the nude, and more importantly by their desire to depict the stories of their gods and heroes

in visual form. In either case they began to make statues that were not only anatomically correct but also seemed to live and move.

The following 150 years, from *c*480 to *c*330 BC, is the **classical** period in the narrow sense. It began with the defeat of the Persian invasions of 490 and 480-79, an event which reinforced the Greeks' sense of their cultural unity and racial superiority. As in previous centuries, the Greek world remained divided into independent states which were often at odds with one another, but, rather like the states of Islam a thousand years later, they shared a common language, common beliefs, and common institutions. The repulse of the Persians in the Aegean, and almost simultaneously the victories of the Greek colonies in Sicily and southern Italy over the Carthaginians and the Etruscans, strengthened the sense of national identity and ushered in an age of comparative stability and unprecedented interstate communication. Artists moved freely from city to city, and the great 'Panhellenic' sanctuaries, notably Olympia, Delphi and Delos, were focal points of artistic activity. The expansion and enrichment of Athens in particular made her a centre of artistic patronage, highlighted by the building programme on the Acropolis in the second half of the fifth century. During this phase naturalism prevailed in art, but it was tempered by idealism. The gods were depicted as aloof and dignified, athletes as perfectly formed and youthful, philosophers and statesmen as wise and remote. Individuality and emotion were alien concepts. In terms of artistic development, the techniques of illusionism in relief sculpture and painting, involving the use of devices such as foreshortening, perspective, and modelling by light and shade, were gradually mastered.

During the fourth century, following the weakening of the Greek states by a series of disastrous internecine wars, a new phase was inaugurated by the conquests of Macedonia, a half-Greek kingdom on the northern fringes of the Greek peninsula. First, King Philip II took over the cities of mainland Greece, effectively ending the great age of the independent states; then his son Alexander ('the Great') took his armies eastwards and conquered the Persian Empire, extending Greco-Macedonian civilization into areas far beyond its original spheres of influence. The new period is called **Hellenistic**, because it was an age in which the newly conquered areas were 'hellenized', ie exposed to, and to some extent won over by, Greek culture. In artistic terms the most important developments were the changes in patronage. Instead of carrying out commissions for city-states and religious sanctuaries, which had promoted an art of patriotism and reverence, artists found themselves working for kings, courtiers, and the wealthy individuals who had benefited from the expansion in trade and from the opportunities for exploitation offered by the conquered territories. This led to new roles for art — putting over the propaganda of the royal court and pandering to the pleasure of the private citizen. At the same time, the increasing academicism of the new age weakened the dominance of the old religious ideals. The result was the admission of subject matter (emotional, playful, trivial, shocking) which would have been deemed inappropriate in earlier periods, and a greater concentration upon virtuosity than upon depth of meaning. While Athens remained an important artistic centre, the focus of artistic patronage now moved eastwards to the wealthy trading cities of Asia Minor and the Near East, and especially to the capitals of the most powerful Hellenistic kingdoms — Alexandria, Antioch and Pergamum.

During the last two centuries BC the Hellenistic world was gradually devoured by

Rome, which established an empire encompassing the whole Mediterranean basin. The history of Rome was traced back by the Romans themselves to the eighth century, but her expansion to a world power began in the fourth and third centuries, with the absorption first of central Italy, then of the whole Italian peninsula and Sicily. This expansion brought her into contact with provincial Greek art, both through the medium of Etruscan art, which was heavily influenced by the Greeks, and directly through the art of the Greek cities of southern Italy and Sicily such as Taras (Tarentum) and Syracuse. The new conquerors developed a passion for Greek art which they plundered wholesale to adorn their temples, public places and private villas in Italy. The conquest of Greece itself in the second century, the acquisition of the Pergamene kingdom in 133, the subjugation of the rest of Asia Minor and the Levant in the early first century, and finally the taking over of Egypt in 30 BC, carried the process further. Ships full of Greek statues, paintings and metal objects plied the routes between the Aegean and Italy. Workshops of Greek artists, based either in the Aegean or in Italy itself, produced new works, often pastiches or imitations of the great art of the past, to satisfy the demand of Roman patrons.

This first phase of Roman history is referred to as the **Republic**. Rome was governed by a senate drawn from the landed aristocracy and by short-term unpaid magistrates who both conducted civil administration and commanded the armies in the field. It was a system that worked well as long as Rome's territories were of manageable size but was ill-suited to the control of a vast cosmopolitan empire. The rise of professional armies that owed allegiance to their commanders rather than to the government in Rome, the abuse of power by officials in the provinces, problems of debt and class division in Italy—all led to the collapse of the Republic in a series of civil wars during the first century BC. The decline was halted by Augustus, who emerged victorious from his struggle with Mark Antony in 30 BC, and gradually forged a new system of government suited to the needs of the empire. The ensuing period is known as the **Empire** or **Imperial** age, and Augustus became the first emperor. From now on the Mediterranean world, and additional territories that were conquered by the Roman armies, including the Alps, the northern Balkans, the western parts of the Iberian peninsula, the regions along the Rhine and Danube, Britain, and, at various times, parts of central Europe and the Middle East as far as the Persian Gulf, formed part of a single state with one man, or a small group of men, at the helm, controlling a complex bureaucracy of long-serving officials and professional garrison armies. Art performed a variety of functions, serving both public and private patrons. It became increasingly available to ordinary people, as evidenced by the vast expansion in numbers of portrait statues and busts, sculptured grave-reliefs and painted house-decorations; but the most successful artists are found working for the state and the emperor, celebrating the achievements and promulgating the ideologies of one man and his circle. In style much art, especially that of the state, remained faithful to the naturalism and idealization inherited from the Greeks, but alongside this traditional Greco-Roman mode there appeared a new simplified style, characterized by a denial of space, an emphasis on frontality, and hieratic variations of scale. This new style concentrated on clarity of presentation rather than fidelity to natural appearances and it was increasingly adopted by the state monuments of the late second and third centuries AD as a more effective means of conveying messages to the people. Subsequently, during

the fourth century, the same factors commended it to the image-makers of the Christian church. The triumph of Christianity and the emergence of a new church-dominated empire, focused on Byzantium (Constantinople) rather than Rome, brought an end to the classical period, and secured the success of the new hieratic style, which was to dominate art for nearly a thousand years.

It is against this backdrop of changing historical situations and patterns of patronage that the processes and practices of art production, which form the subject of the present volume, must be viewed. The reader requires no prior knowledge of ancient art. At the same time he or she should be aware that this is not a general book on the subject: it contains no analysis of evolving styles or of the cultural background. There are many excellent books already available to provide this kind of introduction: eg Boardman (1993), Ramage and Ramage (1991 and 1993), Robertson (1975 and 1981), Strong (1988), and the volumes in the Oxford History of Art series by Osborne and Elsner (both 1998). The Greek and Roman sources, the most important of which are the writings of Pliny the Elder, Pausanias and Vitruvius, are conveniently assembled in two anthologies by J.J. Pollitt (1965 and 1966).

The collection of essays here published is intended to review classical art from the technical standpoint — to look at how it was made. The first six essays concentrate on the processes of production in different media; the remaining ten deal with selected case studies which illustrate the end results — ie art in practice.

The essays on production processes deal with the media which are best known from literary sources and from surviving examples: stone and bronze sculpture, wall painting, vase painting, and mosaic. Five are studies of specific media and the sixth reviews general aspects of the way in which production was organized. Apart from vase painting, included because it is so well represented in the archaeological record and has become one of the staples of modern study, the media selected are the 'monumental' ones, the major figural arts that dominate our impression of ancient visual culture. We should have liked to include other art forms such as silver plate, jewellery, glass, stuccowork and coins, but this would have involved extending the book beyond manageable proportions. Still less have we been able to include architecture, which merits a whole book to itself.

The ten case studies are selected partly for their intrinsic importance, partly as typical examples of a given genus. The first reviews colossal statues, the most ambitious and most famous products of ancient art, known to us (alas) chiefly from literary descriptions and reflections in the minor arts. There follow two chapters on two of the best known sculptural monuments from the realm of state art: the Parthenon in Athens, and the Ara Pacis in Rome. Then come three essays on artistic themes which straddle the public and private domains: portraiture and funerary art (the latter divided into Greek and Roman). Next, two essays on painting examine the most complete groups of murals surviving respectively from Greek and Roman times: the tomb paintings of Macedonia and the domestic wall-decorations of Pompeii. The book closes with essays on a single complex of wall-paintings and an individual mosaic pavement which stand on the threshold of late antiquity: the remarkable paintings of the synagogue at Dura-Europus and the Hunting and Seasons mosaic from the so-called Constantinian Villa at Antioch. The choice of these last two subjects is somewhat arbitrary. The Antioch mosaic could have been substituted

by any one of a hundred other mosaics; it is selected partly for the representativeness of its iconography, partly for the interest of the way that it has been adapted to a modern museum display. The paintings of Dura-Europus are chosen partly for the unexpected light that they shed on Jewish art of the time, partly to illustrate classical art at the margins. Dura-Europus, a remote city on the Euphrates, was only for brief periods a part of the classical world, and the synagogue marks a meeting between the style of the Mediterranean and that of the Middle East — a meeting which points forward to the art which emerged later in the Byzantine Empire.

The essays are written by authors with diverse interests; they include archaeologists, art historians, and classicists, as well as a cultural historian and a practising craftsman. This has been done advisedly: the contributors have to some extent been encouraged to adopt a personal approach. It is hoped that the resulting differences of emphasis will help to highlight the extraordinary richness and diversity of classical art. In the chapters on techniques — and also in the essay on colossal statues — the contributors have been asked to look, where appropriate, at the precedents in earlier civilizations (Egypt, the Middle East and the Aegean), as well as at the aftermath of classical art (a subject which is reprised at the end of the book in a brief epilogue). In the case studies the focus of the writers naturally depends on the topic; but their general brief was to consider the significance of the work (or class of works) in question, to show how it fits into the history of its genre, and to assess how it achieves its purpose — putting over a government message, glorifying an individual or individuals, commemorating the dead, beautifying a domestic environment, reflecting the tastes and aspirations of a householder or householders. The object here is to show something of how the art fits into its social and historical context.

It should be noted that one of our media, vase painting, is confined to the age of the Greek city states. It virtually disappeared in the early Hellenistic period, and none of the subsequent forms of decorated pottery, notably the relief wares of Hellenistic and Roman times, achieved a comparable subtlety and variety of expression. Conversely, mosaic did not acquire importance as an artistic medium before the Hellenistic period, and its great flowering belongs in Roman and early Christian times. Sculpture and painting, however, retained importance more or less continuously throughout the Greek and Roman period. It is with these, therefore, that we begin.

Bibliography and references

See the general bibliography on p8.

1 Stone sculpture

Nicholas Durnan

The role of the ancients in the history of stone sculpture is fundamental. The Greeks and the Romans, working above all in marble, but building on the experience of the Egyptians in limestone and the hard coloured stones local to their region, brought to maturity the tradition of figure-carving which has remained prominent in western art. Classical sculpture in stone is all the more important because much of the bronze statuary which overtook it in popularity, especially in the fifth and fourth centuries BC, is lost. The changes that appear in stone statues during the first half of the fifth century show how artists were liberated from a narrow range of types by the greater tensile strength of hollow-cast bronze, and sought to show the human figure in increasingly adventurous poses. Moreover, the use of stone by the workshops of copyists which developed during the Roman period to service the contemporary fashion for art-collection enables us to study at second hand many of the lost masterpieces of bronze. At the same time, ancient stone-carvers maintained their independence by developing and exploiting textural and other effects peculiar to their medium; and in architectural sculptures, such as those of the Parthenon and the Ara Pacis, they produced work of central importance to the study of classical art.

The present chapter examines, from the standpoint of a practising stoneworker, both the qualities of different stone and marble used by ancient sculptors and the tools and techniques with which they were worked. The first sections will review the materials and techniques available to the stoneworker in ancient times. In the final section, although the historical development of the techniques is difficult to chart precisely, some of the ways in which they were applied are examined, taking advantage particularly of instances where conservation has allowed close examination of working practices through the evidence of the works themselves.

Types of stone used in making sculpture

Stoneworkers tend to classify stone according to its hardness and 'workability', but in geological terms it is classified according to its mode of origin, with all stone types falling within one of three groups: igneous, sedimentary and metamorphic. The availability of the different types varies from region to region and conditions both the appearance and technique of sculpture produced in different periods.

1 *Head carved in basalt: Romano-
 Egyptian priest (mid-first century
 BC). Ht 24cm. Paris, Louvre (Ma
 3530).* Photo R.J. Ling 121/17

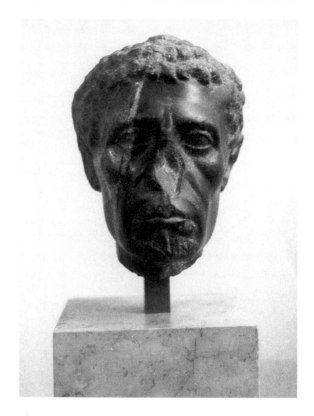

Igneous rocks

Igneous rocks are crystalline forms of cooled magma (molten lava). Although difficult to work, many are prized for their colour, durability and decorative effect when polished. In ancient times, with the exception of porphyry, their use for sculpture was confined to Egypt.

Granite is composed of clearly visible crystals of minerals, mainly quartz, felspar and biotite mica, created during the cooling process. The higher the quartz content, the harder the stone is to carve. It has a granular structure and is capable of taking a very high polish with a range of colour from silvery-grey to red. In Egypt, statues, obelisks and *stelae* were produced in a coarse-grained variety (**colour plate 16**).

Basalt and dolerite are black, dense rocks. Often showing tiny glittering particles, they may be coarse- or fine-grained. Despite being hard, and therefore difficult to work, the Egyptians made use of basalt for statues (**1**). Dolerite was used for pounders to work hard stones like granite and quartzite.

Diorite is a crystalline, granular rock consisting essentially of the minerals plagioclase felspar (white) and hornblende or augite (black or dark green); it may be either fine- or coarse-grained. Diorite was again used for making statues in Egypt: a particularly fine example is the seated statue of Khafre (*c*2500 BC) in the Egyptian Museum, Cairo.

Obsidian is a black or green natural glass of volcanic origin that breaks with conchoidal fractures. Its main use was in the making of tools for shaping softer stone in Egypt and Greece, although it was used for sculpture in the former.

Porphyry contains large, clearly visible crystals set in a fine-grained ground mass. The best-known is the beautiful, fine-grained red or purple rock of Egyptian origin known as imperial porphyry, or *porfido rosso antico*, used in the Roman period for prestigious court sculpture (**colour plate 1**). The other highly prized form is the attractive green porphyry, or *porfido verde antico*. This is of Greek origin and shows lighter green crystals set in a darker green, fine-grained background. In Greece and Rome the stone was in demand for its highly decorative properties, although its exceedingly hard nature limited its use to small objects.

Sedimentary rocks

Sedimentary rocks are formed mainly from compressed sediment of either weathered particles of igneous rocks, which form sandstones, or the fossils of marine organisms, which form limestones. These stones were used in large quantities for sculpture, both in Egypt and in the Greco-Roman world.

Limestone consists essentially of calcium carbonate but may contain small amounts of other ingredients such as silica, clay, iron oxide and magnesium carbonate. It varies considerably in quality, hardness and texture. Limestone was one of the first stones to be used for carving because it is comparatively soft and easy to work. Some of the earliest figurative sculpture from the Palaeolithic period, such as the Venus of Willendorf (*c*30,000 to 15,000 BC), in the Naturhistorisches Museum, Vienna, was carved from this material. Often it has a fine texture, well suited to intricate detail. Some fine examples of its early use as a material for sculpture are found in Assyrian sculpture, including the spectacular man-headed bull from the Palace of Khorsabad (721-705 BC) now in the British Museum, London. In Egypt large quantities of sculpture were carved from this material and it was sometimes used for preparatory models for sculpture in harder stones. In the Greek world it was widely exploited for sculpture in the archaic period, and continued to be used in the classical and Hellenistic periods in areas where marble was not easily available, such as the Peloponnese and Sicily. In the Roman world again it tended to be treated as an alternative to marble in those periods and those regions where the latter was in short supply.

Sandstone consists essentially of quartz and sand derived from the disintegration of older rocks, cemented together by very small proportions of clay, calcium carbonate, iron oxide or silica. Because of its abundance it was often used for statuary and sculptural decoration in Egypt. It also appears at certain Greek sites in southern Italy, such as Foce del Sele, where the metopes of the archaic temples were carved from it.

Onyx marble (Egyptian alabaster) is a compact, crystalline form of calcium carbonate, white or yellowish in colour, translucent when thin and usually banded. This attractive stone was occasionally used in Egypt for statues and sarcophagi, but does not feature elsewhere.

Metamorphic rocks

Metamorphic rocks are sedimentary deposits that have been changed into a crystalline state through heat and pressure.

Marble is a crystalline compact form of limestone composed of calcite and is the most important metamorphic rock for sculpture and for carving. Many marbles are very soft

when quarried, but harden with age. The ready availability of marble, combined with its durability, its crystalline, translucent quality when polished, and the great variety of colours obtainable, have ensured it a pre-eminent place in sculptural work from ancient times to the twentieth century. Among the earliest examples of its use for sculpture are 'idol' figures of the Cycladic period (3200-1200 BC) from the Greek islands. The Cyclades were the main source of marble for sculptors working in Greece, the islands of Naxos and Paros supplying the coarse-grained, sparkling Naxian marble and the more sugary, translucent Parian. The latter was the material out of which the famous statue of Hermes and Dionysus at Olympia, assigned by Pausanias to Praxiteles, was carved (**2**). Pentelic marble, obtained from near Athens, has a tighter grain with an opaque appearance and a distinctive pale-gold colour. This was used for the Parthenon (447-438 BC) and its sculptural programme (chapter 8). The Romans, as well as importing coloured marbles, made widespread use of the marble of the Apuan Alps (Luni or Carrara marble), the source of the material employed for the Ara Pacis Augustae in Rome (13-9 BC) (chapter 9). The Carrara quarries have continued to provide large quantities of fine white marble over the centuries; for example they supplied material for the cathedrals at Pisa, Florence, Siena and Orvieto, as well as for sculptures by Michelangelo, Bernini and Canova. Further important sources of white marble in Roman times were the islands of Thasos (north Aegean) and Proconnesus (Sea of Marmara, Turkey).

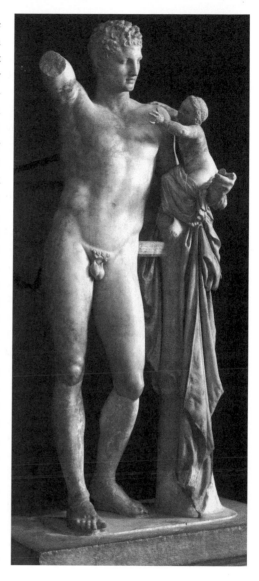

2 *Marble statue of Hermes by Praxiteles, found in the temple of Hera at Olympia c350-340 BC. Ht 2.15m. Olympia Museum.* Photo University of Manchester, Art History collection (Alinari 24857)

Quartzite is a hard, compact variety of sandstone that has been formed from ordinary sandstone by the deposition of crystalline quartz between the sand-grains. It varies considerably both in colour (white, yellowish, or a variety of shades of red) and in texture (fine- or coarse-grained). A brownish-yellow quartzite was used extensively for sarcophagi

and statues in Egypt, but nowhere else in the ancient world.

'Schist' (greywacke) is a fine-grained, compact, hard, crystalline, quartzose rock, very slate-like in appearance and generally of various shades of grey, sometimes with a greenish tint. Like quartzite, it was used for sculpture only in Egypt.

Working the stone

Our knowledge of the history of stoneworking methods derives from a variety of sources, the most significant of which are representations of sculptors at work found in a variety of media; the stone sculpture itself, in particular where the work is left incomplete with different tool marks being discernible (**3, 4, 13, 16**); and, finally, observation of today's stone carvers at work. Research carried out by twentieth-century historians, archaeologists, carvers and conservators has shed light on working methods and tools used in making sculptures from antiquity to more recent times. There have also been experiments to recreate Egyptian, Greek and Roman tool technology, although the exact dates when soft bronze tools were superseded by those of harder iron and tempered steel remain uncertain.

Stone may be shaped simply by striking it with hammer-shaped pieces of harder stone, or by rubbing a hard, gritty mineral against a softer one to wear down the surface through abrasion. However, to achieve a finely worked surface requires the use of metal tools, particularly carefully tempered steel chisels; these produce the most delicately shaped surfaces and finely detailed cutting. Since the earliest surviving stone sculptures, dating from the fourth

3 Unfinished marble statue of a kouros *(standing nude youth) from Naxos (sixth century BC) showing marks of the point. Ht 1.02m. Athens, National Museum 14.* Photo German Archaeological Institute, Athens NM 4887

millennium BC, there have been major technological advances in the development of metal tools. Already in the ancient period copper was followed by bronze, bronze by iron, iron by steel and tempered steel. The twentieth century has seen the introduction of tungsten and industrial diamond-impregnated steel tools.

4 *Unfinished votive relief of the Dioscuri, from Athens (fourth century BC). Ht 37cm. Berlin,
 Staatliche Museen Sk 370.* Photo Staatliche Museen zu Berlin, Preussischer
 Kulturbesitz, Antikensammlung

Despite such advances, the actual process of carving seems to have undergone
comparatively little change over time. To transform a large beach pebble or a block of
rough stone into a sculpture involves three basic procedures: firstly, roughing out (the
removal of the outer surface to provide an approximation of the desired form); secondly,
modelling (the removal of smaller amounts of the material to the point where the shape
is more or less complete); thirdly, finishing and polishing. This final operation is perhaps
the most skilled, requiring the removal of very small amounts of stone. Before the stone
is carved the design has to be transferred onto the block. A squared-up, full-size drawing
can be transferred by eye onto the stone, which has been marked up with an identical grid
pattern (**8**). This was the procedure invariably followed in Egypt and archaic Greece. From
the early fifth century BC onwards, however, sculptors used scale- or full-size models in
clay, plaster or soft stone, transferring their dimensions by measuring with callipers.

Techniques for shaping stone

There are four basic methods used by sculptors in shaping stone: splitting, abrading, pummelling (pulverizing), and cutting.

Splitting is not a carving technique as such, except where it is necessary to remove large areas of stone. It is used mainly for quarrying or for preparing a rough block to the right dimensions for a sculpture. In antiquity, stone blocks were split away from the quarry face through the pressure of expanding soaked oak or hammered iron wedges that were positioned in a straight line (**5**). Iron and steel wedges have been used in this way to the present day.

Abrading is a process where a harder stone is rubbed against a softer stone to remove parts of it. This rubbing may be carried out using either a solid block of abrasive stone or a powdered abrasive with a tool as a vehicle for it. There are four types of abrasive techniques: shaping, sawing, drilling and polishing. Simple shaping may be achieved by employing sharp-grained quartz blocks with water acting as a lubricant. In sawing, a wire- or leather-strung bow saw, used with powdered corundum, garnet or sharp silica sand and water as a lubricant, is effective for cutting through even the hardest stones; but, as this is a lengthy process, it is used mostly to make small artefacts. Drilling, using bow and strap drills with a solid or hollow drill point tipped with flint or other hard stones, has played a part in the sculptural process since before 3000 BC. The drill shaft may be formed from wood, bone or metal. The widespread and continuing use of this tool is evident from the marks that remain on marble statuary, where delicate and deep carving is needed: for example to create the effects of curling hair (**6**), ears, eyes, foliage, lacework etc. Polishing is accomplished most simply with a piece of hand-held leather to work an abrasive powder across the surface.

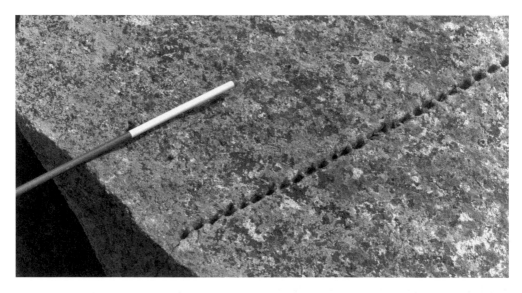

5 Holes cut for wedges to split a block in the Roman granite quarry at Capo Testa, Sardinia.
Photo R.J.A. Wilson

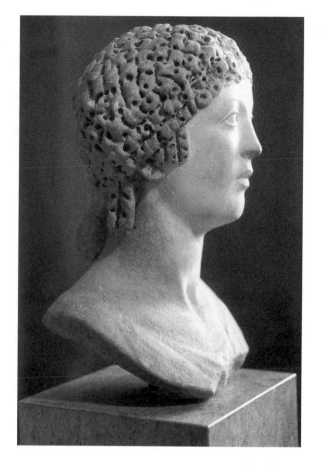

6 *Marble portrait head of an unknown woman showing the use of drillwork in the hair. Ht 34cm. Paris, Louvre Ma 1269.* Photo R.J. Ling 121/27

Pummelling (pulverizing) was a standard way of working hard stones before steel-tempered tools were introduced. It entailed hammering at the area to be removed using stone hammers of greater hardness than the material being worked. The process may initially have been assisted by drilling. This was a laborious method, but it appears to have been used for virtually all Egyptian hard-stone sculpture. The large stones that form Stonehenge (*c*3000-1800 BC) were probably shaped in this way.

Cutting is of course the most important means of working stone. Although softer stones can be pared away using knife-shaped blades of flint or obsidian, the availability of copper, bronze, and iron led to the use of metal tools that were much more effective. Stone-cutting tools may be divided into two main groups: the axe type, where a metal head with a blade or point is attached to a long wooden handle that is held with two hands, and the chisel type, where a metal shaft, shaped to a blade or point at the cutting edge, is struck with a wooden mallet or metal hammer (**7**). The chisel type can be of two forms: either simply a length of metal struck directly, or a metal shaft that is set into a wooden handle which is struck in a similar manner by a mallet or hammer. Tools made from soft metals such as copper and bronze can be struck only by a wooden mallet, unless the metal shaft of the tool is set in a wooden handle (rather like a modern carpenter's chisel) which can then be hit with a metal hammer.

7 *Roman marble relief showing a hammer and chisel. Ht 35.6cm. New York, Metropolitan Museum of Art 23.160.81.* Photo Metropolitan Museum of Art

The two forms of cutting tool, whether or not they were set in wooden handles, would have been made from lengths of metal, square or rectangular in section; both types had a blade shaped to suit the type of work and hardness of stone. Until the introduction of steel, the range of tools for cutting hard stones would have been very limited, the most important being a punch or a stout flat chisel (see below).

It is probable that once tempered steel was introduced, possibly during the sixth or fifth centuries BC, tools used for working harder stones, such as granite or marble, developed into the form of the hand-tools currently used by stone-carvers. The cutting edges of hardened steel tools can be pointed, toothed, flat, rounded or gouged. These need to be of various shapes and sizes according to the hardness of the stone and the nature of the work, be it roughing out the hardest granite or surface-finishing the softest limestone.

Some developments in stone-carving techniques

The history of stone-carving does not form a neat, logical, linear development through time. It is important to realize that different tools and techniques could happily exist in parallel within any location and time, and across cultures. Even today stone-carvers and sculptors working in different parts of western Europe use different tools and techniques for similar tasks. Some prefer simple technology, others use pneumatic and power tools.

Moreover, any identification of tool-use from the marks visible on the stone may be

fraught with difficulties for the historian trying to discern difference. The axe and the adze, for example, produce marks that are often indistinguishable from those of a mallet and boaster (broad chisel); pick marks are very similar to those of the hammer and punch. As Hill states, 'in some cases it is quite impossible to differentiate between work done by different tools. This may be disappointing for the archaeologist, but it is a matter of simple fact which can be demonstrated by any competent banker-mason. Also, it is often the case that there will be a greater difference between the work of two contemporary masons than between works of two different millennia' (Hill 1990: 100).

Nevertheless, a great deal of information may still be gleaned from a close study of sculpture, in particular those parts of any work that were never intended to be scrutinized by the viewer, for example the backs and undercut areas that were only partially worked. Unfinished works provide even more information about a sculptor's working methods.

The Egyptians, as previously indicated, used a great variety of stone in their sculpture, ranging from soft limestones and sandstones to diorite, granite, quartzite and 'schist'. To work the soft stones, copper tools were used until the introduction of the harder bronze (*c*2700-2100 BC). There were also toothed saws and bow drills in both these materials. The sequence of carving where copper and bronze tools were used was probably as follows: picks and points for roughing out the block and creating the form; flat or bullnose chisels for finishing and refining the surface; scrapers and abrasive stones for the final smoothing and polishing. The likely procedure for carving the harder stones was to pummel the surface with dolerite hammers and then to work it over with flint or obsidian scrapers. When the form was achieved, abrasive blocks and grits were used to smooth the surface. To saw hard stone, copper and bronze blades or wire were used with abrasive grit and water. For drilling holes a hollow metal tube rotated by a strap or bow drill was fed with abrasive powder (silica sand, crushed corundum, emery or flint) and water.

The earliest-known Greek marble sculpture (*c*3200-1200 BC) was created before bronze or iron technology had appeared in the Aegean; it was probably produced with the aid of stone hammers, scrapers and abrasives. Recent experiments to reproduce these 'Cycladic' figures using only the stone tools thought to have been available to sculptors of this period have produced successful results (Getz-Preziosi 1985). The procedures followed included blocking out the form with different-sized emery hammers and using smaller ones to shape and smooth the final surface. Obsidian proved useful for executing incised work and 'shaving' the surface to remove unevenness. The use of pumice gave a final soft sheen to the surface.

The inventiveness of the Greeks in developing marble carving is of great significance for the history of sculpture. Marble lends itself well to the imitation of human (organic) form, a subject that was central to western sculptural production from ancient times to the late nineteenth century. Another important feature was that the marble provided an excellent surface for polychromy — applied to all Greek stone sculpture, though rarely now preserved — as well as being a precious, durable and prestigious material in its own right.

The means by which sculpture was produced in Greece has long been the subject of debate. The German archaeologist, Carl Blümel, writing in 1920, held that archaic (*c*700-480 BC) and classical (*c*480-330 BC) works were carved predominantly using the hammer

and point (see below), the point being held at right angles to the stone during work (the vertical stroke). Once the forms had all been carved with a point, they were rubbed down to a smooth surface with abrasives. Adam, in her detailed study of Greek tool use (Adam 1966), disagreed with many of Blümel's findings. She found that the point was used at oblique angles to the stone (the mason's or carving stroke) and that flat, bullnose and claw chisels (see below) were used extensively in the late archaic and classical periods. Adam concluded that it was impossible to explain precisely the technical means by which this sculpture was created, given that the Greek sculptor 'used the most convenient tool in the most convenient way for any job' (Adam 1966: 39). The Belgian sculptor H.J. Étienne believed that the difference in sculptural style before and after *c*500 BC was attributable to the tools available. He asserts that only bronze or iron tools were available before that date and that these could be used only with the 'vertical stroke'. In his practical experiments he found that, if the 'mason's' or 'carving' strokes were attempted with these tools, they would just glide over the marble surface. He implied that steel and tempered steel technology, necessary for making tools for oblique working, was not available until about 500 BC (Étienne 1968). Current views tend towards the opinion that Greek sculptors had access to steel tools from early in the archaic period, and that the differences in sculptural style and changes in working methods are mainly attributable to influences from other media, particularly bronze.

The probable working processes involved in the making of an archaic Greek statue were as follows. A marble block was extracted from the quarry by a combination of cutting channels around it with an iron pick and splitting it away from the rock face with iron wedges. The block would be squared up using a pick or a hammer and point to prepare the surfaces for marking on a grid so that the statue's outline could be drawn accurately (**8**). The statue was then roughly worked to within a centimetre of the final surface whilst lying in a horizontal position, again with a hammer and point, using the 'vertical stroke'. The half-worked statue was then transported to its place of erection, where the final modelling would be carried out using drills, points, chisels and abrasives. Any projecting parts such as limbs which could not be carved economically from the same piece of stone as the rest would be made separately and attached by socket-and-tenon joints reinforced, where necessary, with pins or dowels (**9**). The statue would then be ready for painting.

The tools used by the Greeks were little different from those in use today (**10**). The pick was used primarily for quarrying and roughly dressing the marble block. It had a metal head with a point at both ends, or a point at one end and a flat blade at the other, attached to a long wooden handle which was held in both hands. It makes distinctive marks in the form of crushed grooves, still visible in Greek quarries (**11**).

The punch (or point) is simply a length of a square, rectangular or round-sectioned steel bar, usually about 150-220mm long, hammered to a point at one end. This tool is struck with a wooden mallet or metal hammer. If the tool is held at right angles to the block when struck, the stone is 'stunned' and a piece flakes off leaving an indentation at the point of impact. If the tool is held at an oblique angle, short or long furrows are created on the stone. The furrows are short if the tool is removed after each strike, long if several are made in succession without taking it away from the surface of the block (**12**).

The boaster (or drove) is a wide flat chisel, typically 30mm or more wide. Evidence of

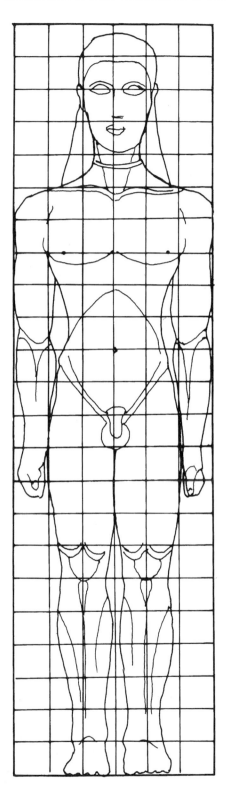

8 *Diagram of the front surface of a block of stone with a grid of guide-lines marked for an archaic male statue (*kouros). Drawing R.J. Ling, after A. Stewart, *Greek Sculpture: an Exploration* (1990), pl 55

9 *Upper part of a marble statue of a female figure holding an offering. The forearm, now missing, was attached in a socket and pinned with a peg. Athens, Acropolis Museum 673. Ht 91 cm.* Photo Alison Frantz collection (American School of Classical Studies at Athens)

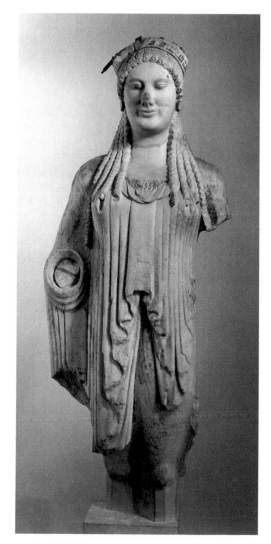

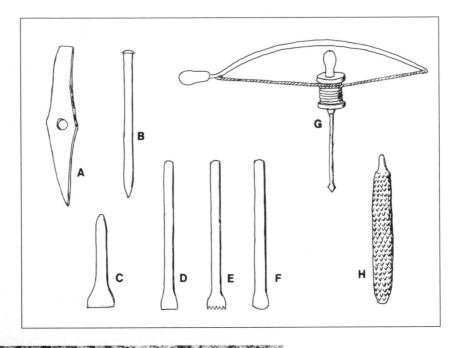

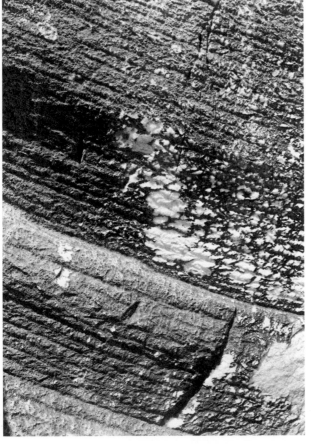

10 *Tools used by Greek sculptors:*
(A) pick, (B) point or punch,
(C) boaster or drove, (D) flat
chisel, (E) claw chisel, (F)
bullnose chisel, (G) bow drill,
(H) rasp. Drawing R.J. Ling

11 *Pick furrows in a marble quarry*
at Apollona, near Komiaki,
Naxos. Photo M. Waelkens

12 *Marks of the point on a tree-trunk support for a Roman copy of a Greek statue of the fifth century BC. The support is an addition of the copyist, working in marble: the original statue would have been of bronze, which because of its greater tensile strength would not have required it. Diadumenus (athlete binding a fillet round his head), from Vaison-la-Romaine, France.* London, British Museum GR 1870.7-12.1. Photo R.J. Ling 119/36

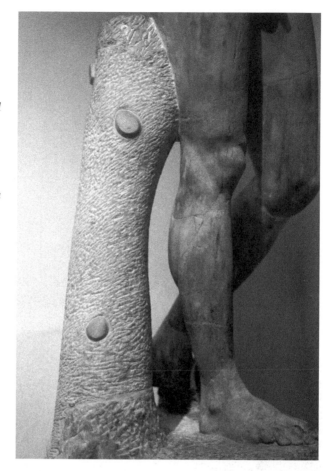

its use is clearly visible on Greek sculpture of the archaic period, when it was employed for working large, flat, carved forms after initial working with points. From surviving pieces it is evident that the boaster was struck at right angles to the stone. After about 500 BC it appears to have been superseded by the narrower flat chisel and the claw chisel to create more deeply modelled forms.

The claw is a chisel with a blade divided into a number of points or teeth and is thought to have been invented by the Greeks. Marks from this chisel first appear on sculpture from the mid-sixth century. The claw chisel, like the point, was used at right angles or obliquely to the stone, leaving a line of small indentations or a series of fine furrows respectively (**13**). Its great advantage is that it bites into the stone, cuts the stone quickly without damaging the surface, and is easy to control. Even today it remains an essential carving tool for sculptors and stoneworkers.

The flat chisel is a narrow tool with a blade whose width depends upon function, ranging from comparatively wide for modelling flat areas to very narrow for delineating areas such as hair. A bullnose chisel has a rounded blade and is useful for modelling. Chisels were used for fine modelling after point and claw work, and to level the surface in preparation for final smoothing by abrasives.

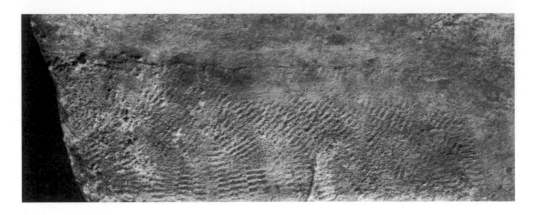

*13 Marks of the claw chisel on an unfinished detail of a Greek relief from Naxos (sixth century BC). London, British Museum (*Catalogue of Sculpture in the Department of Greek and Roman Antiquities *B 303). Photo R.J. Ling 125/29*

The drill in Greece was probably no more than a form of bullnose chisel rotated by a bow or strap (**14**). In sculpture it served to break up enclosed areas of stone, for example between folds of drapery, or between the arm and the torso. It was also used for outlining relief sculpture, for making sockets for joints and attachments, and for delineating ringlets of hair (**6**). The usual technique was to drill a line of holes which then enabled the stone to be cut away quickly and safely with a point or claw. In less visible undercut areas a line of shallow holes or grooves often remains in the side of the resulting channel. A new way of using the drill, known as the running drill, was invented in the first half of the fourth century. Instead of holding the drill at right angles to the stone it was held at about 45 degrees and moved along the stone whilst revolving, producing a groove rather than a circular hole. Its use is indicated by a groove of undulating depth with semi-circular marks at the bottom (**15**). A 3mm groove is about the maximum depth that could be cut at any time, but repeated action could deepen or widen it. An advantage of this method was that little or no further finishing was required. It is sometimes thought that the technique was introduced by a bronze-worker, Callimachus: 'it is tempting to credit him with this refined use of the tool, perhaps either to duplicate in marble his own finicky drapery work in metal, or to rival the shading experiments of the painter' (Stewart 1990: 39).

The rasp is essentially a smoothing tool for removing toolmarks, in preparation for finishing with abrasive stones. It was made by punching a metal shaft so as to raise many small teeth to form a surface like that of a cheese-grater. It was applied gently with a pushing and pulling motion across the surface, and varied in shape and contour to suit the sculptural form. There is little evidence of the rasp having been used on archaic sculpture, although this may be due to the surface having been so well rubbed down with abrasives that any tell-tale marks were removed. Traces of the rasp become more clearly visible as the classical period progresses and there is less smoothing of the surface with stones and powders.

The abrasives used by the Greeks would probably have been emery from Naxos, pumice from Melos and Nisyros, and sandstone. Whether these were used in the form

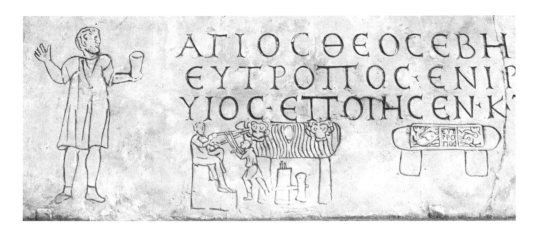

ΑΓΙΟС ΘΕΟСΕΒΗ
ΕΥΤΡΟΠΟС ΕΝΙ
ΥΙΟС ΕΠΟΙΗСΕΝ·Κ

14 Representation of a sarcophagus-maker using a drill (beneath the inscription). The sculptor guides the tool with a rod held in his left hand, while an assistant rotates it with a strap. Engraved slab in the catacomb of St Helena, Rome. Photo Amanda Claridge

of powder on pads or as shaped pieces of stone — both possible procedures — is unknown.

In Rome fine sculpture was predominantly made from marble, with tools and techniques clearly influenced by those of Greece. There were, however, some carving techniques that have been shown to be distinctly Roman innovations (Rockwell 1991). Rockwell has studied unfinished statuary associated with a sculptor's studio in Aphrodisias (western Turkey) that was probably active in the first half of the third century AD. The sculptor in question, rather than adopting the Greek practice of working the block from all sides at a more or less even rate, carved from front to back, as though working in high relief (cf **16**). As the studio was small, with little room for preparatory models, the designs would be drawn directly onto the stone. It is clear that the sculptures here were worked quickly and freely, in a manner that Rockwell describes as 'spirited directness'. The main tools used were the point and chisel; interestingly there seems to have been very little claw work.

The Roman use of the claw chisel has also been studied by Rockwell (1990), who concludes that it served primarily as a finishing tool (see above). The modelling stage, which a modern sculptor would do with a claw chisel, was carried out rather with a combination of fine point and rough flat chiselling. Rockwell further argues that, on certain sculptures, rather than a true claw, the Romans used a toothed scraper in the form of a fine-toothed scraper with a bent-over blade. This tool would have been pulled over the stone surface for final smoothing and texturing. Its marks are recognized as parallel lines that are shallower than those of a normal claw struck with a hammer. They cannot be the result of work with a rasp, which does not leave consistently parallel lines.

The bull-nosed (round-headed or rounded) chisel was much used by the Romans, giving a distinctively subtle, undulating surface, similar to that on Assyrian sculpture. The marks of this chisel are sometimes interpreted as being those of a gouge (a form of chisel

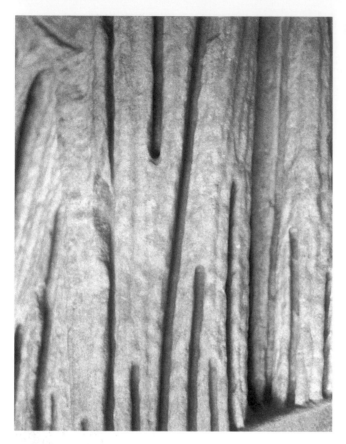

15 Grooves cut with a running drill: detail of the drapery of a marble statue from Cnidos, Asia Minor. London, British Museum GR 1859.12-26.25. Photo R.J. Ling 125/33

with a concave blade), but the latter is not a tool used on marble. The bull-nosed chisel produces marks like a series of very shallow channels with regular curved striations. The marks of a gouge which are usually seen on limestone are again in the form of shallow channels but with regular, straight striations.

One major innovation of Roman sculptors was the use of coloured marbles to complement the standard white. The expansion of the Roman Empire opened up the quarries of the whole Mediterranean basin, and from the first century BC onwards we find the Romans increasingly exploiting a range of variegated materials, such as the yellow, pink and wine-red *giallo antico* from Chemtou in Tunisia and the purple-veined *pavonazzetto* from Docimeum (Iscehisar) in Turkey. A favourite device was to use coloured stone for drapery while white was retained for the head. This practice eliminated the need for painting; indeed, the increasingly coloristic use of textural effects in the treatment of the hair, and especially in the rendering of the eyes, where shallow drill-holes suggested light glancing off the pupils, implies that late-Roman sculptors began to move away from the tradition of painted statuary altogether. Uncoloured sculpture has become the norm in more recent centuries — but only because, ironically, the sculptors of the Renaissance who took their inspiration from antique statues did not realize that these had once been coloured.

From the Roman period to the present there have been few fundamental changes in

16 *Unfinished statuette of drunken Dionysus supported by a satyr: Roman work, showing how sculptors of this period carved from front to back, as if working in relief. Ht 71cm. Athens, National Museum 245.* Photo German Archaeological Institute, Athens NM 4888

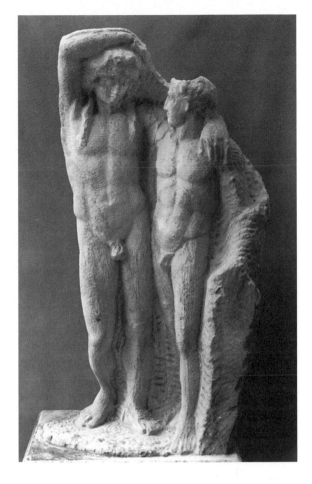

techniques of stone carving. Modern craftsmen still use broadly the same range of tools as their ancient predecessors. There have naturally been improvements in some aspects of mechanical reproduction, as well as changes in the use of materials. In the eighteenth and nineteenth centuries mechanical methods of transfer from a full-size plaster model to marble became more significant and sophisticated, particularly with the introduction of pointing machines in the early nineteenth century. From the mid-nineteenth century sculptors experimented with mixed media to produce 'natural' colour effects, combining, for example, marble and alabaster with bronze and enamel. Finally, there have been two major innovations in the twentieth century that have had an impact on sculptural production: firstly, the tungsten-tipped chisel introduced in the 1950s with a cutting edge that stays sharper for longer; secondly, the pneumatic tool, basically a hand-held air hammer which may be fitted with interchangeable punches, claws and flat chisels, and in which the air pressure may be adjusted to suit different stages of working. But such 'high-tech' methods are not always chosen. Many stone carvers prefer the more traditional methods that have evolved through time — the methods which were first brought to perfection by the sculptors of ancient Greece and Rome.

Bibliography and references

Adam, S. (1966) *The Technique of Greek Sculpture in the Archaic and Classical Periods* (British School of Archaeology at Athens Supplementary Volume 3), London.

Blagg, T.F.C. (1976) 'Tools and techniques of the Roman stonemason in Britain', *Britannia* 7: 152-72.

Blümel, C. (1969) *Greek Sculptors at Work* (2nd edn), London: Phaidon.

Casson, S. (1933) *The Technique of Early Greek Sculpture*, Oxford: University Press.

Étienne, H.J. (1968) *The Chisel in Greek Sculpture*, Leiden: E.J. Brill.

Fant, J.C. (1988) (ed) *Ancient Marble Quarrying and Trade. Papers from a Colloquium Held at the Annual Meeting of the Archaeological Institute of America, San Antonio, Texas, December 1986* (BAR International Series 453), Oxford: B.A.R.

Getz-Preziosi, P. (1985) *Early Cycladic Sculpture: an Introduction*, Malibu: J. Paul Getty Museum.

Hill, P. (1990) 'Traditional handworking of stone: methods and recognition', in J. Ashurst and F.G. Dimes (eds), *Conservation of Building and Decorative Stone* (London: Butterworth-Heinemann) 2: 97-106.

Hodges, H. (1989) *Artifacts: an Introduction to Early Materials and Technology*, London: Duckworth.

Lucas, A. (1962) *Ancient Egyptian Materials and Industries* (4th edn, revised and enlarged by J.R. Harris), London: E. Arnold.

Ridgway, B.S. (1969) 'Stone carving: sculpture', in C. Roebuck (ed.), *The Muses at Work: Arts, Crafts and Professions in Ancient Greece and Rome* (Cambridge, Massachusetts, and London: MIT Press): 96-117.

Rockwell, P. (1990) 'Some reflections on tools and faking', in True and Podany 1990: 207-22.

Rockwell, P. (1991) 'Aphrodisias: unfinished statuary associated with a sculptor's studio', in R.R.R. Smith and K.T. Erim (eds), *Aphrodisias Papers* 2. *The Theatre, a Sculptor's Workshop, Philosophers, and Coin-types* (*Journal of Roman Archaeology*, Supplementary Series 2): 127-43.

Rockwell, P. (1993) *The Art of Stoneworking: a Reference Guide*, Cambridge: University Press.

Stewart, A. (1990) *Greek Sculpture. An Exploration*, New Haven and London: Yale University Press.

Strong, D., and Claridge, A. (1976) 'Marble sculpture', in D. Strong and D. Brown (eds), *Roman Crafts* (London: Duckworth): 195-207.

True, M., and Podany, J. (1990) (eds) *Marble: Art Historical and Scientific Perspectives on Ancient Sculpture* (Papers Delivered at a Symposium Organized by the Departments of Antiquities and Antiquities Conservation and Held at the J. Paul Getty Museum April 28-30, 1988), Malibu: J.Paul Getty Museum.

Vanhove, D. (1987) (ed) *Marbres helléniques. De la carrière au chef d'oeuvre* (exhibition catalogue), Brussels: Crédit Communal

Waelkens, M., De Paepe, P., and Moens, L. (1990) 'The quarrying techniques of the Greek world', in True and Podany 1990: 47-72.

Ward-Perkins, J.B. (1971) 'Quarrying in antiquity', *Proceedings of the British Academy* 57: 137-58.

2 Bronze sculpture

Seán Hemingway

The ancient Greeks and Romans had a long history of making statuary in bronze. Over the course of more than 1000 years they created hundreds of statue types and developed new sculptural styles whose influence on large-scale statuary from Western Europe (and beyond) continues to the present day. Classical Greek idealism, the invention of portraiture, and sculptural types, such as the equestrian statue, are only a few of those achievements. No less significant a legacy are the techniques the Greeks and Romans developed to cast and piece together bronze statuary, techniques whose basic elements remain essentially the same even today. This chapter describes the materials that were used in antiquity and the various methods that were employed by Greek and Roman sculptors to make freestanding large-scale bronze statuary, from the formative stages of the original model to the finishing of the exterior surface.

Bronze is an alloy typically composed of 90% copper and 10% tin. Ancient foundry workers, through trial and error, recognized that the mixture of tin and copper at these percentages had distinct advantages over pure copper for making statuary. Bronze has a lower melting point than pure copper and will therefore stay liquid longer when filling a mould. It produces a better casting than pure copper and has superior tensile strength. While there were many sources for copper around the Mediterranean basin in antiquity, the island of Cyprus, whose Latin name was given by the Romans to the metal, *Cyprium Aes* (literally 'metal of Cyprus'), was among the most important. Tin sources were less common. Consequently, tin had to be imported from places far from mainland Greece and Rome such as Cornwall in England, south-west Turkey, and even Afghanistan. Variations of the tin bronze alloy were adopted and the Roman writer Pliny (*NH* 34.8-10) tells us that the alloys invented on the islands of Delos and Aegina were particularly favoured by the ancient Greeks as was the bronze of Corinth which contained small percentages of silver and gold. Chemical analyses of existing Greek and Roman bronzes have shown that lead, which lowers the melting point of the alloy, was also commonly added to tin bronzes during the Roman period.

The colour of ancient bronze today is usually quite different from its appearance in antiquity, a result of prolonged oxidation and corrosion over hundreds of years. In many cases, most of the original surface has been lost and only the metallic undersurface remains. The rich brown colour of bronze was no doubt valued by the Greeks and Romans for its similarity to oiled, suntanned skin. Bronze statues were also artificially coloured (Born 1990: 188), in whole or in part, either through painting, patination or gilding (Oddy et al. 1990: 103-121) and enlivened by inlays of other materials.

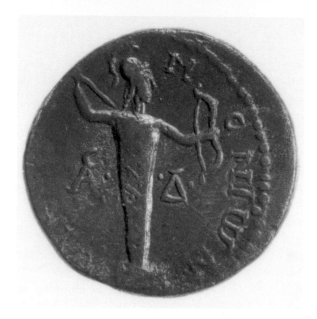

17 *Reverse of Laconian coin from the reign of Commodus illustrating the colossal bronze* sphyrelaton *statue of Apollo at Amyclae. The dotted zigzag lines on the torso represent sheets of metal attached by rivets. Scale approx 3:1.* London, British Museum BMC 80 1855-12-11-40. Photo British Museum

The earliest large-scale Greek bronze statues were not cast. They had very simple forms dictated by their technique of manufacture, known as *sphyrelaton* (literally 'hammer-driven'), in which parts of the statue are made separately of hammered sheet-metal and attached one to another with rivets. Several early Greek monumental cult statues of bronze made in this technique, such as the famous colossal statue of Apollo at Amyclae (Pausanias 3.19.2) near Sparta, are known from literary sources and later images (**17**), but none survives. The technique is better understood from preserved examples of smaller-scale statuary and the study of contemporary bronze vessels and armour (**colour plate 2**) where variations on the *sphyrelaton* technique were also employed (Haynes 1992: 11-23). By the late archaic period (*c*500-480 BC) *sphyrelaton* went out of use as a primary method, and lost wax casting had become the major technique for producing statuary.

Thousands of geometric (*c*900-700 BC) bronze votives from Greek sanctuaries attest to an early tradition of casting small-scale statuettes in Greece. However, archaeological excavations have revealed that the origins of casting large-scale bronze statues in the ancient Mediterranean world belong further east, in Mesopotamia, where statues have been found dating from as early as the third millennium BC. Egypt may have played a fundamental role in transmitting this technology to Greek craftsmen during the so-called orientalizing period of the seventh century BC. Later Greek and Roman authors attribute the local invention of lost wax casting to the East Greek sculptors Rhoecus and Theodorus who were active at this time. Whatever the impetus, the Greeks exploited the capabilities of casting to new limits, and bronze came to be considered the ideal medium for freestanding sculpture, valued for its lustrous beauty and tensile strength. Its popularity remained secure throughout much of the Roman period, when large-scale bronze statues served a multitude of civil, domestic, and religious functions.

Lost wax casting

Lost wax casting was the general technique used by craftsmen to make bronze statuary in classical antiquity. There are three methods for casting by the lost wax process: solid lost wax casting, hollow lost wax casting by the direct process, and hollow lost wax casting by the indirect process. All three methods are closely related. The first and simplest method, solid lost wax casting, in which the model for the object is made of solid wax, was generally used for small-scale objects such as figurines. Occasionally locks of hair and other features of large-scale statues were solid cast and then attached to hollow castings. The direct method was clearly used in the Greek archaic (*c*600-480 BC) and early classical (*c*480-450 BC) periods as a primary technique to make small statuary. In later times it was normally used in conjunction with the indirect process. The indirect process was by far the most commonly used method for producing large-scale statues in classical antiquity. The steps involved in casting by the direct and indirect methods are each discussed in turn below. The essential materials used by the Greeks and Romans for the lost wax casting process, besides bronze itself, were fine beeswax, which was cultivated in antiquity, and clay for the model and mould. Plaster was also sometimes used for models and the cores of statues and statuettes at least in the Hellenistic and Roman periods.

Hollow lost wax casting: the direct method

Since the physical properties of bronze do not allow large solid castings, the use of solid wax models, ie solid lost wax casting, limited the founder to casting very small figures. For example, it is possible to carry only a certain amount of molten bronze; two men can lift and pour about 150lb. Furthermore, the founder can only keep the bronze fluid for a short period of time. If bronze is not cast at a uniform or nearly uniform thickness, it is likely to crack and become deformed as it cools. To deal with these problems, the ancient Greeks adopted the process of hollow lost wax casting. A small early classical head of a youth in the Metropolitan Museum of Art is a fine example of a lost wax casting by the direct method and will serve to illustrate the technique (**18**).

To cast a hollow bronze statue using the direct method, the sculptor first builds up a clay core of the approximate size and shape of the intended statue (**18(1)**). In the case of a large statue, an armature, normally made of iron rods, is used to help stabilize the core. The core is then coated with wax, which is modelled into its finished form. Any final details can be shaped or carved into the wax at this time. It is important to recognize that this is an additive process by which the sculptor may endlessly manipulate the object's form. Such a technique is in contrast to the subtractive process of stone sculpting, where the sculptor must think in negative space; when stone has been removed it cannot be returned to the model. Once the wax model is finished, it is inverted to allow the metal to flow. Wax tubes or gates are attached at key positions for pouring the metal. Other tubes are fitted to the model to act as vents for the hot gases that rise to the surface at the time of casting. Vents facilitate the flow of the metal and allow gases to escape, ensuring a uniform casting. The wax model is linked to the inner core of the clay by iron dowels known as chaplets (**18(2)**), which protrude from the wax model so that they will penetrate the outer layer of clay when it is added in the next step.

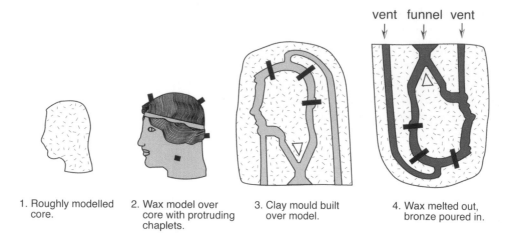

vent funnel vent

1. Roughly modelled core.

2. Wax model over core with protruding chaplets.

3. Clay mould built over model.

4. Wax melted out, bronze poured in.

18 Hollow lost wax casting: the direct method. Drawing S. Hemingway

The entire model is then coated with fine clay to ensure a good cast from the mould. Fine clay will warp less than coarse clay when the mould dries and will render the details of the wax model faithfully. Both the model and the pouring channels are completely covered or invested in a coarse outer layer of clay (**18(3)**). The invested model is heated to remove all the wax, creating a hollow matrix. The mould is reheated for a longer period of time to bake the clay and burn out any wax residue. It is now ready to receive molten metal. Bronze is heated in a crucible by a furnace until it melts. The copper alloy is then poured through the funnel into the mould until the entire matrix has been filled (**18(4)**). When the bronze has cooled sufficiently, the mould is broken open and the bronze is ready for the finishing processes.

Hollow lost wax casting: the indirect method

Indirect lost wax casting is especially well suited to piece casting large-scale statuary. While it is technically possible to cast an entire statue as a unit, there is no evidence that this was done in antiquity. So difficult is it that even during the height of bronzemaking activity in the Renaissance only a few master sculptors — such as Benvenuto Cellini — attempted it, just to prove that it could be done. Typically, large-scale sculpture was cast in several pieces, such as head, torso, arms, and legs. Fundamental to the indirect process is the use of a master model from which moulds are made. Pliny (*NH* 35.153) attributes the first use of master models, of both plaster and clay, for lost wax casting of human statues to Lysistratus of Sicyon, brother of Lysippus, the famous fourth-century BC sculptor. However, the tradition is undoubtedly older than that. While very few master models survive from antiquity, one likely example is a fragmentary Classical Greek standing female figure made of terracotta, now in the Metropolitan Museum of Art (**19**). Excavations of an early-Imperial Roman sculptors' workshop at Baiae near Naples (Landwehr 1985) have yielded many fragmentary plaster casts of statues, which would

have been used as models for bronze statues as well as marble ones. The great advantage of the indirect method is that the original model is not lost in the casting process. It is therefore possible to recast sections if necessary and to make series of the same statue. Despite the great paucity of existing original bronze statues from antiquity, recent research (Mattusch 1996a: 141-190; Mattusch 1996b: 259-262) has identified bronze statues made from the same original model (**20, 21**). Because of these advantages, the majority of all large-scale ancient Greek and Roman bronze statues were made using the indirect method. A typical classicizing statue of a youth is used to illustrate the casting process.

First a model for the statue is made (**22(1)**) in the sculptor's preferred medium. A mould known as a master mould is then made around it to replicate its form. The mould is used in as few sections as can be taken off without damaging any undercut modelling. In the case of a simple form such as an open hand (**22(1-2)**), the mould could have been made in two parts. Upon drying, the individual pieces of the mould are reassembled and secured together. Each mould segment is lined with a layer of beeswax. The beeswax may have been brushed on, applied in slabs, or poured in a molten state (**22(3)**), slushed around the interior, and then poured out (**22(4)**), leaving a thin layer.

After the wax has cooled, the master mould is removed to reveal the working model. At this point the bronze sculptor checks to see that the wax moulds are accurate. If features were disfigured in the transfer from the master model, they can still easily be corrected in the wax before the statue is committed to bronze.

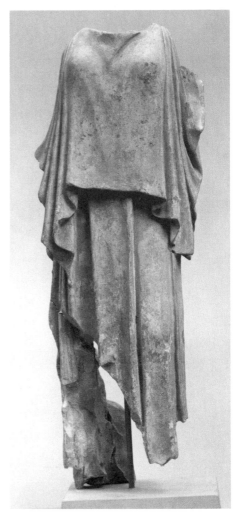

19 *Terracotta model for a small bronze statue of a draped female figure. Greek, c450 BC. Ht 45cm. New York, Metropolitan Museum of Art, Rogers Fund, 1906 (06.1151).* Photo Metropolitan Museum of Art

The sculptor then renders more detail in the wax, such as fingernails (**22(5)**). Several auxiliary measures are taken to ensure that the core and clay investment do not slip when the wax is melted out. An armature, usually consisting of thick iron rods, may be inserted to stabilize and strengthen the core. As in the direct method, chaplets of iron or bronze are stuck through the wax model into the core at several points (**22(5)**). The chaplet heads are left exposed in order to create a bond between the clay and the investment core.

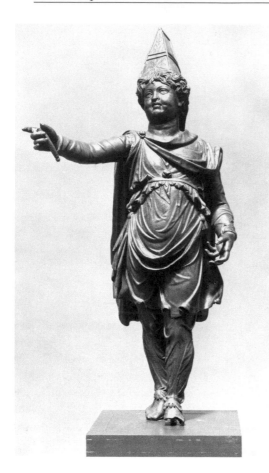
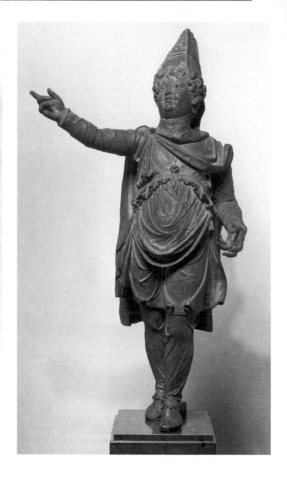

20 (left) Small bronze statue of a boy in eastern costume. Late Hellenistic or Roman, second half of first century BC. Ht 64cm. New York, Metropolitan Museum of Art, Edith Perry Chapman Fund, 1949 (49.11.3). Photo Metropolitan Museum of Art

21 Small bronze statue of a boy, twin to 20. Late Hellenistic or Roman, second half of first century BC. Ht 62cm. Baltimore, Walters Art Gallery 54.1330. Photo Walters Art Gallery

A wax gate system, which will, when melted, become funnel, channels and vents, is attached to the model (**22(6)**). The entire ensemble is invested in one or more layers of clay (**22(7)**). The layer closest to the wax model consists of a fine clay and may be brushed on. The outer layer or layers consist of coarser clay. The mould is filled with a clay core, which may be applied in layers, each one dried before the next is added. As in the direct method, the mould is heated and the wax poured out (**22(7)**). It is then baked at a high temperature. Finally, the mould is reheated and molten metal is poured in. When this metal cools, the mould is broken open (**22(8)**) to reveal the cast bronze hand of the statue (**22(9)**).

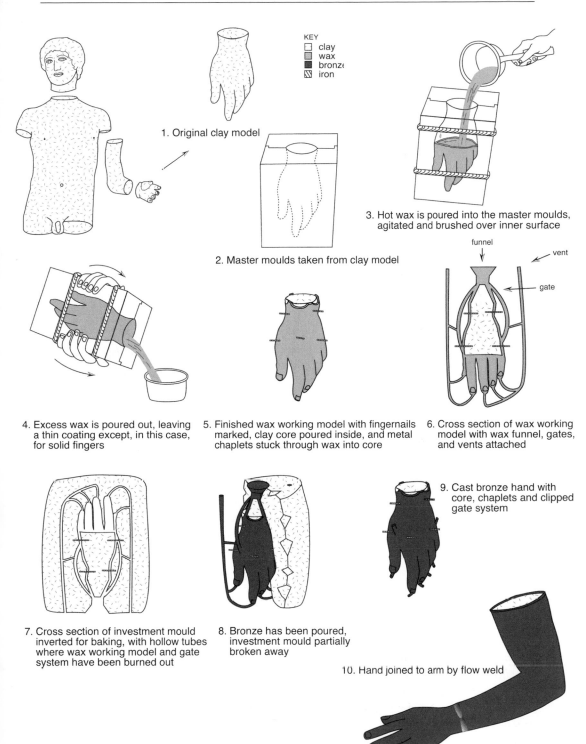

KEY
☐ clay
▨ wax
■ bronze
▨ iron

1. Original clay model

2. Master moulds taken from clay model

3. Hot wax is poured into the master moulds, agitated and brushed over inner surface

4. Excess wax is poured out, leaving a thin coating except, in this case, for solid fingers

5. Finished wax working model with fingernails marked, clay core poured inside, and metal chaplets stuck through wax into core

6. Cross section of wax working model with wax funnel, gates, and vents attached

funnel

vent

gate

7. Cross section of investment mould inverted for baking, with hollow tubes where wax working model and gate system have been burned out

8. Bronze has been poured, investment mould partially broken away

9. Cast bronze hand with core, chaplets and clipped gate system

10. Hand joined to arm by flow weld

22 Hollow lost wax casting: the indirect method. Drawing S. Hemingway

Finishing and joining techniques

When a bronze is first broken open from its mould it has a surface known as a casting skin, often with small imperfections, which needs to be removed to achieve the desired surface finish. While the statue is still in pieces, this casting skin is removed with abrasives and any protrusions left by the pouring channels and chaplets are cut off. The separately cast parts of the bronze are then joined together by either metallurgical or mechanical means or by a combination of the two. One of the most common metallurgical techniques for joining is known as a flow weld. The hand is placed next to the arm and secured in some fashion, possibly with a brace or metal wire. Narrow gaps are left open between the joining edges of the two pieces to create a wider bonding area when the two pieces are joined. Molten bronze is poured onto the join, into the gaps, and on the edges, creating a metallurgical bond (**22**(10)). This is done in a series of pourings, rotating the hand so as to complete the circumference. A temporary mould may have been fashioned around the join to ensure that the bronze flowed only on the correct area.

A few final procedures are performed before the statue is complete. Decorative lines such as hair and other surface details may be emphasized by means of cold working with a chisel. Any significant blemishes on the surface of the bronze and holes created by the chaplets are patched mechanically with rectangular pieces of metal that are hammered into place. Additional elements may be inserted such as glass, silver or even pebbles for eyes (**colour plate 3**). Sometimes features were accentuated by inlaying them with a different metal (**colour plate 4**): typical examples are copper lips and nipples, and silver teeth and fingernails. Garments also received inlay. When appropriate, further decorative elements may have been added, such as necklaces and bracelets.

Modern methods for studying ancient materials and manufacturing techniques

Ancient illustrations, literary testimonia, finds from excavations of ancient foundries, including actual mould fragments and metallurgical tools, modern ethnographic parallels for metalworking — all contribute to the picture of how ancient Greek and Roman bronze statues were made. Just as important is the wealth of objective information yielded from scientific analyses and physical examinations of extant bronzes. Visual examination remains the fundamental starting point for the technical analysis of an ancient bronze statue. Many technical features related to the manufacturing processes discussed above can be identified especially if visual access to the interior of the statue is possible.

Modern technology provides a growing array of analytical techniques for the study of Greek and Roman bronze statues. Chemical analysis can identify the composition of the metal alloy and inlaid materials. Non-destructive techniques, such as X-ray fluorescence (XRF) and proton-induced X-ray emission (PIXE), obtain this information from the surface of the metal. Destructive techniques, such as Atomic Absorption Analysis (AAA) or Neutron Activation Analysis (NAA), require a small sample to be taken from the object but allow for a very precise quantitative alloy analysis. When significant quantities of lead

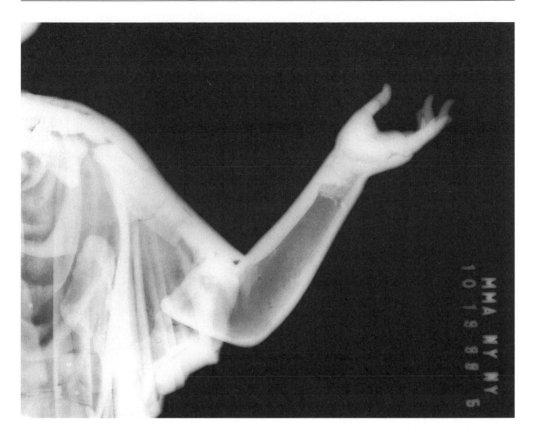

23 X-radiograph of the left arm and shoulder of a bronze camillus *(**colour plate 4**). The ancient socket join between the arm and the tunic is clearly visible. The hand was repaired in antiquity. Modern restoration of the interior includes circular screws and large rectangular patches on the body.* Photo Metropolitan Museum of Art

are present in the copper alloy, as is often the case with Roman and Etruscan bronzes, lead isotope analysis can help to determine the general age of the object and potentially relate the lead to its parent ore source. Other scientific techniques, such as X-ray diffraction analysis and Scanning Electron Microscopy (SEM) can be used to study and identify corrosion products on the bronze. Metallography looks at the structure of the metal by taking a thin section from the bronze, polishing its surface and examining it under high magnification. Radiography (**23**) can clarify the location of joins and other features of the bronze observed by visual examination. The knowledge gained from all of these scientific analyses provides insight into the technical methods and achievements of Greek and Roman bronze sculptors, allowing us to appreciate another, ancient, context of these remarkable works of art.

Bibliography and references

Born, H. (1990) 'Patinated and painted bronzes: exotic technique or ancient tradition', in *Small Bronze Sculpture from the Ancient World* (Malibu: J. Paul Getty Museum): 179-196.

Haynes, D. (1992) *The Technique of Greek Bronze Statuary*, Mainz: Philipp von Zabern.

Landwehr, C. (1985) *Die antiken Gipsabgüsse aus Baiae. Griechische Bronzestatuen in Abgüssen römischer Zeit*, Berlin: Mann.

Mattusch, C.C. (1996a) *Classical Bronzes: the Art and Craft of Greek and Roman Statuary*, Ithaca: Cornell University Press.

Mattusch, C.C. (1996b) *The Fire of Hephaistos: Large Classical Bronzes from North American Collections*, Cambridge: Harvard University Art Museums.

Mertens, J.R. (1985) 'Greek bronzes in the Metropolitan Museum of Art', *Metropolitan Museum of Art Bulletin* 43.2: 1-66.

The Metropolitan Museum of Art, Greece and Rome (1987) New York: Metropolitan Museum of Art.

Oddy, W.A., Cowell, M.R., Craddock, P.T., and Hook, D.R. (1990) 'The gilding of bronze sculpture in the Classical world', in *Small Bronze Sculpture from the Ancient World* (Malibu: J. Paul Getty Museum): 103-124.

Rolley, C. (1986) *Greek Bronzes*, translated by Roger Howell, London: Sotheby's Publications.

3 Wall and panel painting

Roger and Lesley Ling

Introduction

Throughout the history of mankind there has been wall-decoration. From the earliest hand-prints of cave-dwellers over 30,000 years ago, through the marvellous fresco paintings of the classical and Renaissance periods, to modern printed wallpaper and posters, man has had a basic urge to beautify the interior of his home and of the various buildings which form a setting for human activities.

This wall-decoration takes a great variety of forms. It includes hangings, either covering a large part of the surface (tapestries) or forming a focus within it (framed pictures), decorations which are stuck to the surface but may be relatively easily removed (wallpaper and posters), and decorations which are more permanent fixtures. It is with the latter that the present chapter will be concerned. Mural paintings, with a few exceptions, are bonded to the fabric of the wall in such a way that they can be removed only by cutting or chipping them away; if they are to be renewed, they are often simply covered by a new layer.

Being fixed decorations, wall-paintings cannot properly be thought of as independent works of art: they form an integral part of their architectural setting. They are normally created on the spot, and the artist takes account of the physical environment — the size and shape of the room, the position of doors, windows and other features, the sources of illumination. The paintings may be designed to reflect these factors, for example by favouring a particular viewpoint, by adopting a particular scale, or by articulating and organizing architectural space. More specifically they may complement the function of the room by choosing appropriate themes (scenes of revelry in dining-rooms, references to water in bathrooms, and so forth), or may seek to enhance and enlarge the room by the use of visual metaphors (an open sky or an overhanging pergola on the ceiling, vistas of landscape or receding planes of architecture on the walls). The transforming effect of these decorations can be quite remarkable, and the importance attached to them is attested by the technical sophistication achieved by the best work.

Painted panels

The fact that this chapter focuses on fixed wall-paintings does not mean that there were no portable panel-paintings in antiquity, merely that very little is known of them and of their production techniques. All that we have are a few minor pieces, such as the panels

of late sixth-century BC date from a cave at Pitsa near Sicyon, and a series of portraits painted to decorate mummy cases in Roman Egypt (Shore 1962; Walker and Bierbrier 1997) (**colour plate 18**). These were all of wood, mostly coated with a white primer or a thin layer of gypsum plaster to which pigments were applied in the tempera technique (see below). Although there is no direct evidence, we may conjecture that a similar technique was used for the production of the lost masterpieces of Zeuxis, Parrhasius, Apelles, Protogenes and other famous painters of Greek times. But there was also a class of paintings, executed not just on wood but on materials such as stone and ivory, which employed a different technique called 'encaustic'. Here the colours were literally 'burnt in', evidently by mixing pigments with hot wax. Certain painters such as Nicias are said by Pliny to have been specialists in this process, which required the use of some kind of spatula rather than the brush of the tempera painter.

One of the drawbacks of painted wooden panels was their vulnerability. Already in antiquity we hear of famous works which needed conservation and of others which were vandalized or destroyed in fires. The problem of deterioration seems to have concerned even the original painters. A special varnish patented by Apelles was designed to protect the colours of his paintings as much as to enhance them. Protogenes is said to have applied multiple coats of paint to guard against damage and decay. It also appears to have been common to provide panels with doors which could be closed to keep out light and dust (**24**) (sometimes these doors themselves, as in the triptychs of the Renaissance, carried additional paintings, called *parergia*). However, all such measures were ultimately in vain. It is the wall-paintings that have normally survived while the panel-pictures have been lost.

The greater durability of painting executed on lime-plaster in the fresco technique may have been one of the factors that commended the method to ancient patrons; at all events, there is evidence in Roman times for the increasing prestige of wall-painting. The encyclopaedist Pliny, writing in the first century AD, actually laments the switch of emphasis from panels to walls because, in his view, the confining of paintings to the interior of buildings denied them to the wider public. The great panel-painters of the past, he proclaims, had produced their works not for the houses of private patrons but for the benefit of cities. But Pliny's criticism is only partly justified. Many of the murals of antiquity were in buildings which were open to the public; and even those in residential contexts were to some extent accessible to outsiders, given that well-to-do householders, especially in Roman times, often used their homes for the transaction of public business. At the same time, the tradition of wall-painting was clearly much older and more firmly engrained in human experience than the portable pictures admired by Pliny, which were a comparatively recent phenomenon.

Technical processes

The techniques practised by wall-painters in ancient times were determined initially by the nature of the 'support'. This can be divided into three main categories: wooden hoardings fastened to the wall, the wall itself, or a rendering spread over the wall.

24 *Painting of a painted panel (*pinax*) with half-open doors. Pompeii, Villa of the Mysteries,* cubiculum 4, *alcove B, right wall.* Photo J. Engemann

Wooden hoardings were standard in classical Greece, but are attested mainly by negative evidence: drill-holes and fragments of iron pins in the masonry to which they were attached. For the techniques used in painting them and for the conservation problems that they posed the comments already made about portable panels will presumably be applicable.

Paintings applied directly to the wall are known chiefly from caves and rock-cut tombs. In these circumstances they are rarely well preserved except where they have remained protected from bright light and from fluctuations of temperature or humidity. In some limestone caves, however, the paintings have been preserved by a kind of natural fresco process, the damp conditions dissolving calcium carbonate, which then recrystallizes on the surface and fixes the colours.

Painting on a rendered surface is the most common technique. The rendering, designed to cover irregularities in the wall and to provide the artist with a smooth surface to work upon, can be of clay or plaster. Clay is less satisfactory because it shrinks and cracks upon drying, and the slow rate at which it absorbs water causes problems if damp becomes trapped behind it or rises from floor-level. Plaster, or at least lime plaster (gypsum plaster is much less damp-resistant), when mixed with an inert aggregate such as sand or marble dust, dries without much shrinkage, allows moisture to escape through its pores, and produces a hard, light-coloured surface for the painter. Invariably with clay, and frequently with plaster, the pigments are applied after the support has dried (painting *a secco*); in which case they are usually mixed with some form of organic medium, such as gum, animal glue or size, casein, egg white, wax, or vegetable oils, to bind them to the

surface. This is the so-called 'tempera' technique. On plaster, however, the best results are achieved if the pigments are applied to a surface which is still fresh and soft; most of them do not then need a medium because the setting of the plaster itself secures their adherence. When well executed, this 'fresco' technique results in a decoration whose colours are much less vulnerable to flaking or fading.

The success of fresco depends upon the chemical properties of lime. This does not normally exist in an independent form in nature, but is obtained by the roasting or 'burning' of the various kinds of rock which consist chemically of calcium carbonate — limestone, marble and chalk. When heated to a temperature of 850-900°C, these rocks give off carbon dioxide and crumble into powdery lumps of calcium oxide (quicklime), a reaction which can be expressed in the following chemical equation: $CaCO_3 \rightarrow CaO + CO_2$. Quicklime is unstable and takes up moisture from the air to form a fine white powder known as 'slaked lime' (calcium hydroxide): $CaO + H_2O = Ca(OH)_2$. If further water is added, it produces a paste which is mixed with sand or other inert materials for use by plasterers. Then, when this preparation is spread on the wall, it 'sets' as a result of a chemical reaction between the lime and carbon dioxide in the air to re-form calcium carbonate: $Ca(OH)_2 + CO_2 = CaCO_3 + H_2O$.

The process of setting releases water, which escapes to the exterior and evaporates. But if enough water is present a 'supersaturated' solution of calcium carbonate is produced, from which a crystalline layer precipitates over the surface. It is this that binds the pigments in the fresco technique. They do not sink into the plaster, as is often wrongly claimed, but are permeated by the tiny crystals, which knit together and hold them in a kind of web.

It is obviously necessary, if fresco painting is to succeed, that the optimum conditions of dampness are achieved. The wall-fabric and any undercoats of plaster must not be too dry, else they will absorb water needed in the setting process; and the atmosphere in the room must be kept relatively cool and airless to prevent the plaster from drying too rapidly. Even with these precautions the plaster will remain sufficiently 'fresh' for only a day or so. This dictates the most distinctive feature of fresco-work: its piecemeal treatment of the wall. Instead of the whole surface being plastered before painting commences, it is divided into limited areas which are plastered and painted a day at a time: the so-called 'day's work' units, or *giornate di lavoro*. The joints between these units are usually carefully concealed, being made to coincide with divisions in the decorative scheme or with the contours of figures or objects; but sometimes they simply run horizontally across the wall, corresponding to a stage of scaffolding, in which case they are called *pontate di lavoro* (**colour plate 5**). In either event the lack of an overview during the course of painting can present difficulties, especially where the decoration is elaborate. Another feature of work in fresco is the planning of decorative schemes by means of full-scale drawings on the *arriccio*, or plaster undercoat; these *sinopie*, named after the type of red ochre (from Sinope on the Black Sea) in which they are carried out, act as a constant guide to the artist as he completes each section of the final painting.

In addition to true fresco, executed on fresh plaster without the aid of media, there are techniques which might be described as hybrid. On the one hand it is possible to apply pigments mixed with an organic medium to fresh plaster; a dilute size solution, for

example, will retard but not prevent the normal setting of the lime, so a binding can be achieved with both lime and size. With certain pigments which will not readily mix with water such methods are inevitable. On the other hand, if the plaster is already dry, it is possible to apply the pigments suspended in a very dilute solution of lime ('lime water'), which will then react with carbon dioxide in the air just like the lime in fresh plaster. In this technique, often wrongly referred to as 'fresco secco', the colours are again fixed by the precipitation of calcium carbonate crystals, but it is the lime with which they have been mixed, not the lime in the plaster, which acts as a binder.

The prehistoric and protohistoric periods

The first true wall-paintings appear in the palaeolithic cave-dwellings of France and Spain. Images were created directly on the rock, without the addition of a rendering or the use of a medium; but already a number of pigments and a relatively sophisticated range of techniques were employed. At Lascaux in Dordogne, for example, the pigments included ochres, charcoal or bone black, and a white probably obtained from clay, and the techniques of applying them included outline drawing in charcoal, dabbing with a damp pad, and blowing powdered pigments through a tube or from the mouth. The resulting textural effects in the representation of wild animals (**25**) are remarkably true to life.

With the introduction of built architecture in the Neolithic period we get the first wall-paintings applied over renderings. At Çatal Höyük in Anatolia houses of raw bricks were rendered with coats of mud or clay, to which the pigments (ochres, haematite, azurite and charcoal) were applied apparently without a medium. Similar techniques were practised in the great agrarian civilizations which emerged in Egypt and the Middle East during the last millennia BC. But here refinements were rapidly introduced. Often a rendering of clay contained chopped straw to ensure greater cohesion, and from at least the second millennium it became common to provide a surface coat in a finer material. In Mesopotamia there are examples of thin surface coats of limewash, and in Egypt the top layer was of gypsum plaster, obtained from locally available rocks and crystalline deposits (gypsum is a hydrate of calcium sulphate, and is used commercially today to make 'plaster of Paris').

Egyptian paintings, and probably most Mesopotamian ones too, were executed in tempera on a dry surface. But for work on lime-plaster or limewash it cannot have been long before painters discovered, perhaps fortuitously, the fixing properties of fresco. Already at the beginning of the second millennium there were paintings at Alalakh in northern Syria which the excavators believe were executed *a fresco*; and the paintings of Minoan Crete and Mycenean Greece almost certainly adopted the same technique. This is indicated by traces of guide-lines incised or imprinted in the fresh plaster, by surface depressions made at the time of painting, and by horizontal joins between *pontate di lavoro*.

For detailed information on working procedures in the protohistoric period our best source is Egypt, with its numerous well-preserved tomb-paintings. An interesting feature is the use of a preliminary grid of squares to fix the scale and proportions of the subjects represented. This device, employed also by Egyptian sculptors to map out the forms of a

25 *Horse: detail of cave paintings at Lascaux, Dordogne (France). The animal was carried out, at least in part, by spitting or spraying the paint. Approx 17,000 years before present. Length approx 1.50m.* Photo Paul Bahn

statue on the faces of a stone block, can be observed on half-finished paintings, which show construction lines made by snapping a cord soaked in red paint against the surface (**26**). Using the grid as a guide, the painter carried out a preliminary drawing in red, then filled in the areas with flat washes of colour, before overpainting details in other colours. The contours could finally be reinforced in red or black. The pigments employed were mainly the natural earth colours used throughout the early period, but an important addition was blue frit, or 'Egyptian blue', which was produced artificially by baking a mixture of copper, soda and sand. This pigment, introduced from Egypt to Crete by the nineteenth century BC, was destined to remain the standard blue of wall-painters till the Middle Ages.

The classical period

With classical Greece we reach the first wall-paintings recorded in literature: the murals of Polygnotus and Micon in the shrine of Theseus and the Stoa Poecile (Many-Coloured Portico) in Athens, and those of Polygnotus in the Lesche (club house) of the Cnidians at Delphi. These grand multi-figure mythological and historical compositions, which no

26 Egyptian wall painting showing a grid of construction lines. From the tomb of Sarenput II, overseer of the priests of Khnum at Aswan. Dynasty XII, reign of Amenemhat II (1929-1895 BC). Figure approx 1.00m high. Photo R. Partridge, Ancient Egypt Picture Library

longer survive, were evidently executed on wooden hoardings, with the colours applied over a white primer. But the use of wooden panels did not entirely oust the practice of painting on plaster. Tomb-chambers at least were so decorated, as indicated by many examples in the cemeteries of Etruria (which were culturally and artistically dependent on the Greeks), of Greek cities in Italy (notably Paestum), and of the Macedonian kingdom which gained political supremacy over Greece and the Aegean during the fourth century BC. In one tomb of the royal cemetery at Vergina (Aegeae) in Macedonia the two techniques may have been practised side by side: while the interior contained a frieze of a chariot-race painted on the plaster (**117**), on the façade were traces of organic material which the excavator interpreted as belonging to a frieze of painted wooden panels.

It is probable that Greek paintings on plaster normally employed the fresco technique. This is certainly true of a domed chamber-tomb at Kazanluk in Thrace (modern Bulgaria) where the paintings were executed, if not by Greeks, then under strong Greek influence. The lower parts of the walls of the entrance-passage and the domed chamber were burnished after painting, and the burnishing has caused slight compaction of the plaster, which indicates that the plaster was still soft. The practical advantage of such burnishing, which is attested even in Minoan times, was to help to secure the retention of the pigments, both mechanically by smoothing the surface, and chemically by drawing out more lime for conversion into calcium carbonate. In the Hellenistic (late-Greek) period it

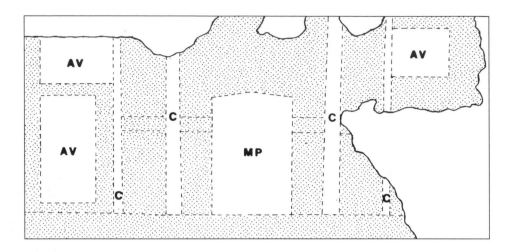

27 Diagram of giornate di lavoro *('day's work' areas) in a frescoed wall in the so-called House of Livia in Rome. The joints are indicated by broken lines; the stippled areas are coarse plaster; the plain areas are fine plaster for detailed painting (MP = mythological picture; C = column; AV = architectural vista).* Drawing R.J. Ling, after *Bollettino d'arte* 34 (1949), 149, fig 8

became a standard procedure, associated particularly with the imitations of coloured ashlar or marble veneer which were the predominant fashion in interior decoration. The best-quality work was burnished till it produced a sheen reminiscent of polished marble.

The techniques of the Hellenistic Greeks were passed on to the wall-painters of Roman times. Here we are much better informed than for previous periods, thanks partly to the abundant remains of painted plaster from archaeological sites such as Pompeii and Herculaneum and partly to the existence of literary evidence.

The principal literary source is Vitruvius, who devotes one of the 10 books in his treatise on architecture (written in the 20s BC) to the methods and materials of interior decoration. He leaves no doubt that wall-painters regularly used the fresco technique: 'When the colours are carefully laid upon the damp plaster, they do not fail but are permanently durable'. To ensure the best results the plaster support must be prepared with elaborate care. No less than seven coats are recommended: a rough rendering, then three coats of a plaster containing sand, and three of a plaster containing powdered marble. Each is to be applied before the previous one is quite dry, and the last layers are made progressively thinner. The whole is worked over with plasterers' floats or similar smoothing implements to produce a firm ground, so that 'when the colours are applied and polished the walls will produce a brilliant sheen' (Vitruvius 7.3.5-7).

The object of this elaborate preparation is to secure a homogeneous mass and one that will retain its moisture for a long period. Too rapid drying reduces the time available to the painter, and also increases the danger of cracks developing. The use of powdered marble in the top coats provides a fine white surface and possibly enhances the lustre produced by polishing, since the effect of the friction will be to force the tiny mirror-like surfaces of the marble crystals into alignment with the plane of the surface.

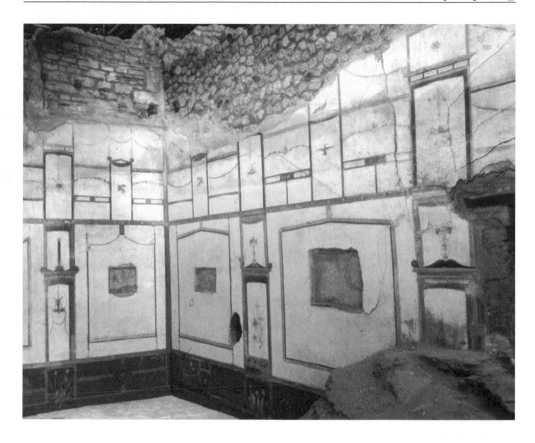

28 Roman wall decoration awaiting painting of the central pictures. Square spaces have been chipped away in readiness for the application of fresh plaster. Pompeii, newly excavated house in Region IX. AD 79. Photo Archaeological Superintendency Pompeii

Naturally, not all Roman plaster lived up to Vitruvius' ideal. The norm at Pompeii is only two or three coats of plaster, and the filler in the surface coat is not marble but sand and some cheaper material such as calcite or gypsum. But the best work in the imperial residences in Rome provides examples of six-layer techniques. In the beautiful frescoes of the Farnesina villa in Rome, dated about 20 BC and thought by some to have been commissioned by the emperor Augustus' daughter and son-in-law, there are three undercoats with an aggregate of sand and *pozzolana* (volcanic earth) and three top coats containing sand and marble-dust (Cagiano de Azevedo 1958). A similar multi-layer technique is attested in the so-called House of Livia, part of Augustus' property on the Roman Palatine (*c*30 BC) (Cagiano de Azevedo 1949).

That the technique used by Roman painters was fresco is confirmed by numerous clear examples of the joints between *giornate* and *pontate di lavoro*. The standard division of the wall was into three *pontate*, which corresponded to the three zones into which the decorative schemes were normally divided; indeed, the emergence of a trizonal decorative system may have been conditioned by this technical procedure. Only in very long walls or

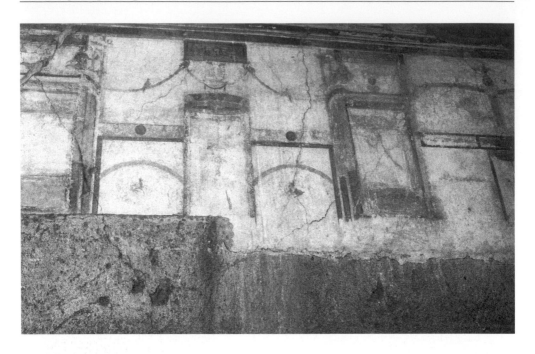

29 Unfinished Roman wall-decoration in the fresco technique. The upper zone of the wall has been plastered and painted, and the craftsman has begun to trim the bottom edge in preparation for the middle zone; work in this house was perhaps interrupted by the disastrous earthquake of 5 February AD 62. Pompeii, House of the Iliadic Shrine. Photo Shelagh Gregory

elaborate decorations are vertical divisions also found. Sometimes, however, as in the so-called House of Livia, there is quite a complex pattern of *giornate*, with finer plaster for figure-subjects and architectural perspectives, and coarser plaster for areas of plain painting (**27**). For elements in the decoration which required special treatment, notably the picture-panels used as centrepieces in the grander schemes, it was not unusual to chip away part of the surface and apply fresh plaster after the rest of the wall had been painted (**28**). (Sometimes, indeed, panel-pictures were executed separately in wooden frames and installed in the wall after completion (Maiuri 1937-8, 1939).) The mode of operation is vividly illustrated in unfinished decorations, such as those of the House of the Iliadic Shrine at Pompeii, where some rooms show one or two of the three zones fully plastered and painted (but with spaces left for the central pictures) while the lower part of the wall still lacks its final coat of plaster. In one bedroom we see how the decorator, having finished a zone, trimmed the irregular edge of the plaster to a straight line before starting the next *pontata* (**29**).

Roman painters used the full range of preparatory drawings found in the fresco work of later ages. Of full-scale *sinopie* on the *arriccio* a well-known example appears on the east wall of the grand saloon in the House of the Labyrinth at Pompeii (**30**); the lay-out of the architectural scheme, which was of familiar type but would naturally have had to be adapted to the size and shape of this particular wall, was mapped out in advance in red

30 Damaged wall paintings showing a sinopia *(preparatory drawing in red ochre) on the mortar undercoat at the left. Part of the finished painting of an architectural scheme survives at the right. Pompeii, House of the Labyrinth. Mid first century BC.* Photo Claudine Allag

ochre. More frequently we find remains of such drawings on the final surface, either in red ochre or (from the first century AD onwards) incised or imprinted in the soft plaster. Not only the basic framework, which was carefully ruled and measured, but also figures and the like were planned in this way (Barbet and Allag 1972) (**31**). For figures, however, the drawings show a remarkable freedom; each was sketched from memory or copied by eye from a pattern-book. There was no mechanical tracing of cartoons. This helps to account for one of the characteristic features of Roman wall-painting: its tendency to compose variations upon a theme (Ling 1991: 128-35, 220). The picture-panels in particular show how standard compositions which ultimately go back to Greek 'old masters' reappear with figures in different positions or postures, with certain figures added or subtracted, with different background settings, and with a myriad of variations in colour and proportion (chapter 14).

If the basic technique was fresco, this does not exclude the use of tempera for some subsidiary elements, and especially for the ornamental detail painted over coloured backgrounds. Once the surface had been coloured and polished, it might have been

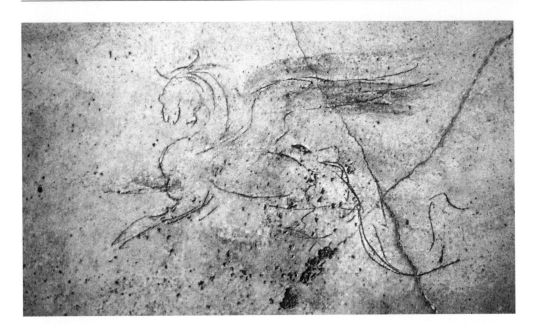

31 Incised sketch for a griffin. The paint has largely disappeared through exposure to weathering, revealing the preliminary drawing which served as the painter's guide. Pompeii, House of the Small Fountain. Third quarter of first century AD. Photo J.-P. Adam

necessary to apply such detail with some form of organic medium which would enable it to adhere. Sometimes, as in the paintings at Dura-Europus discussed in chapter 15, the whole process seems to have been carried out in tempera. But scientific tests aimed at identifying the presence of media in ancient pigments have rarely proved conclusive, and it is clear from close examination of surviving murals that even secondary paint-layers could be fixed by a fresco reaction.

The basic pigments of Roman wall-painting are what Pliny calls the 'colores austeri' ('plain colours') — red and yellow ochre, green earth, chalk white, carbon black, blue frit, and the like. Most of these are water-dispersible and can be applied without difficulty to damp plaster. Black, however, obtained from burning such materials as resin, brushwood or wine-lees, had to be mixed with size because its oily nature would cause it to shed water; it was thus the only pigment which was invariably applied with an organic medium, whether on dry plaster or, as normal, on damp. Other pigments are described as 'florid' and, because of their high cost, were not usually held in stock by painters. Of these, cinnabar, a rich red obtained from Spain, is attested at Pompeii and elsewhere, always in wealthy houses and generally only in the best rooms of those houses. It has the disadvantage of turning black on exposure to bright light, and to maintain it the ancients were forced to resort to an elaborate ritual of treatment with heated wax and oil — an inconvenience which must in itself have militated against widespread use. One last, and doubtless even more expensive, colouring agent was gold leaf. Used to enhance selected details in *de luxe* decorations, notably on vaults and ceilings, it was applied on an undercoat

of white or yellow pigment with the aid of an organic medium such as size or casein.

The Romans may be said to have elevated fresco-painting to a major art form; the most famous artists of the time worked on murals rather than, as in the Greek period, upon easel pictures. At the same time fresco became a universal art form, available even to middle-class householders in small provincial towns. This is not to say that it was produced cheaply. A surprisingly high standard was achieved across the board, and a decoration in an ordinary dining-room could represent a considerable investment. The cost of the paintings and the measures taken to preserve them are indicated by frequent examples of patches or repairs, even if the matching of the style of the repair with that of the original was sometimes crude (**colour plate 6**). Conversely, figure-subjects and decorative motifs were sometimes salvaged from old decorations for reuse in new ones; we even hear of panels cut from walls in historic buildings and set in wooden frames to be exhibited like old masters or collectors' pieces (Vitruvius 2.8.9; Pliny, *NH* 35.154, 173). A more bizarre reversal of the roles of wall-painting and panel-painting could scarcely be imagined.

After antiquity

The techniques perfected in antiquity have remained fundamental to much of the subsequent history of wall-painting. There have naturally been shifts of emphasis from period to period and from place to place, while in certain periods techniques have varied from painter to painter or even from one work to another produced by a single painter. In the Byzantine world, broadly speaking, most important paintings retained the fresco technique, the preliminary drawings and the burnishing characteristic of the best Roman work; their chief novelty was the practice of building up colour by a series of separate overlays. Regional and chronological variations were, however, becoming increasingly apparent. In the West, during the early medieval period, techniques became much more perfunctory, with the application of one or two coarse layers of plaster at best, and a marked absence of burnishing; in the better quality work the normal method of applying colour was in a combination of fresco and secco, though true fresco continued to be used extensively in the catacombs, the early Christian churches of Rome, and the crypts and small churches scattered throughout Europe. In the Romanesque period, techniques became increasingly complex, with the use of *sinopie*, which had tended to lapse in early medieval times, becoming more common again, and embellishment of the painting by gilding and by the incorporation of elements in relief appearing during the later years. In the Gothic period, many northern artists attempted to develop glowing and translucent effects, similar to those achieved in panel painting, by laying first a ground tone or metallic leaf, then translucent layers of paint mixed with carefully selected oils, glues, resins or varnishes, over an impermeable primer.

The Italian Renaissance saw both a studied concern for reproducing the techniques of classical antiquity and also a growing desire to refine and improve existing techniques. During the Early Renaissance, painters employed increasingly complex forms of mixed techniques, combining fresco with tempera in very different fashions, and, in the case of

the Sienese and Venetians, adding relief work, ornamentation and gilding reminiscent of northern work. By contrast, High Renaissance painters such as Michelangelo, Vasari, Raphael and the Venetians made a virtue of using pure fresco, partly because of the supposedly heroic nature of the technique, whilst proceeding to develop a thicker application of the pigments in an *impasto* technique, which gave the painting a more tactile quality. In the planning of the figures the greater complexity of compositions led to increasingly sophisticated preparatory techniques. *Sinopie* became much more common; the division of the scheme into *giornate* became more flexible, with units often following the outlines of individual figures or parts of figures; finally, the outlines of figures were marked by means of simple templates (*patroni*), pouncing stencils (*spolveri*) and cartoons.

Since the Renaissance, the traditional wall-painting techniques have been supplemented by further innovations, notably those involving painting on cloth or canvas which is glued to the wall; but the main tendency, especially in the last 150 years, has been towards the replacement of direct wall-painting by wall-papers and textiles which allow for cheaper and more mechanical production. Nonetheless, the art of wall-painting remains alive and creative. Important works such as Chagall's murals for the Metropolitan Opera House in New York continue the tradition begun by the cave-painters of Lascaux and Altamira — a tradition that was brought to maturity in the classical age of Greece and Rome.

Bibliography and references

General

Mora, P., Mora, L., and Philippot, P. (1984) *Conservation of Wall Paintings*, London: Butterworths.

Guineau, B. (ed) (1990) *Pigments et colorants de l'Antiquité et du Moyen-Age: teinture, peinture, enlumineure, études historiques et physico-chimiques* (Colloque International du C.N.R.S., Paris, 1990), Paris: C.N.R.S.

Egyptian panel paintings

Shore, A.F. (1962) *Portrait Painting from Roman Egypt*, London: British Museum.

Walker, S., and Bierbrier, M. (1997) *Ancient Faces. Mummy Portraits from Roman Egypt* (*A Catalogue of Portraits in the British Museum* IV), London: British Museum.

Studies on surviving wall paintings

Barbet, A., and Allag, C. (1972) 'Techniques de préparation des parois dans la peinture murale romaine', *Mélanges de l'École Française de Rome. Antiquité* 84: 935-1069.

Barbet, A., and Allag, C. (1997) *La peinture romaine du peintre au restaurateur*, Saint-Savin: Centre International d'Art Mural.

Béarat, H., Fuchs, M., Maggetti, M., and Paunier, D. (eds) (1997) *Roman Wall Painting: Materials, Techniques, Analysis and Conservation. Proceedings of the International Workshop Fribourg 7-9 March 1996*, Fribourg: University, Institute of Mineralogy and Petrography.

Cagiano de Azevedo, M. (1949) 'Il restauro degli affreschi della Casa di Livia', *Bollettino d'arte* 34: 145-9.

Cagiano de Azevedo, M. (1958) 'Affresco', *Enciclopedia dell'arte antica, classica e orientale* 1: 101.

Cameron, M.A.S., Jones, R.E., and Filippakis, S.E. (1977) 'Analysis of fresco samples from Knossos', *Annual of the British School at Athens* 72: 123-84.

Klinkert, W. (1957) 'Bemerkungen zur Technik der pompejanischen Wanddekoration', *Mitteilungen des Deutschen Archäologischen Instituts, Römische Abteilung* 64: 111-48. Reprinted in Curtius, L. (1972), *Die Wandmalerei Pompejis*, Hildesheim and New York, Georg Olms: 435-72.

Ling, R. (1991) *Roman Painting*, Cambridge: University Press.

Lucas, A. (1962) *Ancient Egyptian Materials and Industries*, 4th edn, revised by J.R. Harris, London: Edward Arnold.

Maiuri, A. (1937-8) 'Note su di un nuovo dipinto ercolanese', *Bollettino d'arte* 31: 481-9.

Maiuri, A. (1939) 'Picturae ligneis formis inclusae; note sulla tecnica della pittura campana', *Atti della Accademia Nazionale dei Lincei. Rendiconti. Classe di scienze morali, storiche e filologiche* 7th series 1: 138-60.

Moormann, E.M. (1995) (ed) 'Mani di pittori e botteghe pittoriche nel mondo romano: tavola rotonda in onore di W.J.Th. Peters in occasione del suo 75.mo compleanno', *Mededelingen van het Nederlands Instituut te Rome* 54: 52-298.

Mora, P. (1967) 'Proposte sulla tecnica della pittura murale romana', *Bollettino dell'Istituto Centrale del Restauro*: 63-84.

4 Greek painted pottery

Brian A. Sparkes

Introduction

Greek painted pottery is one of the most easily recognizable products of the classical world. The shapes are precisely controlled, gracefully proportioned and carefully finished; there is a striking colour-contrast between the terracotta of the unslipped surface and the black of the fired slip; and the decorative patterns, whether geometric, floral or figured, are attractive to the eye. These brightly painted objects were produced by potters and painters in the many different areas of the Mediterranean world that were inhabited by Greeks — the Greek mainland, the islands that spread across the Aegean to the coast of Asia Minor, the coastal settlements of Asia Minor itself where Greeks had established their presence, and the overseas communities that the Greeks developed in such regions as southern Italy and Sicily. The techniques and appearance of the Greek pots were also reproduced in areas occupied by non-Greeks, such as the Etruscans in northern Italy, who traded with the Greeks, bought their pottery and occasionally had the services of Greek craftsmen who had emigrated to the neighbourhood.

The shapes the potters created and the compositions the painters added on the surface give some idea of the functions that the pots were intended to carry out. They were most often containers for liquids of various sorts (water, wine, oil, etc), and by their shapes, their size and the presence or absence of handles or feet they furnish clues to their function, eg for transporting, storing, mixing, pouring and drinking, or for holding oil to rub on the body, to offer to the dead and to fill lamps. Sometimes special shapes were fashioned that were not used in everyday life and were made specifically for burial with the dead, but more often the pots that were laid in the graves shared the forms of the ordinary products and had earlier been used in the lives of the people with whom they were buried.

From the close of the Bronze Age, there was a continuous tradition of decorated pottery that lasted for about 700 years (1000-300 BC). The basic techniques of throwing, painting and firing the pots continued over these generations, with a slow series of developments and changes in the shapes and decoration. The first centuries are those of protogeometric and geometric pottery (c1000-700 BC), named after the curved and angular designs that they display. Production was carried out in a number of centres, of which Attica (the territory which includes Athens) was the most important, with well articulated shapes and balanced decoration. The geometric patterns were created with a brush and slip, there was little engraving, no added colour, and the colour of the fired slip was brown, not the deep shiny black of later. This basic technique and simple decoration were continued after 700 BC by some of the less progressive workshops. However, from

750 BC onwards figured funerary scenes — mourning at the bier, chariot processions, death in battle — became a feature of the decoration, particularly of Attic pottery (**97**), with the silhouette figures conceptualized. During the seventh century Corinthian craftsmen, under the influence of ideas and techniques imported from the East, chiefly Syria, were shaping and painting the most sophisticated pieces (**32**), usually in precise miniature form with florals borrowed from eastern imports and figure compositions that illustrated mythical subjects. It was Corinthian potters and painters who borrowed the technique of engraving on metal, and invented the black-figure pottery technique by incising inner details on the black silhouettes and adding extra colours (mainly purple and white). Others followed suit, and of these Athens became once again the dominant centre. At first her craftsmen produced large vases with rather undisciplined figure scenes. However, soon after the beginning of the sixth century the potteries that had been dotted around the territory of Attica became less important, and workshops were concentrated in urban localities. With improvements in the preparation of the clay and the firing of the finished pots, the Athenian craftsmen perfected a technique of producing vases that had crisp outlines, a strong terracotta-coloured background and a jet black paint. The centuries 600-300 BC saw the development and the fall of three techniques. The black-figure

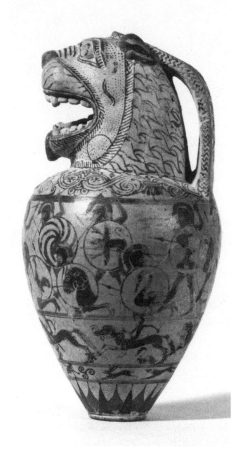

32 Protocorinthian aryballos *from Thebes, attributed to the Chigi Painter (c640 BC). Ht 6.8cm. London, British Museum 1889.4-18.1 (B 1533).* Photo British Museum

technique (**53**) was produced in many different areas, such as Laconia, Boeotia, the islands, the settlements of Asia Minor, and some of the western outposts (**colour plate 7**), many of them heavily influenced by Attic pottery or pale reflections of it. In the sixth century the range of subjects widened and scenes from the everyday life of the elite (hunting, *symposium*, etc) became popular.

Around 530 BC Athenian potters and painters reversed the black-figure technique by leaving the figures in the colour of the clay and painting the background to fire black and thus created the red-figure technique. This technique was produced in greater quantities in Athens than the black-figure had been but was less widely adopted elsewhere. It was not until some potters emigrated from Attica to southern Italy and Sicily in the mid-fifth

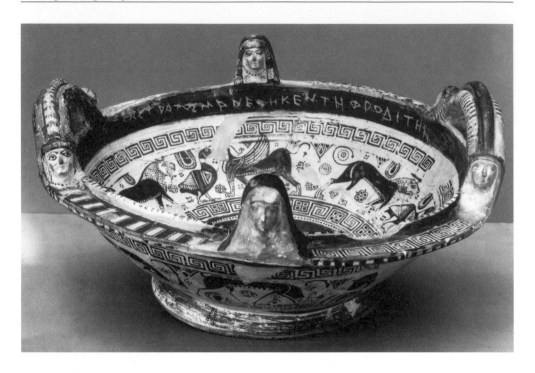

33 Chiot bowl from Naucratis, attributed to the Painter of the Aphrodite Bowl (c600 BC). Diam 38cm. London, British Museum 1888.6-1.456. Photo British Museum

century and set up potteries there that the Attic industry had any rivals (**colour plate 8**). The third technique, that of white-ground, is found in various centres (eg **33**) but was less popular than black- or red-figure, and after a brief period of use in Athens in the fifth century on *kylikes* (**colour plate 9**) and *lekythoi* for the dead it was abandoned. After 300 BC the pottery shops turned their attention to less labour-intensive methods of production. The workshops issued products that were often vertically ribbed, covered all over with a slip that was fired black, and decorated with applied relief and added colours (white, purple, gold) (**34**). Another major line in pottery at this time was a type of hemispherical bowl with relief scenes that copied the more expensive silver shapes of the period. These pottery bowls were made by centring a mould on the wheel and throwing the bowl inside as the wheel turned. Hand-made pottery with painted scenes was becoming a thing of the past.

Although modern study tends to concentrate on figure-decorated vases, they were of course not the only vessels produced. There was a great deal of undecorated black fine ware that often shared the same shapes as the patterned and figured. Potters also shaped household pottery for mixing and storing, and the heavy-duty shapes such as the transport amphorae for wine, oil and preserved foodstuffs, and the *pithoi* (Ali Baba jars) in which a family's store of grain would be held. None of the fine and heavy-duty wares were suitable for cooking; instead a coarse but thin, lightweight fabric was fashioned to withstand the heat of the fire.

In what follows we shall concentrate on the decorated fine wares which were made on the wheel and fired in kilns. The heavy-duty shapes such as the *pithoi* were built up in a series of coils and fired on the spot where they were built; the cooking wares were shaped by paddle-and-anvil and are likely to have been fired in bonfires on open ground.

Clays

The basic craft of a potter was noted for being hard and dirty, and the materials a potter needed were few but vital: suitable clays, expert hands and correct firing conditions. Clay is found in most parts of the Greek world, and, whilst some clays are suitable for the production of fine wares, others are better fitted to the shaping of cooking pots. When baked, the terracotta is virtually indestructible and is useless for recycling, hence the amount of material available for study is immense. The vases found in graves are usually complete, if not whole, whereas those from settlement and sanctuary sites are more likely to be fragmentary. It is possible to glean information not only about the shapes of the pots, the style of the painting and the subject-matter of the scenes, as well as the distribution up and down the Mediterranean and beyond, but also about the composition of the clays and the techniques used in the forming, decorating and firing of the different shapes. The clays lend themselves to scientific investigation: petrographic analysis to find the origin of the raw materials in the clay is most effective for the study of coarse wares, whereas chemical analysis which seeks to find the chemical composition of clays by distinguishing different elements is more useful for sorting out fine wares.

The most useful type of clay is that known as 'secondary' or sedimentary: the clay is weathered rock that has moved over time from its original location through the effects of erosion or glacial action, and in so doing has picked up foreign bodies in the form of such impurities as sand, limestone, and vegetable matter of all sorts. 'Primary' or residual clays are those

31 Black-gloss amphora with overpainted decoration, from Fasano, Apulia (late fourth century BC). Ht 78.7cm. London, British Museum F 560 (1856.12-26.10). Photo British Museum

65

which have remained in their original location and are free of impurities but were less useful for the production of Greek fine wares. The most striking contrast is in the nature and appearance of Corinthian and Athenian clays. The Corinthian is a relatively pure clay which fires to an off-white colour, whereas the Athenian is secondary and rich in iron, producing a strong red colour when fired.

The first task for the potters was to locate and mine the clay that they needed. It was sensible to establish pottery workshops near the site of clay beds, but it was often necessary to transport the heavy material some distance, whether in carts, by donkeys or by human means. Once it had been brought to the pottery, the clay had to undergo various treatments to make it suitable for working. The larger impurities had to be removed, which meant diluting the clay with water in settling tanks to allow the foreign matter to separate from the clay and sink to the bottom. The slurry was left to stand for a time, and then the finer mixture was transferred to another shallower basin, partially dried and allowed to age for about six months. Still more preparation was needed before the shaping on the wheel could begin. The clay had to be 'wedged' or beaten to remove the bubbles, to be mixed with other clays, if wanted, and to be made into a mass of a homogeneous consistency.

Apart from the evidence of kilns (see below), we know little about the plan of the pottery workshops in classical antiquity. We can perhaps use analogies from modern Greek workshops that still use the traditional methods to create an idea of a possible layout (**35**). Space was needed for the clays in their various stages of preparation (being dried, aged, settled, etc) and for the storage of the fuel for the kiln(s). The workshop needed room for the clay near at hand, for the wheel, for drying racks and so forth. Near the kilns an area was set aside for the arrangement of the pots to ensure that they were thoroughly dry before the firing, and access was needed for the men to stoke the kiln and observe progress. Beyond this it is difficult to go. Pottery scenes (eg **53**) show only a handful of men and boys at work but it is not possible to say whether the small number was due to the exigencies of the field available for the composition or reflected actual practice. Women are very rarely shown, and again the reality of that presentation could be questioned.

Shaping

As mentioned above, some of the heavy-duty and coarse wares were shaped by methods such as the coil and the paddle-and-anvil. Some fine wares such as drinking vessels and containers for perfumed oil in the shape of human and other heads (**36**) or animals were made in moulds. However, the majority of fine wares were thrown on the wheel. The fast wheel had been used in Greece since the beginning of the second millennium BC. The wheel itself was a thick, heavy disc less than a metre in diameter, usually of wood, and balanced near the floor on a pivot fixed into the ground. The kick wheel, which the potter rotates with his own feet, was unknown in the period under consideration; a boy assistant was set the task of spinning the wheel to the instruction of the potter who squatted or stood next to the wheel (**53**).

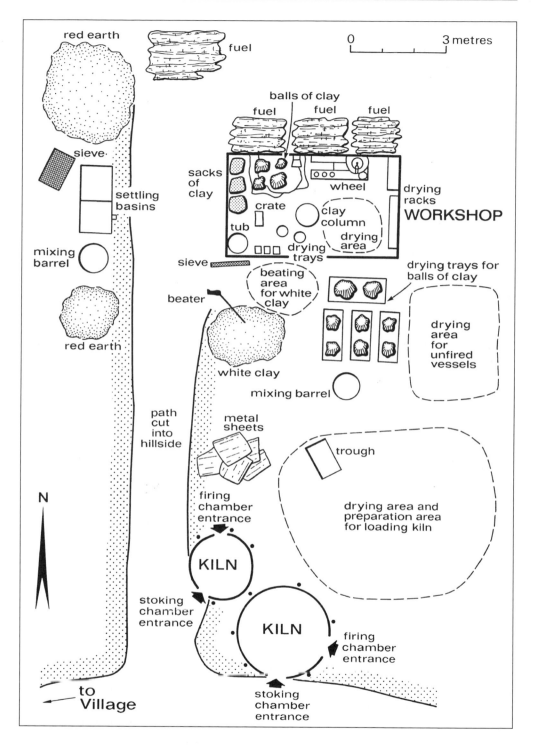

35 *Plan of modern potter's workshop in Greece.* Drawing adapted from P.P. Betancourt, *East Cretan White-on-Dark Ware* (1984), fig 18.3

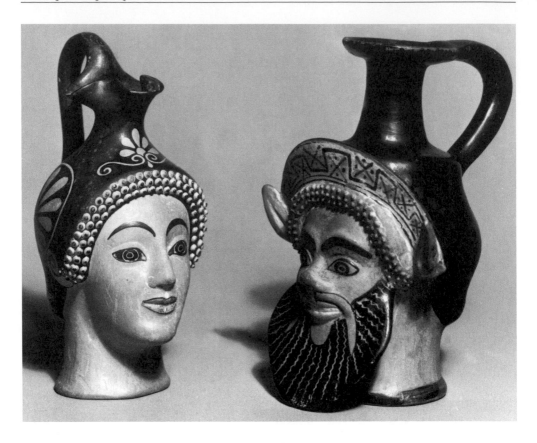

36 Two head jugs in the shape of a maenad and a satyr, attributed to the Oxford Class and the Chairete Class (c500 BC and 500-450 BC). Ht 15cm. Oxford, Ashmolean Museum 1920.106 and 1946.85. Photo Ashmolean Museum

Having centred the lump of clay, the potter worked with his hands to create the basic cylinder shape and then proceeded to fashion the specific form he had in mind. There was a wide but fairly standard range of shapes: Greek potters were not in the business of experimenting with novel and unusual shapes; they had objects to sell, and the tried and tested shapes were likely to be the most popular with customers. Changes, of course, did come about but they were usually slow. The potters' output mirrored demand for pottery to suit social occasions, such as weddings, drinking parties, religious gatherings and funerals. Each required its own range of shapes, eg various closed containers for storing oil, water, and wine, and open shapes for drinking and ritual libation.

The basic body of the vase, if simple, might be thrown as a single shape and removed from the wheel by drawing a cord beneath the pot while the wheel was spinning. But it was often necessary to build the body, if it was large or complex, in sections (usually joined at places where this was least conspicuous), as the weight of the wet clay was too heavy to maintain its shape in the drying process. Once the sections were sufficiently dry, they were joined through the application of wet clay. When the pot had started to become leather-

37 *Attic red-figure* kylix, *signed by Euphronios as maker and attributed to the painter Onesimos (c500 BC). Diam of bowl 33.6cm. London, British Museum E 44.* Photo British Museum

hard but was still soft, the vase was returned to the wheel and turned, ie it was trimmed and shaved of its unwanted clay, and wet sponges were used to remove the tool marks. Such accessories as feet, handles and spout, and any appliqués that were needed, were usually attached at this stage by the application of a wet clay slip (a process known as 'luting') and again the joins were sponged to smooth the surface. The balance and tensile strength of the Attic clay can be seen in such spreading shapes as the broad and shallow stemmed *kylix* (37). The different parts of a pot were given anatomical terms similar to the ones that we tend to use: for the Greeks handles were 'ears', there was a 'head', a 'mouth' and a 'belly'. Greek potters were keen on articulating the parts of each vase distinctly. There are many shapes which show the influence of metal vases (gold, silver, bronze), whether in details such as raised terracotta discs that imitate rivets or in the generally metallic sharpness of the profiles and the glossy sheen of the fired slip.

For ease of communication, there is an accepted vocabulary of vase names. Some are correct borrowings from ancient Greek, others are misunderstood ancient words which have become conventionally attached to shapes to which they did not originally belong, others are modern terms or invented words that have now become accepted elements of the terminology.

It is not now difficult to recognize or scientifically analyse local schools of pottery and it is also possible, though more difficult, to distinguish by eye the work of individual potters by close attention to the details of each shape. The modern technique of tomography, which uses x-ray photographs to highlight details in selected planes of the vase's body, as in radiography of the human body, may in future become a more widespread method. Few makers have left their names on pots, and when the names are

present it is uncertain whether the 'making' refers to the actual shaping of the pot itself or whether the person named is the 'maker' in the sense of owning the shop in which someone else carried out the manual labour. The names which occur occasionally from the seventh to the fourth centuries sometimes give us information on the origin of the 'makers' (eg 'Sikanos' = 'the Sicanian' (from western Sicily); 'Brygos' = the Phrygian'), their status, and the fact that some are both makers and painters (eg Exekias). On occasion the inscriptions show that the business was handed down from father to son, as is usual in traditional crafts (eg 'Kleophrades, son of Amasis', and we also know of a son and grandson of Ergotimos).

Decorating

There were various methods of decorating pottery: painting, incising and impressing, or adding embellishment by means of relief designs and figures applied direct to the surface or made in moulds and fixed with a slip. Most popular was painting, for which we again have some evidence from the scenes on figured pottery (**53**).

It is generally agreed that the paint that was used for creating the patterns and figures on Greek pottery was a liquid clay slip which the firing converted into a high gloss coating. Attic clay contained illite which is rich in iron oxide, and the slip was a fine solution of the clay which had potash (that is, wood ash soaked in water) added to it. The particles of the slip lie flat when painted on the surface and form a densely packed plate-like structure that forms a hard shell when fired. The slip, which was evaporated in the sun to a creamy consistency for application, was painted on the clay surface when the surface was still damp. It was best to have the slip mixed from the same material as the clay so that they would react in the same way in the firing. The slip before firing was a deeper red than the reddish brown of the clay, but the contrast was not all that striking, so care was needed in painting the designs and mistakes did occur. Some pots show that the surface of the vase was burnished to produce a sheen.

On many vases it can be seen that the figured design was given a preliminary shape by a trial sketch. This sketch may have been fairly commonly applied by the use of a charcoal image which disappeared in the firing, but what is still possible to see are those preliminary designs that were marked with a fine pointed stick and made an indentation in the damp clay (**38**). As can be seen in the illustration, the painter sketched in many details of the naked boy's anatomy and of the objects in the composition. It was usual to carry out the preliminary sketch of a nude figure even if the intention was to clothe it in the finished painting. Sometimes the final design differed considerably from the original sketch.

The two major techniques of vase-painting — black-figure and red-figure — produce a totally different effect on the finished article after firing, but from the painter's point of view they would have started in the same way with a brush loaded with slip. For black-figure the slip was applied to create a silhouette figure in solid paint that fired black, for red-figure it was the background that was filled in with solid paint, a task left to the last stage of the decoration, perhaps carried out by an apprentice. Unfinished pots (eg **39**)

38 Cup-bearer at symposium. *Attic red-figure* kylix *from Italy, attributed to the Foundry Painter (c480 BC). Philadelphia, University Museum of Archaeology and Anthropology 31.19.2.* Photo Philadelphia University Museum of Archaeology and Anthropology (neg. 2955)

show that the figures and objects in red-figure were initially outlined with a line of contour (an eighth-of-an-inch stripe). In black-figure the interior lines of the figures were incised through the slip to the clay beneath and so when fired showed up in the background colour of the clay; in red-figure the interior lines of the figures were produced by slip painted on the unslipped clay, and they became black in the firing.

The sombre scheme of the black and the red was enlivened in various ways. Apart from the incision that marked out the inner contours of the figures and the objects, other colours that could withstand the heat of the firing were applied to different areas. The main colours were a matt purple (mainly red ochre) and a matt white (the pure 'primary' clay with minimal iron oxide). The purple was used to distinguish blood, hair bands,

39 Woman. Attic red-figure krater *fragment (trial piece) from Athens, attributed ('probably') to the Methyse Painter (c460-450 BC). Max dimension 10.5cm. Berlin, Staatliche Museen V.1.3362.* Photo Staatliche Museen zu Berlin, Preussischer Kulturbesitz, Antikensammlung

tongues, clothing and so on (**colour plates 7 and 9**), the white women's skin, animals, marble objects, etc (**colour plates 7 and 8**). Purple was also the colour of the lettering that was added on the black background of red-figure to name the potter or painter, the characters in any scene, and the 'toast' to a figure of the time (eg 'Leagros is handsome'). Variety of visual effect could also be obtained by thinning the clay slip for the less important lines in red-figure; this dilute slip, which fired golden brown, was sometimes also used for shading (**40**). Added clay and gold were also applied on the gaudier vases to indicate metal objects, wreaths and so forth. These added colours do not always adhere well and sometimes show up only as a dull matt area.

Another means of creating a varied effect was the application of a relief line. This was introduced in the mid-sixth century on Attic pottery and is found in black-figure and red-figure on Attic pots and in red-figure on those produced in southern Italy and Sicily. The relief line stands proud of the surface — it can be felt with a touch of the fingers — and the ridges catch the light (**40**). The slip seems to have been of a thicker consistency than normal but it is not the composition of the slip but the method of creating such a continuously thick line that has been a subject of debate. Suggestions have been that a syringe was used (like an icing bag), that the implement was a reed or quill of some description, or a long-haired brush. There is still no agreement.

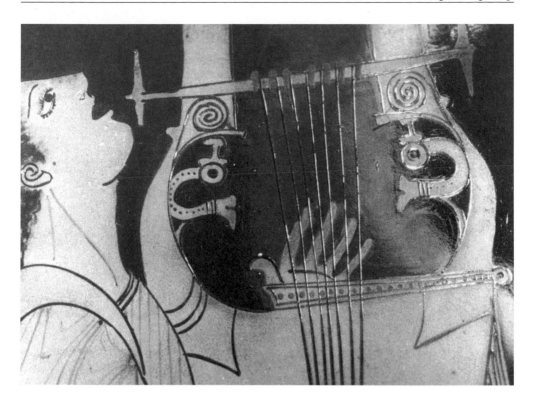

40 *Citharode* (cithara *player). Detail of Attic red-figure amphora (type C), attributed to the Berlin Painter (c490 BC). New York, Metropolitan Museum of Art 56.171.38 (Fletcher Fund, 1956).* Photo Metropolitan Museum of Art

A third technique found in a number of local potteries, for example on pottery produced on the island of Chios (**33**), but best known on Attic *kylikes* (**colour plate 9**) and *lekythoi* of the fifth century BC, is white-ground. As the name suggests, the background surface is covered with a clay slip that fires white, and on to this the standard clay slip was applied, initially to produce black figures on a white ground. These white-ground shapes were mainly produced as ritual or grave goods; they were not used in everyday life. As time went on, the potters created black outline figures, then dilute outlines, and finally used a wider palette of mineral and vegetable colours (blues, greens, pinks) which were applied after firing and which thus did not adhere well. Such a piece as **colour plate 9** gives us a tantalizing glimpse of what the effect of contemporary wall-painting may have been. Rarer techniques include the short-lived Six technique (named after the Dutch scholar, Jan Six, who first studied it), where the background is painted black and the figures were added in white on top. A more difficult technique is what is known as intentional red in which the painters were able to produce glossy black and coral red on the same vase from the same firing.

A major academic concern over the last century has been the search for the identity of individual painters at different centres. Some have left their names on the pots (eg at

Corinth Timonidas; at Athens Sophilos, Exekias, Euphronios, Makron, Douris; at Paestum (in southern Italy) Assteas, Python). As with the study of potters, some of the names of painters that are inscribed on the pots tell us of their origin (eg 'Skythes' = the Scythian), status (eg 'Lydos' with 'being a slave' added after the name, 'Epiktetos' = 'Newly Acquired') and familial connections. But it has been the study of the individual style of painters, whether named or not, that has led to the discovery of hundreds of separate craftsmen. Those without names have been given sobriquets: for example, in Attic Geometric the Dipylon Painter (**97**), in Chalcidian black-figure the Inscription Painter (**colour plate 7**), in Attic red-figure the Berlin Painter (**40**), in Apulian red-figure the Underworld Painter (**colour plate 8**). Much of this work was carried out by J.D. Beazley on Attic black-figure, red-figure and white-ground vases, and there have been many scholars who have followed in his footsteps by applying a similar approach to Attic vases and those of other fabrics. The approach demands a painstaking study of all aspects of the vases: the ways of drawing the details of the figures (eyes, knees, fingers, etc), the arrangement of the composition and how it fits the shape, the choice of subject, the types of floral decoration surrounding the scene, the use of the relief line and colours, etc. A network of painters and potters has been constructed that presents us with a detailed picture of the craftsmen's individual work and their relationships over 300 years (600-300 BC).

Firing

The evidence that we have for the methods of firing the pots is various. Kilns have been excavated in different regions of the Greek world, the best known being those in the potters' quarter at Corinth and in the Ceramicus at Athens. It is these constructions that have survived whilst the other features of the pottery workshops have been lost. The pots themselves give us some help by providing technical details of their making, and analogy with traditional methods of firing that are still used has a part to play. There are also some painted scenes on plaques and vases (Corinthian and Attic) that present potters' workshops with men at work shaping, painting and firing the pottery (**53**).

We have a fairly clear idea of the size and shape of Greek kilns (**41**), though obviously there was a range of possibilities. They were partly sunk in the ground, usually about 2m in diameter and 3m high, and were topped by a dome. The base-ring was well constructed and comprised a firing chamber and stoking tunnel through which the brushwood that was the main fuel was introduced. Above the firing chamber the floor of the stacking chamber was supported by a central column and had perforations all the way across. The dome above was less well constructed and was most likely demolished and rebuilt after each firing, so it may have been possible for the pots to be stacked before the dome was built. There was a vent hole that could be closed on top of the dome, and to the side there was an opening through which the pots could be introduced for stacking. The slip on the pots was not sticky and therefore the pots could be set in and on top of one another and packed fairly tightly. The dome also had a small spy-hole in its side; this enabled the potter to observe the progress of the firing and to remove any trial piece (**39**) to find out what

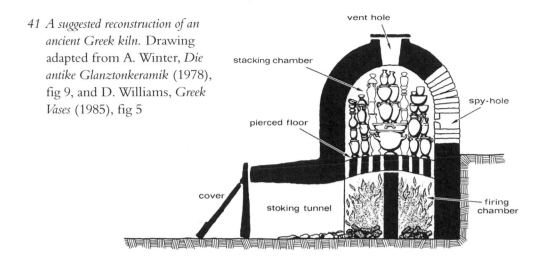

41 *A suggested reconstruction of an ancient Greek kiln.* Drawing adapted from A. Winter, *Die antike Glanztonkeramik* (1978), fig 9, and D. Williams, *Greek Vases* (1985), fig 5

stage had been reached. Some of the representations also show a ladder which enabled the workman to reach the vent. The whole operation demanded experience and care, and some kilns carried a lucky mascot to help with a successful firing (**53**).

The process of firing was a risky business, and the success of the work of many days or even weeks depended on the outcome. To produce the red and black effect on the vases required one firing in three stages. The first stage was an oxidizing one when the air was allowed in to the upper chamber and the temperature was raised to *c*800°C; this turned both the clay and the slip to a red colour (red ferric oxide). The second stage was a reducing one when the air vents were all closed and damp wood or wet leaves were introduced along the stoking tunnel, and the temperature was raised to *c*950°C; this turned both the pots and the slip from red to black (black ferrous oxide). At this stage the slip was vitrified into a glossy shell that was impervious to any further changes. The third stage was a re-oxidizing one with the air allowed back into the upper chamber. This affected the unslipped surfaces and turned them back to a red colour but was unable to have any effect on the smooth gloss, provided that the pots were removed at the correct time.

The whole firing process lasted about 6-8 hours and after it was over the kiln took about 12 hours to cool down. It was only then that the workmen were able to see whether they had had a successful firing. Reasons for failure were many. It may have been that the slip itself had not been of a proper consistency or perhaps not thickly enough applied. Sometimes it can be seen that details were omitted in the actual painting. The pots, when stacked in the upper chamber, may have been unsteady and toppled over, or some pots may have masked others from the full effects of the heat. Some may have warped, cracked or even exploded in the kiln. The temperature itself may have been too high and affected the gloss and turned some of the surface back to red. Conversely, if too little time had been given to the second oxidization, the clay might retain a greyish tinge from the reduction stage. It was only the experience of the potters that enabled the time to be finely gauged and the temperature to be correctly set: there were no accurate clocks and no precise thermometers to assist them.

The three-stage process was the most widespread in Greece, though others were tried, such as grey 'bucchero' which was achieved with two stages only. But it was during the Hellenistic period (after 300 BC) that the potters moved over to a simple oxidizing operation which created a glossy red finish for the clay and the slip. This was used in the East (eg at Pergamum) but is best known from its adoption by the potters of Italy and the western Roman provinces.

Finished articles

Once the firing was over, it was time to consider the problem of marketing the finished articles. Many potteries would serve a very restricted clientele; the craftsmen may have been members of one family, perhaps only working for a short season of the year and firing pots for themselves. Others may have been itinerant craftsmen going from village to village. The pots that were for sale might be sold at the workshop, having been ordered specially, or taken to the centre of the town for sale at a booth or stall. Purchasers could be individuals who wanted pottery for home use, for a funeral, a party or an offering at a local sanctuary, as can be seen from figure **33** where the bowl carries a graffito stating that it was dedicated by Sostratos to Aphrodite. Some special orders may have come from the officials of a community. We know that Athenian officials placed orders for the Panathenaic amphorae which were to contain the olive oil that was awarded as prizes to the winners in the Panathenaic Games every four years; this must have been a lucrative commission for any pottery to receive, as at least 1400 were needed for distribution. Some of the major pottery producers such as Corinth and Athens were able to export their wares to other parts of the Mediterranean and beyond.

The prices charged for painted pottery are still a matter of contention. Our evidence for them is meagre and difficult to interpret. The most important evidence comes from graffiti scratched on the underside of Attic pots, but these are in the salesmen's secret language, intentionally obscure, and it is not possible to say to which precise stage in the marketing process the prices apply. It is likely that many of the pots were cheap, but price and value are not synonymous, and the lead rivets and holes that indicate repairs on a good number of vases show that their owners wished to keep them for whatever reason and whatever the purchase price that had originally been asked. The dedications by potters on the Athenian Acropolis would suggest that some at least made a decent living from their craft, but it is likely that they were very few.

Bibliography

Arias, P.E., Hirmer, M., and Shefton, B.B. (1962) *A History of Greek Vase Painting*, London: Thames and Hudson.

Beazley, J.D. (1944) 'Potter and painter in ancient Athens', *Proceedings of the British Academy* 30: 87-125 (reprinted in Kurtz 1989: 39-59).

Beazley, J.D. (1951; 1986) *The Development of Attic Black-figure*, Berkeley: University of California Press.

Boardman, J. (1998) *Early Greek Vase Painting*, London: Thames and Hudson.

Boardman, J. (1974) *Athenian Black Figure Vase Painting*, London: Thames and Hudson.

Boardman, J. (1975) *Athenian Red Figure Vase Painting: the Archaic Period*, London: Thames and Hudson.

Boardman, J. (1989) *Athenian Red Figure Vase Painting: the Classical Period*, London: Thames and Hudson.

Brijder, H.A.G. (1984) *Ancient Greek and Related Pottery: Proceedings of the International Vase Symposium in Amsterdam 12-15 April 1984*, Amsterdam: Allard Pierson.

Cook, R.M. (1997) *Greek Painted Pottery* (3rd edn), London and New York: Routledge.

Corbett, P.E. (1965) 'Preliminary sketch in Greek vase-painting', *Journal of Hellenic Studies* 85: 16-28.

Freestone, I., and Gaimster, D. (eds) (1997) *Pottery in the Making: World Ceramic Traditions*, London: British Museum Press.

Jones, R.E. (1986) *Greek and Cypriot Pottery: a Review of Scientific Studies*, Athens: British School at Athens.

Kanowski, M.G. (1984) *Containers of Classical Greece: a Handbook of Shapes*, St Lucia: University of Queensland Press.

Kurtz, D.C. (1989) *Greek Vases: Lectures by J.D. Beazley*, Oxford: Clarendon Press.

Mayo, M.E. (ed) (1982) *The Art of South Italy: Vases from Magna Graecia*, Richmond: University of Virginia Press.

Noble, J.V. (1965; 1966; 1988) *The Techniques of Painted Attic Pottery*, New York: Watson-Guptill Publications and the Metropolitan Museum of Art/London: Faber and Faber/London: Thames and Hudson.

Rasmussen, T., and Spivey, N. (eds) (1991) *Looking at Greek Vases*, Cambridge: University Press.

Richter, G.M.A. (1923) *The Craft of Athenian Pottery*, New Haven: Yale University Press.

Robertson, M. (1992) *The Art of Vase-painting in Classical Athens*, Cambridge: University Press.

Schreiber, T. (1999) *Athenian Vase Construction: a Potter's Analysis*, Malibu: J. Paul Getty Museum.

Sparkes, B.A. (1991) *Greek Pottery: an Introduction*, Manchester: University Press.

Sparkes, B.A. (1996) *The Red and the Black: Studies in Greek Pottery*, London and New York: Routledge.

Trendall, A.D. (1989) *Red Figure Vases of South Italy and Sicily*, London: Thames and Hudson.

Vickers, M., and Gill, D. (1994) *Artful Crafts: Ancient Greek Silverware and Pottery*, Oxford: Clarendon Press.

Williams, D. (1985; 1999) *Greek Vases*, London: British Museum Press.

5 Mosaic

Priscilla Henderson

Introduction

Pliny, writing in the first century AD, described mosaic as 'imitation of painting' (*NH* 35.3). To some extent his description was valid. At times in its history mosaic has been perceived as a means of painting durable pictures in unfading colours. Nevertheless, it is an art form in its own right. As such it carries unique stylistic demands and requires specialized techniques.

Briefly defined, mosaic is a medium in which small pieces (called tesserae) of coloured stone, glass, or other material are cemented together, side by side, to form pictures or patterns (**42**). The mortar joints between the stones contribute to the overall effect. This divisionist aspect of mosaic demands simplified line and some degree of stylization. Each tessera is equivalent to a single dot of colour not unlike the 'pointillist' techniques of neo-impressionist painting. Like a pointillist painting, it is best viewed from a distance. Thus, although mosaic has been used for small items, pictures, icons, household ornaments and furniture, its versatility and decorative potential make it particularly suitable for monumental and architectural decoration.

Mosaic is a familiar sight on the façades of public buildings, on interior walls, and in the more functional surroundings of swimming pools, railway stations and bathrooms. Children make mosaic objects at school. It is not always recognized, however, that, as an art form, mosaic is very ancient and geographically widespread. Examples range from the Sumerian wall decorations at Uruk (modern Warka) of around 3000 BC to the masks and ornaments of pre-Columbian America, and from the Hellenistic world to modern London or Paris.

Almost 2000 years ago, Pliny observed that mosaic paving originated with the Greeks (*NH* 36.184). His remark implies a distinction between floor mosaics and wall mosaics. Such a distinction is upheld by the different materials and methods used for each.

Floor mosaics

The earliest-known mosaic pavements, found at Gordium in Asia Minor and dating from about the eighth century BC, were made of large, black and white, water-smoothed pebbles, set in simple, geometric patterns. By about 400 BC, at Olynthus, on the Chalcidice peninsula in northern Greece, a number of pavements were made with complex figural patterns depicting mythological and hunting scenes. The number of these pavements, their advanced technique and complex patterns indicate that, by this time,

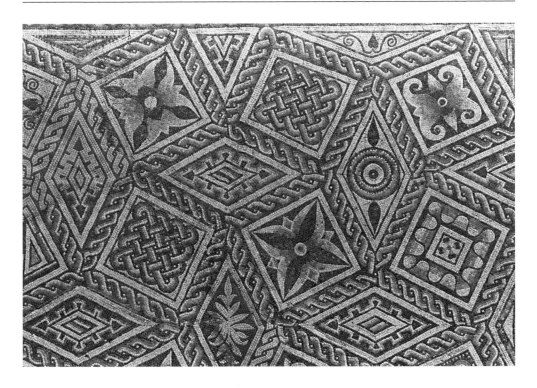

42 Detail of a Roman tessera mosaic with a geometric pattern. From a villa at El Hinoja, near Mérida (Spain), now in Mérida, National Museum of Roman Art. Photo R.J. Ling 117/5

pebble mosaics had developed into a well-established art form.

A century later, at Pella in Macedonia, small, coloured pebbles were used, while some details of the figures were outlined with lead strips (**colour plate 10**). More or less contemporary with the Pella floors, in the vestibule of the temple of Zeus at Olympia, cut stones were used among the pebbles to fill particular details. These precursors of tesserae were easier to lay and more effective than irregular pebbles. The way was open for the development of mosaic as a sophisticated art form.

The earliest documented mosaic, made of coloured tesserae and representing the story of the Trojan Wars, decorated a floor in a ship, given as a gift by a Sicilian ruler to Ptolemy III of Egypt, in the third century BC. Magnificent mosaics, probably from the first half of the second century BC, have been found on the island of Delos (**colour plate 11**); others, of approximately the same date, were found in the royal citadel of Pergamum. By the end of the century mosaics had spread from the Hellenistic East to Italy. An outstanding example, depicting the encounter of Alexander the Great and Darius at the Battle of Issus (**colour plate 12**), was found in the House of the Faun at Pompeii.

These Hellenistic mosaics were intended to imitate paintings and, as such, to imitate nature. The mosaics of the Pergamene school, with their minute tesserae and skilfully executed chiaroscuro, were carefully rendered paintings in stone. The Alexander mosaic from Pompeii is thought to have been copied from a painting of Philoxenus. Other Italian

43 *Unswept room: Roman mosaic based on a concept by Sosus of Pergamum (second century BC). Vatican Museums, Lateran collection (10132).* Photo Alinari/Art Resource, New York (Anderson 24158)

mosaics perpetuate Hellenistic traditions of illusionism as well. The popular *asaroton*, or unswept floor design, which reproduced a composition of Sosus of Pergamum, was an amusing *trompe l'oeil* in which scraps of food — fish heads, fruit-peelings, nut shells, a wishbone — were realistically depicted to simulate objects thrown onto the floor (**43**). The work was skilled and detailed. Small mosaic panels, called *emblemata*, were set into the floor, rather as a rug would be placed in a prominent position within a room; at the same time they gave an illusion of depth which contrasted with the flat surface of the floor.

These mosaics were created for a wealthy elite. But, with the establishment of the Imperial era in the first century AD, a greater emphasis on personal luxury developed. Mosaic pavements became popular, not only in public buildings and palaces, but in houses. They began to appear in large numbers throughout the Roman Empire. Increased demand led to a need for cheaper production which, in turn, brought about a change in technique. While the tradition of the polychrome *emblema* remained strong in the provinces — in Antioch, for example, it survived until the fourth century — through much of Italy, by the first century AD, a fashion had developed for black and white mosaics.

With the introduction of monochrome pavements the time-consuming and exacting techniques of *emblema* production became unnecessary. Larger tesserae were set to fill the

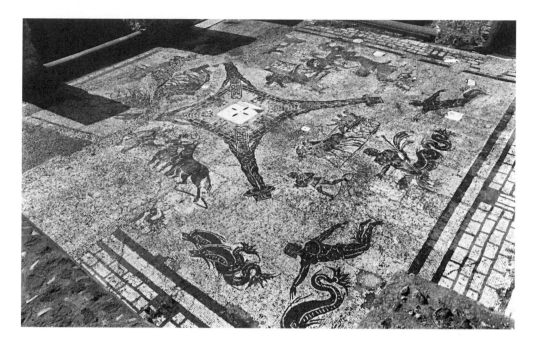

*44 Black and white mosaic with marine creatures in the Baths of the Cartdrivers, Ostia (c.AD 120). The sea creatures and swimmers move clockwise round the outside. At the centre four supporting figures (*telamones*) converge digonally on a city-wall which encloses a central drain-hole; between them are the mules and carts which give the baths their name.* Photo R.J. Ling 99/6

outline: shading and chiaroscuro were no longer important. The monochrome scheme demanded a simplified design, which took on a graphic quality not unlike a lino-cut. The silhouetted figures were modelled by the use of white lines marking anatomical forms and garment folds (**44**). The black figures, set against a white ground, now spread across the entire floor area. The imagery of the floor often reflected the function of the room. Marine scenes decorated baths, vintage scenes from the Dionysiac repertoire were placed in dining rooms, and images related to the import trade were found in shipping offices. At the same time, the function of the floor as a surface to walk on, and of mosaic as a surface decoration, was asserted.

By the end of the third century, a further development occurred. The all-over designs of the monochrome floors were executed in colour, with wide, decorative borders. Images were no longer confined within the borders of the *emblema* and composition became freer. An outstanding example is the large complex at Piazza Armerina in Sicily, of around AD 300, where the public areas of what may have been an imperial hunting lodge were decorated with scenes of hunting, the circus, fishing and the vintage.

This imagery passed into the traditional repertoire and was adopted by the Christian church. Combined with images from the Dionysiac and seasonal cycles, and genre motifs from life on the Nile, it was appearing in churches all around the Mediterranean by the

end of the fifth century. Jewish synagogues too were paved with mosaics, often with these same designs. Mosaic and its traditional imagery also passed into Islamic use and appeared in palaces and mosques.

The Great Palace mosaic from Istanbul, probably made in the sixth century, must be seen as a last flowering of the Byzantine mosaic pavement tradition. A few, later pavements are mentioned in medieval texts and one or two small, twelfth-century panels are known. But, for the most part, floors in the metropolis were made in *opus sectile*, a type of inlay in which geometric patterns were made from quite large pieces of marble cut into standardized shapes. The popularity of mosaic paving seems to have waned in the eastern Mediterranean during the seventh century. A group of floors from Jordan date from the late eighth century, and only isolated examples are known from the ninth and tenth centuries. A resurgence of interest in the art during the eleventh century led to the production of fine pavements in a number of Romanesque churches across western Europe, from Cologne and Rheims in the north, to Brindisi and Otranto in southern Italy. Their iconography was often complex, combining the traditional Christian repertoire with images from classical legends and mythology. By this time, however, the great age of pavement mosaic had passed and wall mosaic had reached its zenith as the great art medium of the Christian church.

Wall mosaics

One school of thought claims that mosaic moved from the floor to the walls of buildings, thus causing the demise of the pavement tradition. In fact, the two forms coexisted for several centuries. Buildings collapse, the walls and ceilings disintegrate. While the rubble forms a protective layer over the floor, the presence of wall mosaic is often indicated only by loose tesserae lying amidst the debris. The origin of mosaic as decoration on walls and vaults is therefore unclear. Seneca, in the first century AD, talks of vaults 'hidden by glass' (*Epistulae* 86.6), a reference to the glass tesserae used in the technique. Because of its waterproof surface, mosaic seems first to have been used on fountains (**colour plate 13**), columns and the garden façades of houses. For the same reason it was also used in baths where the damp atmosphere made wall painting unsuitable. Not only were mosaics more durable but the glass or stone tesserae introduced stronger colour and clearer definition of the images, even from a distance. When wet, the colours were intensified and the tesserae sparkled. The reflective surface meant that lighting effects within the building could be enhanced.

By the third century, mosaic was being used in cult buildings. Significantly, in a Lupercal chapel in Rome, now destroyed but known from drawings, these decorations were distributed around the chancel, thus anticipating the programmes of later Christian churches. Mosaic remains have also been found in catacombs and cemeteries in Rome and Naples. The origins of Christian mosaic tradition in a funerary context can further be seen in the catacomb of Domitilla and in the Tomb of the Julii in the necropolis below St Peter's in Rome where, as well as Jonah and the Good Shepherd, Christ is depicted as Sol, the sun god.

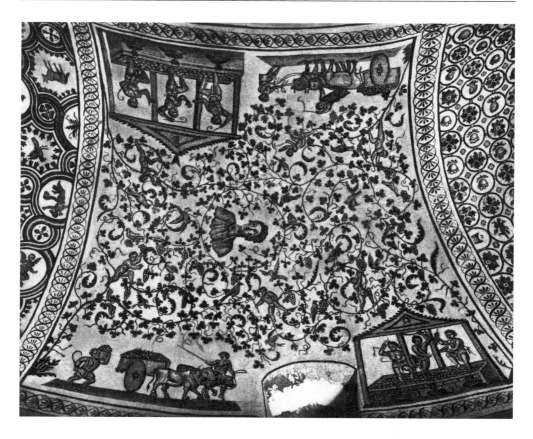

45 *Cupids conducting the vintage and treading grapes. Detail of the vault of the circular corridor round the mausoleum of Constantina (now the church of Santa Costanza) in Rome. Second quarter of fourth century AD.* Photo University of Manchester, History of Art collection (Alinari 28517)

The fourth-century church of Santa Costanza in Rome offers the earliest extant example of a complete mosaic decorative programme (**45**). The entire dome and vaulted ambulatory of this circular building, designed as a mausoleum for the daughter of the emperor Constantine, was originally covered with mosaics. Apart from some figures of biblical personages, the imagery derived directly from Roman funerary art. Santa Costanza thus demonstrates the adaptation of Roman monumental decorative traditions to the new Christian ideology.

From this date on, mosaic became the favoured medium of Christianity, not only for its beauty but because it was capable of expressing, in symbolic form, the mysteries of the Church. Schemes of decoration developed which can be traced from the extensive cycles in Santa Maria Maggiore in Rome, through the complex iconographic programmes of the fifth- and sixth-century churches of Ravenna (**colour plate 14**) to the hierarchical canon of decoration seen in the churches of the later Byzantine world. In its basic structure this was formalized, to express the teaching and liturgical function of the church. The sense of

'otherworldliness', induced by hieratic figures and accentuated by the stylizing tendency of mosaic technique, is enhanced by the use of gold tesserae for the backgrounds. It is in these mosaics, in churches such as the monastery of Hosios Loukas, near Delphi, in Greece, the Nea Moni on Chios and the Kariye Camii in Istanbul, where the figures appear in frontal pose, remote but at the same time projecting themselves into the viewer's space, that mosaic decoration achieved total unity with architecture.

The continuation of these traditions, and their influence, can be seen from Kiev to Istanbul, from the Greek mainland to the Levant and in other places around the Mediterranean. In the Islamic world, the Ommayyad (eighth-century) mosque of Damascus and the Dome of the Rock in Jerusalem, as well as the Mameluke (thirteenth- to fifteenth-century) buildings of Egypt and Syria, follow these conventions. In Italy, churches such as San Marco in Venice, Torcello cathedral and the twelfth-century churches at Cefalù and Monreale in Sicily, bear testimony to their Byzantine heritage. At the same time, the iconography and the softer, more naturalistic style are Western. The same modifications are seen in the baptistery of Florence and in the churches of Rome, decorated by artists such as Cavallini, Torriti and Giotto. With the fall of Constantinople to the Turks in 1452, church building and mosaic decoration passed into history in the East. In Italy, with its interest in the art of the past, the use of mosaic decoration continued, but with changes of method and tradition.

Materials

The tesserae used for mosaic pavements in the ancient world were usually made of coloured limestone or marble. For reds and yellows an alternative source was terracotta. Because of its fragility, glass was used only where colours such as dark red and blue, not available in stone, were required. Glass tesserae or *smalti* came into their own with the development of wall mosaic techniques.

Smalto is glass, coloured with metal oxides. An infinite number of colour shades is therefore possible. To cut the tesserae, a cake of glass is placed over a metal blade on a block and tapped with a hammer. Gold and silver tesserae are made by sandwiching gold or silver leaf between two layers of glass. Other materials were also used. Faces, for example, were worked in marble, carefully mixed and shaded to approximate skin tones and shadows. Mother-of-pearl and semi-precious stones were sometimes used to simulate jewellery, or to add sparkle and texture to embroidered clothing.

The traditional materials are still manufactured and still used even in the present day, but mosaicists now have a variety of cheaper, commercially-made materials at their disposal, including vitreous mosaic, machine-cut into tesserae of uniform size, and ceramic, either glazed or unglazed, cut or broken to any shape or size. Traditional tesserae may be used in conjunction with tile, slate, metal or *smalti*; *objets trouvés* may be incorporated into the work. Industrialization has provided a wide range of materials and an infinite number of colours from which to choose.

46 Make-up layers for a mosaic pavement of the sixth century AD superposed on one of earlier date (fifth century?). Monastery of Martyrius, at Ma'ale Adumim (Khirbet el Murassas), Israel. Photo P. Henderson

Technique

The function of a mosaic determines the technique. A floor is, by definition, a flat, smooth and durable surface on which to walk. Wall and vault mosaics are not subjected to the same usage, but they need to be seen as clearly as possible from a distance and often in poor light. This calls for a different method than that employed for mosaic pictures or decorative objects seen at close range.

A floor must take weight, wear and tear and, if it is outside, extremes of heat, cold and rain. The foundations are, therefore, all-important. Vitruvius, in his treatise on architecture, recommended the ideal method for laying pavements (7.1.3-4). The base was excavated, levelled and firmly compacted. Three layers of bedding were then laid (**46**): the first of rubble, the second of coarse stones and mortar, and a top layer of fine cement into which the tesserae were set. In practice, short cuts were often taken and many floors were laid on two layers only. The design was worked out on the second layer and painted on with *sinopia* or incised into the mortar (**47**). The top layer was then applied over an area that could be worked while the mortar was soft. If an *emblema* was used it would be laid in place, on its tray or backing, and the rest of the floor laid around it. When the mortar was dry and hard the pavement was smoothed and polished.

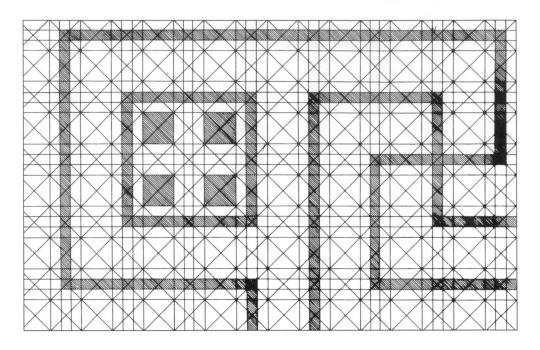

47 *Laying out a mosaic design:*
 (a) system of guide-lines incised and painted in the mortar undercoat;
 (b) detail of the final pattern of tesserae laid out on the guide-lines. Roman villa (Villa Varano)
 at Stabiae, Italy. Scale approx 1:10. Drawings R.J. Ling, after C. Robotti, *Mosaico e*
 architettura. Disegni, sinopie, cartoni (1983), figs 3, 6, 8 and 9

Many *emblemata* were laid on trays of terracotta, some with raised edges which lay flush with the level of the floor. Many more, while obviously made separately from the floor, have no apparent backing. This fact, and certain inconsistencies in the composition of a few mosaics, has given rise to the theory that the Romans used a system of 'indirect' or 'reverse' setting. It is argued that the tesserae were glued, face down, onto paper or canvas, transported to the site and embedded in the mortar. The backing, now on top, could be removed, revealing the finished mosaic.

Scholars continue to debate the question. It is argued, especially in the case of large or elaborate mosaics, that such a method would facilitate the transport and laying of the panel. It would also reduce the amount of sanding back in the final stage because the tesserae could be laid level, on a firm surface. Nevertheless, while the indirect method is widely used today, there is no archaeological or documentary evidence to suggest that this technique was used in the ancient world (Ling 1994). There is, in fact, no real evidence that the method was used before the nineteenth century.

The method of setting the tesserae depended on the type of pavement. Modelling, shading and tonality in a finely worked *emblema* were achieved by the technique known as *opus vermiculatum*, a term deriving from the Latin word, *vermiculus*, a worm. This involved the use of tiny, closely-set tesserae which were arranged in lines to follow the contours of the figures. Between one and three lines of tesserae outlined the figures while the background was usually set in orderly rows. The colours were closely graded. The *emblema* was then set in place in a pavement of coarser work called *opus tessellatum*. The tesserae were larger and less closely set; the background was white, and geometric patterns of varying complexity formed borders and minor, decorative panels. The illusionism of the *emblema* contrasted with the rest of the floor. It negated the natural properties of the stone and took on the qualities of painting. Thus, a tension was created between the illusionistic qualities of the picture and the functional flatness of the floor.

With the development of the all-over pavement design, the distinction between *opus vermiculatum* and *opus tessellatum*, never absolute, became blurred. In the all-over pavement background and imagery were set with the same sized tesserae, generally larger than those used for *vermiculatum*. The spaces between them were wider and the coursing became more pronounced. Images were not confined within the frame of the *emblema*. They extended beyond the borders and spread over the floor. The flatness of the floor reasserted itself and composition became freer. By this time, however, a somewhat different technique, called *opus musivum*, was being used on walls and vaults rather than floors.

A mural mosaic, like a pavement, requires a stratified base. The problems encountered are similar to those of fresco painting. Walls are subject to rising damp or to cracking due to earth movement. The layers of mortar must be well keyed to the base wall. In the past, this was usually done by roughening the wall with a hammer. Nails were sometimes driven into the wall to provide a key but they tended to rust. In addition, unless the mortar was of exact consistency it did not adhere well. Thus, if insufficient care was taken, this mortar separated from the wall, and the mosaic collapsed.

The top layer of mortar contained powdered marble which served to whiten and brighten the ground into which the tesserae were pressed. It was laid in small sections, of a size which could be worked while the mortar was soft. The design was sketched in

sinopia onto the wall before the final plaster was laid. In some cases the picture was fully painted out in colour areas, like a fresco. This gave the mosaicist a clear idea of the way the completed work would look and enabled him to modify elements as the mosaic was set.

The mortar was often left with an undulating surface, into which the tesserae were pushed at different angles. Byzantine mosaicists used much smaller tesserae to work faces, which were sometimes made separately and inserted in the manner of an *emblema*. The undulating surface of the wall, combined with the uneven surfaces of the tesserae themselves, enhanced the refractive potential of the mosaic. The glass and gold tesserae, like so many tiny mirrors, reflect the changing light as it, and the viewer, move through the building.

A number of other methods are now employed in mosaic production. Large mosaics are usually assembled in the workshop, in sections. They are then fixed to the wall or floor and the seams are filled with tesserae. The reverse method of setting the tesserae is also widely used. Ready-made or precast panels, often reinforced by wire, are used for smaller mosaics. With modern adhesives, tesserae may even be glued straight onto a backing, the joints then grouted. Modern artists are able to experiment with new materials and develop new methods. Nevertheless, in the workshops concerned with restoring and copying ancient works, the traditional techniques of setting mosaics remain.

Workshops, mosaicists and patrons

The term 'workshop', as it is understood today, can be misleading. A permanent studio, even with a shopfront, would have been possible for the makers of *emblemata* and portable mosaics. It is the norm today for both large workshops and the individual artist. It was not feasible, however, for artisans who worked directly on the walls and floors of buildings. In this context the term 'workshop' applies to a group, perhaps a family, of itinerant artisans who moved from place to place, setting up a temporary base on site, rather like a mason's yard. Excavations have revealed glass smelting works as well as rooms containing small heaps of pre-cut or unfinished tesserae, sorted according to colour, in close proximity to some mosaic sites. Removal of pavements has also revealed pieces of polychrome marble which had been cut on site and buried as the work progressed.

Wall and floor mosaics were executed by different groups of artisans. The *Codex Theodosianus*, compiled in 438, distinguishes between the *tessellarius*, who worked on floors, and the *musivarius*, who decorated the walls. The earlier *Edict of Diocletian* cites different categories of mosaic artisans and their rate of payment. Most highly paid was the *pictor imaginarius*, who executed the figures and earned three to four times more than the less skilled artisans. Some early texts, and later Latin and Greek inscriptions on mosaics, distinguish between the artist who designed the work and the mosaicists who carried it out. Other inscriptions refer to the maker of the mosaic as both artist and mosaicist (**48**). Even so, it must be assumed that some assistance would have been necessary: how much is difficult to assess. An *emblema* was made by a highly skilled craftsperson but the tessellated floor into which it was set required less skilled work. Even with complex all-

48 Signature of a mosaicist in baths near Enfida, Tunisia: 'Sabinianus Senurianus designed (painted) and laid this mosaic. Have a good bath.' Elsewhere in the same pavement Sabinianus boasts of working 'without a painter' alongside a very crudely rendered bust of a woman or goddess. Repair (fifth or sixth century AD) to an earlier pavement (third century?). Sousse, Archaeological Museum. Photo German Archaeological Institute Rome 64.315

over floor and wall mosaics, the same principle would apply. It is often possible to identify different hands in the draftsmanship or setting of figures, and inscriptions occasionally name two or even three mosaicists. Despite this, it is not clear exactly what role each played, nor what assistance might be required to prepare the base, cut the tesserae, set the backgrounds, or to finish and polish the work. In a large city, with many commissions, division of labour is more likely to have been specialized. In a rural area, a single mosaicist may have been assisted by his family.

Little is known of individual mosaicists. Sosus achieved fame in Pergamum in the second century BC. Other mosaic artists are named in inscriptions on later mosaics (cf **55**). Generally speaking, however, the master remained anonymous. It was not until the Renaissance, and the subsequent elevation of the status of the artist, that mosaic designers, many of whom were painters of renown, were recognized. Even then, the artisans who realized the work remained unnamed.

Decorative schemes were based on traditional forms, not freely devised by the mosaicist. The widespread transmission of motifs and themes is usually attributed to the use of workshop pattern books. This appears reasonable, especially when it is known that later mosaics, such as those of San Marco in Venice, derive from manuscript illumination. There is, however, no certain evidence that pattern books were used by ancient mosaicists. The issue remains controversial.

Whatever the origins of the design, the final composition and iconography of any monumental mosaic requires the approval of the patron. If a pavement was commissioned for a Roman villa, the owner might want it to reflect his social position and wealth. In a

church, the decorative programme must fulfil orthodox requirements. In some cases, as at Santa Maria Maggiore in Rome, San Vitale in Ravenna or the Palatine Chapel at Palermo in Sicily, the programme was devised to express specific religious dogma or political events, and had to be devised by a knowledgeable iconographer. The same principles apply today in any religious commission. But even in secular works, in an era when free invention on the part of artists is the norm, those commissioned to execute a monumental mosaic must, to some extent, do so within the confines of patronage.

The style and content of mosaics have changed over the centuries in accordance with their function. So too has the status and role of both artist and patron. Workshop practice and structure have been adapted to meet these changing conditions while technique has kept pace with new developments and mass-produced materials. Yet, with all this, the time-honoured art of mosaic must be seen as a continuing tradition in the history of Western art.

Bibliography and references

Bertelli, C. (ed) (1989) *The Art of Mosaic*, London: Cassell.

Donderer, M. (1989) *Die Mosaizisten der Antike und ihre wirtschaftliche und soziale Stellung. Eine Quellenstudie*, Erlangen: Universitätsbund Erlangen-Nürnberg.

Dunbabin, K.M.D. (1999) *Mosaics of the Greek and Roman World*, Cambridge: University Press.

Fischer, P. (1971) *Mosaic: History and Technique*, London: Thames and Hudson.

Haswell, J.M. (1973) *Manual of Mosaic*, London: Thames and Hudson.

Ling, R. (1994) 'Against the reverse technique', in P. Johnson, R. Ling and D.J. Smith (eds), *Fifth International Colloquium on Ancient Mosaics held at Bath, England, on September 5-12 1987* (*Journal of Roman Archaeology* Supplementary Series 9) I: 77-88.

Ling, R. (1998) *Ancient Mosaics*, London: British Museum Press.

L'Orange, H.P., and Nordhagen, P.J. (1966) *Mosaics. From Antiquity to the Early Middle Ages*, London: Methuen.

Neal, D.S. (1976) 'Floor mosaics', in D. Strong and D. Brown (eds), *Roman Crafts* (London: Duckworth), 241-52.

Rossi, F. (1970) *Mosaics. A Survey of their History and Techniques*, London: Pall Mall Press.

Sear, F.B. (1976) 'Wall and vault mosaics', in D. Strong and D. Brown (eds), *Roman Crafts* (London: Duckworth), 231-9.

Sear, F.B. (1977) *Roman Wall and Vault Mosaics* (*Mitteilungen des Deutschen Archäologischen Instituts. Römische Abteilung*. Ergänzungsheft 23). Heidelberg: F.H. Kerle.

6 Working practice

Roger Ling

The foregoing chapters have concentrated on the technical processes of production. This chapter will look rather at the artists themselves and how they operated. We shall consider topics such as how workshops were organized, the physical settings in which artists worked, and matters of patronage and payment.

It is, of course, difficult to generalize. In terms of workshop organization, for example, conditions applying to the production of large-scale statuary were very different from those involved in painting wooden panels. In regard to physical environment, there was inevitably a difference between work that could be carried out in a studio or similar long-term base and work such as fresco-painting which, by its very nature, had to be executed on the spot.

In regard to patronage and payment, there must have been a huge gulf between the leading artists carrying out state commissions and the jobbing artisans catering for the popular market (funerary sculptures, house decorations, etc). It is a well-known fact that the Greeks and Romans had no separate words for 'art' and 'craft': the same terms, *techne* in Greek and *ars* in Latin, literally meaning 'skill', embrace all forms of artistic production. But the references in Pliny and other ancient writers testify firmly to the prestige obtained by great artists and, generally, to the differential valuation of works of art (expressed, in Greek times, by the institution of competitions in painting and sculpture). This had a profound effect on the ways in which artists worked and on their social status. There was also a difference between the situation in archaic and classical Greek times, when private patrons played a much more restricted role in the commissioning of art, and that prevailing in the Hellenistic and Roman periods, when alongside the patronage of the king or emperor and other organs of the state there developed a vigorous private art-market, exemplified by domestic wall-paintings, mosaics and garden statuary.

For these reasons it seems advisable to review the organization of workshops by media and questions of patronage and payment chronologically. Before we do this, however, it is worth making some general points about ancient artists.

Firstly, as in many more recent societies, there was a tendency for craftwork to be passed from father to son. This is attested by the literary and epigraphic evidence relating to famous artistic families. The mid-fourth-century sculptor Praxiteles, for instance, was a member of a dynasty which spanned at least four generations, most of whose members were named either Praxiteles or Cephisodotus. Lysippus, though not himself the scion of a bronze statuary (he began as a simple 'bronze smith'), passed on his craft to his sons Daippus, Boedas and Euthycrates, as well as to other pupils; his brother Lysistratus, too, took up bronze sculpture, making innovations in portraiture and the taking of casts. A late-Hellenistic dynasty of sculptors originating from Athens but known from signatures

to have been active on the island of Delos, and from literary accounts to have carried out commissions in Elateia and Rome, included at least one Dionysius son of Timarchides, a Polycles son of Timarchides, a Timocles son of Polycles, and at least one Timarchides son of Polycles; since the same names could have recurred in different generations, attempts to reconstruct the family tree have failed to achieve a result that is universally agreed (Stewart 1990: 304-5). In the field of panel painting, the fourth-century Theban artist Aristides was followed by his son Nicomachus, whose pupils included his brother Ariston and his son Aristides, while the younger Aristides counted his own sons Niceras and Ariston among his pupils. The examples could be multiplied almost endlessly.

Obviously there were many exceptions to this rule. In times of high demand, and for large commissions, an artist would have needed to take on extra apprentices. We also hear of leading artists taking pupils on a commercial basis: Pamphilus charged 500 *drachmae* per year for the privilege of receiving instruction from him (the most distinguished beneficiary was Apelles). But this was at the top end of the scale. The maintenance of craft traditions within the family was the more normal pattern — a natural enough situation in a society where employment opportunities and mobility of labour were often rather restricted.

Secondly, while some artists specialized in one particular medium, there were many who, like Michelangelo in the Renaissance, showed great versatility. Phidias, though most renowned for his colossal works in gold and ivory, also made the Athena Promachos and other statues in bronze, and was reputed to have carved in marble (a medium in which at least two of his pupils specialized). Moreover, he is said to have begun his career as a painter — a report that is given credence by the well-attested specialization in painting of his brother Panaenus. In the following century Euphranor made *colossi* (presumably in bronze or mixed materials), marble statues, and reliefs, as well as painting in the encaustic technique. Several other sculptors, such as Alcamenes and Praxiteles, could turn their hands to either bronze or marble. In the Roman period, the south-Italian Greek Pasiteles made not only an ivory Jupiter but also sculpture in metal and stone. Many bronze statuaries are known to have engraved silver plate: among those cited by Pliny are Ariston, Stratonicus and Posidonius. Pasiteles, too, according to Cicero, included silver-working among his many skills.

Some of this versatility is explicable as the result of production processes which required combinations (or an awareness) of different skills. Marble statues were painted, a practice which brought together famous specialists such as Praxiteles the sculptor and Nicias the painter, but which could alternatively, where a sculptor coloured his own works, have encouraged versatility. Bronze sculpture was copied in marble, especially in Hellenistic and Roman times, which may have entailed the marble sculptor learning about some of the problems and technicalities of statuary in bronze. The cold chiselling employed in the final stages of making a bronze statue would not have been an entirely dissimilar process from the engraving of metal plate. Such congruences may have stimulated an artist familiar with one craft to try his hand at another. But it is not the whole story. There was obviously a sense that the arts formed an allied group and that the creative impulse could transcend the boundaries between one medium and another. We are talking mainly, of course, about the upper echelons of artistic production. The small

producer who could barely eke a living from his craft lacked the time and the resources to experiment. Even successful producers might not have been prepared to risk abandoning a profitable line in favour of a more uncertain one. The leading artists, however, would have been motivated by an urge to find new ways of expressing themselves. To them a switch, say, from painting to sculpture or from marble to bronze would have presented a challenge that they found hard to resist.

Thirdly, most artists were male. This was not just a matter of gender stereotyping — of an acceptance that the role of the woman was primarily to bear children and to remain in the home undertaking only domestic crafts such as weaving. There were practical considerations. Many forms of artistic production, particularly sculpture, involved a degree of physical labour that tended to preclude women (besides discouraging 'well-bred' males). It is significant that, with the exception of a scene on a vase-painting which shows a woman apparently engraving a vessel in a metal-worker's shop, all the female artists of whom we hear from the literary sources or see represented in art (**49**) are panel painters, that is specialists in a field that involved comparatively little physical exertion. Even here it seems that the female practitioners normally followed their fathers: in Pliny's list Timarete, Irene and Aristarete were all the daughters of painters. Even if, like a certain Olympias, female painters could subsequently train male pupils, it was the family tradition rather than a completely independent initiative that had originally brought them to their vocation.

Organization of workshops

Certain arts such as panel-painting could be practised on an individual basis. This is implied by Pliny's stories about Protogenes, who spent years perfecting a single painting, and whose cottage on the outskirts of Rhodes was protected as a safe haven for the artist during Demetrius Poliorcetes' siege of the city. At the most a panel-painter might employ one or two assistants to prepare materials. An anecdote about Apelles and Alexander refers to 'boys who ground pigments', and a certain Erigonus is said to have started by grinding pigments for the painter Nealces before going on to found a school of his own.

Even marble-carvers could have operated on an individual basis, though here it would be an obvious economy if apprentices carried out much of the initial shaping of the block, leaving the master to concentrate on the more tricky final stages. In larger enterprises, however, it is possible to envisage a scenario where one sculptor carved the body of a figure and another, more skilled, finished the head. This is implicit in the production of those portrait statues of Romans which combined a conventional nude body, mechanically copied from a Greek prototype, with an individualized head (**95**). Sometimes the work was shared in such a way that two or more carvers could sign as joint artists. Already in the Greek archaic period we hear of Telecles and Theodorus, the sons of Rhoecus, carving separate halves of the same statue in different cities: though probably apocryphal, this story suggests that a division of labour (or at least a sharing of credit) between artists of equal importance was not unknown at the time. There is plenty of evidence for shared commissions where multiple statues or figure-groups were involved. The Cretan

49 Paintress at work: painting from Pompeii. Ht 32cm. Mid-first century AD. Naples, Archaeological Musum 908. Photo Archaeological Superintendency Naples C 413

sculptors Dipoenus and Scyllis, again in the archaic period, were engaged, apparently as a team, to make various statues of gods at Sicyon. Later, complicated multi-figure compositions such as the Laocoon, the statue-groups at Sperlonga (**50**), and the original of the so-called Farnese Bull were claimed as joint works by two or three master artists, who may each have carved a separate figure or figures within the group, or separate blocks of stone that were joined to form parts of the group (unless some altogether more complicated division of labour took place). Joint production may also have been counselled by the size of a figure. The statue of Jupiter made by Polycles and Dionysius for the temple of Jupiter Stator in the Portico of Octavia in Rome was perhaps a large-scale cult-image which it would have taken one man too long to complete.

Stone-carving, by its very nature, is a labour-intensive process requiring continual periods of skilled labour in which one ill-judged blow of the chisel can undo many

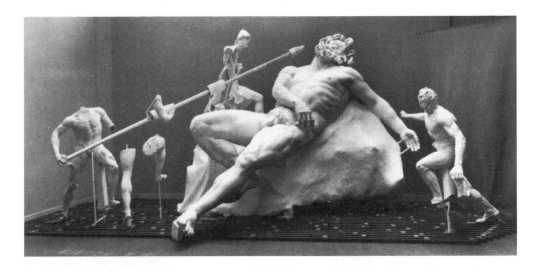

50 Multi-figure statue group showing Odysseus and his colleagues blinding Polyphemus. The composition, one of several displayed in a grotto in an imperial villa at Sperlonga, south of Rome, was made by three sculptors from Rhodes, Hagesandros, Athanadorus and Polydorus. First century AD, based on an original of the second century BC. Ht of Polyphemus approx 3.50m; ht of other figures 2 to 2.20m. Photo German Archaeological Institute Rome 72.2416

months of work. The emergence of life-size hollow-cast bronze statuary at the end of the archaic period, rather like the development of concrete architecture in Roman times, changed the character of the production process. In this medium much of the skill lay in the planning stage. The master artist would make the clay model or models from which the statue was cast, but the actual casting could be left to semi-skilled assistants. Moreover, the use of the indirect lost-wax method, universal after the middle of the fifth century BC, ensured that the original clay model and the piece-moulds taken from it were not destroyed in the casting process and could thus be reused if something went wrong. All this meant a much more effective use of the master's time. Apart from the making of the model, his main role (one imagines) would have been to carry out the cold chisel work and other detailed surface treatment of the completed statue. The semi-industrial nature of bronze statue-making, with its use of a 'production line', is illustrated by the workshop scenes on the so-called Foundry Cup in Berlin (Mattusch 1980) (**51**). Here slaves are engaged in stoking the kiln and scraping dross from the surface of a statue, while an apprentice is assembling pieces of another statue, and two well-dressed men, perhaps owners of the workshop (or clients?), watch the finishing stages being done. Such modes of production tend to favour the emergence of a situation where the original master becomes an entrepreneur rather than a practitioner. It is difficult to believe the report that Lysippus made 1500 works in bronze if he was personally responsible for all of them, even if many of them were small pieces, but it becomes more plausible if we recognize that many of them were made by pupils and assistants working under his supervision. Similarly, where bronze statuary is attributed to joint authors (like the Tyrannicides by

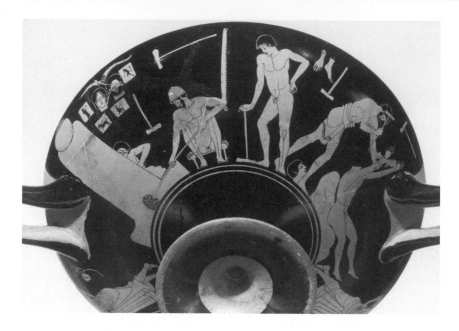

51 *Scenes of work in a bronze foundry. Attic red figure cup from Vulci (c490 BC). Berlin, Staatliche Museen F 2294.*

(a) A slave stokes the kiln, while an apprentice bronze-worker stands watching; another apprentice assembles pieces of a bronze statue; hanging on the wall in the background are samplers, tools and the feet of a statue.

(b) Two well-dressed men (perhaps the workshop owners, perhaps clients) watch a couple of slaves or apprentices scraping the surface of a statue of a warrior.

Photo Ingrid Geske (courtesy Staatliche Museen zu Berlin, Preussischer Kulturbesitz, Antikensammlung)

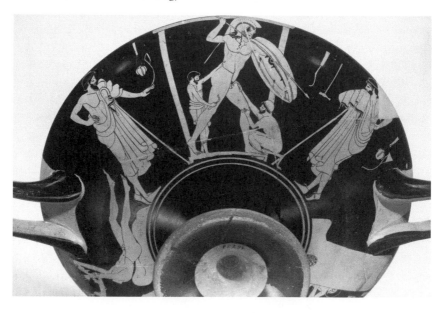

Critius and Nesiotes (**52**)), it is possible that one of them was the owner of the workshop, or that they were joint owners, rather than that they physically collaborated on a work.

A factory form of production can also be observed in the painted pottery industry. Here the skill lay in the shaping and painting of the pot: the firing process and other menial tasks could be entrusted to semi-skilled assistants. Depictions of pottery workshops (**53**) show the numbers of workmen involved — not only the slaves stoking the kiln and bringing out the pots for firing but also assistants turning the wheel on which the potter worked. The scale of production attested by the extensive discoveries of Athenian pottery in Italy, Spain, the Black Sea and many other regions, not to mention Athens itself, could hardly have been achieved without such well-organized production lines. Even the skilled input could be shared. Where signatures refer to a maker and a painter, we may suspect that this often indicates that one man fashioned the pot while another painted it: signatures such as those of Exekias which claim credit for both making and painting imply that the two processes were regularly divided. The signature of the 'maker', however,

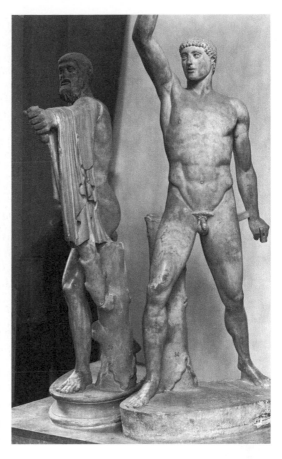

52 Tyrannicides. Roman marble copies of a bronze statue group by Critius and Nesiotes, set up in Athens in 477 or 476 BC. Ht 1.85m. Naples, Archaeological Museum. Photo German Archaeological Institute Rome 58.1791

more frequently occurs alone, and in such cases probably indicates the owner of a workshop, who may have been a potter, a painter, or both. Sometimes this owner was perhaps simply an entrepreneur. The famous red-figure artist Euphronios is thought to have begun as a painter, but later in life, perhaps as a result of failing eyesight, to have concentrated on running his business and delegating the production to others — an activity which brought him sufficient wealth to pay for an expensive dedication on the Acropolis.

For fresco painting, while it is hardly appropriate to speak of factory production, there was certainly a division of labour. A typical team of decorators is illustrated in a well-known Roman funerary relief at Sens in France (**54**), where we see one man mixing plaster on the floor and a plasterer and painter operating simultaneously (so clearly in the

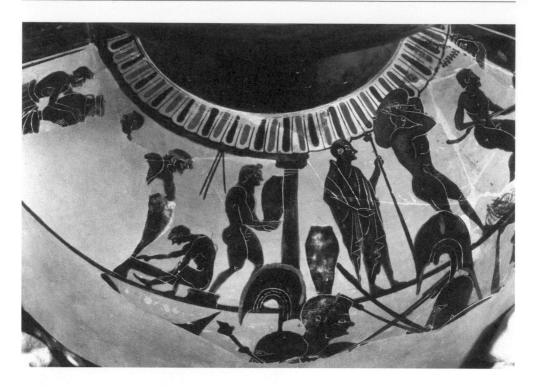

53 Pottery workshop. Shoulder of Attic black figure hydria, attributed to the Leagros Group. At the left an assistant perhaps holds a jar for a painter to decorate it; next, a potter shapes a jar while an assistant turns the wheel; then comes a further assistant carrying a finished jar towards a kiln which is being stoked by two slaves under the watchful eye of the workshop owner. A mask on the kiln may be designed to protect it from evil. c510 BC. Munich, Staatliche Antikensammlungen und Glyptothek 1717. Photo Staatliche Antikensammlungen, Munich

fresco technique) on the wall, while a fourth figure sits at one side consulting a scroll. Here we may conjecture that the painter at work on the wall is applying the background colours or subsidiary ornament, while the seated figure is the *pictor imaginarius* (figure painter) who will move into action once the preliminary work has been done: his scroll may be a pattern book with sample drawings similar to the artists' trial pieces on a recently published papyrus from Roman Egypt (Gallazzi and Kramer 1998).

That wall-painters operated in teams is clearly indicated by the evidence of Pompeii. There has recently been some debate as to whether these were people who regularly worked together in teams or whether they were *ad hoc* groups assembled for specific jobs (Allison 1995). Some have seen the painters of the central pictures in particular, who were obviously the most accomplished artists, as freelance operators hired for specific contracts. Whatever the detailed arrangements, there must have been recognized contractors who organized the work, and it is difficult to believe that they would not have regularly employed the same craftsmen, even if they did not run 'workshops' organized on a formal basis. The teams engaged on a contract could be quite large. This is implied by the

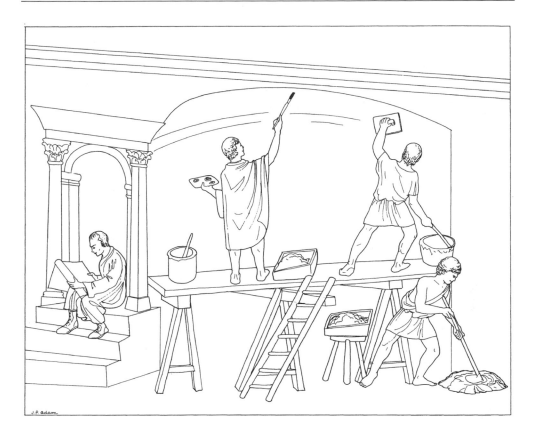

54 Funerary relief of decorators at work from Sens (France). Second century AD. Sens Museum.
Drawing J.-P. Adam

situation visible in Pompeian houses where work was left unfinished as a result of the fatal eruption (or of an earthquake which preceded it). In the so-called House of the Iliadic Shrine, as many as six different rooms were being plastered and painted simultaneously and had reached various stages of completion. In a recently excavated house where work was in progress on a large dining-room, the numbers of paint-pots and the variety of pigments found in them have been used to calculate that the paintings involved four separate craftsmen. Here the upper zone had been finished, but the middle zone was not quite done (**colour plate 15**): one painter was executing architectural ornament on the east wall, another was half-way through the central picture on the north wall, a third was about to spread the background colour on a newly plastered surface in the north-east corner, and a fourth was perhaps applying ornaments in a *secco* technique over a coloured background somewhere else in the room (Varone 1995; Varone and Béarat 1997).

Mosaicists must have been organized in a similar way to wall-painters. Obviously the fine pictorial *emblemata* set as centrepieces in mosaic pavements of the Hellenistic and early Roman periods were generally, like panel paintings, the work of individual artists, a fact confirmed by surviving signatures at Pella, Pergamum, Alexandria and Pompeii. But the

surrounding ornamental borders of such pavements, and the all-over decorative schemes prevalent in Roman times, were clearly the work of teams. These would have varied in size according to the scale of the operation: two men might have sufficed for an average room in a private house, but three, four or even more are attested for larger areas such as the interiors of early Christian basilicas. Standard decorative setting was evidently shared equally, with each mosaicist responsible for a different part of the surface; the only other member of the team was perhaps an assistant (or assistants) who prepared the tesserae, mixed the mortar for the bedding, and so forth. But in finer pavements the work may have been divided into tasks requiring different degrees of skill: laying plain backgrounds, carrying out repetitive ornament, and doing figure-scenes. A division of this kind is clearly acknowledged in certain signatures which distinguish between the roles of a 'painter', presumably the craftsman responsible for the design if not also the execution of figure-scenes, and an ordinary mosaicist, who either put the other's designs into effect or made the less demanding motifs. The 'painter', whose name takes precedence, was the more skilled artist (one mosaicist who boasted of being able to work 'without a painter' was patently deficient in pictorial ability (**48**)), but he was not necessarily the owner of a workshop: a signature in Spain names the owner as Ma...nus and the painter as Hirinius (**55**).

The place of work

Very little is known of the physical environments in which artists worked. Long-term workshops or studios would have existed only where the producers could be assured of a ready local market for their work, or where this work was portable and a well developed system of distribution was to hand. Of excavated examples the best are a couple which belonged to marble-workers: a house-cum-workshop in the Athenian Agora, which is thought to have been in use from the mid-fifth to the early third century BC, and a similar establishment in the centre of Aphrodisias, Asia Minor, which functioned at least from the first half of the third to some time in the fourth century AD. In both cases identification is guaranteed by the finding of unfinished sculptures, stone-carving tools and the like. The workshop at Aphrodisias had two rooms opening via broad doorways on to a public *piazza* and clearly depended to a large extent on casual sales; the pieces produced were thus small decorative items, reproductions of well-known statues, and stock portrait statues to which a customer's individual features could be added — all things that might have been bought 'off the peg' by well-to-do shoppers (Rockwell 1991).

We can guess that similar workshops with attached show-rooms characterized the Athenian painted pottery industry, though no examples have actually been excavated. The demand for fine-quality vessels would have kept the producers permanently employed, and the portability of their products, combined with proximity to a major port at Piraeus, would have enabled them to supply the overseas market without moving from the Athens potters' quarter. Similar conditions would have operated in Corinth, whose position controlling sea-routes to both east and west favoured the wide distribution of its successful animal-figured ware in the seventh and early sixth centuries BC.

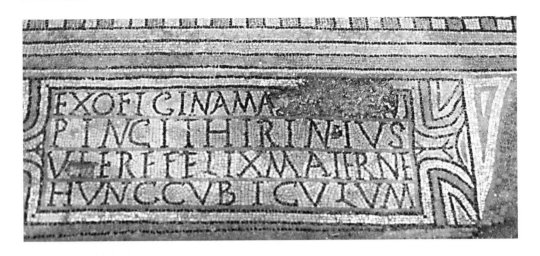

55 Mosaicists' signatures in a Roman villa at Carranque, near Toledo, Spain (fourth century AD): 'From the workshop of Ma[....]nus, painted by Hirinius. Good luck, Maternus, in the use of this room.' Photo J. Arce

But many artists and craftsmen would have had to travel to find work. They would have taken their tools and other equipment with them and set up temporary workshops wherever they acquired commissions. This was true not just of modest artisans but also of the major artists who established international reputations (see below). In the Greek period we hear repeatedly of well-known sculptors and painters moving from city to city in pursuit of, or in response to, commissions commensurate with their artistic standing. Phidias, for instance, having gained fame for works in his home city of Athens, was commissioned to make various statues elsewhere. While some of these, such as the wounded Amazon entered for a competition at Ephesus, could conceivably have been manufactured in Athens and shipped to their destinations, the artist must have transferred to Plataea to supervise construction of the colossal acrolithic statue of Athena Areia, and he certainly set up shop at Olympia to make his most celebrated statue, the gold and ivory Zeus. The workshop that he built there is mentioned by Pausanias (5.15.1) and its remains, incorporated into a Byzantine church, were identified by the German excavators of the 1880s and 1950s (Mallwitz and Schiering 1964). Its main room, 18.41m long, 12.57m wide and over 13m high, corresponded closely to the dimensions of the interior of the temple in which the statue was to be installed, and must therefore have been designed to accommodate a full-scale assemblage. As in the temple chamber, there was a row of columns at each side, dividing the space into a nave and aisles; the purpose of the columns was to carry a two-storeyed working platform rather than to support the roof frame, but they would have given the artist an idea of how the statue would look when framed by the internal colonnades of the temple.

The Olympia statue was a prestigious project involving the use of precious materials, and Phidias' workshop, though temporary, was unusually large and massively built. Most itinerant artists needed no such elaborate edifice. They could rent premises locally or

construct makeshift shelters. Sculptors who, like Phidias, were engaged on commissions for a temple or sanctuary would have done much of the work on the actual building site, even if the preliminary stages (roughing out a block of stone in the quarry, or making clay models for a bronze statue) were done elsewhere. Vivid testimony to on-site production is provided by the casting pits for bronze statues found alongside certain Greek temples, such as those of Apollo Patrous and Hephaestus in Athens (Mattusch 1977a, b).

Artists responsible for architectural surface-decorations such as frescoes and mosaics inevitably had to operate mainly on the spot. Even if the finer figure-scenes sometimes took the form of inserts prepared separately in a workshop or bought ready-made on the art-market (or plundered from older walls and pavements), the subsidiary decoration was generally applied directly on the wall, floor or ceiling. The building for which the decoration was designed thus became itself a kind of workshop. Evidence for this on-site activity is found in circumstances where the craftsmen were interrupted before the job was done. The unfinished wall-paintings in a recently excavated house at Pompeii, already mentioned, are associated with heaps of materials for making mortar, with jars of lime, and with numerous paint-pots, many of which contained remains of pigments. In various houses and villas throughout the Roman world the activity of mosaicists is attested by heaps of tesserae, often graded according to size and colour. In all these cases the home of the art-work was also the place of its execution.

Patronage and payment

Patterns of patronage varied through antiquity. At all periods there were small independent operators reliant on market forces, such as the vase-painters of Athens, but at certain times there was greater state control of art production. And even in societies where artists were nominally free operators, there was a tendency for the more successful ones to gravitate towards state-sponsored projects whether at home or abroad.

The heyday of the independent operator was Greece's golden age, the fifth and fourth centuries BC. Famous sculptors such as Myron, Phidias, Polyclitus, Praxiteles, Scopas and Lysippus, and famous painters such as Polygnotus, Micon, Zeuxis, Parrhasius, Nicias, Apelles and Protogenes, all worked for different patrons in different parts of the Greek world. They travelled partly as a result of the fame that they acquired, partly in response to economic dictates. The projects that offered them financial rewards commensurate with their standing tended to arise in different places at different times. Major undertakings such as the Periclean building programme in Athens and the construction of the Mausoleum at Halicarnassus attracted the leading artists of the time like bees to a honeypot. When these were finished, they had to look elsewhere for employment. After the fall of Athens in 404 BC, for instance, many of the sculptors and other artists who had worked on the Acropolis buildings found themselves obliged to go to other states (some of them may have been absorbed in the teams which worked on the temple of Asclepius at Epidaurus), or to reconcile themselves to more mundane forms of production. To those who stayed in Athens the recently revived fashion for elaborately carved tombstones must have offered a welcome lifeline.

In the second half of the fourth century things began to change. The decline of the classical city state and the rise of bureaucratic monarchical societies meant that the leading artists became more dependent on the patronage of kings and high officials. The trend began even before the cities were directly controlled by kings. Already at the end of the fifth century the painter Zeuxis had been engaged by King Archelaus of Macedonia to decorate his palace. When in the mid-fourth century Scopas, Bryaxis, Timotheus and Leochares were employed by Artemisia, a foreign queen, to carve the sculptures of the Mausoleum at Halicarnassus, they were tacitly confirming the demise of the old Greek cities as important sources of patronage. With the Macedonian conquests the changes in the artist's role became more marked. From now on he (or she) was increasingly dependent on a more personalised and propagandist kind of patronage. Alexander the Great led the way by issuing licences for approved artists to make his portrait in different media: Lysippus had the rights in bronze sculpture, Apelles in painting, Pyrgoteles in gem engraving. Although these artists (or at least the first two) certainly carried out many other commissions, their position in the service of the king and his successors must have had a defining effect on their careers.

In the Hellenistic kingdoms royal patronage became dominant. We know from literary and archaeological evidence that the kings of Pergamum attracted leading artists from Athens, Rhodes and various cities of Asia Minor to work on the victory monuments of their capital, and a similar role must have been played by the other great dynasties — the Ptolemies in Egypt, the Seleucids in Syria, and the Antigonids in Macedonia. It was not just the erection of public monuments in the narrow sense but also the decoration of the royal palaces that would have provided employment. Descriptions of the paraphernalia of public pageants at Alexandria give a hint of the possible luxury of the palaces that have been lost, while the surviving palace at Pergamum, though surprisingly modest, has yielded mosaics of first-rate quality. The only mosaicist known from written sources, Sosus, may well have worked for the Pergamene royal family.

The patronage of kings gave place in Roman times to that of generals and emperors. Here some of the artists, initially at least, were slaves or in some other form of direct dependency on their patrons. The situation to some extent recalled that of Pharaonic Egypt where many of the great architectural and sculptural achievements had been carried out predominantly by slaves, whether under the control of the Pharaohs themselves or in the service of temples. In the last two centuries BC, benefiting from the influx of slaves and prisoners of war that resulted from Rome's conquests in the East, Roman magnates were able to acquire skilled craftsmen — architects, painters and sculptors — who could be employed directly in the adornment of their owners' villas and gardens. In the early Empire there were many such people in the imperial household. The epitaphs of the slaves and freedmen of Livia and other members of the Julio-Claudian family found in their surviving *columbaria* (communal tombs) at Rome, include not only painters but also goldsmiths and engravers.

Alongside thraldom as a slave or other forms of direct dependency, the artists employed by Roman potentates were also held by looser ties. In 168 BC, after the battle of Pydna, we hear that the victorious general Aemilius Paullus retained the Athenian painter and philosopher Metrodorus to paint pictures for his triumphal procession in the

capital. Metrodorus was not enslaved; he was selected by the Athenians in answer to a request from Paullus; but it was hardly a commission that he could have refused. In later times, too, we hear of artists who worked predominantly, if not exclusively, for the emperors — for example, Fabullus, who painted in Nero's Golden House, or, extending our remit to include an architect, Apollodorus of Damascus, the designer of Trajan's Forum. Such men certainly owed their positions to imperial patronage. The extent of their dependence is illustrated by the fate of Apollodorus, put to death by Trajan's successor Hadrian for daring to criticize the emperor's own architectural blueprints.

The financial rewards secured by artists naturally depended on the amounts their patrons and customers were prepared to pay. Not surprisingly it was the freelance artists who, once their names were established, were able to accumulate the greatest wealth. Some of the artists of classical Greece became renowned for their affluence, and especially the painters, whose finished works would have involved lower outlays in time and materials than those of sculptors. We hear, for example, that Zeuxis was sufficiently well off to be able to give away paintings to the city of Agrigentum in Sicily and to King Archelaus of Macedonia, and that Nicias could afford to reject an enormous offer by King Ptolemy for his painting of Odysseus' visit to the Underworld, preferring to donate it to his home city of Athens. Similarly, Polygnotus was able to renounce a fee for his work on the Stoa Poecile (Painted Stoa) in Athens. But sculptors too could make big money. Praxiteles built up sufficient resources for his son and successor to be one of the 300 richest citizens of Athens, obliged to contribute to the maintenance of the Athenian navy (Lauter 1980), and Lysippus is said to have left 1500 gold pieces at his death. It is clear, moreover, that many of these artists, for all the adverse comments of later writers such as Lucian, who described the lot of a sculptor such as Phidias as unenviable, became celebrities, enjoying the friendship of statesmen and kings, and receiving honours and privileges in reward for their achievements.

If we leave aside the highly prestigious state or temple commissions of which Phidias' gold and ivory statues at Athens and Olympia are the supreme examples, one of the chief bases of the artist's wealth was the art-market. Paintings and statues were not always made to order. Often, as the story of the offer rejected by Nicias reveals, they were effectively available to the highest bidder. An interesting anecdote recounted by Pliny tells how Apelles artificially inflated the value of Protogenes' paintings by offering large sums for them, thus spurring the citizens of Rhodes to revise their estimation of what they were worth. Later, in Hellenistic and Roman times, as the mania for art-collection took hold, prices went through the roof. 'Old masters' fetched the kind of sums now paid for a Monet or a Van Gogh. However, contemporary artists benefited too: Julius Caesar paid 80 talents for two paintings by a living artist, Timomachus of Byzantium. At the lower end of the scale, the growth of the Roman art market provided a lucrative income for workshops of copyists, especially those specializing in reproductions and pastiches of famous statues.

It was a different story for works of art that were fixtures — architectural sculptures, wall paintings, and floor mosaics. The artist was here paid only the fee that was agreed at the time; there was no possibility of exploiting the open market. Generally there would have been some form of contract based on payment for work completed. For architectural

sculptures we have valuable information from Greek building accounts, notably those relating to the Erechtheum in Athens (late fifth century BC) and the temple of Asclepius at Epidaurus (first half of the fourth century BC). The figures of the Erechtheum frieze, each carved separately and dowelled to the background, were commissioned from different sculptors at 60 *drachmae* each. At Epidaurus sculptors received commissions for blocks of work, the payment for a set of pedimental figures being 3010 Aeginetan *drachmae* (4300 Attic *drachmae*). It has been calculated that these sums were based on a standard rate per statue dictated by the size and material, in other words by the amount of time that the work would take, plus an additional sum to cover the costs of quarrying and transport. This rate in turn was based on a conventional wage of one *drachma* per day, a sum which, in fifth-century Athens at least, was adequate but hardly generous (it was the same sum as paid for service in the ranks of the Athenian army). For the Parthenon pediments, apparently, the sculptors actually received the daily wage of one *drachma* rather than being paid by the piece — a circumstance which might have allowed them to lavish more care on their work (piecework contracts naturally encourage cost-cutting) but which, in practical terms, would have made them no more wealthy. It is clear that the remuneration for this sort of work was far less than that for free standing statuary.

Of payments for wall-paintings and mosaics we have very little direct evidence. By implication the murals on wooden panels executed by Polygnotus and Micon in the fifth century BC were comparatively well rewarded, but these were major state-financed projects. The frescoes and pavements commissioned by private patrons for their houses in Hellenistic and Roman times cannot have earned the craftsmen vast sums. Presumably most commissions were paid for on a piecework basis: a contractor would agree a price with the patron and would then be responsible for all the costs of labour and materials (though we learn that certain of the more luxurious pigments used in wall-painting had to be provided by the patron, ie by special arrangement). The price would obviously have been higher for a more elaborate decoration involving more expensive materials and a greater investment of time and skill. It was natural that those craftsmen entrusted with more demanding work, such as figure-painting, should be paid more than those who carried out the lesser tasks. This difference is borne out by the one document that gives figures for wages and prices in Roman times, Diocletian's Edict of AD 301 (Gracer 1940). Unfortunately this represents a government attempt to impose maximum levels of payment, and we do not know how far it corresponded to reality or how effective it was; nor can we be sure whether it reflected conditions across the whole Empire (most of the surviving fragments of the inscriptions by which it was promulgated come from the East), and whether the relative values that it indicates can be extrapolated to other periods. Nonetheless it gives a rough guide to what bureaucrats of the early fourth century AD felt was appropriate. For the figure painter (*pictor imaginarius*, probably a producer both of wooden panels and of the central pictures in wall-decorations), it laid down a wage of 150 sesterces a day, plus subsistence. For the ordinary wall painter (*pictor parietarius*) it allowed only 75 sesterces. But this last figure was still in excess of the wages prescribed for mosaicists. The wall and vault mosaicist (*musearius*) received only 60 sesterces, the floor mosaicist (*tessellarius*) only 50, the same as the wage of a builder, a baker, a joiner, or a blacksmith.

Whatever the precise significance of the figures in Diocletian's Edict, it was possible for wall-painters and mosaicists in the Roman age to achieve a degree of wealth and standing. At Cyrene in the second century AD a wall-painter named L. Sossius Euthycles, who was responsible for figure-paintings in major local buildings, was admitted to membership of the local senate, probably in recognition of his work. At Perinthus on the Black Sea, again in the second century, a mosaicist named P. Aelius Proclus not only gained admission to the local senate but also had sufficient resources to fund the decoration of a sanctuary of Tyche (Fortune) from his own pocket. But these were the success stories — artists who won public commissions sufficiently prestigious and remunerative to bring them social advancement. The average painters and mosaicists were certainly less fortunate.

We may conclude by mentioning amateur artists. As in more recent times, there were Greeks and Romans who dabbled in art without any need to profit from it. Not surprisingly, it is panel painting, less demanding in terms of time and cost than other art forms, for which we have recorded examples. We know that, in Greek times, partly as a result of the influence of Pamphilus, painting came to be taught at schools. In the Roman period it was not part of the normal curriculum, but Pliny mentions a number of men of standing who turned their hand to painting, including Q. Turpilius, a member of the high-ranking equestrian order, Titedius Labeo, who had governed the province of Gallia Narbonensis (southern France), and Q. Pedius, the grandson of a Roman consul. Like the Winston Churchills of modern times, however, these individuals were noteworthy less for the distinction of their works (though those of Turpilius were described as 'beautiful') than for the fact that they painted at all. Indeed, the young Q. Pedius was given lessons in painting only because his muteness disqualified him from the public career appropriate to his social position, while Titedius Labeo was actually derided for his efforts. Art was properly left to the professional artist, whatever his or her reputation, and however secure the living which he or she made from it.

Bibliography and references

General works
Burford, A. (1972) *Craftsmen in Greek and Roman Society*, London: Thames and Hudson.
Stewart, A. (1990) *Greek Sculpture: an Exploration*, New Haven and London: Yale University Press.

Organisation of workshops
Allison, P.M. (1995) '"Painter-workshops" or "decorators' teams"?', *Mededelingen van het Nederlands Instituut te Rome* 54: 98-109.
Gallazzi, C., and Kramer, B. (1998) 'Artemidor im Zeichensaal. Eine Papyrusrolle mit Text, Landkarte und Skizzenbüchern aus späthellenistischer Zeit', *Archiv für Papyrusforschung und verwandte Gebiete* 44: 189-208.
Mattusch, C.C. (1980) 'The Berlin Foundry Cup: the casting of Greek bronze statuary in the early fifth century BC', *American Journal of Archaeology* 84: 435-44.

Varone, A. (1995) 'L'organizzazione del lavoro in una bottega di decoratori: le evidenze dal recente scavo pompeiano lungo Via dell'Abbondanza', *Mededelingen van het Nederlands Instituut te Rome* 54: 124-36.

Varone, A., and Béarat, H. (1997), 'Pittori romani al lavoro. Materiali, strumenti, tecniche: evidenze archeologiche e dati analitici di un recente scavo pompeiano lungo via dell'Abbondanza (Reg. IX ins. 12)', in H. Béarat, M. Fuchs, M. Maggetti, and D. Paunier (eds), *Roman Wall Painting: Materials, Techniques, Analysis and Conservation. Proceedings of the International Workshop Fribourg 7-9 March 1996* (Fribourg: University, Institute of Mineralogy and Petrography), 199-214.

The place of work

Mallwitz, A., and Schiering, W. (1964) *Die Werkstatt des Pheidias in Olympia* (Olympische Forschungen 5), Berlin: De Gruyter.

Mattusch, C.C. (1977a) 'Bronze and ironworking in the area of the Athenian Agora', *Hesperia* 46: 340-79.

Mattusch, C.C. (1977b) 'Corinthian metalworking: the Forum area', *Hesperia* 46: 380-9.

Mustilli, D. (1950) 'Botteghe di scultori, marmorarii, bronzieri, e caelatores in Pompei', in A. Maiuri (ed), *Pompeiana. Raccolta di studi per il secondo centenario degli scavi di Pompei* (Naples: Macchiaroli), 206-29.

Rockwell, P. (1991) 'Aphrodisias: unfinished statuary associated with a sculptor's studio', in R.R.R. Smith and K.T. Erim (eds), *Aphrodisias Papers 2. The Theatre, a Sculptor's Workshop, Philosophers, and Coin-types (Journal of Roman Archaeology*, Supplementary Series 2): 127-43.

Thiersch, H. (1938) 'Ergasteria, Werkstätten griechischer Tempelbildhauer', *Nachrichten von der Gesellschaft der Wissenschaften zu Göttingen. Philologisch-historische Klasse Fachgruppe 1. Altertumswissenschaften* NF 3: 1-19.

Patronage and payment

Gracer, E.R. (1940) 'The Edict of Diocletian on maximum prices', in T. Frank (ed), *An Economic Survey of Ancient Rome* V. *Rome and Italy of the Empire* (Baltimore: The Johns Hopkins Press), 305-421.

Lauter, H. (1980) 'Zur wirtschaftlichen Position der Praxiteles-Familie im spätklassischen Athen', *Archäologischer Anzeiger*: 525-31.

7 Colossal statues

Roger and Lesley Ling

Introduction

Colossal statues are a rare breed. The cost in time and materials and the technical difficulties involved in creating them mean that they occur chiefly (with one or two notable exceptions, such as the famous giants on Easter Island) in societies which are relatively affluent and have a highly developed artistic tradition. Nonetheless, we know of hundreds of examples over the ages, a few of them truly 'colossal' (up to 30m or more high). The earliest recorded are those of ancient Egypt and Babylonia, most of them known only from passing references in Greek literature, though a certain number of Egyptian specimens survive in part or in whole. Of the *colossi* of ancient Greece and Rome we have no more than a few miserable fragments: our knowledge is based almost entirely on literary descriptions and on surviving representations or replicas. But this evidence is sufficient to reveal that they were works of unprecedented ambition and unparalleled fame. They included some of the most important statues to have been created in the ancient world.

A colossal statue may, for convenience, be defined as any statue that is at least twice life-size. Broadly speaking, the aim of such a statue is to impress — to be metaphorically, as well as physically, larger than life. The subject-matter of the statue is not necessarily different from that of a life-size or smaller statue, but by being enlarged it becomes more striking, more commanding, more awe-inspiring. In ancient societies *colossi* were often used to represent deities, with a view to impressing contemporary viewers with the might of the god, and at the same time to act as a kind of homage to the deity in question: the huge statue, like a gigantic temple or a medieval cathedral, was an especially expensive and showy gift. But in all periods *colossi* have had another role: to advertise the wealth of the state or of the individual patrons that commissioned them. Often the actual subject represented glorifies the state or the individual, directly or indirectly. In these cases the role of the statue is overtly propagandist. In democratic states it may be a personification of a state ideal, like Liberty, prominently displayed to visitors, or a representation of a patron deity who is in some sense identified with the state, like the Athena Promachos. In monarchical states, such as Egypt or the Roman Empire or the France of Louis XIV, it may be a portrait of the ruler, given a godlike standing by the enhancement of scale.

Mesopotamia and Egypt

In the monarchical societies of Mesopotamia and Egypt, colossal scale was frequently used for statues of rulers as well as gods. Since, in Egypt at least, the ruler was endowed with a

divine nature, one can regard the use of *colossi* for depictions of him as a means of making his divinity manifest.

For Assyria and Babylonia, most of our evidence comes from written sources. They refer exclusively to *colossi* in gold. Such were the three statues of deities, identified by Greek writers with Zeus, Hera and Rhea, said to have been set up by the Assyrian queen Semiramis (Sammuramat, *c*800 BC) at the summit of her ziggurat in the city of Babylon. Zeus, 40ft (12m) high, was shown erect and stepping forward, Rhea seated with lions at her knees, and Hera standing; before them was a golden table carrying drinking cups, censers and mixing bowls. The statues were not solid gold, but were executed in the *sphyrelaton* technique, with gold foil hammered onto a surface built up in less costly materials. Nonetheless, the figures for the weight of the gold quoted by our sources, Herodotus and Diodorus, show that huge quantities were employed.

Another golden statue is referred to in the Book of Daniel: the image 90ft (27.5m) high and 9ft (2.75m) wide which Nebuchadrezzar (605-562 BC) set up in the plain of Dura and directed his governors and officials to worship. It was their resistance to this directive that led to the casting of the Jews Shadrach, Mesach and Abednego into a furnace.

These examples represented deities, but that the cultures of western Asia sanctioned colossal portraits of rulers too is suggested by accounts of the tomb of Zarina, queen of the Sacae, a people from the region to the east of the Caspian Sea. Constructed about the middle of the sixth century BC, this took the form of a pyramid with sides reputedly 1800ft (540m) long and a height of 600ft (180m). On top was a colossal gold statue of the queen herself. The fact that this was a funerary monument may have facilitated the use of colossal scale, since divine status could readily be conferred upon a ruler who was dead. What is especially interesting is that Zarina's monument, with its pyramidal form, seems to have been related to the royal tombs of Egypt. We are especially reminded of the two pyramids crowned by colossal seated statues of the Pharaoh Amenemhet III (1878-1842 BC) and his queen set in the centre of Lake Moeris in the Fayum; the fame of such works, recorded by ancient writers and still extant as late as the sixteenth century AD, may well have inspired imitations in other parts of the Middle East.

In Egypt the normal material of colossal statues was stone. The first examples appear at an amazingly early date. Pieces of three figures excavated at Coptos in Upper Egypt came from a deposit beneath an XVIIIth Dynasty temple and must be dated either to the Predynastic or to the Early Dynastic period, at all events around 3000 BC. They evidently depicted a male fertility god wearing a broad belt and holding a wooden staff or the like in his hand; his head was bald but he wore a long beard and was equipped with a separately carved phallus. An estimate of the original height produces a figure of 4.10 m, that is well over twice life-size.

There are some other colossal works dating to the third millennium, the best known of which is the Great Sphinx of Chephren at Gizeh, carved from a natural outcrop of limestone. Most of the surviving *colossi*, however, belong to the New Kingdom (XVIIIth to XXth Dynasties, *c*1567-1148 BC) and represent Pharaohs. They derive both from the temples of other deities, where the Pharaoh may be regarded as an earthly manifestation of the deity in question (or at least as an intermediary between the deity and his or her mortal worshippers), and from the Pharaoh's own mortuary temple, the focus of his

posthumous cult. In either case, like the more numerous life-size or less than life-size images, they were regarded as a substitute for the king, being animated by his life-force and thus able to participate magically in religious ceremonies. The surviving specimens are 10, 15, even 18m high and are without exception serene, remote and impersonal; they are generally shown either seated with hands on knees or standing with arms at sides and one leg advanced. The general uniformity of style often makes it difficult, where inscriptions do not survive, to identify which king was intended; and in many cases a statue of one Pharaoh was usurped by a later one, or even by more than one. Any physical resemblance between a statue and the individual portrayed was clearly not binding upon viewers of later generations; a new inscription was sufficient to change the identity and to validate the rituals appropriate to the new owner.

Statues of the Pharaoh were frequently reduplicated within a single context. A favourite theme was a pair of seated *colossi* framing the entrance of a temple. In the façade of the Temple at Luxor, two such statues, representing Ramesses II (1290-1224 BC) wearing the lofty double crown of Upper and Lower Egypt, still survive, along with one of the four standing figures which were placed alongside them, a pair to the left and a pair to the right. The seated statues are 13m in height, their heads alone (including the crowns) 4.5m high, and the fingers 54cm long. The same Pharaoh's rock-cut temples at Abu Simbel were fronted by seated *colossi* nearly 20m high, with members of his family carved in relief on a smaller scale between the legs (**56**). In the mortuary temple of Amenhotep III (1384-1345 BC) in western Thebes the seated *colossi* framing the entrance are all that remains of the whole complex, which was destroyed by a later Pharaoh; they stand in glorious isolation, 21.3m high, in the Theban plain. One of them was famed in antiquity for emitting a sound like a broken lyre-string at sunrise (though the Greco-Roman geographer Strabo suspected that this was a fraud perpetrated by one of the crowd of bystanders!).

Further *colossi* were naturally erected within the interior of temples. In the Temple at Luxor there were more examples representing Ramesses II, perhaps usurped from unfinished statues of the temple's founder Amenhotep III. Ramesses' mortuary temple in western Thebes contained several *colossi*, fragments of the largest of which indicate a seated statue about 17.5m high, with a torso seven metres wide from arm to arm, and the index finger one metre long. It is calculated that the original weight of this giant was over 1000 tons.

Another favoured role of royal sculpture was as a series of large-scale figures in high relief attached to columns or pillars in the courtyard of a temple. Once again this device is seen in the mortuary temple of Ramesses II, where figures of the Pharaoh show him in the form, and with the attributes, of the god Osiris, king of the dead, with whom the Pharaohs were assimilated after death (**57**). Ancient writers refer to a similar series of pillar-statues erected by Psamtik (Psammetichus) I (664-610 BC) at Memphis.

The labour involved in fashioning these enormous Egyptian statues must have been prodigious. Rather than carving them from the relatively soft limestone which was the normal material for small-scale sculptures, the artists employed hard stones, notably quartzite from the Cairo region and the red and grey granite from Aswân. These materials were too hard to be carved with punch and chisel, so were pounded and rubbed into shape

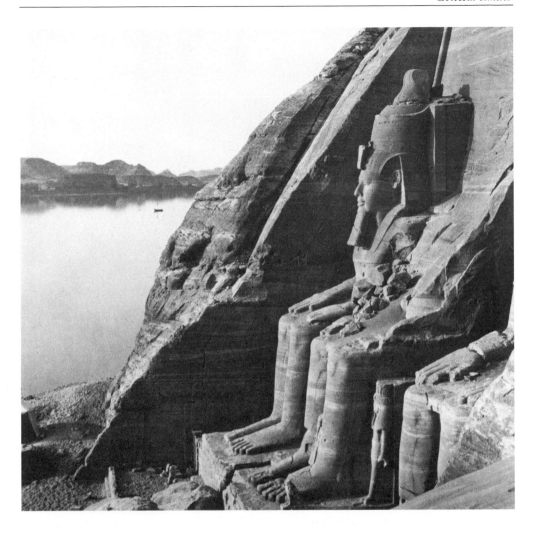

56 *Detail of colossal statues on the façade of a rock-cut temple dedicated to Ramesses II, Amun, Ptah and Re-Herakhty at Abu Simbel (Upper Egypt). Dynasty XIX. The figures are approx 20m high.* Photo Manchester Geographical Society (courtesy Manchester Museum)

with balls of a still harder stone, such as dolerite, using sand as an abrasive (chapter 1). The reasons for choosing hard stones were perhaps partly psychological, partly aesthetic. On the one hand, these materials may have been deemed more appropriate to the divine monarch because of their durability and of the very effort entailed in working them. On the other, the hard material was more suitable to large-scale sculpture than to small, because it was not susceptible to delicate modelling; it lent itself to the kind of broad unmodulated surfaces which were best viewed from a distance. Colour may also have been a factor; that it was deliberately exploited is shown by some of the statues of Ramesses II from his mortuary temple which employ a natural change of colour in the granite to obtain a pink head on a dark grey body (**colour plate 16**).

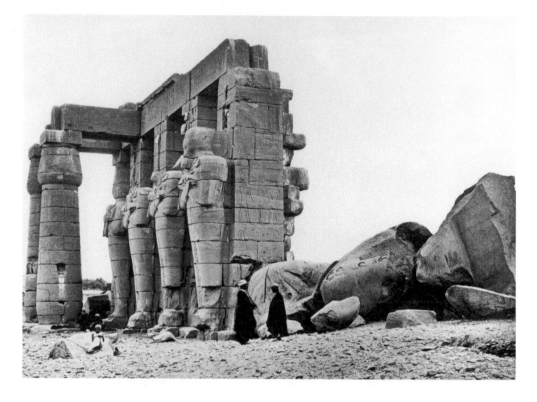

57 Osirid figures and a fallen statue of Ramesses II in the mortuary temple of Ramesses II at western Thebes (Dynasty XIX). The fallen statue was approx 17.50m high. Photo Manchester Geographical Society (courtesy Manchester Museum)

Equally laborious was the transport of the work from the quarry to the temple. The statue was largely finished in the quarry to avoid conveying surplus stone, and much of the journey was presumably accomplished by water; even so, the business of getting it down to the river and unloading it at the other end must have posed tremendous logistical problems. A tomb-painting accompanied by an inscription reveals that hundreds of men were employed in the operation and that the statue was dragged on a sledge (**58**); wooden beams or rollers could be successively introduced beneath it to carry it over soft or stony ground. A ramp of earth would have been used to raise it into position.

Greece and Rome

In the city-states of archaic and classical Greece, where the prevailing forms of government were oligarchies or democracies, colossal statues of rulers had no place. Instead, such works were created in honour of the gods or as statements of national pride.

The Greeks began to create colossal statues almost as soon as they were able to produce life-size ones. The first examples appeared in the central Aegean, where sculpture in stone

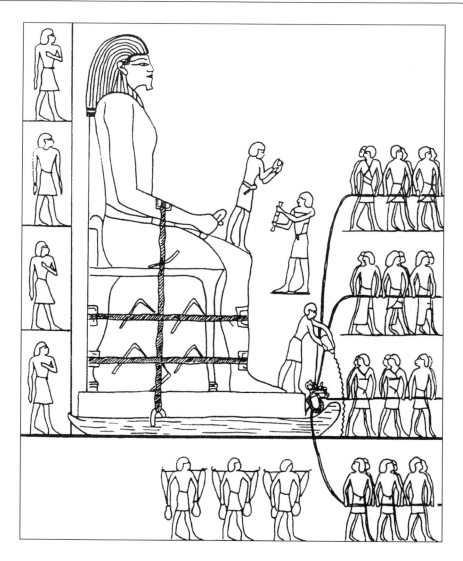

58 Relief showing the transport of a colossal statue in Egypt. The statue, which represented the local prince Djehutihotpe, is recorded as having been 13 cubits (ie about 6m) high and made of alabaster. From the tomb of Djehutihotpe at Deir el-Bersheh (Dynasty XII, reign of Sesostris III). Drawing R. Partridge, after P.E. Newberry, El Bersheh *I (1894), pl XV*

made an early beginning, exploiting the fine white marbles of Naxos and Paros, and borrowing techniques and artistic forms from Egypt. The so-called Colossus of the Naxians, erected in the sanctuary of Apollo on Delos about 600 BC, is the earliest known. Like other Greek statues of its time it represented a standing male figure, stiff and frontal, and naked save for a belt (a curious feature due perhaps to the sculptor's need to justify the abrupt caesura at the waist in early sculptural types). What distinguished it from other statues was its immense height — probably about 8.5m, ie five times life-size. According

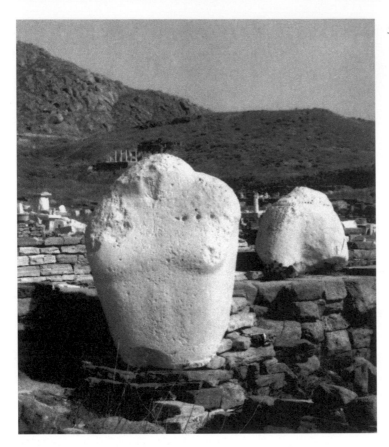

59 Fragments of colossus dedicated by the Naxians on Delos. Early sixth century BC. Ht of torso 2.20m; abdomen 1.20m; original ht approx 8.50m. Photo École Française d'Athènes (Ph. Collet)

to the original inscription the work was 'of the same stone, both statue and base', but the truth of this statement is impossible to assess: the statue was laid low in antiquity, felled by the collapse of a bronze palm-tree dedicated in 417 BC by the Athenian general Nicias, and, though it was subsequently re-erected and re-dedicated, it had been broken up by the fifteenth century, when the surviving pieces were seen and drawn by Cyriac of Ancona. The only substantial remains are two fragments of the trunk (**59**), sadly eroded by weathering and defaced by graffitists. The head, hands and feet are said to have been removed in the seventeenth century, and part of the plinth is now in the British Museum.

A second inscription reveals that the statue was dedicated to the god Apollo (whom it no doubt represented) by the people of Naxos. Its role in advertising their wealth and munificence is all too obvious. The status of Delos as the religious centre of the Aegean, focus of a festival attended by delegations from the islands and coastal cities, ensured that their offering would be widely seen and admired; and its grand scale meant that it literally overshadowed the dedications of other states. That it was not the only such work attempted by the Naxians, and that their boast of executing it from a single block of stone had a basis in fact, is indicated by the presence of a couple of half-finished *colossi* lying in the marble quarries of Naxos. The larger one (**60**), a bearded draped deity, is 10.5m long. The basic forms of the statue have been roughed out, but work was abandoned, perhaps because the marble had developed cracks.

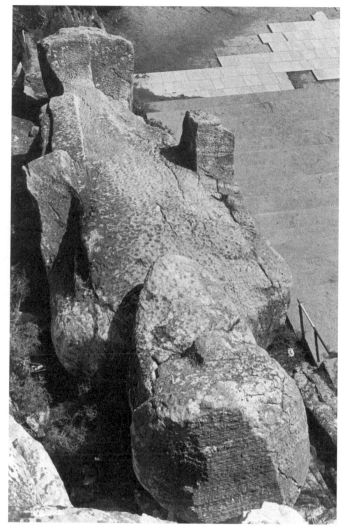

60 Unfinished colossus *lying in a marble quarry at Apollona, near Komiaki, Naxos. Length 10.45m.* Photo German Archaeological Institute Athens 84/256

Works on this enormous scale at such an early date were inevitably dedications set in the open air: the earliest Greek temples were not large enough to contain statues of 10m. Even with the construction of the first gigantic temples at Samos and Ephesos around the mid-sixth century and of those in the Sicilian colonies a little later, we know of no cult-statues larger than twice life-size before the middle of the fifth century. But the *colossi* erected out in the open became ever more impressive and ambitious. An important development was the introduction of bronze in place of stone. Bronze, when hollow- or part-hollow-cast, is lighter than marble and its greater tensile strength makes it less vulnerable to breakage; moreover, the techniques of production enable experimentation and adjustment — luxuries not available to the marble-carver, whose whole effort can be ruined by a flaw in the material or by an ill-judged blow of the chisel. Visually, bronze has the attraction of being susceptible of burnishing to a resplendent golden colour; its costliness as a material also lent it a certain prestige which was lacking to marble (though,

ironically, the cost of actually making a large statue in marble may have been rather greater). Already in the sixth century it seems that hammered bronze was used for the statue of Apollo, an 'old and uncouth' work about 45ft (over 13m) high, which formed the centrepiece of an elaborate altar at Amyclae, near Sparta, described by Pausanias (3.19.1) (*see* **17**). In the fifth century, after the Persian Wars, we hear of a bronze Apollo at Delphi 18ft (over 5m) high financed from the spoils of the battles of Artemisium and Salamis, and of a colossal Zeus Eleutherios (Liberator) at Syracuse dedicated by the people of the city in thanks for the overthrow of the tyrant Thrasybulus in 466. It is likely that both made use of hollow-casting techniques, which by this date had reached a considerable degree of sophistication. More famous was a great bronze statue of Athena, later known as 'Promachos' (Champion), set up by the Athenians on their Acropolis about 455 BC from the spoils of the battle of Marathon (*see* **61a**). The work of Phidias, it was about 9m high and the tip of its spear and the crest of its helmet were reputedly visible to sailors 10km away as they rounded Cape Zoster on their route to Athens' port at Piraeus.

The first truly colossal cult-statues within temples began about the same date, and the three earliest examples are all attributed to Phidias. Probably the earliest of them was the statue of Athena Areia (War Goddess) at Plataea, again financed with the aid of booty from the Persian Wars. It was 'not much smaller than the Promachos', and employed an 'acrolithic' technique, face, hands and feet being made of Pentelic marble, while the rest was of gilded wood. The greater security and protection offered by a closed environment encouraged the use of precious or semi-precious materials, and it was not long before the 'chryselephantine' technique, in which the flesh-parts are of ivory and the drapery of gold, was adapted to colossal sculpture. The pioneer in this respect was the 39ft (11.5m) statue of Athena in the Parthenon, dedicated in 438 BC (**colour plate 17**). This work, which borrowed the format of the Promachos, with a shield and spear at its side and a personification of Victory on its palm, is described in chapter 8. Its renown led to Phidias being commissioned to produce the cult-image for the temple of Zeus at Olympia, his last and greatest work and the most admired statue of antiquity. Executed in the 430s and 420s, a generation after the temple was built, the seated figure of the god was ill-adapted to the setting: a later writer comments that it could not have stood up without taking the roof off

61 (opposite) Roman coins illustrating Greek colossi.

(a) Coin of Athens showing the Acropolis in Athens, with the colossal statue of Athena Promachus between the Propylaea and the Parthenon. Diam 4cm. London, British Museum (Catalogue of the Greek Coins in the British Museum, Athens no 805*). Photo British Museum.*

(b) Coin of Elis (reign of Geta: AD 211-12) showing Phidias' colossal gold and ivory statue of Zeus at Olympia. Diam 4cm. London, British Museum C 110.21 (Catalogue of the Greek Coins in the British Museum, Elis no 160*). Photo British Museum.*

(c) Coin of Argos (reign of Antoninus Pius: AD 138-61) showing Polyclitus' colossal cult statue of Hera in the temple of Hera at Argos. Diam 4.5cm. London, British Museum C114.T.1 (Catalogue of the Greek Coins in the British Museum, Argos no 156*). Photo British Museum*

the temple, which fixes its height at over 12m. Nonetheless it created a tremendous impression on those who saw it. Ancient writers claimed that any man who stood before it would 'forget all the terrible and harsh things that one must suffer in this mortal life' (Dio Chrysostom, *Orationes* 12.51) and that its beauty seemed 'to have added something to received religion' (Quintilian, *Institutiones oratoriae* 12.10.9). We can barely judge its quality from the miniature representations on coins of the Roman period (**61b**) and from the small-scale copies of the head in stone; but they indicate that its colossal scale and rich materials were accompanied by the grand aloofness which is a hallmark of the Phidian style. The god borrowed from Athena the motif of a Victory poised on one palm, and held a sceptre surmounted by an eagle in the other hand. For all its huge size the statue was replete with decorative detail, coloured glass being used to trick out its drapery, and reliefs and inlay adorning the legs, struts and back of the throne; before it lay a pool of oil, copied from the water-basin in the Parthenon, no doubt for the aesthetic effect of the reflection. The strength of its reputation was such as to ensure its place among the Seven Wonders of the World.

The three colossal cult-statues by Phidias were all, of course, first and foremost hymns to the gods; but they can also be seen as propagandist works and as status-symbols for their cities. The Athena Parthenos was as much a symbol of the success of Athens in defeating the Persians and establishing a hegemony in the Aegean as a thank-offering to Athena for her role in guiding the city to achieve these aims. Similarly, the Athena Areia can be regarded as reflecting glory on the Plataeans for their role in the Greek victories at Marathon and outside their own city. At Olympia, the greatest of the Greek

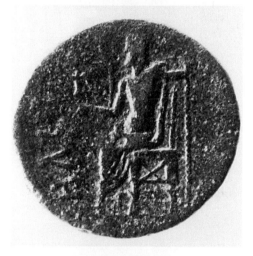

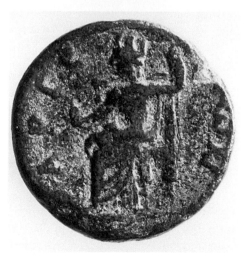

117

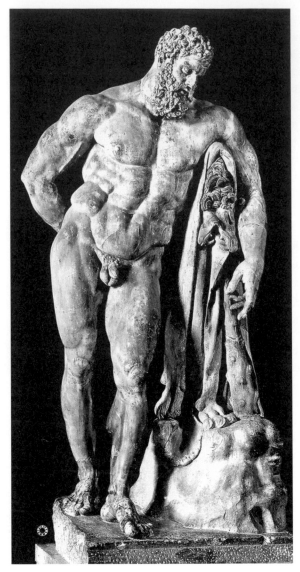

religious centres, the Zeus was intended to outdo all other cult-statues in scale and splendour, and thus to establish the primacy of the sanctuary and indirectly to promote the city which ran it, Elis. Other states, too, were anxious to acquire comparable showpieces. Soon after Phidias had completed the Zeus at Olympia, Argos 'joined in the act' by setting its greatest sculptor Polyclitus to the task of producing a colossal chryselephantine cult-statue for its temple of Hera, rebuilt after an earlier temple had been destroyed by fire in 423. The goddess (*see* **61c**) was shown seated, like the Zeus, but with the attributes appropriate to her: a pomegranate in one hand and a sceptre surmounted by a cuckoo in the other. She also wore a crown adorned with reliefs of the Graces and Seasons. To a later writer the statues by Polyclitus in this temple were 'artistically the most beautiful of all statues, but in richness and size came second to those of Phidias' (Strabo 8.6.10).

In the course of the fourth century the civic and nationalistic aspect of colossal statues became more important. *Colossi* were set up not just in sanctuaries or in temples, where their religious role was self-evident, but also in secular locations. The colossal bronze statues of Lysippus and his school bear witness to this trend. A Heracles at the sculptor's home-city Sicyon, thought by some to be

62 *Heracles Farnese. Roman marble copy (by Glycon of Athens) from the Baths of Caracalla, Rome, of a bronze statue by Lysippus (late fourth century BC). Ht 3.17m. Naples, Archaeological Museum.* Photo Alinari/Art Resource, New York (Alinari 35351)

reproduced in the 3.2m Heracles Farnese found in Caracalla's Baths in Rome (**62**), stood in the market-place. At Tarentum (Taranto) in southern Italy a 60ft (18m) statue of Zeus again stood in the market-place, while a colossal seated Heracles was set on the Acropolis,

probably here a normal citadel rather than, as at Athens, a religious sanctuary. At Rhodes the famous 105ft (31m) statue of the Sun-God by Lysippus' pupil Chares — the statue which established the term 'colossus' (previously used chiefly by Greek writers referring to Egyptian works) for the whole species — stood on a mole at the entrance to the harbour. The Sun-god was the patron-deity of Rhodes, but the position and size of the statue show that its primary object was to impress visitors approaching the city by sea.

The Zeus at Tarentum and the Sun-god at Rhodes were the most ambitious *colossi* attempted by the Greeks, and in their different ways they testify to the nature of the technical problems which such statues posed. Of the Zeus it was said that Lysippus took precautions to ensure its protection from gales by erecting a column a short distance away to act as a wind-break. The Colossus of Rhodes was constructed stage by stage like a building, with an ever-growing mound of earth piled up round it to provide a firm platform for the bronze-casters (**63**); it was reinforced internally by an armature of iron scaffolding and squared blocks of stone. Despite all precautions, however, it collapsed in an earthquake 56 years after it was created; it keeled over at the knees and remained a ruin throughout antiquity, almost more impressive in its wrecked state than it was when standing. Pliny (*NH* 34.41) describes it:

> . . . even lying on the ground it is a marvel. Few people can make their arms meet around its thumb; the fingers are larger than most complete statues. Huge caverns gape where limbs are broken; inside one sees rocks of massive size, with the weight of which the artist stabilized it during the erection process. It is said that it took twelve years to complete and cost 300 talents, money realized from the equipment of King Demetrius which he abandoned when he got tired of the protracted siege of Rhodes.

During the ensuing Hellenistic and Roman periods *colossi* proliferated. In Rhodes alone we hear that by the second half of the first century AD there were 'another hundred *colossi* . . . which, though smaller than this one [the Colossus of Chares], would each have been sufficient to bring fame to any place where they had stood alone; and besides this there were five colossal statues of gods made by Bryaxis' (Pliny, *NH* 34.42).

When the Romans took over the Greek world they acquired, along with a general passion for Greek art, a taste for colossal statues. Many Greek examples were shipped off to Rome as plunder. The seated Heracles by Lysippus at Tarentum was removed by Fabius Maximus when he captured the city in 209 BC (he left the Zeus because it was too difficult to move); a 45ft (13m) Apollo by Calamis was taken from Apollonia on the coast of the Black Sea by Lucullus in 73 BC; a colossal statue-group of Zeus, Athena and Heracles by Myron was taken from Samos by Mark Antony (but two of the three figures were later returned by Augustus). The emperor Caligula even gave orders to remove Phidias' Zeus from Olympia, but the plan failed. Inevitably, plunder led to imitation. We hear of a Jupiter which Spurius Carvilius had made from armour captured from the Samnites in 293 BC, 'so big that it is visible from the temple of Jupiter Latiaris' (16km away from Rome on the Alban Mount) (Pliny, *NH* 34.43); and, further afield, an artist named Zenodorus in the mid-first century AD made a statue of Mercury in Gaul 'which

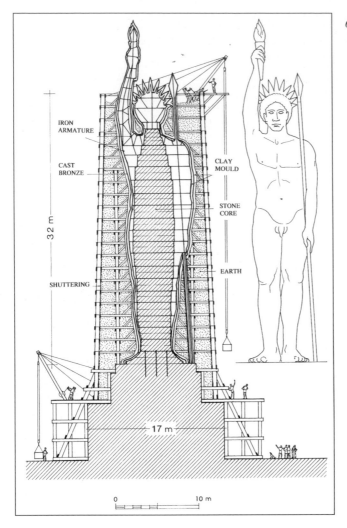

IRON
ARMATURE

CAST
BRONZE

CLAY
MOULD

STONE
CORE

32 m

EARTH

SHUTTERING

17 m

0 10 m

63 Reconstruction of the Colossus of Rhodes by Chares (early third century BC), showing construction methods. Drawing J.-P. Adam

surpassed all statues of this kind in size' (*NH* 34.45): the commission took him 10 years and earned him a fortune.

With the establishment of monarchy as the pre-eminent system of government, and with the associated tendency to equate rulers with gods, colossal statues of kings and emperors appeared alongside the traditional types. The Ptolemies, the Hellenistic kings of Egypt, naturally took over the role of the Pharaohs and were the subject of gigantic statues showing them with divine attributes. We have no specific evidence for colossal statues of members of the other leading Hellenistic dynasties, but there can be little doubt that they existed. The mountain-top tomb of a minor dynast who reigned in Commagene, in the far east of Anatolia, during the first century BC has yielded at least nine colossal statues, including seated figures of the king himself and of various Greco-Oriental gods, all rendered in sculptured courses of ashlar masonry (*see* **64**).

In Roman times, while some emperors were chary of blatant self-exaltation, others had no such qualms; and in the eastern Mediterranean the emperors naturally succeeded to

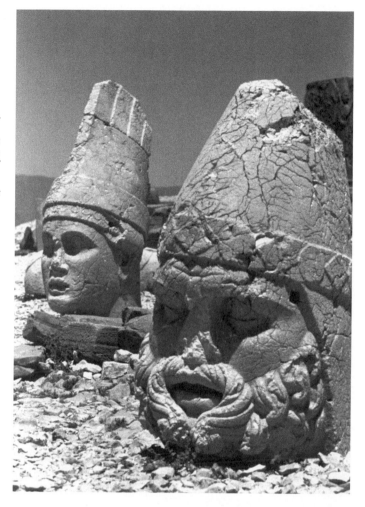

64 Heads of colossal limestone statues at Nemrud Dagh, eastern Turkey: monument of Antiochus I of Commagene. In the foreground is the head of Antiochus himself, in the background that of a god. Ht of heads approx 1.60m. Photo Andrew Stewart

the divine role of Hellenistic kings; at all events colossal statues were frequently employed to convey the majesty of the ruler to his far-flung peoples. To some extent, of course, the scale depended on position; the statues of Augustus set in the theatres at Arles and Orange, high above the stage, needed to be much larger than life to be effectively seen. It was also normal to use colossal scale for posthumous portraits of deified emperors set up in the temples of the Imperial Family (or the like) which served as focuses of loyalty in the municipalities. We have remains of at least three galleries of colossal portraits of Augustus and the Julio-Claudian emperors from such temples (from Veii and Cerveteri in Italy, and Lepcis Magna in Tripolitania).

As time went on, colossal statues of the living emperor became more common, even in Rome itself. Nero, one of the first emperors to adopt an openly despotic stance, commissioned a 120ft (35m) *colossus* of himself in the forecourt of his Golden House, the luxury villa which he created in the middle of Rome after the great fire of AD 64. Retained after his death but re-dedicated to the Sun-god, this gave its name to the Colosseum, the huge amphitheatre built by Vespasian adjacent to it. Later, as the emperors became

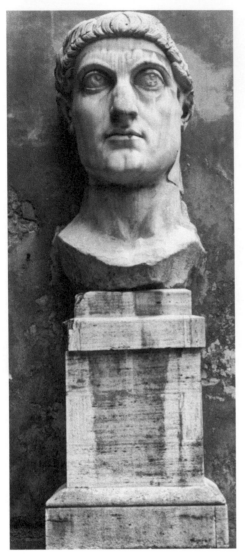

increasingly remote figures at the pinnacle of an elaborate bureaucracy, the colossal statue served as a more appropriate expression of their elevated plane of existence. The acrolithic statue of Constantine I from his Basilica in Rome is a fine example: the wooden parts of the seated figure have long since perished, but the stone head (**65**), hands and feet remain as a vivid testimony to the chilling and impersonal effect that such works must originally have had.

The legacy

The Constantinian age was the last great period of colossal statues in antiquity. The production of such works lapsed in the medieval period, when grandeur of scale became the prerogative of architecture rather than sculpture: the prevailing ideology, Christianity, interpreted the relationship between God and man in a way which saw no need to emphasize the divine power through sheer size, whilst centralized powers with the disposable resources or the will to glorify themselves through the creation of *colossi* were almost non-existent. The single notable exception was the Holy Roman Emperor Frederick II, who used colossal portraiture at Lanuvium and Capua to proclaim his standing and imperial mission.

65 Head of a colossal seated statue of Constantine I from the Basilica of Constantine, Rome. Ht 2.60m (original ht of statue approx 10m). Rome, Palazzo dei Conservatori 757. Photo R.J. Ling 95/10

Like so much else, colossal sculpture was revived, as part of the general emulation of the antique, in the Renaissance: in Italy, fifteenth-century academic studies, temporary festival pieces and elaborate but abortive programmes led to multiple and varied production — at least 50 examples, single or in groups, appearing during the sixteenth century. During the following century the tradition was to flourish still further under the influence of Bernini. As in antiquity, one of the attractions of creating such works was clearly the sheer physical difficulty of wrestling with size: theorists justified the achievement as much in terms of the struggle and the skills involved as in terms of the aesthetic appeal of the

finished work. Thus colossal scale was used not just for aggrandizing portraits of rulers, secular and religious, but also for virtuoso works in urban or garden settings; subjects included ancient gods and heroes, allegorical figures, and genre pieces, as well as geographical personifications, such as the 11m high figure of the Apennines carved by Giambologna from a natural outcrop of rock supplemented by stone and cement at Pratolino.

Many further examples have been produced down to the present day. From Medici Florence the genre spread (via the marriage connection) into France, then, under the dual influences of the Counter Reformation and the political doctrines of absolutism, throughout the monarchies (and empires) of western Europe and Tsarist Russia. Under new ideological influences, it has spread throughout the world. The persistence of what has been termed 'the emotional value of volume' is attested by the spread of the idea to the USA, where the carved heads of Mount Rushmore echo Dinocrates' plan to turn Mount Athos into a likeness of Alexander the Great, or Michelangelo's to turn Mount Carrara into one of Julius II, while the Statue of Liberty owes something both to the Colossus of Rhodes and to the Athena Promachos in Athens. Political, religious and ideological images may change, but the psychological impact of size has not been outmoded. Napoleon, the Republican idealists of France and the United States, the Fascist and Communist dictators of twentieth-century Europe — all have continued to use colossal sculpture as an effective vehicle for their different objectives. In so doing, they have consciously or subconsciously followed in the footsteps of the Pharaohs of ancient Egypt, the city-states of Greece, and the emperors of Rome.

Bibliography

General

Lesbazeilles, E. (1876) *Les colosses anciens et modernes* (Bibliothèque des merveilles), Paris: Hachette.

Egypt

Aldred, C. (1980) *Egyptian Art*, London: Thames and Hudson.

James, T.G.H. and Davies, W.V. (1983) *Egyptian Sculpture*, London: British Museum.

Lange, K., and Hirmer, M. (1968) *Egypt: Architecture, Sculpture, Painting in Three Thousand Years*, London and New York: Thames and Hudson.

Smith, W.S. (1982) *The Art and Architecture of Ancient Egypt* (Pelican History of Art), 2nd edn. (revised by W.K. Simpson), Harmondsworth: Penguin.

Greece and Rome

Dickie, M.W. (1996) 'What is a *kolossos* and how were *kolossoi* made in the hellenistic period?', *Greek, Roman and Byzantine Studies* 37: 237-57.

Marriott, H. (1956) 'The Colossus of Rhodes', *Journal of Hellenic Studies* 76: 68-86.

Leipen, N. (1971) *Athena Parthenos: a Reconstruction*, Toronto: Royal Ontario Museum.

8 The sculptures of the Parthenon

Roger Ling

Introduction

The building which came to be known as the Parthenon (**66**), sited on the sacred citadel of Athens, the Acropolis, was first and foremost a religious edifice. It was a temple of the city's patron goddess Athena. At the same time it served as a statement of civic and nationalistic pride. It glorified not only the goddess herself but also the successes achieved by the city under her guidance and the piety of the Athenians in their observance of her cult. All this through one of the most lavish and carefully planned displays of architectural sculpture produced in antiquity.

We are fortunate to have so much of the building and its sculptures still surviving. Indeed, had it not been for a well-aimed shell in a bombardment of Athens by the Venetians in 1687, which ignited a powder-store and blew out the middle of the temple, they might have been largely complete. Much of the sculpture, admittedly, is now divorced from the structure. Large parts of it went to the British Museum in the collection of Lord Elgin, whose liberal interpretation of a permit granted by the Turkish rulers of Greece at the beginning of the nineteenth century enabled him to remove it from its setting. Further extensive remnants recovered in excavations after the Greeks gained their independence in 1830 are in the nearby Acropolis Museum. Other pieces, after suffering a wide variety of vicissitudes, have arrived in the Louvre, the Vatican Museums, Copenhagen and elsewhere. Nonetheless, by pooling the scattered evidence, we are able to form a remarkably complete picture of the Parthenon's decoration.

Begun in 447 BC and completed in 432, the temple was the first and most conspicuous monument of a grand rebuilding of the Acropolis promoted by the city's leading statesman Pericles. The occasion for the rebuilding was the destruction wrought during the Persian sack of Athens in 480, and the specific role of the Parthenon was to replace a temple designed in thanksgiving for the earlier Athenian victory at Marathon (490). This Marathon temple, which was less than half complete at the time of the Persian attack, had been a large and ambitious undertaking, but its successor surpassed it in almost every respect.

The Parthenon's scale and grandeur have to be seen in the context of inter-state rivalries. Ancient Greece, like Renaissance Italy, was not a unified country but an aggregation of independent city-states which were invariably in competition, if not actually at war, with one another. Athens, though a prosperous and influential city in the sixth century, had only emerged as one of the leaders of the Greek world as a result of her role in the Persian Wars. It was one of the main planks of Pericles' policy to promote the glory of Athens upon the world stage and to outdo other Greek states such as Aegina,

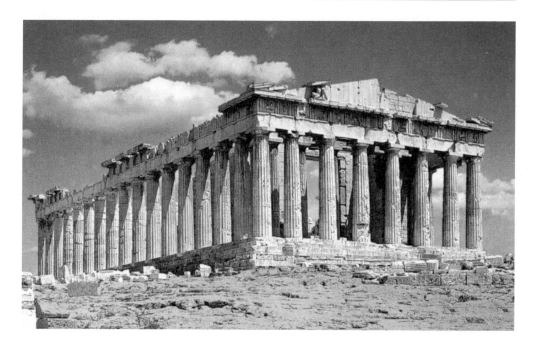

66 Athens, the Parthenon (c447-432 BC), seen from the north-west

Corinth, and especially the military superpower Sparta. This he tried to achieve not just by force of arms and by economic expansion but also by endowing the city with splendid works of art and fine buildings — 'decking out the city like a brazen woman dressed in precious stones and statues and thousand-talent temples', as a political opponent put it. Statues like the 30ft (9m) bronze Athena known as the Promachos (Champion) were meant to be bigger and better than comparable works set up by other cities. The Parthenon was the latest and most grandiloquent of these artistic status symbols.

That Athens could build such a lavish structure was due to her immense wealth in the mid-fifth century BC. This resulted partly from her access to valuable mineral resources but chiefly from her exploitation of her 'allies' in the Aegean. It is ironic that an ancient city which is renowned for its democratic institutions and its respect for free speech should have buttressed these ideals with a policy of imperialism; but Pericles deliberately set out to convert the Confederacy of Delos, the free alliance which had fought to rid the Aegean of the Persians, into an empire which paid tribute to Athens. He then quite unashamedly used the wealth which accrued from the allies' payments to beautify Athens, and, when criticized for doing so, justified it as a reward for guaranteeing the allies protection.

Specifically, the Parthenon was designed to outdo the temple of Zeus at Olympia. This temple, recently constructed as the centrepiece of the most important religious sanctuary of the Greek world, was at the time the largest building in the traditional Doric style to have been put up in European Greece (only the more grandiose temples in the colonies of Sicily exceeded it in scale). It had a conventional 6 by 13 column peristyle (surrounding

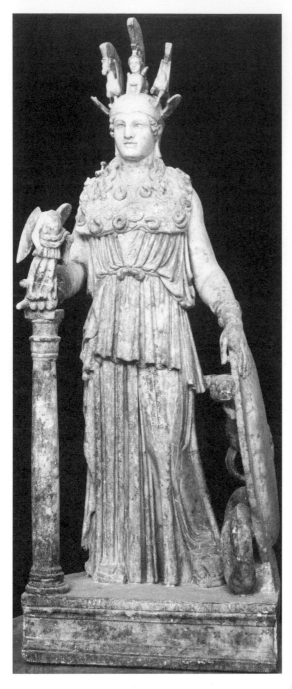

67 Varvakeion statuette: Roman-age trinket (marble) based on the Athena Parthenos. Ht (including base) 1.05m. Athens, National Museum 129. Photo University of Manchester, Art History collection

colonnade) and was constructed predominantly in limestone. The Parthenon, however, consciously imitated the great Ionic temples of the East by widening the façade to eight columns and lengthening the flanks to 17, and by using marble for all visible parts of the structure apart from the inner ceilings (which were of wood). It sought to surpass Olympia also in the richness and variety of its sculptures.

The statue of Athena

Ancient temples were not intended for congregational worship; communal ceremonies, the most important of which was the 'sacrifice' (an offering of food or drink to the deity), generally took place at an altar outside. A temple was literally the god's house, a sacred container for his or her cult-image. In the case of the Parthenon, one of the main reasons for the enlargement of the normal plan was to provide an adequate interior space to house its spectacular icon, the 11.5m high gold and ivory statue of Athena. Designed by the greatest artist of the day, Phidias (who was also the overall supervisor of Pericles' building programme), this was the first of the colossal statues in precious materials which were to become a feature of the more ambitious Greek and Roman temples. It was destroyed at some stage in the Byzantine period, but descriptions by ancient authors, coupled with small-scale copies and echoes in other art forms, enable us to get a fair idea of its original appearance (**colour plate 17**; **67**). Constructed

round an armature of wooden beams (one writer tells us how the interiors of such statues were colonised by mice), it was presumably shaped in wood or bronze before the precious materials were applied: ivory for the flesh parts, gold leaf for the drapery. Evidence from the workshop in which Phidias made his later gold and ivory statue of Zeus at Olympia suggests that further enrichment might be added in coloured glass. The goddess stood majestic and imposing in the military guise which suited her role as patroness of Athenian military success. She wore her traditional long robe, the *peplos*, with the goatskin (*aegis*) of her father Zeus upon her breast, a shield held beside her left leg, sheltering her sacred snake, and a spear resting against her left shoulder; on her head was an elaborate triple-crested helmet in which the central crest was formed by a crouching sphinx and the side-crests by winged horses (*pegasi*), while the cheek-pieces were decorated with griffins (fabulous creatures with a lion's body and the head and wings of an eagle); on her right hand, supported by a column, rested a winged female figure personifying Victory (Nike), a reference to the Athenian successes at Marathon and in subsequent campaigns against the Persians.

Further decorative detail covered available surfaces. The exterior of the shield carried *repoussé* reliefs of the legendary battle of the Greeks against the Amazons, a race of female warriors from Asia; the interior of the shield was engraved with the mythical battle of the gods and giants, in which the forces of reason overcame the earthborn powers of darkness; the rims of the goddess's sandals carried the battle of Lapiths and centaurs, in which the king of the Lapith tribe, helped by the legendary Athenian hero Theseus, frustrated the drunken designs of the half-man half-horse centaurs upon his bride and the other womenfolk attending his wedding. All three subjects can be regarded as allegorical of the recent triumphs achieved by civilization (represented by the Athenians and other Greeks) over barbarism (the Persians) under Athena's guidance.

The effect of this great *colossus*, gleaming gold and white in the gloom of the temple interior, framed by an imposing backdrop of double-tiered colonnades, can only be imagined. It was enhanced still further by the reflection in a rectangular pool of water in the floor in front of it. The purpose of this pool was to create the atmospheric humidity needed to prevent the ivory from drying out and cracking, but its aesthetic effect was so striking that Phidias imitated it for his Zeus at Olympia. As the damp atmosphere at Olympia made the original function redundant, he substituted the water with oil.

The architectural sculptures

Leaving aside the *acroteria* (crowning sculptures on the roof above the angles of the pediments), here in the form of floral ornaments, there were three major categories of sculpture on the Parthenon: the reliefs on the metopes (squarish slabs in the Doric frieze round the exterior); a continuous sculptured frieze (a feature borrowed from Ionic architecture) atop the inner wall of the peristyle; and the free-standing statues which filled the two pediments (the low gables at the ends of the temple).

The metopes (about 1.2m square) were probably the first to be installed. Each face of the temple carried a series apparently focused on a single theme of conflict. On the south

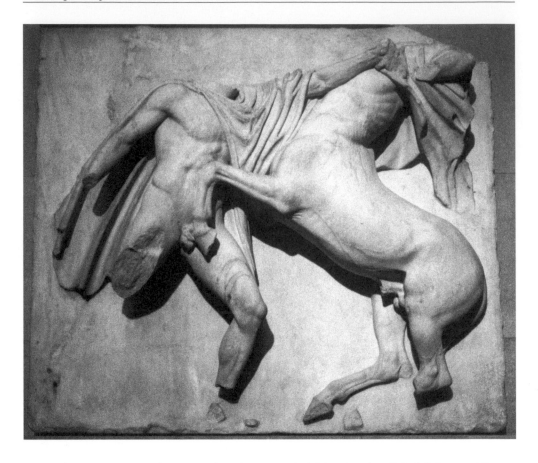

68 Parthenon metope (south 7): Lapith and centaur. Ht 1.20m. London, British Museum. Photo
R.J. Ling 119/8

side, and best preserved (perhaps because less visible or less accessible to Christian and
Moslem iconoclasts), was the battle of Lapiths and centaurs. The outermost metopes
showed the battle in full flow, with a duelling pair on each slab (**68, 69**); nearer the middle
were Lapith women being seized by their assailants; and at the very middle, destroyed by
the explosion of 1687 but known from drawings carried out by an artist, probably Jacques
Carrey of Troyes, who had visited the Acropolis 13 years earlier, were several quieter
scenes whose interpretation is uncertain — perhaps pairs of wedding guests before the
outbreak of the fracas. On the north side, incomplete and badly damaged, were scenes
from the sack of Troy; most are unrecognizable, but parallels in Athenian vase-painting,
including a scene showing Menelaus reclaiming Helen, confirm the interpretation. On
the west side were battles between Greeks and opponents with the long sleeves and
leggings of Orientals, probably Amazons. On the east side was the battle of gods and
giants.

The frieze must have been installed soon after the metopes, and its carving may already
have been in progress before the metopes were finished; it is usually assumed to have been

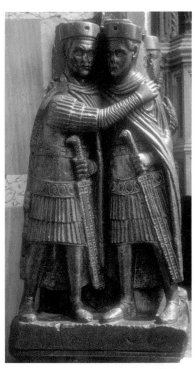

1 *Statues in porphyry representing two of the four Tertrarchs (joint emperors) cAD 300. Venice, corner of St Mark's cathedral.* Photo L.A. Ling

2 *Hammered bronze helmet with winged youths. Cretan, late seventh century BC. Ht 21cm. New York, Metropolitan Museum of Art, gift of the Norbert Schimmel Trust, 1989 (1989.281.50).* Photo Metropolitan Museum of Art

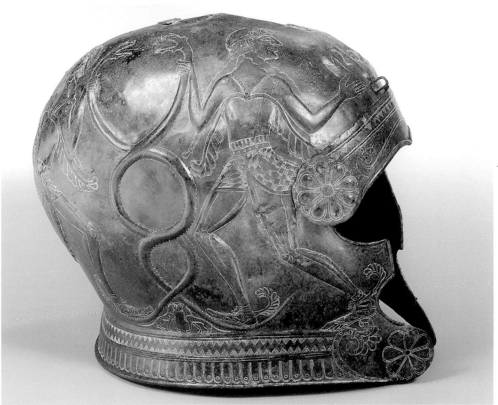

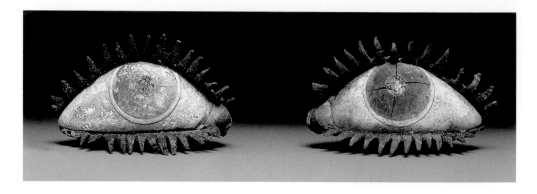

3 *Pair of eyes made of marble, frit, quartz, and obsidian with bronze lashes. Once inlaid in a statue about twice life-size. Greek, fifth-first century BC. Width of left eye 5.8cm; width of right eye 6cm. New York, Metropolitan Museum of Art, purchase, Mr and Mrs Lewis B. Cullman gift and Norbert Schimmel bequest, 1991 (1991.11.3ab).* Photo Metropolitan Museum of Art

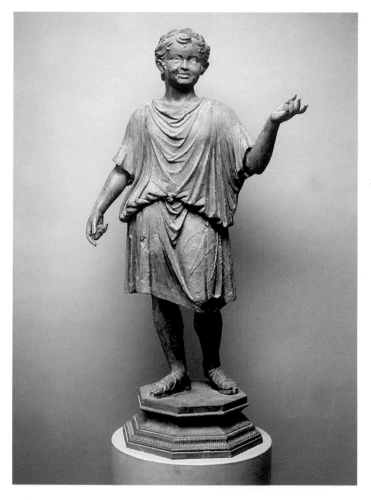

4 *Bronze statue of a camillus (religious acolyte). Roman, Julio-Claudian, cAD 41-54. The eyes are inlaid with silver, the lips with copper, and the tunic with strips of copper to suggest woven or embroidered bands of colour. Ht 1.17m. New York, Metropolitan Museum of Art, gift of Henry G. Marquand, 1897 (97.22.25).* Photo Metropolitan Museum of Art

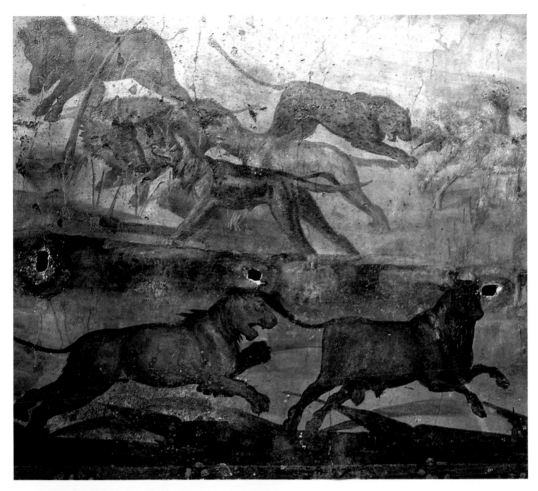

5 *Pompeii, House of the Ceii, garden
 painting of wild animals showing*
 pontata di lavoro *and put-log holes for
 scaffolding.* Photo A. Barbet

6 *Example of a wall-painting showing
 repair in a different style: the pale blue
 and black paintings at the left belong to
 the original decoration in the Pompeian
 third style (second quarter of first century
 AD), the yellow ones at the right are a
 repair in the fourth style (between AD
 62 and 79). No attempt has been made
 to achieve a match. Pompeii, House of
 the Theatrical Panels.* Photo A.
 Barbet

7 The killing of Rhesus by Diomedes. 'Chalcidian' black-figure neck-amphora attributed to the Inscription Painter (c540 BC). Ht 39.6cm. Malibu, J. Paul Getty Museum 96.AE.1. Photo J. Paul Getty Museum

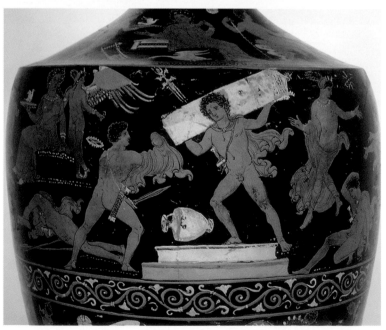

8 Rape of the daughters of Leucippus. Detail of Apulian red-figure lekythos, attributed to the Underworld Painter (c330 BC). Richmond, Virginia Museum of Fine Arts 80.162. Photo Virginia Museum of Fine Arts

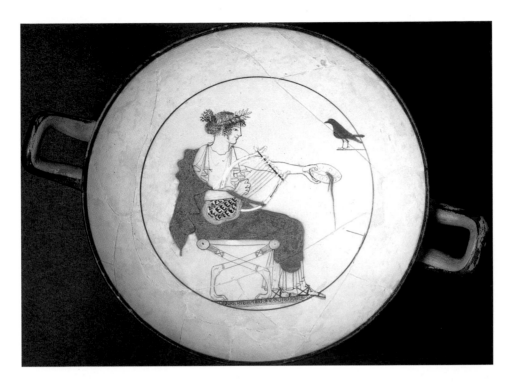

9 *Apollo. Attic white-ground* kylix *from Delphi (c480 BC). Diam 17.8cm. Delphi Museum 8410.* Photo Archaeological Receipts Fund, Athens

10 *Pebble mosaic showing a lion hunt at Pella (northern Greece). The pebbles are carefully graded to achieve realistic pictorial effects; linear divisions are achieved with terracotta strips. Last quarter of fourth century BC. Panel approx 1.9m high; pebbles 5mm to 1cm.* Photo Getty Research Library, Wim Swaan collection, 96.P.21

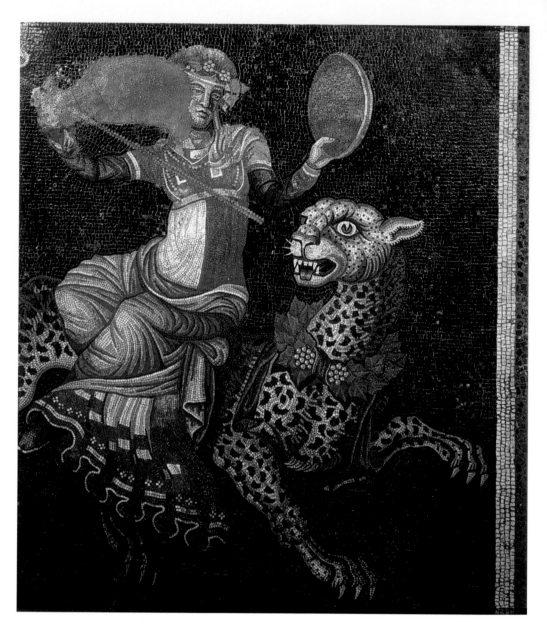

11 *Mosaic panel in* opus vermiculatum, *Delos: Dionysus riding a leopard, from the House of the Masks. Late second or early first century BC. Ht of panel 1.01m; tesserae 2-3mm square.* Photo Getty Research Library, Wim Swaan collection, 96.P.21

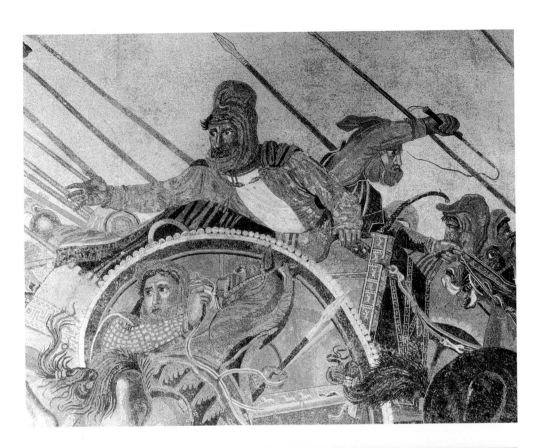

12 *Darius in his chariot. Detail of the Alexander Mosaic, from the House of the Faun at Pompeii. Ht of king's head approx 30cm. Now in Naples, Archaeological Museum.* Photo Getty Research Library, Wim Swaan collection 96.P.21

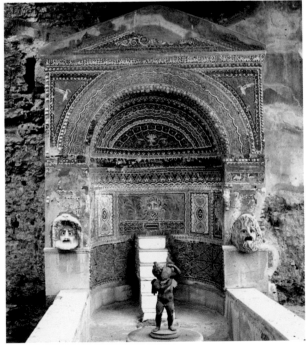

13 *Garden fountain decorated with mosaics. Pompeii, House of the Large Fountain. Third quarter of first century AD.* Photo A. Barbet

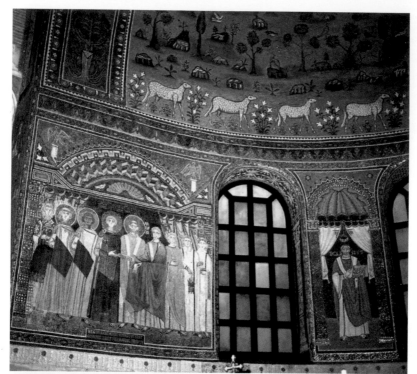

14 Detail of mosaics in the apse of S. Apollinare in Classe, Ravenna (sixth–seventh centuries AD). Photo A. Barbet

15 Half-finished wall-paintings in the principal dining room of a recently excavated house at Pompeii (IX 12). The red fields of the main zone and the architectural elements in the left-hand interval have been painted, but the architecture in the right-hand interval is barely started; the central picture and the socle have not been started at all. Photo Archaeological Superintendency Pompeii

16 *Upper half of a colossal statue of Ramesses II (Dynasty XIX, c1250 BC) from his mortuary temple in western Thebes. The natural banding of the granite is exploited to produce a pink face and a grey body. Ht 2.67m. London, British Museum (EA 19).* Photo British Museum

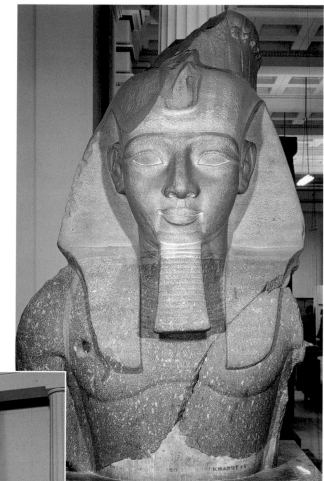

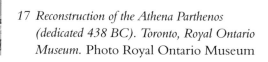

17 *Reconstruction of the Athena Parthenos (dedicated 438 BC). Toronto, Royal Ontario Museum.* Photo Royal Ontario Museum

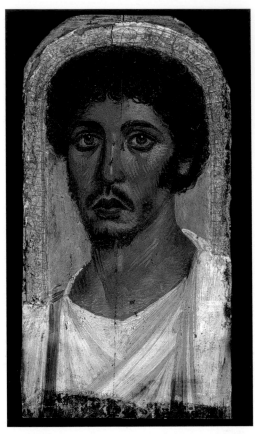

18 Romano-Egyptian mummy portrait of a young man, painted in the encaustic technique on limewood. From Hawara, mid second century AD. Ht (including gilded stucco frame) 42.7cm. London, British Museum (EA 74704). Photo British Museum

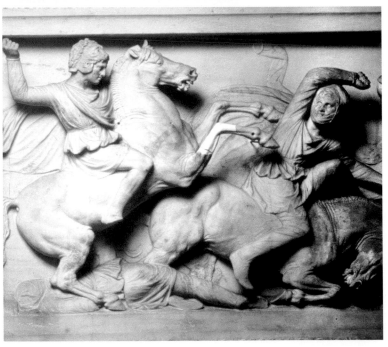

19 Detail of battle scene on the so-called Alexander Sarcophagus from Sidon (c320-310 BC). Ht of frieze 69cm. Istanbul, Archaeological Museum. Photo Getty Research Library, Wim Swaan collection, 96.P.21

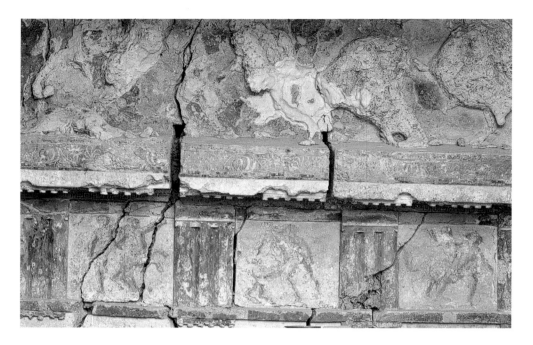

20 *Lefkadia, detail of the façade of the Great Tomb: Doric frieze with painted metopes imitating reliefs of centaurs and Lapiths (compare **68** and **69**) and Ionic frieze with stucco reliefs depicting a battle of Greeks and Amazons. Late fourth or early third century BC.* Photo Getty Research Library, Wim Swaan collection, 96.P.21

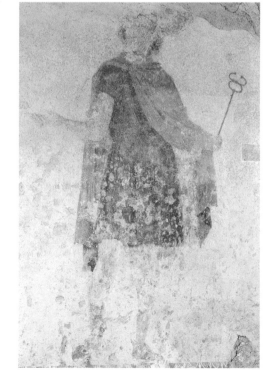

21 *Lefkadia, figure of Hermes, conductor of souls to the underworld: façade of the Great Tomb (late fourth or early third century BC). Ht approx 1.1m.* Photo Getty Research Library, Wim Swaan collection, 96.P.21

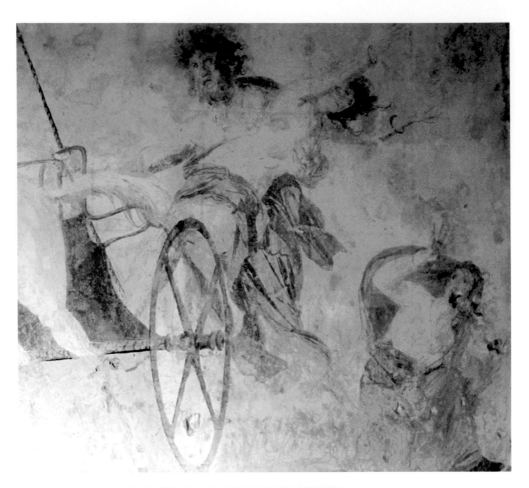

22 *Vergina, Tomb of Persephone: Pluto carrying off Persephone in his chariot. Second half of fourth century BC. Ht approx 1m.* Photo A. Barbet

23 *First-style decoration in the House of Sallust, Pompeii (VI.2.4). Second or early first century BC.* Photo E. de Maré

24 Detail of second-style architectural paintings in the Villa of the Mysteries, Pompeii. Second quarter of first century BC. Photo E. de Maré

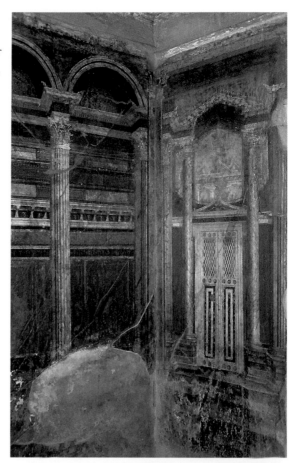

25 Dionysiac frieze in the Villa of the Mysteries at Pompeii: east wall. The divine couple, Dionysus and Ariadne, are at the centre, with scenes of ritual or divination at either side. Second quarter of first century BC. Ht of figure frieze 1.62m. Photo A. and P. Foglia

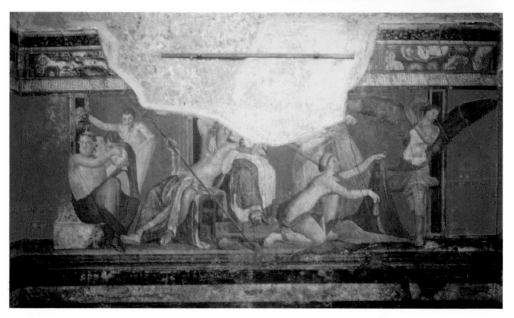

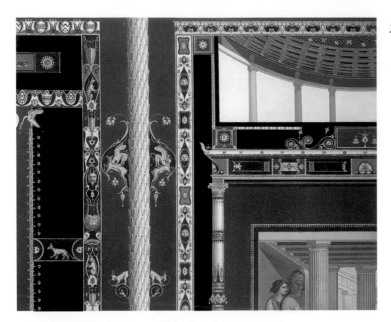

26 *Detail of a third-style wall decoration showing polychrome decorative detail (colour lithograph). Pompeii V.1.26 (House of L. Caecilius Jucundus). Second quarter of first century AD.* After A. Mau, *Geschichte der decorativen Wandmalerei in Pompeji* (1882), pl XIV

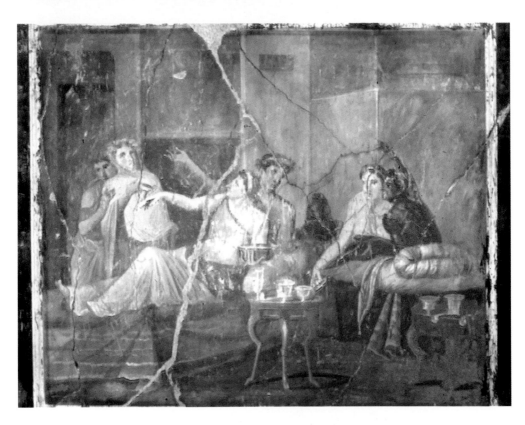

27 *Banquet scene: west wall of dining room in the House of the Chaste Lovers (IX.12.6). Second quarter of first century AD.* Photo Archaeological Superintendency Pompeii

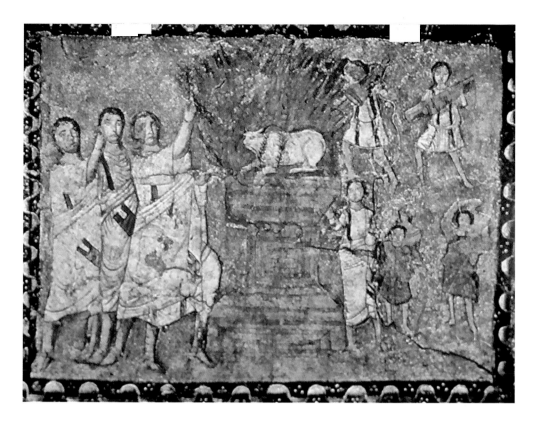

28 *Painting of Elijah on Mount Carmel. Dura Europus synagogue, panel SC 4.* Photo The
Jewish Museum, New York/Art Resource, New York

29 *Hunting and
Seasons mosaic
from Antioch
(mid-fourth
century AD):
general view of
the section
displayed in the
Louvre, from
above. 8.07 x
8.04m. Paris,
Louvre Ma
3444.* Photo S.
Tebby

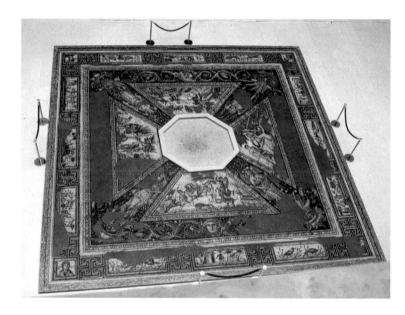

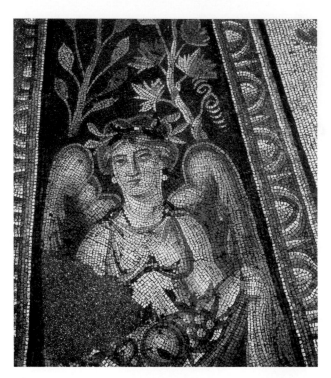

30 *Personification of Autumn:*
detail of the Hunting and
Seasons mosaic from Antioch.
The Season is characterized by
the fruit that she carries in front
of her. Mid-fourth century AD.
Paris, Louvre Ma 3444.
Photo A. Barbet

31 *Bronze statuette of Alexander*
the Great on horseback, from
Herculaneum. Based on statue
of late fourth century BC.
Compare the pose with that of
the left-hand huntsman in
135*. Ht approx 45cm.*
Naples, National Museum
4996. Photo Getty
Research Library, Wim
Swaan collection, 96.P.21

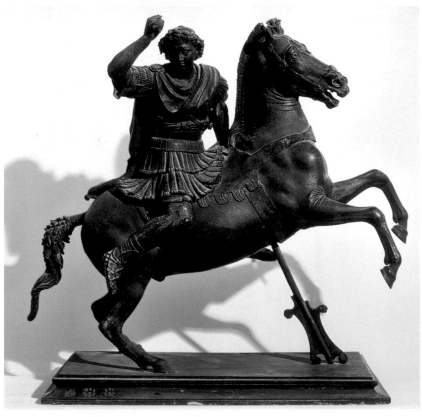

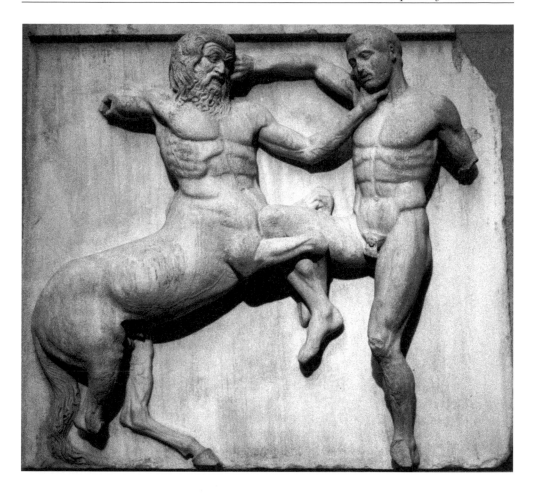

69 Parthenon metope (south 31): Lapith and centaur. Ht 1.20m. London, British Museum.
Photo R.J. Ling 119/31

complete before 438, when the temple was formally consecrated, but the sculptors could conceivably have continued to work on it even after this date. It was decorated with a single continuous subject; the total length of 160m makes this the longest coherent composition known to us from Greek antiquity.

As early as the eighteenth century, it was recognized that the theme was the ceremonial procession undertaken in honour of Athena every fourth year on the occasion of her festival, the Panathenaea. This remains the most likely interpretation, despite recent attempts to find alternative meanings rooted in Athenian legend (Kardara 1961, 1982; Connelly 1996). The object of the Panathenaic procession was to bestow a new *peplos* woven by two girls belonging to a sisterhood known as the Arrephoroi upon the old wooden image of the goddess housed in another temple on the Acropolis. That this was the subject of the Parthenon frieze is confirmed by the central scene above the main (eastern) entrance of the temple (**70**). The precise stage of the ceremonial depicted is

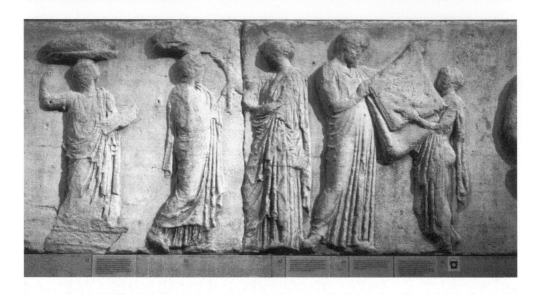

70 Parthenon east frieze (V, figures 31-35): peplos *ceremony. Ht 1.05m. London, British Museum.* Photo R.J. Ling 119/1

uncertain, but a large cloth which can only be the *peplos* is prominently visible, being folded by a bearded man and a child, presumably the Archon Basileus (the minister of state for religion) and one of the Arrephoroi, while two attendants bring stools, perhaps for the Archon and Athena's priestess, who is shown receiving them, to sit on during the ritual. This *peplos* may, as some believe (eg Robertson and Frantz 1975: 11), be the old one, removed from the wooden cult-image in readiness for the new one to take its place, but, if so, it is surprising that there is no sign of the new one elsewhere in the frieze. More likely the new *peplos* has reached its destination and the priest is blessing it prior to placing it on the image. On either side of the ceremonial group, somewhat larger in scale than the mortals, sit the twelve Olympian deities, the most important gods of the Greek pantheon (**71**). They seem to turn their backs on the ritual, but the fact that Athena, the owner of the temple, and Zeus, king of the gods, are adjacent to the scene shows that their lack of interest is apparent rather than real: they are turned away to distinguish them more clearly from the mortals. At the same time they appear to face, and thus to show interest in, the oncoming procession, the leaders of which have rounded the north-east and south-east corners of the temple and are converging on the central group.

The procession advances in parallel along the north and south sides of the temple. It actually begins at the south-west corner (it could hardly begin at the middle of the west side without creating the absurd effect of two cavalcades setting off in opposite directions), and the west side is occupied by preparations, with youths mounting or reining in their horses; the movement is from right to left, and a single marshal at the north-west angle beckons them onwards. Once round the corner they advance at a canter, as many as seven abreast (**72**). Further along, on both the north and south flanks, come chariots, armed warriors jumping in and out of them in a daring display which formed one of the

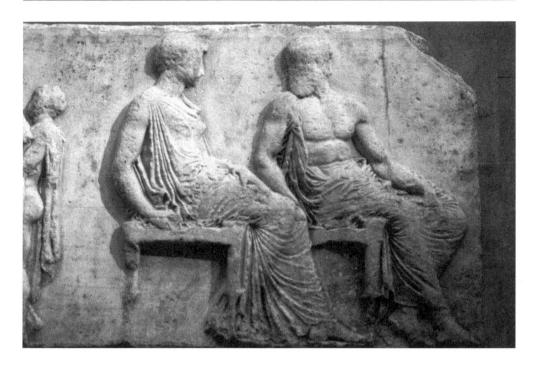

71 *Parthenon east frieze (V, figures 36-37): Athena and Hephaestus. Ht 1.05m. London, British Museum.* Photo R.J. Ling 119/13

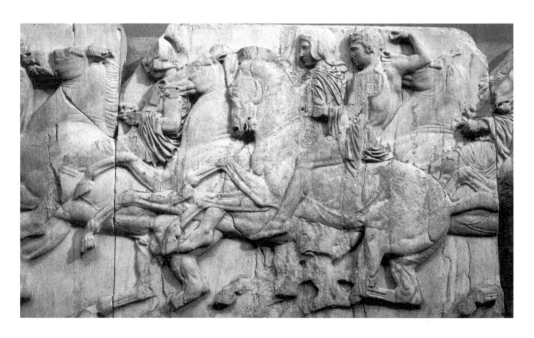

72 *Parthenon north frieze (XLII-XLIII, figures 117-121): cavalcade of horsemen. Ht 1.05m. London, British Museum.* Photo R.J. Ling 119/18

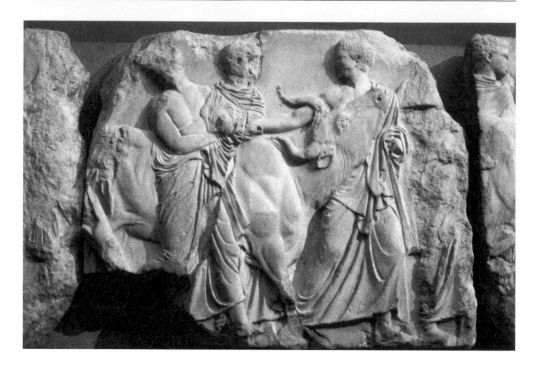

73 Parthenon south frieze (XIV, figures 133-136): attendants with sacrificial heifer. Ht 1.05m. London, British Museum. Photo R.J. Ling 119/11

highlights of the festivities. At the front come musicians and sacrificial animals (sheep and cattle) (**73**) and, round the corners, further attendants and assistants, including girls carrying various ritual objects (**74**). A conspicuous omission is the ship on wheels which carried the *peplos*, but, if the *peplos* had already reached its destination, its absence would not be surprising; besides, its very size would have precluded a realistic depiction within the confines of the frieze. The final figures, standing in informal groups between the leaders of the procession and the unseen audience of gods, are intermediate in scale between mortals and immortals and are normally identified as legendary heroes of Athens, perhaps the eponymous founders of the ten tribes into which the population of Athens was divided.

Whatever the precise moment depicted in the *peplos* scene, it is clear that the frieze plays tricks with time and place. Whereas most other sculptured friezes in Greek art of the classical period (fifth and fourth centuries BC) show events which can be regarded as strictly contemporaneous, this one develops chronologically as we trace it from west to east. On the west the procession is getting ready, on the north and south sides it is in full swing, on the east the leaders are approaching their goal. Given the fact that the procession traversed the city from the north-west gate (the Dipylon) to the Acropolis, it is impossible to believe that the vanguard was arriving on the Acropolis while the stragglers were still assembling at the starting-point. In addition, the chariot-jumping is out of place, since it cannot have formed part of the procession, but rather belonged to separate military

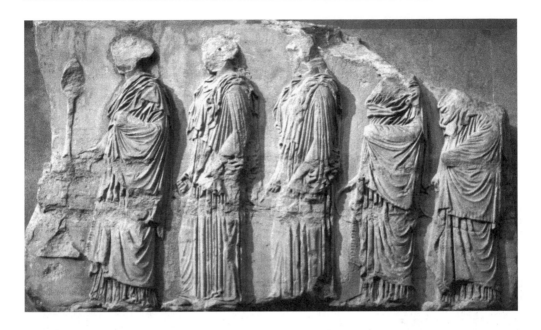

74 *Parthenon east frieze (VIII, figures 57-61): girls with sacrificial implements. Ht 1.05m. London, British Museum.* Photo R.J. Ling 119/15

displays or competitions which took place during the festival. The disruptions in time and logic would certainly have been less distracting when the frieze was in position on the temple; the viewer would most easily have seen it in snatches between the columns of the peristyle (Stillwell 1969), so that, to borrow cinematic terms, it would have appeared as a series of still frames rather than as a moving picture.

The final sculptural element in the ensemble was the great statue-groups of the pediments, apparently completed and installed in the years 437-432 BC, after the temple was consecrated. These are the only Parthenon sculptures, other than the statue of Athena, mentioned in a surviving ancient text. Pausanias, in his second-century AD antiquarian guidebook, gives a terse statement to the effect that the west pediment depicted the dispute between Athena and Poseidon, god of the sea, for possession of Attica (the region of which Athens was the capital), while the east showed the birth of Athena. Without this vital clue, we should never have identified the theme of the east pediment and might have been hard put to recognize that of the west.

Most of the central figures of the east pediment are lost without trace, destroyed when the early Christians turned the Parthenon into a basilica and inserted an apse at the east end (thus reversing the characteristic orientation of the Greek temple). All that survive are a startled figure moving leftwards from the centre, a number of superb seated and reclining figures in the angles, and a pair of chariot teams, one rising from the floor at the extreme left, one sinking into it at the right. We can deduce that the chariots are those of the rising Sun (Helios) and the setting Moon (Selene), traditionally portrayed in ancient literature and art as charioteers; they have been stopped in their tracks by the cataclysmic

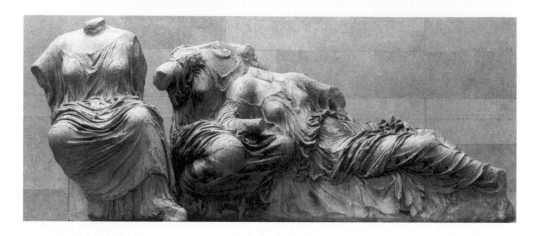

75 *Parthenon east pediment, figures K, L and M: so-called Three Fates (actually Hestia, Dione and Aphrodite, or Leda, Artemis and Aphrodite). Length 2.33m. London, British Museum.* Photo R.J. Ling 125/35

shock of Athena's birth. This Sun and Moon motif was a favourite of Phidias' circle; the great artist had framed the relief of the birth of Pandora on the base of the temple's cult-statue with the same pair of charioteers, and was to repeat the idea yet again on the base of the statue of Zeus at Olympia. All attempts to reconstruct the central figures of the pediment, at least ten of which are missing, must remain speculative, despite the potential assistance offered by markings on the ledge which carried the statues and the cuttings for iron bars which helped to support their weight. According to the myth, Zeus swallowed Metis (Wisdom), who was pregnant by him, to frustrate a prophecy that she would later bear a god more powerful than he; he then gave birth to Athena when Hephaestus, the craft-god, split his head with an axe. She sprang fully armed from her father's skull. A possible echo of the Parthenon's central group is preserved on a Roman cylindrical altar, later reused as a well-head, now in Madrid. From this it can be inferred that Zeus was shown enthroned at the central point, with Hephaestus stepping back on one side, and Athena springing away at the other, perhaps with a small figure of Victory crowning her as an earnest of the triumphant career ahead of her. On either side must have come the various Olympian deities, some violently disturbed from their otherworldly detachment, others blissfully unaware of the turn of events. The trio of draped females in the British Museum (**75**) often identified as the Three Fates, attendants of births, are perhaps Aphrodite, goddess of love, her mother Dione, and the hearth-goddess Hestia (or alternatively Aphrodite, Artemis and Leda). A Michelangelesque male figure reclining with what may have been a wine-cup in its hand (**76**) was probably Dionysus.

The west pediment is better known, though attempts by the Venetian general Morosini to remove some of the central figures after his capture of Athens in 1687 resulted in their being smashed. Here Carrey's drawing of 1674 shows most of the figures still present, and additional statues which he did not see have been recovered in modern excavations. The iconography can also be studied in Athenian vase-paintings which were

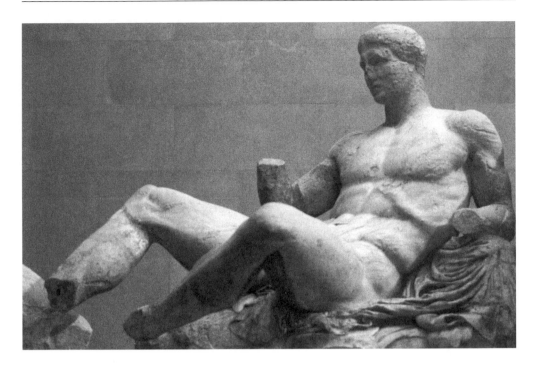

76 *Parthenon east pediment, figure D: reclining god (Dionysus?). London, British Museum.*
Photo R.J. Ling 119/25

influenced by the Parthenon. At the centre, in the much favoured 'chiastic' or 'conflict motif', moving away from, but turned back towards, each other, came the two deities. Their right arms were raised, Athena holding a spear and Poseidon a trident. Between them stood the olive tree, the gift with which Athena won the contest (a sacred olive tree still grew on the northern part of the Acropolis and was later incorporated in the precinct of the Erechtheum). To either side were the chariots from which Athena and Poseidon had apparently descended, like Homeric heroes, to 'do battle'. Their charioteers, Nike and Amphitrite respectively, were shown reining back the horses, which reared in alarm at the divine confrontation taking place before them. Behind them were groups of seated and reclining spectators, some with children on their laps. Though opinions differ, these are best interpreted as personalities from Athenian legend and personifications of Athenian landmarks such as the streams to the north and south of the Acropolis.

The decorative programme

It comes as a surprise to the modern observer, used to the iconographic programmes of Christian churches, to learn that the sculptural decorations of Greek temples were rarely so coherent or relevant as that of the Parthenon. Temples of the sixth century had generally been decorated with representations of mythical monsters or stories which bore

little or no relation to the deity of the temple; one of the pediments of an early temple on the Acropolis, for example, had contained a lion and lioness tearing apart a bull and, on each side, the legendary hero Heracles confronting a fish- or snake-tailed monster, the Triton at the left and a three-bodied creature at the right. These subjects were chosen not for their appropriateness but for decorative convenience: the two crouching animals of the central group fitted the slope of the roof, the fish-tails tapered into the angles. Even in the fifth century sculptures were often not directly related to the deity of the temple. At Olympia the east pediment was certainly appropriate, since it showed the patron deity, Zeus, presiding over preparations for the legendary chariot-race between Pelops and Oenomaus which was the forerunner of the event in the Olympic games; but the west pediment contained a legend which had no Olympic connection, the brawl between the centaurs and Lapiths, with a different deity, Apollo, standing at the centre. The sculptured metopes inside the front and back porticoes were decorated with the 12 labours of Heracles. Heracles was the traditional founder of the sanctuary; his superhuman exploits were an apt paradigm for the athletes who competed at the Olympic Games; and one of his labours, the cleansing of the Augaean stables, had taken place locally; but an equally powerful reason for the choice of theme was doubtless the fact that the number of labours exactly fitted the number of metopes available.

In the Parthenon almost every subject can be seen as integrated in a programme glorifying Athens and her patron goddess Athena. The focus of this programme was of course the great cult-statue, whose scale and resplendence paid fitting homage to the authoress of the city's military successes. The decoration on her shield and her sandals epitomized the recent victories over the barbarian invaders, and the same allegories appeared on the metopes, three of whose four subjects — gods and giants, Greeks and Amazons, Lapiths and centaurs — repeated those on the statue. The frieze showed the citizens of Athens celebrating the greatest festival of their goddess. The representation of ordinary contemporary people on a temple is unusual, but the importance of the occasion and the non-specific nature of the representation (the subject is the Procession as an idea rather than the actors within it) justify the departure from normal practice. A recent theory (Boardman 1977) that the horsemen and chariot-jumpers were the dead of Marathon, elevated to the status of 'heroes' (demi-gods), is ingenious and attractive (the Parthenon, after all, replaced a temple begun in honour of the battle of Marathon), but may not be necessary. Finally, the pediments specifically narrated the two events from Athena's life which would have meant most to the Athenians: her birth and the contest which established her link with Attica.

Throughout this programme there were further subtle accents and interactions. For instance, the east end of the temple was prioritized by its divine content: the metopes showed a struggle involving gods (the Gigantomachy) rather than one involving Greeks (the Amazonomachy and Trojan War) or Lapiths (the Centauromachy); the east frieze contained the seated Olympians in attendance at the ceremony of Athena's *peplos*; the east pediment depicted the birth of Athena, an event which took place on Mount Olympus in the presence of the gods, whereas the contest of the west pediment happened in Attica in the presence of Athenian heroes. From the east end, too, as one entered the temple, one would first have glimpsed the tremendous gold and ivory statue in the interior.

All this shows a carefully thought out scheme, no doubt the work of a master-artist, presumably Phidias. To interpret it, however, there must have been a team of several dozen sculptors, many of them masters in their own right.

The sculptors and their methods

The presence of different hands is most readily apparent in the first sculptures to be completed, those of the metopes. In the best preserved series, those of the south flank, there are such striking disparities that Rhys Carpenter argued (unnecessarily) that many were pieces originally prepared for an earlier temple (Carpenter 1970). Some are stiff and almost archaic in style, others already have the majestic fluency which is the hallmark of the Parthenon sculptures. At the same time the treatment of drapery, of hair, of horses' tails and the like is endlessly varied; of the 18 best preserved metopes no two need be the work of the same hand. Epigraphic and literary evidence show that Greek sculptors gravitated from city to city in response to commissions, and any major programme would bring together artists from a wide range of backgrounds; their different schooling alone would be sufficient to explain the disparities in workmanship. Nonetheless they were certainly working to detailed specifications, if not to actual sketches or models. The constant changes of composition, and the arrangement of metopes to secure variety and balance, betoken a guiding-plan rather than artists left to their own devices.

Planning was inevitably still more important in the frieze, given its continuity and its single subject. By now some of the less able and more old-fashioned sculptors had been weeded out or schooled to the Parthenon style; the treatment, for all its variety in detail, is more consistent and homogeneous, imbued with the timeless quality which is one of the outstanding hallmarks of the Parthenon sculptures. How the work was apportioned between different artists is uncertain, but the reliefs of the west and east ends tend not to overlap from slab to slab and could thus have been prepared on the ground by separate sculptors. On the two long sides the joints between slabs frequently bisect figures, and it is easier to believe that most or all of the carving was done after the blocks were in position. If divisions of labour coincided with divisions between blocks, two halves of the same figure would have been the work of different men, which would have encouraged the assimilation of individual styles to a common stamp; but some other system of distribution may have been used. In either case the artists' freedom of action was still sufficient to admit some improvisation and even *pentimenti*, such as a horse's head skilfully turned into part of the cloak of a rider (**77**).

The pediments too, though varied in detail (the drapery in particular is sometimes modelled like dough, sometimes effortless in its grandeur, sometimes exquisitely fussy), show a uniformity of spirit and planning which is the result of close teamwork. By the time that these sculptures were being carved, Phidias had left Athens for Olympia to work on the statue of Zeus, so, if he had drawn up the designs, his pupils were left to put them into effect. There were something like 22 statues, life-size or over, in each pediment, and, given that modern estimates allow a year for the production of a life-size statue in fine-grained marble, a minimum of 12 craftsmen must have been engaged. Interestingly, they

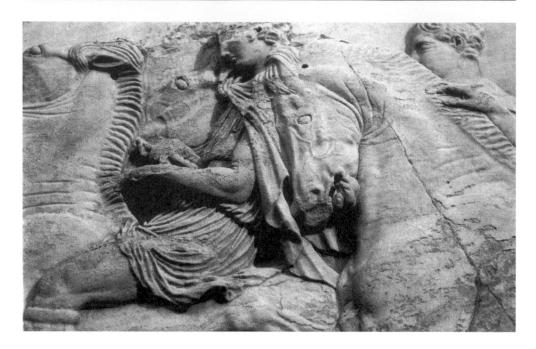

77 Parthenon north frieze (XLVI, figures 129-130): detail of cavalcade of horsemen, showing recarved horse's head. The original head, misplaced too far to the left, has been turned into the cloak of a rider. London, British Museum. Photo R.J. Ling 119/22

generally worked the hidden parts of statues almost as fully as the visible parts, whereas at Olympia the pedimental figures were sometimes only roughly worked at the rear (or the rear parts, as with some horses and centaurs, were completely omitted). The sculptors obviously carved their statues on the ground prior to installation and were under instruction to produce finished works. Only minor trimming and adjustments took place when these works were hoisted into place.

The question of the extent to which the Parthenon sculptures were accommodated to the position of the viewer is a fascinating one. The high relief of the metopes is clearly designed to make them stand out among the projecting elements around them and to withstand the deadening effect of strong sunlight. The frieze, conversely, is in low relief (4.5 to 5cm) to avoid excessive shadow in the subdued lighting of the peristyle. Yet, situated nearly 12m up, the frieze can never have been easy to see from the ground, even when it had its original colours (the Parthenon sculptures, like all Greek sculpture, were painted). The carving was in slightly higher relief at the top than at the bottom, but the angle of vision within the peristyle would have been too steep for clear visibility. A better view would have been obtained from outside, but the glare of the sun on the white marble columns must have made it difficult for the eye to adjust to the shadow of the interior. Whether the fine detail could ever have been fully appreciated by the ancient spectator must be doubted. Similarly the pedimental sculptures, though in some cases tilted to compensate for the spectator's viewpoint, could never have been studied with the close

scrutiny that the delicacy of carving seems to demand. The backs were, of course, never visible at all. Their present museum location gives us a totally false perception of their original impact, 15m from the ground.

The importance of the sculptures

The Parthenon sculptures are the most important architectural sculptures of antiquity. They represent the finest achievement of the artistic capital of classical Greece during the acme of its power and prosperity; they embody the ideals and values of that state during the heady years when the Persians had been defeated and the world seemed to be at its feet. For the Greeks of modern times they are a symbol of past glories, a reminder of the great age when their ancestors evolved the first democratic form of government and bequeathed the western world philosophy, drama and oratory.

In artistic terms the Parthenon sculptures were the culmination of the early development of temple decoration. The metope reliefs included the most successful attempts at showing action and variety within the confines of a small square slab. The frieze was the first great unfolding quasi-narrative in western art, with effects of depth and overlapping (as many as seven horsemen abreast) achieved within a remarkably shallow plane of relief. The pedimental compositions were at once the most crowded and the most fluent of all ancient exercises in filling this most unpromising of fields, awkward in shape yet demanding a unified and symmetrical theme. Overall, the sculptural decoration was, along with that of two later monuments, neither of them temples (the Mausoleum at Halicarnassus and the Altar of Zeus and Athena at Pergamum), the most ambitious such project known to have been undertaken by the Greeks. No other temple had more sculptured metopes (elsewhere only a few small sandstone or limestone temples in Italy had all their exterior metopes carved), none had a longer sculptured frieze, or larger and more elaborate pedimental groups.

For the modern world the Parthenon sculptures are equally important. Their 'rediscovery' in the early nineteenth century was the climax of the neo-classical era and one of the great landmarks in the study of classical art; it contributed more than almost any other factor to the establishment of a separate identity for Greek art, previously known chiefly through Roman copies and pastiches. Richard Payne Knight, an influential critic, vainly argued that they were second-rank works datable in part to the reign of the Roman emperor Hadrian; more discerning judges realized that they were matchless originals of the fifth century BC. More important still, the established practice of 'restoring' ancient sculptures — of replacing lost limbs or heads with modern pieces, which had resulted in the transformation or disfigurement of so many ancient masterpieces — was here for the first time abandoned. Lord Elgin asked two of the most respected sculptors of their day, Canova and Flaxman, to carry out restorations on his marbles, and both declined: Canova because he considered himself unequal to the task, Flaxman because Elgin was unable to meet his estimate for the job. The subsequent acclaim accorded to Lord Elgin's collection, incomplete and damaged as the pieces were, opened a new chapter in the history of the study of classical sculpture; thereafter it became normal to respect the sanctity of the

ancient works and to avoid all additions that might distract from, or falsify, the intention of the original artist. This change, more than any other, ushered in the modern museum age. Ancient works of art ceased to be regarded solely as paradigms for contemporary artists; they also became documents for antiquarian study. The treatment of the Elgin marbles set standards that are fundamental to the practice of modern archaeology.

Bibliography and references

Ashmole, B. (1972) *Architect and Sculptor in Classical Greece*, London and New York: Phaidon: 90-146.

Berger, E. (ed) (1984) *Parthenon-Kongress Basel. Referate und Berichte*, Mainz: Von Zabern.

Boardman, J. (1977) 'The Parthenon frieze—another view', in *Festschrift für Frank Brommer*, Mainz: Von Zabern: 39-49.

Boardman, J. (1985) *Greek Sculpture: the Classical Period*, London: Thames and Hudson: 96-145.

Boardman, J., and Finn, D. (1985) *The Parthenon and its Sculptures*, London: Thames and Hudson.

Bowie, T., and Thimme, D. (1971) *The Carrey Drawings of the Parthenon Sculpture*, Bloomington and London: Indiana University Press.

Brommer, F. (1963) *Die Sculpturen der Parthenon-Giebel*, Mainz: Von Zabern.

Brommer, F. (1967) *Die Metopen des Parthenon*, Mainz: Von Zabern.

Brommer, F. (1977) *Der Parthenonfries*, Mainz: Von Zabern.

Brommer, F. (1979) *The Sculptures of the Parthenon*, London: Thames and Hudson.

Bruno V. (ed) (1974) *The Parthenon*, New York: Norton.

Carpenter, R. (1970) *The Architects of the Parthenon*, Harmondsworth: Penguin.

Connelly, J.B. (1996) 'Parthenon and *Parthenoi*: a mythological interpretation of the Parthenon frieze', *American Journal of Archaeology* 100: 53-80.

Cook, B.F. (1984) *The Elgin Marbles*, London: British Museum.

An Historical Guide to the Sculptures of the Parthenon (1962), London: British Museum.

Hooker, G.T.W. (ed) (1963) *Parthenos and Parthenon* (*Greece and Rome* 10, Supplement), Oxford: Classical Association.

Jenkins, I. (1994) *The Parthenon Frieze*, London: British Museum Press.

Kardara, C. (1961) 'Glaukopis—ho archaios naos kai lo thema tes zophorou tou Parthenonos', *Archaiologike Ephemeris*: 61-158.

Kardara, C. (1982) 'He zophoros tou Parthenonos: ho kurios muthikos tes puren kai to panhellenion programma tou Perikleous', *Archaiologike Ephemeris*: 1-60.

Leipen, N. (1971) *Athena Parthenos: a Reconstruction*, Toronto: Royal Ontario Museum.

Palagia, O. (1993) *The Pediments of the Parthenon*, Leiden: Brill.

Robertson, M., and Frantz, A. (1975) *The Parthenon Frieze*, London: Phaidon.

Stillwell, R. (1969) 'The Panathenaic frieze: optical relations', *Hesperia* 38: 231-41.

9 The Ara Pacis Augustae

Karl Galinsky

The Altar of Augustan Peace was built in three and a half years (13-9 BC) at the height of the first Roman emperor's reign. Several of its aspects make it an exemplary illustration of Roman public sculpture. It is the first major surviving monument in Italian marble: the quarries at Carrara, which have been producing their famous white marble to the present day, were discovered in the 50s BC. Earlier monuments in Rome had been made of Greek marble, but the Greek tradition did not stop at that point. Both on the technical level and in terms of overall conceptualization and artistry, the Ara Pacis is a paradigm of the marriage of Greek and Roman. One of the unique aspects of Roman culture was its openness to Greek forms in art, architecture, literature, and religion. Far from being slavish imitators, the Romans revitalized and innovated Greek traditions, and this synthesis reached a high point in the age of Augustus (31 BC-AD 14).

Yet another aspect of the monument is that of its function. Today, we are leery of 'official' art. Proper appreciation of Roman official art encountered even more problems due to its noisy appropriation by the Fascist regime in the 1930s. One reaction was the most influential book written on Augustus in the twentieth century. In *The Roman Revolution* (1939), Sir Ronald Syme cast Augustus as the Roman precursor of the dictators of his time, and concepts like 'ideology' and 'propaganda' were easily transferred to the period of Augustus. Fortunately, public art in Rome went beyond such stereotypes. The function of the Ara Pacis is enhanced by its combination of sophistication in design and concept with accessibility for a non-elite populace. And, quite appropriately, this Augustan monument is Janus-like: as Augustan culture in general, it looks back to earlier traditions while also being a forerunner of later imperial sculpture.

The monument consists of a stepped altar and an almost square enclosure, which measures 10.6m by 11.6m and has an opening on each of the two shorter (east and west) sides (**78**). The entire structure was extensively decorated with reliefs. Most of the decoration of the actual altar has been lost, except for the two volute-shaped side wings and parts of the small processional friezes with sacrifical animals, their attendants, and the Vestal Virgins (**79**). The walls of the precinct are carved in relief on both the inside and outside. Extensive remains have been recovered since the first discovery of some of the relief plates in the sixteenth century. The process was largely completed by the late 1930s; one caveat is that many of the heads of the human figures in the 'processions' on the two long sides are eighteenth-century restorations, thus making secure identifications impossible in all but four cases. Today the monument stands at a different location than it did in antiquity. Its present axis also runs approximately from north to south, whereas its orientation in antiquity, like that of most Greco-Roman altars, was from east to west.

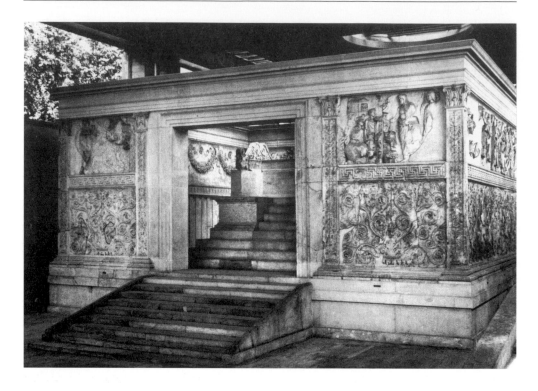

78 *Ara Pacis (13-9 BC): general view of the altar (through the main entrance) and the enclosure from the west. Mars relief on the left; Aeneas relief on the right.* Fototeca Unione 1038

The Ara Pacis Augustae is the most representative work of Augustan art. It is important to view it in its original setting and removed from the connotations which 'Augustan' acquired in later ages, such as monolithic, static, and frigidly neoclassical. Instead, it is a splendid example of Augustan culture in general because of its combination of experimentation, deliberate multiplicity of associations and inspirations, and clear overall meaning. Similarly dynamic are the aspects of its production and of its reception by the viewer in terms of levels of understanding. We are dealing not with a one-dimensional system of representations or messages, let alone 'propaganda', but, as in Augustan poetry and even in Augustus' own account of his accomplishments, the *Res Gestae*, with a highly sophisticated work that incorporates many layers of intention and suggestion. They begin with the genesis and the very form of the monument.

We know from several sources, including Augustus' own mention of it in the *Res Gestae* (12.2), that an Ara Pacis Augustae was voted to him by the senate upon his return to Rome on 4 July 13 BC, after three years of military campaigns in Gaul and Spain. Peace, to the Roman mind, always connoted ongoing conquest; *pax* was the pact which the conquered had to accept. The Pax Augusta, therefore, has two primary aspects: on the one hand Augustus brought an end to almost 100 years of civil war for a populace that was more than ready for tranquillity; on the other, he added more territories to the Roman domain than anyone before him, including Julius Caesar. The monument was to

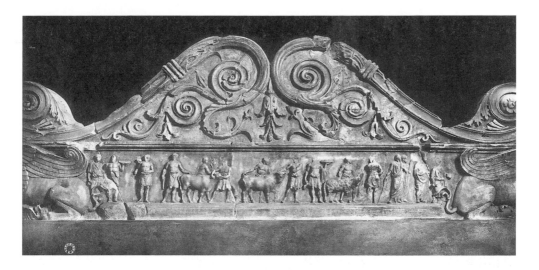

79 Ara Pacis (13-9 BC): upper section of the altar, facing outside. Sacrificial procession. Photo Alinari/Art Resource, New York (Anderson 41087)

commemorate both these aspects of *pax*. Typically, however, it was a monument as understated as Augustus' return and, for that matter, his style of government: he avoided a large public outpouring by entering the city quietly at night. He refused both a triumph, the grandiose procession to the Capitol that was the traditional honour for a victorious general, and the senate's offer to build an altar in the senate chamber itself in honour of his return. Instead, he approved the building of an Altar to *Pax Augusta* one mile inside the sacred boundary of the city, its *pomerium*, on the Field of Mars. Crossing the *pomerium* marked the transition of a Roman magistrate's power from the military to the civil or domestic realm. The Altar, standing as it does on the Field named after the Roman god of war, again shares in both these aspects.

With this, the multiplicity of dimensions that is so typical of Augustan art only begins. The exact ceremony in which Augustus, his family, and Roman senators and priests are shown as being engaged (in the upper portion of the outside of the marble enclosure wall of the Altar (**89**)) cannot be limited to one specific, 'historical' occasion. It is neither the actual 'constitution' of the Altar on 4 July 13 BC, nor its dedication on 30 January 9 BC. It includes, along with the stone garlands hung up on the inside of the enclosure walls (**80**), elements that fit both events, but it goes beyond either. The principal intent is to present the idea of the return of Augustus, the guarantor (*auctor*) of peace who ruled by his *auctoritas* — connoting influence, ability, and persuasion — rather than by ordinary or dictatorial powers; formally, it presents, as one scholar has aptly put it, 'the meeting that could have taken place' (Torelli 1982: 55). Using art to express general, underlying ideas rather than specific reality was a typically Roman concept. Hence it is also left open whether Augustus and his entourage form two processions or one, or whether they should be envisaged as standing in a circle (**81**). But there is no ambiguity about the central intent: the attention is focused on Augustus (**89**), and he, his arrival in Rome, and the rite he is

80 Ara Pacis (13-9 BC): inside of the enclosure wall. The altar is on the right. Fototeca Unione 1049

performing are enhanced by the representation of Aeneas on the panel next to his. The legendary refugee from Troy and ancestor of Augustus and the Roman people, accompanied by his son Julus from whom the Julian family took its name, sacrifices to the gods upon his arrival in Italy (**78**). Augustus' original name was Octavian and he had been adopted into the Julian family by his grand-uncle, Julius Caesar. The scenes of sacrifice with Aeneas and Augustus are complemented with the representation of the ritual reality of the annual sacrifice on the altar itself: a procession of sacrificants and animals on the small frieze that runs, as we have seen, along the top of the actual altar (**79**).

The structure and function of the building exhibit the same qualities of dynamic tension between formal variety and unified conceptualization. The concept is unmistakable: this was to be a sacred monument to Pax under her Augustan aspect. It is, therefore, more than a mere altar: it is a *templum*, a precinct, carved out of the Field of Mars. The word *templum* is derived from the Greek *temenos*, which literally means 'a piece of land cut or marked off from common uses and dedicated to a god'. Greek tradition is combined with Roman practice: several of the Altar's details, especially the lower, inside wall of the precinct with its simulation of wooden boards or slats (**80**), closely follow Roman tradition and precepts for the establishment of small *templa* according to the laws of the augurs, who were an archaic caste of Roman priests. With its two accesses in the east and west, the structure also recalls the shrine of Janus that stood in the Roman Forum. He was, of course, the god who looked in two directions at once. According to tradition (Livy 1.19.2), the second of Rome's early kings, Numa, had founded the shrine as an 'indicator of peace and war'. The closing of its doors signified peace throughout the Roman world.

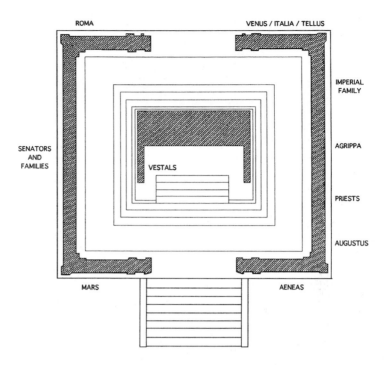

81 Ara Pacis (13-9 BC): diagram of the figural decoration.
Drawing by Chris Williams

This did not happen too often, but there were three such occasions during Augustus' long reign. It is no coincidence that Augustus highlights them in his *Res Gestae* immediately after his mention of the Ara Pacis.

As we have seen, the Altar is the monument that Augustus chose in lieu of a triumph. Despite its understatement, the triumphal dimension is not absent. It is not accentuated in the relief decoration of the Altar, but the larger building context into which the Altar was inserted made it, if anything, into something far more significant and imposing.

The procedure is similar to the architectural and ideological context of Augustus' house on the Palatine Hill. It was unpretentious in comparison with the houses of the well-to-do at the time, but it was extraordinary because it was integrated with the Temple of Apollo. Similarly, the Ara Pacis was part of a gigantic sundial whose hand was a 100ft obelisk imported from Egypt. This, as its dedicatory inscription reveals, was a monument to the conquest of Egypt and dedicated some time between June 10 BC and June 9 BC. Its dedication date probably coincided with that of the Ara Pacis, ie 30 January 9 BC, which was also the birthday of Augustus' wife Livia (as well as the last day of the month dedicated to Janus). The dynastic dimensions were palpable: both monuments were begun in 13 BC, when Augustus turned 50, and Augustus' mausoleum, which was built some 15 years earlier, became part of the overall design (*see* **104**). More speculative is the assumption that the Ara Pacis and the obelisk were built on the basis of a precise mathematical relationship so that on 23 September, which was close to the autumnal equinox, the obelisk's shadow pointed directly to the centre of the Altar. It would make perfect sense: that day was Augustus' birthday — he was born to peace, *natus ad pacem*. It was, however, a peace based on world domination, which was symbolized by a globe, with

145

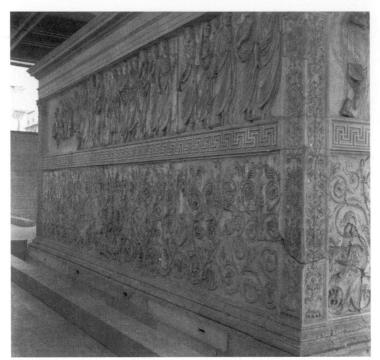

82 Ara Pacis (13-9 BC): north face with floral scroll and procession of senators. Fototeca Unione 1042

a diameter of more than 60cm, directly below the point of the obelisk. This obelisk cast its shadow on an elaborate system of lines, marked in bronze on the travertine surface, which indicated the days, months, and seasons. The sundial was centred on the winter solstice (in Capricorn), the day of the conception of Augustus, who used the capricorn as one of his emblems. The whole piazza, double the size of St Peter's Square and probably connected with a system of parks built by Augustus' son-in-law Agrippa, was undoubtedly one of the most remarkable public spaces in Rome.

To return to the Ara Pacis proper: it is an example of remarkable multiplicity also in terms of artistic styles and traditions. The processions, for instance, 'cite' those of the Parthenon, but they also draw on traditions of Etruscan painting which in turn may be indebted to Greek monumental painting. Other similarities with Greek monuments, such as the fifth-century Altar of Pity in Athens, seem to be no more than generic. The artistic style of the figural reliefs cannot be reduced simply to neoclassicism, but combines classical, Hellenistic, and Roman elements. The head of Augustus (**89**), for instance, does not follow the prevailing, classicizing Prima Porta type, but a more lifelike type. Similarly, the floral friezes on the outside of the enclosure walls (**82**), which are larger than the figural ones, can be related to Etruscan, Italic, and Pergamene traditions, among others. All this amounts to more than the schematic source-hunting so dear to classical scholars: Augustan culture, and especially the arts, architecture, and poetry, were a sophisticated and cosmopolitan blend of many traditions. Rome was now the head of the world in a more significant sense than mere power. She drew on many traditions and revitalized them. That, too, is an aspect of the Pax Augusta; some scholars have aptly spoken of a 'cultural revolution' at the time of Augustus (Wallace-Hadrill 1997).

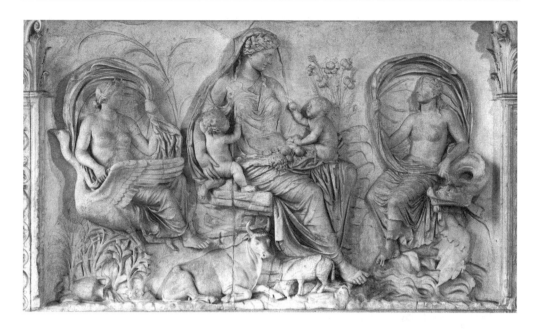

83 Ara Pacis (13-9 BC): relief of female deity with symbols of fruitfulness. Ht 1.57m. Photo
German Archaeological Institute Rome 86.1448

The same deliberate pluralism of meanings and traditions applies to the mythological
reliefs on the outside of the east and west precinct walls. The challenge undertaken by the
artists was to convey the many dimensions and associations of the Augustan peace. A
simple statue of Pax — such representations are attested especially by Roman coins — was
inadequate for the purpose. Its absence once occasioned the argument that the monument
therefore could not be the Ara Pacis. This line of reasoning, however, ignores that the
pictorial programme as a whole and in all its richness is the expression of the concept of
the Pax Augusta in its many ramifications.

The relief in which this many-layered suggestiveness is most evident is that of the so-
called Tellus on the south-east side (**83**). In its centre, a female figure is seated amid
abundant vegetation. She holds two children who look up to her and she is flanked by two
companion figures on the right and left who, with billowing veils, are seated on a sea
creature and a swan or goose. A sheep and cow are at the feet of the central figure. To
varying degrees, the iconography draws on that of Mother Earth, Venus, Ceres, and
possibly even Pax herself. Of all the individual panels, this one expresses the blessings of
the age of peace most fully, but we cannot limit the figure to any specific type. The various
images of the Altar's decoration are meant to be viewed in conjunction with one another,
just as the meaning of individual wall paintings in early Imperial houses in Pompeii is
enlarged when they are viewed in relation to the other paintings in the same room. Peace
alone, for example, is too unspecific because this is a monument to the Pax Augusta. The
aspect of the figure, therefore, that relates best to the dynastic dimension, which is
prominently illustrated by Augustus and his family (**89**), and by the presence of Aeneas

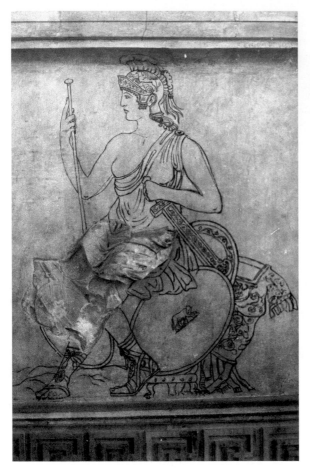

84 Ara Pacis (13-9 BC): relief panel with the goddess Roma (reconstructed). Photo H. Serra (courtesy of Capitoline Museums, Rome)

(**78**), the son of Venus and ancestor of the Julians, is that of Venus. The figure also complements that of the goddess Roma, who is sitting on a pile of arms accumulated in the process of war (**84**). Not much is left of the original relief with Roma, but the figure could be easily reconstructed on the basis of her frequent representation in Roman art and descriptions in literature. War and victory were the precondition for the Pax Augusta; as Augustus himself puts it in the context of the Ara Pacis and the shrine of Janus: 'Peace was created through victories' (*Res Gestae* 13). Venus was also known as a goddess of Victory, Venus Victrix. Venus Victrix and Venus Genetrix (ie the maternal ancestress) were combined by Julius Caesar into Victoria Caesaris, Caesar's Victory. Mars on the west side is connected with all of this. He was the god of war but also the ancestor of the Romans. Therefore he was shown with Romulus and Remus who were the result of his union with the priestess Rhea Silvia. They were nourished by the she-wolf, who was also represented there.

Similarly, Venus, through Aeneas and his son Julus, was the ancestress not only of the Julian family but of the Roman people in general. Accordingly, members both of that family and representatives of the Roman people populate the north and south sides of the frieze (**82, 87, 89**).

These are only some of the connections which can be usefully pursued and which the artistic programme of the Altar in fact is asking us to make. It is, in the best sense of the Augustan programme, a monument that solicits the viewers' participation rather than suffocates them with the massive onslaught of frozen neoclassical forms that we know from public buildings of the nineteenth century. Three important and related aspects bear on the involvement of the viewer.

Firstly, the intentional multiplicity of meanings can be experienced on several levels, depending on the viewer's sophistication. To some, the pictorial programme would be

understandable in relatively simple terms: prosperity; the linking of the Augustan present to the Roman past in the basic manner of Virgil's *Aeneid*; references to peace and relaxed tranquillity, indicated, too, by the demeanour of some of the participants in the procession. *Cognoscenti* would appreciate the complex allusiveness of the imagery far more. For them, the function and appeal of the reliefs individually and in their entirety would be that of a 'picture for contemplation' (Zanker 1988: 175): you can go back time and again, look at the icons, and discover new meanings and associations. They are rooted in rich artistic, literary, religious, and mythological traditions. It is like reading Virgil's *Aeneid*, which was so much more than a typical national epic. At the same time, it is not a matter of purely subjective and impressionistic understandings, which lead to misinterpretation, but the ensemble has a clearly established overall meaning.

Secondly, an important part of that meaning is a return to communal values. The most controversial initiative of Augustus was his legislation on marriage and morals. Among other things, it made marriage compulsory in order to revive a sense of social responsibility (*pietas*) and to set an end to some of the manifestations of excessive self-centredness on the part of individuals in the late Republic. This was part of his restoration of the republic: *res publica* simply means 'the public thing', with the connotation of common weal or common good. The opposite was 'private matters', *res privatae*. In the late Republic, individual interests had taken priority over the *res publica*. We can observe the phenomenon in Roman art, which did not simply exist for art's sake but reflected social and political conditions. In the arts of the late Republic, and especially on the coinage, there appears a plethora of personifications into which the representation of formerly communal concepts, such as liberty, dutifulness (*pietas*), peace, and trust (*fides*) had been dissolved by various statesmen for the projection of their personal interests. The selfish fragmentation of the pictorial programmes only reflected the political one, ie the disappearance of generally shared values in favour of a multiplicity of individual ones. The ancestral Venus Genetrix of the entire Roman people, for instance, yielded to the Venus Victrix of individual generals, celebrating their victories. On the artistic level, this created a problem: the available iconography was not enough to express the new multiplicity of meanings. The same female head, for instance, could represent Pietas, Libertas, or Venus, just as the same male head served for different gods, such as Vulcan, Saturn, Jupiter, and Neptune.

We can see the change that comes about in the pictorial programme of the Ara Pacis. Compared with the confusing multiplicity of Republican images there is now a reduction, in Augustan public art in general, to a few repeated motifs. This quantitative reduction, however, is more than compensated for by their richness of associations, as we have seen in connection with the 'Tellus' (**83**). There is less fragmentation into individual artistic programmes; at the same time, the images, and the connections between them, are more complex and therefore challenge the viewer to explore their full range. We can see how removed this is from simple, straightforward propaganda.

Thirdly, the full understanding of every last facet of such a work of art presupposed an exceptionally high level of education and sophistication. The existence of such a level is indicated by an honorary monument set up in Rome in 91 BC by the Mauretanian king Bocchus for the Roman general, and later dictator, Sulla (Hölscher 1988: 384-6). Its

149

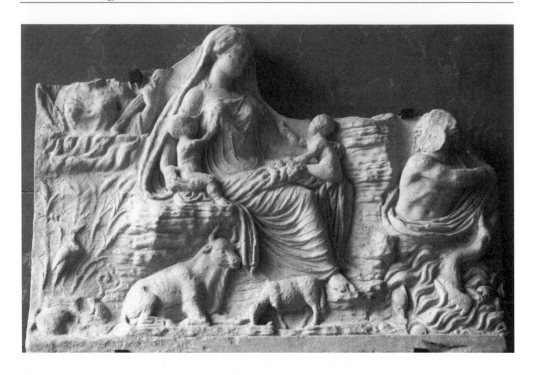

85 Relief from Carthage (first century AD): female deity and companion figures. Compare with 83. Ht 79cm. Paris, Louvre Ma 1838. Photo R.J. Ling 121/10

sculptural decoration consisted of a well-ordered series of emblems and representations that suggested the various qualities of the honoree. They included goddessses of Victory, the head of Heracles (a model of bravery), and shields with the goddess Roma and one of the Dioscuri, who were the patrons of the aristocratic Roman cavalry. The monument is notable not for its vividness but for its high degree of conceptualization. The viewer needed to be able to understand how the various icons formed an ensemble that unfolded Sulla's military and governmental programme.

The Ara Pacis is far less abstract and far more successful in its integration of the suggestive power of such concepts by means of a more vital imagery, but in that sense it was also an experiment which was not repeated. On a relief from Carthage (**85**), therefore, the complex iconography of the 'Tellus' relief is simplified: the accompanying figures are transformed into an astral goddess and a male sea deity. The resulting programme of land, air, and sea is made more intelligible while it is given a cosmic interpretation.

Yet the appreciation of the Ara Pacis was not limited to an intellectual elite. Motifs from it could be easily transferred to private art. A good example is funerary reliefs, commissioned by middle-class people, that adopt the grouping of adults and a child tugging at the parent's dress (**86**). The motif is not found in art before the Ara Pacis where it occurs twice (**87**). It is the kind of privatization of themes from public art that cannot be decreed and, once more, has nothing to do with 'propaganda'. A monument like the Ara Pacis was successful because it appealed to a variety of people and sensibilities.

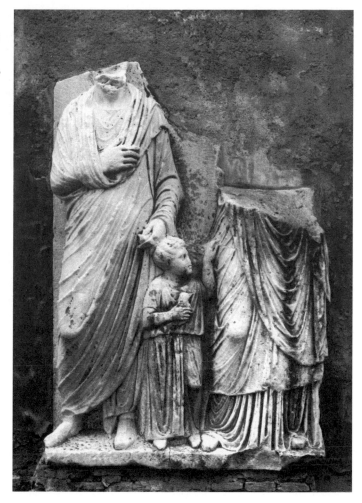

86 *Funerary relief from Augustan times: parents with child. Rome, Villa Doria Pamphili.* Photo German Archaeological Institute Rome 62.641

Part of the reason is that it is one of the most humane monuments ever built by a powerful ruler. In contrast to the Parthenon frieze (chapter 8) — let alone one of its imperial predecessors, the reliefs of the Persian kings at Persepolis — mothers and children are represented (**87**). It is a pity that many of the original faces of the Romans on the Ara Pacis were lost and replaced with eighteenth-century restorations (mostly by the Italian sculptor Carradori), but, as we can tell from those that have been preserved and from the posture of the figures, there was an exquisite balance between stylization and informality. The variation of the postures, gestures, and demeanour of the human participants in the 'procession' goes beyond the aesthetic endeavour to avoid monotony. These are real people. They chat, even to the point of having to be admonished to be quiet, and the children wiggle and squirm as we know them to do at any official ceremony or church service. This is not the pompous and grim monument of a party leader whose subjects are bullied into conformist submission. Although *gravitas*, the serious demeanour which the Romans prized so highly, is certainly not missing, the relaxed attitude of the participants is in fact another manifestation of the blessings of the Augustan peace.

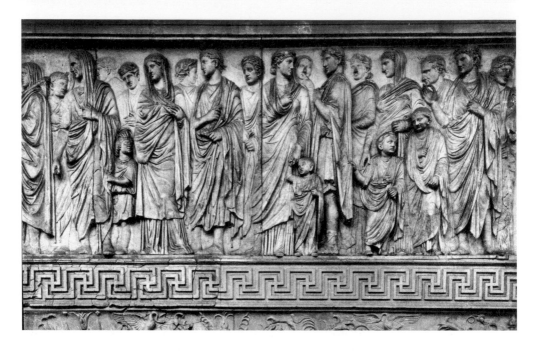

87 Ara Pacis (13-9 BC): south frieze with members of the imperial family. Ht of frieze 1.57m.
Photo German Archaeological Institute Rome 72.2403

The contrast between the Ara Pacis and other rulers' monuments could not be clearer. At Persepolis, there is the relentless monotony of imperialism, while the Parthenon friezes bespeak more cosmic grandeur, which in Rome was shifted to the Augustan sundial. Nor are any such humane touches recaptured in later classical adaptations, whether we look at the monument of Victor Emanuel in Rome with all the tribes of Italy on its typewriter-like configuration, or at Albert Speer's and Adolf Hitler's designs for the new capital of the world, Berlin, or at the routinely neoclassical government buildings of nineteenth- and twentieth-century America with their panoply of frozen symbols.

It is typical of the range of associations of Augustan art and the Ara Pacis in particular that the representation of the Romans as families has the additional dimension of a serious moral purpose. It reflects Augustus' social policy and especially his legislation on morals and marriage. People with children were rewarded and adultery was made a public crime. *Pax* and *imperium* (empire) cannot be sustained without maintenance of *mores*, as exemplified first and foremost by a commitment to and responsibility for families. Once more we are dealing with the primary function of Roman 'historical' reliefs. They are not simply a rendition of events or political reality, but they aim to convey the ideas and values that underlie the Roman experience.

The abundant floral frieze (**82**), which is larger than the figural ones, sets the tone for much of the monument and enhances its many aspects. It expresses the abundance and fertility of nature without assuming the dimensions of a 'paradisiac' Golden Age. Augustus' return to Rome, which the Altar commemorates, was marked not by exuberant

fantasies of the sort, but by the more realistic assurance that the returning soldiers would no longer be compensated with land, a measure that 'in the rest of the population . . . aroused confident hopes that they would not in the future be robbed of their possessions' (Dio 54.25.6). Amid the leafage, there are reminders that peace and growth are never unthreatened: a snake attacks a bird's nest, for instance, and scorpions and other pests are present, even if discreetly. The basic floral motif is an acanthus, developed in an orderly fashion especially in the form of candelabras, including some shoots of laurel and ivy. Nature is ordered, but not excessively so: there are some asymmetries, though barely perceptible to the eye. For instance, the distance between the swans and the floral stalks varies on the north and south friezes. The swans are symbols of both Apollo and Venus — according to Suetonius (*Augustus* 94), Apollo was the real father of Augustus, and Augustus prominently associated himself with the god — and thus underscore the dynastic aspects of the monument. Not by accident, therefore, the most immediate predecessor at Rome of that kind of decoration happens to be the frieze from the Temple of the Deified Julius Caesar (completed by his adopted son Augustus in 29 BC). There figures of Victories, rising from acanthus flowers and surrounded by floral scrolls, recall not only Venus Genetrix but also Venus Victrix and Venus' vegetal associations.

Finally, the Ara Pacis is a good example, in several ways, of Augustus' *auctoritas* or 'influence', which, in contrast with mere 'power' (*potestas*), he proclaimed to be the true basis for his government. The Altar was not decreed by him, but was established at the initiative of the senate, an initiative that was authorized by him and involved some negotiation. No doubt he was involved in the consultations about the design and pictorial programme. No doubt he was not simply their sole author: 'the key elements of this vision,' in Paul Zanker's words, 'originated in Augustus' inner circle' (Zanker 1988: 176). It included the poets; numerous passages can be adduced especially from Virgil's and Horace's poetry that read like a commentary on the Ara Pacis.

The design of the Ara Pacis — and this applies to public sculpture in the early Roman Empire in general — involved multiple creators. Our ancient sources, therefore, neither record their identities nor do they single out a master artist. There was no known Michelangelo in Augustus' Rome. There were, however, workshops of sculptors and carvers who specialized in a variety of techniques. Due to a recent study (Conlin 1997) we are better informed about them, although the extent of their role in the creative design of the monument cannot be ascertained. Detailed analysis of the stone-carving techniques of the authentic Augustan layers of the north and south friezes indicates that the artisans 'both relied on established local Etrusco-Italian carving traditions' (which were used to softer stones), 'and simultaneously experimented with contemporary Greek techniques' because the Greeks had more experience working with marble (Conlin 1997. 57). It is another instance of the general Augustan paradigm: traditionalism combined with experimentation, and eclectic, but meaningful, synthesis of Greek and Roman. Technique and content are complementary and characterized by the same tendencies. It is in this respect, too, that the monument reflects the spirit of its age, an age not just of political stability but also of unsurpassed cultural creativity.

Bibliography and references

Borbein, A.H. (1975) 'Die Ara Pacis Augustae. Geschichtliche Wirklichkeit und Programm', *Jahrbuch des Deutschen Archäologischen Instituts* 90: 242-66.

Castriota, D. (1995) *The Ara Pacis Augustae and the Imagery of Abundance in Later Greek and Roman Imperial Art,* Princeton: University Press.

Conlin, D. (1997) *The Artists of the Ara Pacis*, Chapel Hill and London: University of North Carolina Press.

Elsner, J. (1995) *Art and the Roman Viewer,* Cambridge: University Press.

Galinsky, K. (1996) *Augustan Culture*, Princeton: University Press.

Hölscher, T. (1988) 'Historische Reliefs', in *Kaiser Augustus und die verlorene Republik. Eine Ausstellung im Martin-Gropius-Bau Berlin 7. Juni-14. August 1988* (Mainz: Philipp von Zabern), 351-400.

Koeppel, G. (1988) 'Die historischen Reliefs der römischen Kaiserzeit V. Ara Pacis Augustae', *Bonner Jahrbücher* 188: 97-106.

La Rocca, E. (1983) *Ara Pacis Augustae: in occasione del restauro del fronte orientale*, Rome: 'L'Erma' di Bretschneider.

Moretti, G. (1948) *Ara Pacis Augustae*, Rome: Libreria dello Stato.

Settis, S. (1988) 'Die Ara Pacis', in *Kaiser Augustus und die verlorene Republik. Eine Ausstellung im Martin-Gropius-Bau Berlin 7. Juni-14. August 1988* (Mainz: Philipp von Zabern), 400-26.

Simon, E. (1967) *Ara Pacis Augustae* (Monumenta artis antiquae 1), Tübingen: Wasmuth.

Simon, E. (1986) *Augustus. Kunst und Leben in Rom um die Zeitenwende*, Munich: Hirmer.

Spaeth, B. (1996) *The Roman Goddess Ceres*, Austin: University of Texas Press.

Torelli, M. (1982) *Typology and Structure of Roman Historical Reliefs*, Ann Arbor: University of Michigan Press.

Wallace-Hadrill, A. (1997) '*Mutatio morum*: the idea of a cultural revolution', in T. Habinek and A. Schiesaro (eds), *The Roman Cultural Revolution* (Cambridge: University Press): 3-22.

Zanker, P. (1988) *The Power of Images in the Age of Augustus*, Ann Arbor: University of Michigan Press.

10 Portraits

Janet Huskinson

'Making a likeness of a person': few people would argue with that as a working definition of the art of portraiture. But what makes an individual image a successful portrait or even a portrait at all is somewhat harder to pin down. Today we are used to a wide variety of portrait types, from the idealized images of the monarch on stamps and coins, or the realism of photography, to quite abstract forms like the portraits painted by Francis Bacon. Each presents an individual in terms of some kind of likeness, yet in different ways and in different contexts. All of this was also true for Greek and Roman portraiture, and then, as now, the kind of portrait produced was influenced by two crucial factors. The first is the circumstances of its creation, who commissioned it and why. These are important questions to think about, even if we do not always have the information to answer them: portraits are not fleeting 'snapshots' but conscious and deliberate presentations of their subjects which involve some selection and editing of features. The second factor is the balance between the internal and external in the portrait: how far is it concerned with representing the inner person as well as purely physical characteristics? This question has to be resolved in the making of any portrait, and was recurrent, as we shall see, in the making of ancient portraiture.

Sources and evidence

Fortunately we are helped in our understanding of how these factors worked in the making of Greek and Roman portraits by the survival of a good deal of evidence, from the images themselves and from ancient written sources.

Greek and Roman portraits were made in a wide range of materials. Most of those which have survived are stone sculptures — free-standing and reliefs — or images on coins, but bronze statuary and painting were also popular media. Mosaic, ivory, precious metals, gems and cameos (**88**) were used on occasions: Pompey the Great is said to have been portrayed in pearls (Pliny, *NH* 37.14), while at the opposite end of the scale was the fantastic proposal (never realized!) to turn Mount Athos into a landscape portrait of Alexander (Plutarch, *Moralia* 335).

Portraits came in all sizes, from colossal statues and life-sized figures, busts and heads to small-scale images. Portrait heads were sometimes made to be attached to bodies which had been prepared according to a standardized form (a draped standing figure, an equestrian or an 'orator-type' for instance); this happened particularly in the Roman period and, as we shall see, these 'bodies' often give important clues as to how the portrait as a whole should be read.

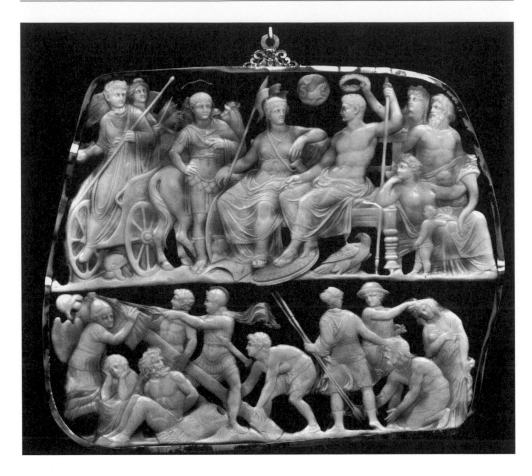

88 Gemma Augustea: sardonyx cameo (19 x 23cm) with reliefs commemorating Tiberius' German campaigns of AD 10-11. Augustus is seated, upper right. Vienna, Kunsthistorisches Museum IX A 79. Photo Arts Council of Great Britain

However, portraits do not always survive in the form in which they were originally made: material, size and context may all be different. For instance, bronzes were often reproduced in carved marble, and full-figure portraits adapted as heads, busts or herms (heads sculpted on to pillars). Such alterations have obvious implications for how we study ancient portraits: a change of material can mean a change in technique, while a change of context may distort our picture of the image's social value. All this can be illustrated by portraits from the so-called Villa of the Papyri at Herculaneum. This private collection of sculpture belonged to a wealthy Roman intellectual in the first century BC, and included copies of Greek portraits, many of which had been made for public contexts. There was a large group of Hellenistic ruler portraits and adaptations of other well-known works, such as the herms taken from the full-length statue of Demosthenes in Athens. Whether reproduced in bronze or marble these copies seem to have been quite accurate versions of their originals, yet even so there are small tell-tale differences in the treatment

of hair and details of drapery (Smith 1988: 71-2). For some famous portrait types the existence of many copies provides a means of reconstructing the lost original.

Another means is through written sources, particularly those which describe the works of famous artists. For surviving examples, historical accounts, inscriptions and anecdotes can all be useful in identifying portraits and subjects. Various literary genres such as biography and eulogy were also concerned with creating portraits in words, and analogies were sometimes drawn with the process of visual representation. This is a useful reminder of the fundamentally rhetorical nature of portraiture. Presentation, as we have seen, was an important factor in this, and often involved emphasizing particular features. Literary sources show how this may tie in with the ancient study of physiognomics which related physical features to moral traits, making the body, and especially the face, an image of the whole person. This equation is important in understanding ancient portraiture, not just individual pieces but whole stylistic trends. It also explains one of the standard arguments against portraiture that crops up from time to time across the period: the austere Republican Cato the Elder (Plutarch, *Life of Marcus Cato* 19) argued that his true portrait was in the hearts of his fellow men, and a similar sentiment is attributed to the Neo-Platonic philosopher Plotinus in the third century AD (Porphyry, *Life of Plotinus* 1).

Patrons and purposes

Patrons' needs and purposes played a central part in the making of ancient portraits, and also in the historical development of portraiture as an art form, as we shall see. They could affect choice of style and attributes as well as fundamental details like the shape and size of the image.

To be a patron obviously needed motivation, access to craftsmen, and money. Public statuary was often set up and paid for by the community, perhaps after negotiation with the subject who might propose modifications or even contribute funding. For private patrons having a portrait was one way of displaying their status, and they often chose to follow images of their social superiors. Norms tended to be set in terms of the elite adult male and his interests, and other members of society were defined accordingly. Hence the boy Q. Sulpicius Maximus (**109**) is portrayed like a middle-aged orator to show the cultural values his family aspired to, while Roman matrons of the same period were portrayed with the bodies of a nude Venus in a combination of beauty and domesticity that fitted society's vision of the ideal wife (D'Ambra 1993b). Occasionally, though, these 'other' members of society are portrayed in their own terms. Women could be patrons of portraiture as is clear from dedications and from the images themselves. Again, they were not necessarily elite, as a splendid portrait of a woman vegetable-seller from Ostia suggests (Kampen 1981: fig 40). Roman funerary altars (*see* chapter 12) were often set up by non-elite patrons; some were dedicated to slaves showing them at their particular tasks. Around the Roman empire the portrait styles of metropolitan Rome often blended with local traditions, revealing some interesting cross-cultural relationships: painted mummy portraits from Fayum in Egypt (**colour plate 18**) and statues from Palmyra provide vivid examples.

Many ancient portraits were made for funerary settings (*see* chapters 11-13). The emphasis is often (but certainly not always) on the individual as a private person, portrayed in prospective terms looking forward to the next world, or retrospectively in terms of this life's achievements. In Greek funerary portraits this could involve some degree of heroization which opens up some ambiguity (eg Lykeas and Chairedemos on a relief from Salamis (**102**): are they alive or dead?), while Roman Republican portraits often show a stark realism which has been linked to the traditional practice of parading ancestral death masks in patrician funerals.

Funerary portraiture is often subject to social conventions like these, but is also influenced by the physical nature of the monument or the materials used. On the Fayum mummies, for instance, facial features are depicted in some detail by painting, although the portraits themselves were limited in shape and size by their position on the mummy (**colour plate 18**). Other monuments show a similar combination of convention and practicality in placing the portraits of the dead: Attic *stelae* of the fourth century BC, Roman freedmen reliefs with their rows of frontal busts, and Roman sarcophagi are obvious examples. Apart from a few grand pieces which must have been specially commissioned, such as the Portonaccio sarcophagus in Rome (**110**), many sarcophagi were partially prefabricated and personal details such as portrait faces completed on purchase (although this was not always done, as the central figure on the Portonaccio sarcophagus shows). Portrait features were given to all kinds of figures on sarcophagi — ordinary men and women, mythological figures (eg Wood 1993), hunters, Muses, philosophers, and soldiers — and show how the combination of a generic figure with a portrait head can make a graphic statement about the individual commemorated. This could also be done by combining a generic figure with some specific, personal detail: a vivid example is the memorial to the young poet, Q. Sulpicius Maximus, which includes all his prize-winning verses (**109**).

Equally rich is the range of portraits made for civic contexts, which could take the form of free-standing sculptures or reliefs. From archaic times statues were set up in sanctuaries or civic centres to record an individual's participation in community. One of the earliest examples is the sculptural group of the so-called Tyrannicides, Harmodius and Aristogiton (**52**). The first version of this was erected a few years after they had killed the Athenian tyrant Hipparchus, but this was looted by the Persians and then replaced by this group around 477 BC.

Portraits of leaders were perhaps the most important and influential type of public statuary. They were set up in central locations in the town and in its civic buildings, sometimes through the wishes of the ruler himself, sometimes as an honour voted him by the local community in thanks for favours received or in the hope of new ones. The creation of dynastic ruler imagery can be traced back to Philip II of Macedon, who around 338 BC commissioned statues of himself, his wife, parents, and son, Alexander, for a special monument in the sanctuary at Olympia. Later, Alexander developed his own image, evolving types which were to inspire the portraiture of his Hellenistic successors. With the Roman Empire the need for official portraits of the leader increased sharply. Identifiable images were required, to command loyalty and, when appropriate, to emphasize dynastic connections. Thus statues of the imperial family were set up in public

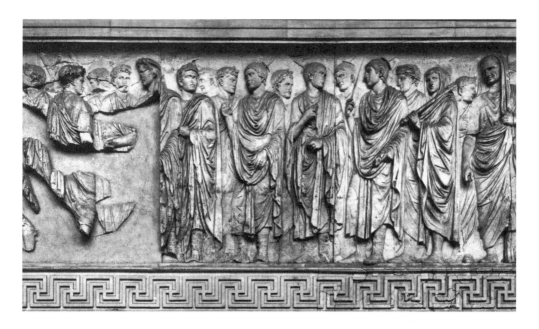

89 Rome, Ara Pacis (13-9 BC): detail of processional frieze on south face, showing Augustus (the fragmentary figure centre left) with priests and attendants. Ht of frieze 1.57m. Photo German Archaeological Institute Rome 72.2400

places by communities across the empire, and the groups were added to, or figures removed or re-cut, as the situation demanded. There was obviously an official system for transmitting the recognized image throughout the empire; approved prototypes were copied in Rome or in provincial centres and sent out to towns and cities. These images appear not only on public monuments but also on coins and small luxury goods (such as the cameo in **88**) which may have been used as gifts. Imperial images also found their way into private homes where the emperor and his family had a place in domestic shrines.

Public portraits like these are expressions of social power, and develop a visual 'language' which can be understood or quoted in various contexts and media. One element in this was the repetition of features reminiscent of some hero of the past. Another was the use of significant dress. Who you were shown with also counted. The emperor Augustus was a past master at this kind of manipulation (Zanker 1988). Compare the images of him on the Gemma Augustea (**88**) and the Ara Pacis (**89**). The facial features are similar, but in one he is dressed like a god and shown with other gods and personifications; in the other he stands veiled, as about to sacrifice, in the company of priests, officials, and members of his family. The cameo presents him as a god-like ruler, while the sculpted frieze makes him a pious *paterfamilias* (head of the family). This same mechanism to convey status by association was also used by members of the elite who incorporated portraits of the imperial family alongside images of their own in monuments they had erected: the wealthy benefactor Herodes Atticus did just this in the statues which decorated a fountain he had built at Olympia.

Underlying much of this funerary and civic portraiture was the aim of presenting people as examples (*exempla*). The concept of *exempla* was especially strong in Roman culture, and is reflected in several aspects of contemporary portrait art and literature. A particularly common theme was the use of figures exemplifying philosophy and learning, part of the culture (*paideia*) which bound educated people together across the Roman world. So in funerary contexts quite ordinary people had themselves portrayed as Muses or philosophers (Zanker 1995), while houses were decorated with sculptures and mosaics depicting famous intellectuals of the past (Schefold 1997). Most of these were Greek, but Virgil was also portrayed in a mosaic from Sousse in Tunisia. Other *exempla* had a more political background. One practice that may seem strange to us was the depiction of non-historical characters from the past. This can be seen in the parading of ancestral images at patrician funerals and in the statues of leading figures from Rome's past — going back to mythology — which Augustus erected in the Temple of Mars the Avenger in his forum at Rome. In both these instances there are moral and dynastic aspects to the 'examples', which also illustrate for us how boundaries between the historic and mythical could be more blurred in antiquity.

Historical review

All this suggests that ancient portraits are not always helpful as a source for their own history. They may be posthumous, re-cut, copied, or imaginary; they may have acquired new settings, size or material. This is true even for portraits of Hellenistic rulers and Roman emperors where there is evidence from other sources (such as coins and inscriptions) to construct a basic chronology for portraiture; there the picture can be complicated by retrospective allusions (for instance, by including physical details associated with 'good emperors' of the past), and by regional variations. Modern studies, too, have sometimes painted a complex picture, particularly those which have tried exhaustively to categorize styles (for instance, the various 'realistic' styles found in Roman portraiture), or have got side-tracked by an interest in identifying the subjects. And there has sometimes been a tendency to oversimplify, expecting 'idealism' in Greek portraits and 'realism' in Roman.

Yet the history of ancient portraiture can be traced quite clearly within the overall development of ancient art, in terms of its styles and its relationship to wider cultural and social developments. Changes, for instance, from the Greek classical *polis* to the more cosmopolitan world of the Hellenistic kingdoms, and from the Roman Republic to the Empire involved shifts in values which were reflected in, and often reinforced by, how contemporary portraits were made. Today there is a strong interest in the various themes and subjects depicted in ancient portraiture (for example Schefold 1997), especially in the context of different social groups or cultural interests (for example Kleiner 1987; Zanker 1988 and 1995).

Many of the earliest examples from archaic and classical Greece can be counted as portraits not for any kind of likeness, but because they represented individual people who are named in accompanying inscriptions. Good examples are the *kouros* placed above the

grave of Kroisos (**98**) and the family group from the sanctuary of Hera on Samos (*c*560-550). Known now as the Geneleos Group after the sculptor who made them, several figures are individually named, yet use standard types without any individuality. Yet 50 years or so on and in a different context there seems to have been a limited move to introduce some distinctiveness in the portrait group of the Tyrannicides, known now through Roman copies (**52**). Here the two figures are clearly differentiated, with Aristogiton shown as an older, bearded man and Harmodius as more youthful. But gestures and heroic nudity are also important in the making of this particular portrait: the men are shown as individuals but moving jointly in the decisive action which made them heroes. Despite this early example of honorific statuary, official public portraits which appeared to aggrandize individual citizens were generally frowned upon in Athens and the next recorded instance in the city was not until a century later. But portraits of private people continued to be made for sanctuaries or in places outside Athens and it is in such contexts that two of the best-known portraits of classical Athens belong. One is the sculpture of Themistocles (*c*528-*c*460), reproduced in a Roman herm from Ostia. The original was probably made around 460 BC and shows a much

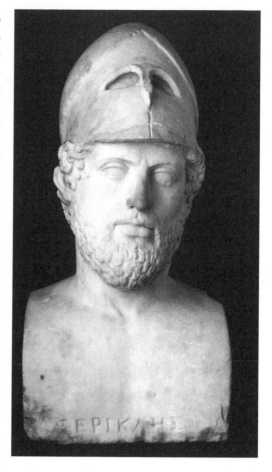

90 London, portrait of Pericles. Roman copy of head from bronze statue of c429 BC. London, British Museum (ex Towneley collection) GR 1805.7-3.91. Ht (including pillar) 58cm. Photo British Museum

greater individualism, with its round face, thick neck and heavy brow, than do the faces of the Tyrannicides. The other image (**90**) is of Pericles (*c*500-429) known through a number of reproductions apparently of the same Greek original. Most probably this was the statue made by Cresilas and erected on the Athenian Acropolis a little after Pericles' death. With its classical idealism and clear yet generic features this image achieves a brilliant balance in representing the individual and the values of his society: it evokes the austerity and nobility of purpose which had made Pericles come to be seen as the great leader of Athens.

In the following century this classicism gradually gave way to a greater variety of styles which tended to be less restrained. At the same time portraiture became more widespread as an art form. In funerary monuments of the time more classical styles remain, and

161

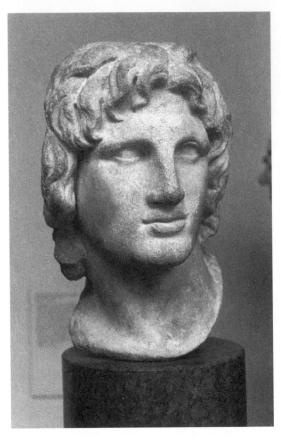

figures are shown as types rather than individuals, with stock poses and composition. The fourth century also saw the creation of posthumous portrait types for various leading people in Greek cultural life such as Socrates and the playwrights Sophocles and Euripides. Although these images were not 'portraits' in the sense of living likenesses they are extremely important as representations of significant individuals which became so well-known that they were repeated time and again in later Roman art. They also helped to establish characteristic appearances for particular types, such as the philosopher, on which many Roman private types came to be based (Zanker 1995).

Perhaps the most significant subject of late fourth-century portraits was Alexander the Great (ruled 336-323) (**91**). His image was hugely influential as a model of a powerful and charismatic leader: physical traits like the distinctive sweep of his hair, or the upturned gaze of his later portraits, were used in their portraiture by would-be Alexanders such as Pompey the Great (**92**) and the emperor Caracalla in the third century AD.

91 Alexander the Great (336-323 BC): head from Alexandria (second or first century BC). Ht 37cm. London, British Museum GR 1872.5-15.1. Photo R.J. Ling 125/27

Alexander's portraitist Lysippus became famous in antiquity as the only artist who could capture his inner nature as well as his physical characteristics (Plutarch, *Life of Alexander* 4.1). Various Alexander portrait types have survived: later ones show him as increasingly god-like, evoking images of the young Dionysus, and others depict him in appropriate activities, such as hunting and in battle. The famous 'Alexander Mosaic' (**colour plate 12**) almost certainly reproduces a Hellenistic painting showing Alexander fighting the Persian king Darius. Resonances of Alexander's portraiture can be seen in the images of various kings who succeeded him. Their status was shown by attributes of kingship, such as the diadem or flat band or fillet, or of divinity, and they were frequently depicted in heroic nudity or as soldiers on horseback. From the late fourth century rulers were also portrayed on their coinage.

The Hellenistic age saw important innovations in the styles of portraits and the contexts in which they were displayed. There was a new interest in exploring

individualism within a universal context, and in expressing the inner person as well as outer characteristics such as race or age. This created portraiture which looked individual and often quite natural, but was actually quite artificial. A good example is the head of an elderly poet, the so-called 'Pseudo-Seneca' (**93**); the physical features are vividly represented, yet the essential personality (a rather weary intelligence) shines through the tense, focused gaze.

From the later second century on, we find Romans and Italians operating in the Hellenistic Mediterranean world as patrons and subjects of portraits. The impact of this is shown by sculpted portraits from the Greek island of Delos, which was a prosperous commercial centre from 166 to 67 BC. Rather than the liveliness of Hellenistic portraits, with their artifice and careful balance of interest between external and inner characteristics, the emphasis here falls on the surfaces of the face, its lines and

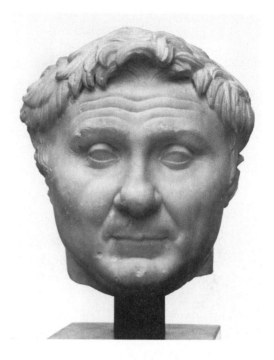

92 Head of Pompey. Ht 26cm. Copenhagen, Ny Carlsberg Glyptotek 597. Photo Jo Selsing (courtesy Ny Carlsberg Glyptotek)

wrinkles and volumes of flesh. The effect is unsparing, almost clinical in its observation. The body, in contrast, often continues to use a heroic type, creating the kind of awkward combination of generic figure and realistic head which will prove particularly characteristic of Roman portrait figures. A graphic example is the figure of the so-called 'Pseudo-athlete' (**94**). This new type of realism in the treatment of the head was picked up by some Greeks in the first century BC, especially those who may have wanted to ally themselves to Roman power; but it was to become a hallmark of Republican portrait sculpture in Rome.

Various factors may explain this popularity. One is the contribution of portrait styles already used in Italy, although this has been much debated: Etruscan figures (as on the lids of urns) often have sharply individual faces and linear detail. Roman patrician funerary traditions were probably another influence. Literary sources tell how masks of ancestors were kept at home and displayed at funerals. These were made of wax or some other portable, lightweight substance, but the question remains of how lifelike they were and how far they might have contributed to the 'warts and all' type realism of Republican portraits in stone. The busts held by a patrician depicted in a statue from Rome (**95**) belong to this tradition but seem to be in different styles. Yet another factor may be a shift in social values: whereas the qualities of beautiful youth had been prized by the Greeks, worldly experience and *gravitas* were more valued in Republican Rome and these were

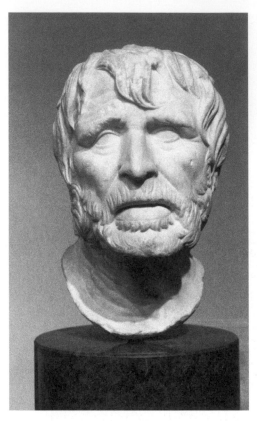

well expressed through the wrinkles of elder statesmen. Although these portraits look highly 'real' and individual, they do in fact have certain formulaic ingredients (Nodelmann 1993), and this is a reminder of the social rhetoric that underlies them. In the battle of personalities which marked the end of the Republic portrait images had a role to play and we can see the manipulation of styles and settings for political ends: this is the context of Pompey's portrait with its allusions to Alexander (**92**) and of the portraits of Julius Caesar, who was the first living Roman to be depicted on coins.

Under Augustus the art of portraiture developed in some critical ways which influenced its course for the next three centuries or so. These were not wholesale innovations but rather concerted moves to establish an imperial language of style and iconography that would be intelligible throughout the Roman world. In style there was a move back to the classicism of fifth-century Athens for its connotations of moral probity and universality. In iconography there was an important development of set-piece scenes in which the emperor was shown acting out imperial qualities such as clemency and magnanimity. Repeated time and again on sculpture, coins and silverware, these remain staple ingredients in imperial imagery well into the fourth century. Another aspect was the creation of family likeness (often expressed through hairstyles as much as facial resemblance), which was invaluable for dynastic purposes. This too was a mechanism used by many later emperors in times of need, but for the Julio-Claudians who succeeded Augustus it provided immediate models to be followed. During their era there was a move towards increased realism which culminates in portraits of Nero, although the latest of these also re-introduce imagery of the heroic, Alexander-style leader with their deep-set eyes and sweeping hair.

Reactions to this hyperbole followed in the much more down-to-earth styles adopted by Vespasian and Titus, the first Flavian emperors. These are more than a little reminiscent of Republican 'realism'. But Flavian portraiture also had an interest in textures, which is shown, for instance, in exploiting the contrasts between smooth flesh and the elaborate 'honeycomb' hair-pieces then in fashion for women. These two features, retrospective

93 Portrait head: so-called Pseudo-Seneca (Hesiod?). Ht 32cm. London, British Museum GR 1862.8-24.1. Photo R.J. Ling 125/25

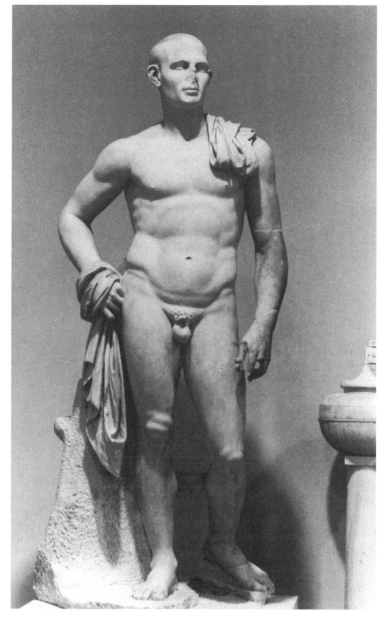

94 So-called Pseudo-
 Athlete, from Delos.
 Statue of a Roman
 merchant or official
 whose portrait head
 has been attached to
 a conventional
 heroic nude body.
 Early first century
 BC. Ht 2.25m.
 Athens, National
 Museum 1828.
 Photo Getty
 Research Library,
 Wim Swaan
 collection,
 96.P.21

allusion and exploration of textures, recur throughout the next century or so of imperial portraiture. Classicism emerges again with the philhellenic emperors Hadrian in the early second century and Gallienus in the mid-third, while realism (though of a different style) appears in portraits of third-century soldier emperors such as Philip (**96**). In these the interest in texture shows in the pecked surface of hair. But it is not all a matter of oscillation between styles; there are changes in details. The beard becomes popular for men after Hadrian, and details of the eye are carved rather than painted from roughly the same time.

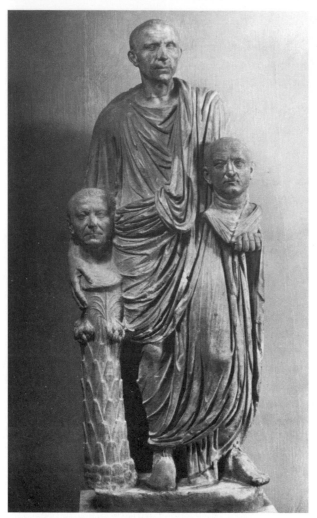

95 Man carrying busts of his ancestors in a funerary procession. Ht 1.65m. Rome, Palazzo dei Conservatori 2392. Photo German Archaeological Institute Rome 37.378

If this discussion has concentrated on rulers it is because private portraits were so heavily influenced by imperial fashions. This was perhaps particularly the case in Rome but happened also in the provinces: even the painted mummy portraits from Egypt show influences of imperial fashions as well as local traditions (**colour plate 18**). Throughout the empire funerary contexts provide much of the private portraiture where, as we noted, portrait style was often constrained by conventional schemes of decoration. From the second century on sarcophagi come to replace funerary urns and altars and are a major source of private portraiture in Rome until the middle of the fourth century AD.

From the early third century, signs appear more frequently of styles which later come to characterize the art of late antiquity. Organic forms of the body become more abstract, and facial expressions seem to reveal an inner life so tense and troubled that many modern commentators have interpreted them as reactions to the political troubles of the time or to a deep spiritual yearning. It is important here (as always) to avoid reading too much into these portraits from hindsight. Instead they can be seen as part of the same culture as the

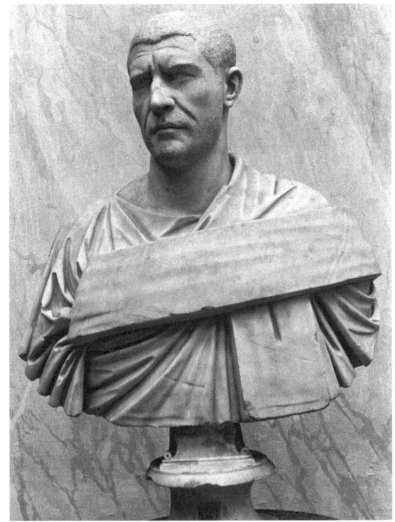

96 Bust of Philip the Arab from Castel Porziano. Ht (without base) 71cm. Rome, Vatican Museums, Museo Chiaramonti (2216). Photo RJL 97/19

philosophy of Plotinus which emphasized the importance of inner qualities over material substance. The down-playing of external individuality in order to stress essential similarities played an important part in the imagery of the Tetrarchs at the end of the third century. In the famous porphyry group at Venice (**colour plate 1**) the four rulers are shown in terms of their equal status and not as individuals. But a fitting conclusion to this history is provided by the fourth century panels on the Arch of Constantine (AD 315) which show the emperor and people. Status, individuality and likeness are key issues here. The rigid horizontal divisions which separate the different lines of figures suggest a separation of social ranks. The figures have generic bodies yet the heads have been made with variation and rather studied 'individuality'. In their centre presides the emperor: unfortunately his head is lost but his commanding frontal position speaks for itself. This figure appears as much an icon as a portrait. It is a reminder that there is more to portraiture than physical likeness.

Bibliography and references

D'Ambra, E. (ed) (1993a) *Roman Art in Context. An Anthology,* Englewood Cliffs: N.J: Prentice Hall.

D'Ambra, E. (1993b) 'The cult of virtues and the funerary relief of Ulpia Epigone' in D'Ambra 1993a: 104-14.

D'Ambra, E. (1998) *Art and Identity in the Roman World* (The Everyman Art Library), London: Weidenfeld and Nicholson.

Kampen, N.B. (1981) *Image and Status: Roman Working Women in Ostia,* Berlin: Mann.

Kleiner D.E.E. (1977) *Roman Group Portraiture. The Funerary Reliefs of the Late Republic and Early Empire,* New York and London: Garland Publishing.

Kleiner D.E.E. (1987) *Roman Imperial Funerary Altars with Portraits*, Rome: G. Bretschneider.

Nodelman, S. (1993) 'How to read a Roman portrait', in D' Ambra 1993a: 10-26.

Richter, G. M.A. (1984) *Portraits of the Greeks* (revised by R.R.R. Smith), London: Phaidon.

Schefold, K. (1997) *Die Bildnisse der antiken Dichter, Redner und Denker*, Basel: Schwabe and Co.

Smith, R.R.R. (1988) *Hellenistic Royal Portraits*, Oxford: Clarendon Press.

Stewart, A. (1993) *Faces of Power: Alexander's Image and Hellenistic Portraits*, Berkeley: University of California Press.

Walker, S., and Bierbrier, M. (1997) *Ancient Faces. Mummy Portraits from Roman Egypt*, London: British Museum Press.

Wood, S. (1993) 'Alcestis on Roman sarcophagi' in D'Ambra 1993a: 84-103.

Wood, S. (1999) *Imperial Women. A Study in Public Images 40 BC-AD 68*, Leiden: Brill.

Zanker, P. (1988) *The Power of Images in the Age of Augustus* (translated by A. Shapiro), Ann Arbor: University of Michigan Press.

Zanker, P. (1995) *The Mask of Socrates: the Image of the Intellectual in Antiquity* (translated by A. Shapiro), Berkeley, Los Angeles and Oxford: University of California Press.

11 Greek funerary monuments

Peter J. Holliday

Greek emphasis on the individual and personal achievement fostered two parallel attitudes to death: it must either be the very reverse of life — sad, lonely, and cheerless — or a transcendent version of it. Generally, Greeks found little to look forward to in the afterlife. Homer's heroes end up in Hades as feeble, disembodied shades, the 'wasted dead' (*Odyssey* 11.491). Even Achilles, whose power is great among the dead, would gladly trade places with the poorest peasant on earth. A privileged few reach the Elysian Fields and similar paradises or, like Heracles, the Dioscuri and Asclepius, the realm of the gods. Yet Homer also calls heroes, priests, seers, singers, and heralds 'godlike', and by *c*450 Empedocles remarked that 'with other immortals they share hearth and table, having no part in human sorrows, unwearied' (Kirk *et al* 1982: no 409). Manly excellence or virtue – *arete* — was the deciding factor.

The Egyptians, who were obsessed with providing for the deceased's future in the afterlife, created funerary images that functioned as an everlasting house for the soul. Greek tomb sculpture, however, affirms and perpetuates the deceased's *arete* among men: it functions both as a marker (*sema*) for the deceased and as his memorial (*mnema*). As a marker, it may employ apotropaic symbols (lions, gorgons, sphinxes) to discourage desecration, while as a memorial it often features the image of the deceased, either in the round or in relief. In essence, Greek tomb sculpture affirms the belief that immortal fame (*kleos*) is the only compensation for death, and only poetry or art can confer *kleos*. Pessimism about the afterlife understandably heightened interest in this most worldly form of personal immortality in an attempt to negate the fate that all shared.

> Mourning your dearest friend, be wise in grief.
> They are not dead, but on that single road
> Which all are bound to travel, gone before.
> We too in after days shall overtake them;
> One roadhouse shall receive us, entered in
> To lodge together for the rest of time.
> (Antiphanes, translated by T.F. Higham:
> see Higham and Bowra 1938: 518, no 451)

The idea of marking a grave with a sculptured tombstone had been practised in the late Bronze Age, though the examples that we have are limited to the sixteenth-century royal tombs at Mycenae. When the Bronze Age cultures collapsed, mass migrations changed the eastern Mediterranean and the Greek cities were devastated. Even Athens, which escaped destruction, shows no tradition of stone sculpture during these 'Dark Ages'. Yet memories

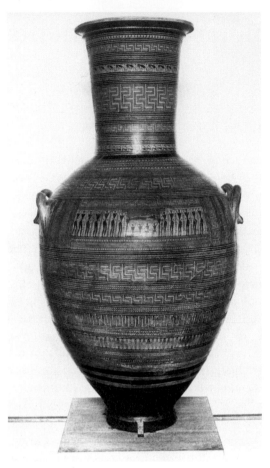

of the past remained alive. The Greeks of the archaic, classical and even Hellenistic periods regarded the Myceneans as their heroic ancestors whose deeds come down to us as the myths and legends that form the staple subjects for Greek poetry and art.

In the ninth and eighth centuries a plain stone was sometimes placed on a grave in the Athenian cemetery (the Ceramicus). To set beside this stone marker a huge vessel decorated with figured scenes seems to have been the first step in the revival of monumental art (**97**). Such vases are of normal shapes, but their scale is exceptional. The largest stood at 1.55m, the height of a human being. Tradition determined the type of vase it was to be. During the preceding centuries, when the Athenians generally cremated their dead, the ashes of women were buried in belly-handled amphorae. When inhumation became the preferred form of burial, the remains of women rested beneath such amphorae rather than in them, and craters marked the graves of men. The floors were deliberately broken or punctured, perhaps to receive libations poured by mourners, but the vessel's function was essentially commemorative.

97 Geometric grave-vase from Athens ('Dipylon vase'). Mid eighth century BC. Ht 1.55m. Athens, National Museum 804. Photo German Archaeological Institute Athens NM 5944

Painters introduced figures in response to the funerary function of the vases. Perhaps under the stimulus of the Orient and Greece's own Bronze Age past the vase painter desired to turn his observations of nature and ceremony (in which his vases played an important part) into solemn commemoration. The earliest formulaic figures are surely intended to exalt the dead and preserve ritual. They represent the Greek impulse for the archetypal that is also expressed by the Homeric epithet: a descriptive word or two that fills out the hexameter line while establishing what is constant and unchanging about a character. Brought into the ordered geometric world, their appearance signals the end of the Dark Ages.

Aristocrats projected images of their own importance in the elaborate burials and battles decorating their grave-markers. Scenes of *prothesis* illustrate the highly patterned ritual that included the lying in state of the corpse. A horse may symbolize the aristocratic

rank of the dead, a man wealthy enough to afford the expenses of a horse and therefore exalted as a *hippeus* (knight). It may also allude to the ritual procession known as the *ekphora* and stand for the team that drew the funeral wagon to the pyre. Battles on land and sea represent early manifestations of the characteristically Attic impulse for dynamic narrative. Such scenes may stand for a glorious episode in the life of the deceased or even the occasion of his death: the kinds of action that undoubtedly won Athenian aristocrats considerable glory in the early eighth century and that made them more like the heroes epic poets sang about.

Although Attic vase-painting would enjoy a distinguished future, monumental vases for tomb-markers did not: they went out of style in the course of the late seventh century, a period in Athens marked by social disruption. Throughout Greece economic crises led to strife between aristocratic factions and the rise of 'tyrannies' (unconstitutional monarchies). When aristocrats lost power to hoplites (the regular infantry soldiers) and autocrats, they also lost their economic monopolies. The seventh century coined the proverb 'money makes the man' — not birth, land, good looks, nor *arete*. Aristocrats quoted the proverb bitterly, for it was their status and their values of *arete* and *kalokagathia* (the ideal union of beauty and goodness) that were undermined. The resulting spread of wealth may have had something to do with changing tastes among the graves of aristocrats, for, when the practice of setting up expensive grave markers shortly resumed around 600 BC, they were of marble and represented youths.

Communications throughout the eastern Mediterranean were by now as easy and regular as they had been in the Bronze Age. Monuments seen in Egypt and the Near East may have encouraged the Greeks to turn to stone for their newly evolving styles of architecture and sculpture. Figures of nude youths (*kouroi*) and clothed maidens (*korai*) are archetypal and non-specific, and thus could be put to a variety of uses, usually either as the grave-markers or as dedications in a sanctuary. Some regions of Greece preferred one use or the other: the Athenians generally employed the *kouros* solely as a tombstone while the Boeotians employed it as a votive offering. The sculptures were essentially the preserve of a privileged class who could afford them. But aristocrats did not commission them merely for conspicuous consumption: they did so to promote their ideals of *arete* and *kalokagathia*.

Exemplary is the *kouros* placed above the grave of an aristocratic youth named Kroisos in a cemetery at Anavysos (**98**). The base of the statue is inscribed with a call to mourning:

> Stop and grieve at the tomb
> of dead Kroisos, whom
> raging Ares destroyed while
> fighting in the foremost ranks

The statue and the epitaph seem to our eyes incongruous. Although the inscription commands grief, Kroisos' statue, his eternal embodiment, is not melancholy or pitiable but an affirmation of power and substance. Such *kouroi* were perpetuating symbols of the physical prowess, moral authority, goodness, and beauty that aristocrats considered innately aristocratic. Placed over their graves, they were meant to please the dead as well, in the same way that they pleased the gods when placed in sanctuaries.

Greek sculptors represented the deceased as in life, but tended to eschew realistic portraiture for the ideal or the typical in each case. Embodying the deceased at the height of his beauty and *arete*, funerary monuments allude to life's 'jewelled springtime' and recall the splendour of Homer's heroes and heroines. What the funerary *kouros* promised was not a happy life beyond the grave but eternal heroization among the living. For the archaic Greek monuments last, *kouroi* preserve, and the remembered dead enter a state of timelessness and timeless *arete*.

> His tomb and children are notable among men,
> and his children's children, and his race thereafter;
> His noble memory is not destroyed nor his name,
> but he is immortal, though he lies beneath the earth,
> Whomever, excelling in valour, standing fast, and
> fighting for his land and children, raging Ares destroys.
> (Tyrtaeus: West 1971: 12, 29-34)

A new type of grave-slab began to appear in the Ceramicus about the same time as the *kouroi*: a tall narrow pillar crowned by a lightly ornamented capital supporting a sphinx. During the last few decades of the seventh century the sphinx is abandoned and the ornament modified into a tall palmette supported on double or (later) single volutes. From about the second quarter of the sixth century, the shaft begins to be adorned with carving in relief: a figure of the dead in profile (life-size or a little over), and sometimes below the feet a small predella panel. One early predella shows a gorgon — a death-figure, like the sphinx above — but more often there is a scene illustrating some activity from the deceased's life: a man riding a horse, or armed for combat. The larger figure, too, is sometimes shown integrated into the social fabric, a typical member of the *polis* community in one of the avocations of life, as athlete or soldier. Sometimes he is bearded to show that he had reached mature age. The evidence suggests that reliefs from women's graves are much less common than from men's; the rare females are nubile girls or dutiful matrons. Grave-reliefs of women and girls will be regular in classical Athens, and at that time too the carved tombstone is common to all classes. In the sixth century it seems a limited luxury.

At the end of the century tombstones in Athens ceased to be carved with figures, probably because of laws controlling funeral expenditure. (Such laws were a common method in antiquity of attempting to impose some degree of state control on private expenditure.) The appearance of similar stones during the early fifth century in various parts of the Greek world suggests that some of the sculptors who had specialized in this production in Attica sought employment abroad.

One piece, found at Orchomenos in Boeotia, bears the signature of one Alxenor, who describes himself as Naxian, and concludes the verse of his inscription with an injunction to look at his work (**99**). The tall, narrow field is filled by the figure of a man, cloaked and bearded, who leans on his stick and offers a cicada to a dog that stretches up for it. Fragments of two sixth-century Attic stones found in the Agora also show masters accompanied by their dogs. The earlier and finer had the man standing or walking, not

leaning on his staff; but in the second this was probably the motif. It reappears with little variation on two other early classical pieces of different provenance and style. Alxenor's work, of the early fifth century, is in the low, flat relief generally found in the archaic Attic pieces. His inscription is outside the relief-field, on the lower part of the stone, also following Attic practice.

Phidias oversaw numerous highly trained craftsmen for the decoration of the Parthenon, and its completion will have left many of them without work. A law permitting the erection of private figured tombstones in Athens may well have been passed to ease their situation as well as to contribute to the adornment of the city. Sculptured grave-markers suddenly reappear, commonly a short broad type crowned by a projecting cornice which normally supports a shallow gable with palmette *acroteria*, suggesting the end elevation of a temple. The side elevation could be suggested by omitting the gable and crowning the cornice with palmettes, like the antefixes (decorative end-tiles) along the edge of a roof. Numerous surviving monuments run in an unbroken series down to about 317 BC, when another law once more forbade their erection. Thus they form a useful continuous thread by which to trace changes in artistic approach from the classic moment of the Parthenon to the verge of the Hellenistic age. The tall narrow form continues in use alongside these, and occasionally bears a panel relief, but is more often decorated only with the palmette finial, two rosettes near the top of the shaft, and just below them the inscribed name. Family plots often used both types of stone and marked the ends of the plot with smaller monuments such as marble vases.

The earliest of the revived Attic series closely resemble the figures of the Parthenon frieze. Some are indeed so similar that it is reasonable to imagine that the same men carved

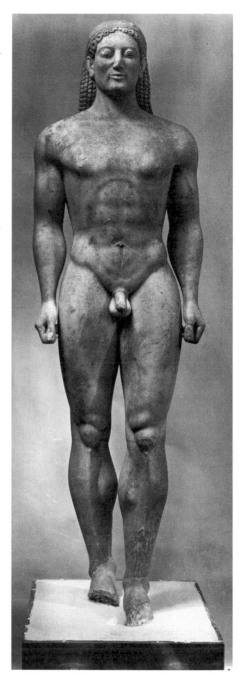

98 Marble kouros *of Kroisos from Anavyssos. c530 BC. Ht 1.94m. Athens, National Museum 3851.* Photo German Archaeological Institute Athens NM 4262

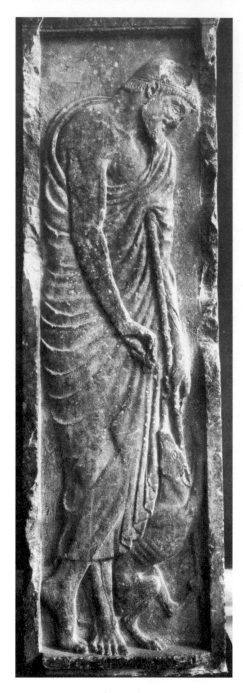

99 Marble grave stele by Alxenor from Orchomenos (Boeotia). c490 BC. Ht 2.05m. Athens, National Museum 39. Photo German Archaeological Institute Athens Hege 1133

them. Typical is that of Sosinous, described as of Gortyn (a Cretan city) and as a bronze-worker (**100**). He was therefore a 'metic', one of the class of foreign (non-Athenian) craftsmen and traders whom Solon had first encouraged to settle in Athens and who had remained an important element in the population. On the tombstones citizens are often given their father's name as well as their 'deme' (the local division under which every citizen was enrolled). Wives and daughters feature the name of their husband or father. A verse tells us that Sosinous' sons erected the monument in honour of his virtues. He sits like one of the gods on the frieze, holding a staff but with his other hand resting on what seems to be his bellows; its surface is roughened, apparently to be finished in stucco. Throughout the series the ideal changes and a greater naturalism is introduced, but it is doubtful if even in the latest there is the intention of portraying personal features.

Other stones feature more complex compositions, often a seated figure with first one, then later several, standing companions. Like contemporary white *lekythoi*, some scenes were definitely connected with death, whereas on the surface others appear purely domestic but with the detectable implication of an awareness of something beyond. (In some cases the point is made explicit with a verse.) The stele of Hegeso, daughter of Proxenos, shows the two-figure composition in one of its simplest and most favoured forms (**101**). The dead woman sits on a chair, her feet on a stool, taking jewels from a box offered her by a young slave-girl. The whole has a wonderful calm beauty that is given a faint sadness through the inclination of the heads. The impression this work makes is that of a regular tombstone-carver who here surpasses himself.

Nevertheless, important artists did accept commissions for grave monuments. Praxiteles may have done so, although the record in his

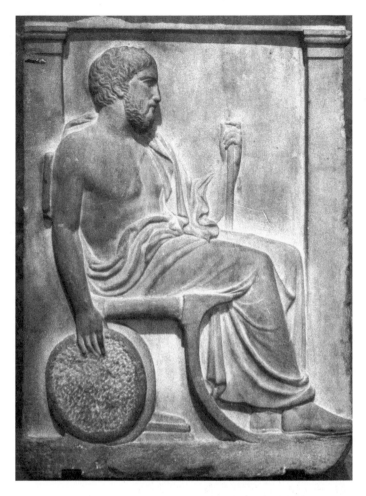

100 *Marble grave-relief of Sosinous from Athens. Third quarter of fifth century BC. Ht 1.00m. Paris, Louvre Ma 769.* Photo R.J. Ling 121/35

case may refer rather to memorial statues or statuary groups. Painted tombstones are certainly ascribed to his colleague Nicias, and among surviving reliefs some are so extraordinary as to suggest that they are the work of master sculptors. Even among the rest there are fine, felt pieces; but there is a tendency towards stereotyped compositions and to listless though usually competent execution. Nevertheless, though these craftsmen will hardly have initiated any major movement, the stones display a development of their own, and at the same time reflect the discoveries and fashions of greater art. Figures may be bound together by a handshake that transcends the worlds of life and death, sunk in their own private reflections, or even (though rarely) indulging in an open show of grief. Often the dead cannot be distinguished from the living, which may be partly a matter of commercial convenience, but may also reflect a decided ambivalence toward the act of parting.

In Athens there are few status distinctions between the living and the dead: had any existed, one would expect the *stelae* or their inscriptions to suggest them. To the Greek such distinctions inevitably meant posthumous heroization, and of the recent dead only battle casualties (publicly interred with elaborate ritual in communal graves outside the

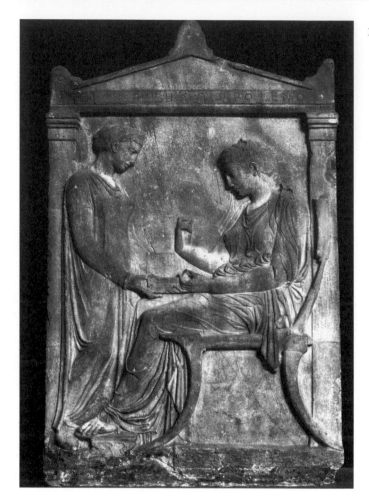

101 Marble grave-relief of Hegeso from Athens. First quarter of fourth century BC. Ht 1.49m. Athens, National Museum 3624. Photo German Archaeological Institute Athens Hege 1688

city) and unique individuals of towering achievement were accorded this honour. Battle-scenes were never common on tombstones, although some show foot-soldiers either striking down an enemy or going into battle. A noble example is a large stone found on Salamis bearing life-size figures of two young men, named Chairedemos and Lykeas (**102**). Both are bareheaded but carry shields and spears. They move side by side, in attitudes recalling the Polyclitan Doryphorus. They were perhaps brothers who fell in action together. The monumental scale and imposing figures of the stone look forward to the most common type of Attic gravestone in the fourth century: a group of life-size figures in high relief set in a deep shrine-like frame.

A parallel development throughout the fifth and fourth centuries in grave-reliefs is small scenes in very low relief carved on marble vases. These are not actual vessels, being made solid, but are copied on a large scale from two pottery shapes. One, the *lekythos*, is specially connected with the dead; the other is the *loutrophoros*. This is a very tall narrow vessel with an almost equally tall and even narrower neck. It was used to bring water from the sacred spring Callirrhoe for ritual washing at an Athenian wedding; and by extension was placed in the graves (and perhaps used at the funerals) of those who died unmarried.

102 *Marble grave-relief of*
 Lykeas and Chairedemos
 from Salamis. Late fifth or
 early fourth century BC. Ht
 1.81m. Piraeus Museum.
 Photo German
 Archaeological Institute
 Athens PIR 204

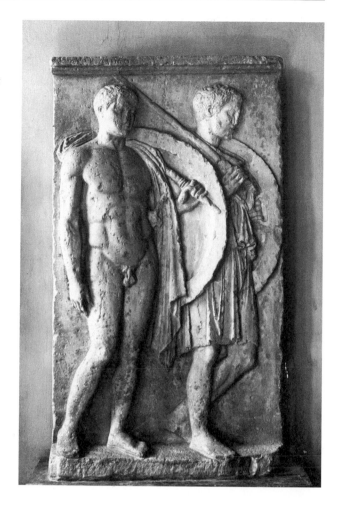

The stone versions of these vessels begin to be made during the period of the Peloponnesian War and last into the fourth century. Some of the *lekythoi*, among them perhaps the earliest, were painted, not carved in relief; and among the last white *lekythoi* in clay is a group of huge vessels, evidently imitated in their turn from the marble ones and like them designed as grave-markers — the last descendants of the great geometric vessels. Around 400 BC, the clay originals gradually go out of fashion. A play by Aristophanes produced in 392 BC includes allusions to both types of funeral *lekythos*, the clay vessel and the stone monument. On both, from the beginning, the relief is normally a small design near the centre of the body on one side, unrelated to the decorative system of the clay vessels. The subjects are those commonly found on other tombstones: the dead alone, or with husband, wife, or friend; the family group; and a warrior's departure. Tombstone reliefs came to show such stone vases, either singly or in groups, themselves adorned with figure-reliefs. The phenomenon is interesting as a last echo of the old struggle between potter and sculptor to dominate the graveyards of Athens.

One must remember that tomb-markers are also religious works. The idea that the dead have become in some sense divine is a very old one in Greece and by no means

forgotten at this time. Heroes were divine beings; though not gods they had their own worship in their own sanctuaries; but they had been mortal men once, not always in the distant past. The Spartan general Brasidas, killed in the defence of Amphipolis against the Athenians in 422 BC, was buried in the market-place and given the honours of a hero. The same thing happened a century later at Syracuse to the Corinthian Timoleon. These were special cases, but every dead man and woman attained a kind of divinity, and the offerings at the graves shown on white *lekythoi*, the *lekythoi* themselves, and the grave-reliefs, are part of a cult in which the dead were not only 'honoured' but also worshipped. Family groups, which show the living united with the dead, echo the votives which show the worshipper and his family in the presence of the gods.

In Asia Minor, from the late archaic period onwards, Greek work and influence became paramount in Lycia, but inscriptions and occasional representations show that the elite preferred memorials more sumptuous than mere *stelae*, including complete funerary shrines or even large built tombs. By the fourth century Greek craftsmen regularly built such structures. The most famous was the tomb of Mausolus of Caria. The 'original' Mausoleum, it fixed the basic form: a high rectangular podium, a colonnade, and a roof all regularly adorned with sculptures. When Mausolus died in 353 BC, his widow Artemisia hired two Greek architects, Satyrus of Paros and Pythius, and at least four of the most celebrated Greek sculptors of the day — Scopas, Bryaxis, Timotheus and Leochares — to create for him a magnificent temple-tomb. Two years later, when she succumbed to her grief, the work was still unfinished, but the artists agreed to complete it, 'for their own glory', according to Pliny. The friezes included heroizing themes like the Amazonomachy, and the monument was crowned with portrait statues of Mausolus and Artemisia in a chariot. It became immensely celebrated, one of the 'Seven Wonders of the World'. The Mausoleum spawned numerous Hellenistic imitations from Syria to Sicily.

The Greek artists active in Lycia found native pupils and imitators who, from the fourth century on, carved in a debased Greek style, often on tombs cut in the native rock. They are of interest primarily for their reproduction of local architectural styles, rather than for the history of Greek art. Exceptions are some with views of cities and siege-scenes related to Greek painting, such as those from the Heroum at Gjölbaschi-Trysa. This recalls the hero-shrine found also in Greece at many periods: a small building in an irregular enclosure surrounded by a wall. Here the decoration is on the circuit wall rather than the building itself (the Greeks did not put reliefs on such walls). The hero-shrines of Theseus and the Dioscuri at Athens were adorned with wall paintings, which were sometimes placed on the interior of circuit walls; the Heroum may imitate this practice.

Four sarcophagi from a royal cemetery at Sidon in Phoenicia are also un-Greek in form, decorated for foreign patrons by Greek artists working in their own style. The largest and finest of these sarcophagi, the 'Alexander Sarcophagus', was probably carved for Abdalonymos, the last king of Sidon, who was indebted to Alexander the Great for his throne (**colour plate 19**). On one long side Greeks battle Persians, while on the other they join in a lion hunt. The heads are all idealized and similar in features, but some have discerned portraits of Alexander, his friend Hephaestion, and other historical figures. Certainly the antagonists are distinguished by details of costume and weaponry, but the composition, generalized and symmetrical, prohibits the identification of specific events.

Following the Athenian ban on sculptured memorials in 317, migrant carvers kept the Attic tradition alive in Macedon, Ionia, and Egypt for a time. The door to innovation, however, was now effectively open. Of the thousands of Hellenistic and Roman gravestones from East Greece, for instance, many name the deceased as hero and carry explicit signs of heroization, of which the most telling is the funerary banquet. Near Eastern in origin, the motif appeared on Greek votives to heroes from *c*500, and sporadically on gravestones from *c*400, but became really popular in the third century. Here as in other classes of *stelae* the deceased is usually larger than his neighbours, and is regularly surrounded by symbols of the earth and of heroes, such as snakes and horses; sacrifices and libations sometimes emphasize the point. The traditional significance of *arete* as a means of securing *kleos* has been replaced with a general appeal for distinction. The urge to heroize the dead, whether prompted specifically by the teaching of new philosophies and mystery religions, or by the general sense of impotence felt by Hellenistic man, swiftly transformed Greek funerary art out of all recognition once the example of Attic restraint was removed. From a vignette of an ideally recollected past, tomb sculpture now became a vehicle for distancing the individual from this world, a locus for symbolism and cult — in short, a votive to the dead.

Bibliography and references

Higham, T.F., and Bowra, C.M. (eds) (1938) *The Oxford Book of Greek Verse in Translation*, Oxford: Clarendon Press.

Hurwit, J.M. (1985) *The Art and Culture of Early Greece, 1100-480 BC*, Ithaca: Cornell University Press.

Kirk, G.S., Raven, J.E., and Schofield, M. (1983) *The Presocratic Philosophers*, 2nd edn, Cambridge: Cambridge University Press.

Richter, G.M.A. (1961) *The Archaic Gravestones of Attica*, London: Phaidon

Vermeule, E. (1979) *Aspects of Death in Early Greek Art and Poetry*, Berkeley: University of California Press.

West, M.L. (1971) *Iambi et Elegi Graeci*, Oxford: Oxford University Press.

12 Roman funerary monuments

Diana E.E. Kleiner

In recent years, there has been a striking confluence of public life, private life, and the afterlife. The personal lives of public individuals have been revealed to a global audience and deceased princesses transformed into divas. The situation was much the same in first- and second-century Rome. In Rome, the private lives of public families were deliberately presented to the populace as a means of influencing public opinion, private residences were places of public business, and dead emperors and empresses were routinely granted divine status. While lacking today's information superhighway, the Romans made up for it by creating one of the most sophisticated communication systems ever invented. While they used bronze coins and marble statuary instead of streaming video and electronic digits, the Romans effectively got their message across. Nowhere is this better demonstrated than in the funerary monuments that were intended to preserve for posterity the personal and professional histories of those who were memorialized there. The making of Roman funerary monuments offers a case study of the impact that social class, ethnicity, gender, and religion had on the form of a work of classical art. Classical making differed greatly from modern making in that the Romans demonstrated a striking disregard for the artist's personal predilections and individual style, preferring to emphasize the collective Roman vision of the world.

The Romans had an active public life, with orators delivering fiery speeches in the Forum, judges deciding contentious cases in the nearby law courts, merchants and customers haggling over prices in the open-air market, and chief priests in temple precincts predicting the future from the entrails of animals. While the major players in such milieus were men, Roman women did appear in public, as they accompanied their husbands to theatrical performances, gladiatorial combats, and religious sacrifices.

Roman private life took place in single or multi-family dwellings in urban settings or in sprawling villas in the lush countryside. Nonetheless, this private life was not a full retreat from the world. The Romans developed a sophisticated pageantry for greeting and entertaining business associates and friends in their residences that approximated official court protocol. The *paterfamilias*, or male head of household, was the moving force behind these domestic customs, but, when he was away at war or on business, his wife stood in for him. The *materfamilias* was responsible for seeing that the household was in working order, that the slaves were performing their duties effectively, and that their children were being properly educated.

While playing out their lives in these public and private spaces, the Romans made plans for life in the hereafter. They favoured mythological stories where the main protagonist ventured into the Underworld and came back again. However, in case that scenario did not come to pass, they planned *memoriae* for themselves and their families that would live

on in their place. These memorials were written documents inscribed on bronze plaques or stone tablets, monumental marble or brick sepulchres, altars, coffins (sarcophagi), tombstones, and urns. Some were decorated with ornamental motifs; others with family portraits, still others with mythological or professional scenes. More important than their size, shape, and decoration were their location and distinctiveness. To be noticed was to be not forgotten.

Roman cemeteries were not situated in remote areas. They were prominently placed along all the major thoroughfares leading out of the city and amidst spectacular villas that fronted those roads. Inscriptions on some Roman tombs beckoned visitors to stop and contemplate the lifetime accomplishments of the deceased; others threatened an eternal curse on any one who defaced a tomb in a way that diminished its effectiveness as a personalized billboard. Literate members of the intelligentsia left detailed written accounts of their accomplishments. Julius Caesar recorded his war in Roman Gaul and Augustus compiled a list of everything he accomplished (*Res Gestae*) that was inscribed on bronze plaques in front of his mausoleum in Rome. Those who could not read or write or wanted to reach a broader audience provided a pictorial account of their lives. Foremost among the surviving remains of such sagas is the narrative of bread-making carefully recorded on the frieze of the Tomb of Marcus Vergileus Eurysaces, a baker in Rome (**103**). The grain is ground, the dough formed into loaves, which are then baked, and the finished product is weighed and made ready for sale.

The line between the living and dead was as blurred as that between public and private space. Residential shrines held wax masks of deceased ancestors that were brought out on the anniversaries of departed relatives and worn in processions by the living relation who most approximated the deceased in appearance. Tombs resembled houses with sloping eaves and 'windows' that contained portraits of entire families, some living and some dead. The commissioning of tombs was a universal experience in ancient Rome. Wealthy emperors built vast sepulchres to house their remains and those of an entire imperial dynasty. Those with meagre financial resources settled for broken amphorae inserted into the earth. The vast underground burial chambers or *columbaria* containing niches with hundreds of memorial urns and portraits served as the last resting place for slaves and freedmen and freedwomen. Their communal memorial was often more of a tribute to the wealth and status of their masters than to their own achievements.

The burial ground or *necropolis* of every Roman city was located outside the city's walls, a separate city of the dead, but one that was proximate, accessible, and highly visible. The privilege of being buried inside the walls was granted only to emperors and other members of the imperial family. The emperors took advantage of their exemption, constructing massive family sepulchres on prime real estate on the banks of the Tiber River.

Rome's first emperor, Augustus, took the lead. Plagued by personal illness that made him obsessive about his own mortality and determined to identify the male heir who would succeed him, Augustus began to plan his tomb immediately after becoming sole ruler of the Roman world (**104**). He drove his architects to design and build it within five years (28-23 BC), readying it for his occupancy nearly four decades before his death. Since Augustus was first in the imperial line, he had the opportunity to decide what kind of a

103 Tomb of M. Vergileus Eurysaces, Rome. Detail of baking frieze. Late first century BC. Photo
D.E.E. Kleiner and F.S. Kleiner

tomb was appropriate for a Roman emperor and his dynasty. The possibilities were endless
and dizzying. Should he be buried like an Egyptian pharaoh, a Hellenistic potentate, or an
Etruscan king? Were such choices too pretentious for a man who was positioning himself
as *primus inter pares* or first among equals? Perhaps something more modest was a better
choice. And did he want to be buried in the same way as other elite Republican men? After
all, he was claiming to be in the process of restoring the values and principles of the
Republic.

The Late Republic had been a period of intense competition. Triumphant Roman
generals, with spectacular military victories under their belts, returned to Rome flush with
booty that could be translated into architecture — architecture that beautified the city but
also spoke to their elevated personal status. Some of these individuals poured their
resources into their tombs, which had the potential to preserve their successes for
posterity. Their decisions about the form of their tombs also had an impact on Augustus.

The Mausoleum of Augustus had a central burial chamber, intended to hold the
cremated remains of Augustus himself, surrounded by a series of concentric concrete
rings that culminated in a white stone outer wall. The inner walls of each of these rings
were pierced with burial chambers for the ash urns of the other members of the imperial
family. Simple inscription plaques naming the imperial residents of the tomb were placed
inside the burial chambers. A sizeable earthen mound surmounted the ringed base. This

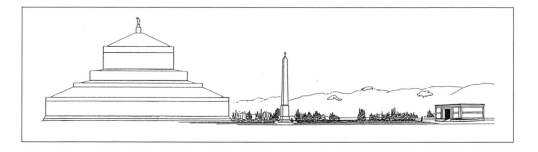

104 *Mausoleum of Augustus: reconstruction of complex with Ara Pacis Augustae (right),*
ustrinum, *and obelisk (centre). 28-23 BC (mausoleum), 28-9 BC (complex). The*
Mausoleum should actually be imagined as standing behind (to the north of) the obelisk; it is
also some 350m distant from the obelisk, whereas the Ara Pacis is only 100m away. Drawing
adapted from G. Buchner, *Die Sonnenuhr des Augustus* (1982), fig 14

tumulus was planted with cypresses or juniper trees and crowned by a gleaming bronze
statue of the emperor.

Vast in size, the Mausoleum of Augustus was situated in the Campus Martius and
looked out over the Tiber, pronouncing the importance of its famous occupants, and soon
serving as one component in an architectural complex. This compound also included an
obelisk from Egypt that signalled Augustus' victory over Mark Antony and Cleopatra at
the Battle of Actium (31 BC) and the emperor's Ara Pacis Augustae, or Altar of Peace (13-
9 BC) (*see* chapter 9), which commemorated a diplomatic truce in Spain and Gaul. The
emperor's dominion over the East and West was thus celebrated in the shadow of his last
resting place, as dramatic a re-enactment as an emperor could have of his lifetime
accomplishments. The scale of Augustus' sepulchre made it visible and its surroundings
made it an attractive draw, offering an adjoining public park with an abundance of trees
and spacious walkways.

The Mausoleum of Augustus was the most consequential tomb built in Roman
antiquity, defining what was appropriate for an emperor's sepulchre and serving until the
fall of Rome and even after as the prototype against which all later tombs were judged.
Whether Augustus' contemporaries and successors followed his lead or departed from it
is the essence of the story of Roman funerary art and architecture.

After its completion, Augustus' tomb became the model for numerous other tombs in
Rome and central Italy. The Tomb of Caecilia Metella was based on Augustus' mausoleum
as was the Tomb of the Plautii near Tivoli. Elite patrons who commissioned tombs for
such sepulchral streets in Pompeii as the Via dei Sepolcri (**105**) and the Via di Nocera
followed suit. Even those lower down on the Roman social pyramid were impressed by
these massive sepulchral structures and looked to them for inspiration but, at the same
time, they rapidly developed their own artistic vision.

Funerary architecture was the most experimental of all branches of Roman
architecture. Freed from any purpose other than to make a receptacle for the body of the
deceased, the patrons and architects of Roman sepulchres were free to allow their

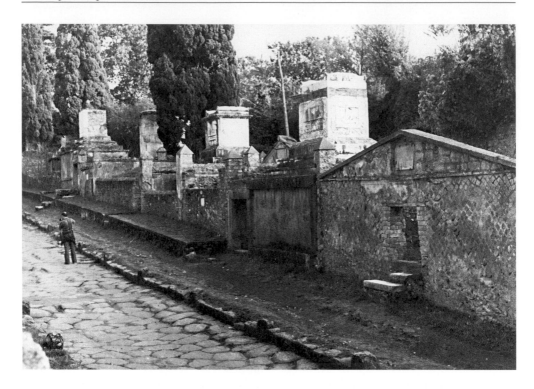

105 Pompeii, Via dei Sepolcri, general view. First century BC-first century AD. Photo Photo
German Archaeological Institute Rome 77.2192

imaginations to soar and to play out their fantasies in architectural form. The tomb of the
baker Eurysaces possessed vertical and horizontal cylinders that are thought to imitate
grain measures and Eurysaces' wife, Atistia, was buried in an urn in the shape of a bread
basket. Several leading magistrates in Pompeii built tombs in the form of benches that
could be used by passers-by to rest and also to think about the achievements of the
deceased. Gaius Cestius decided to provide his family with a tomb in the shape of an
Egyptian pyramid so that they could be buried with comparable grandeur to the pharaohs.
While tombs of elite patrons like Augustus and Cestius included commemorative statues
of deceased family members, non-elite freedmen and slaves favoured portraits in relief
and made them the hallmark of a very distinctive brand of funerary sculpture that appears
to have been confined to them.

These slaves and freedmen were part of the multi-cultural society of imperial Rome.
Its diversity was due to the vast infusion of slaves into Rome following Rome's ambitious
expansion into the Mediterranean, beginning under Augustus and culminating with
Trajan. Many of these slaves came from civilizations much more developed than Rome's
own and were already highly-trained professionals — doctors, lawyers, businessmen,
teachers, architects, and so on. They physically resembled their countrymen, continued to
speak their native language, and practised the religion of their homeland. Nonetheless, in
Rome they made art like Romans, fashioning funerary monuments that may have been

different from those commissioned by Roman aristocrats but so similar to one another within their class as to be essentially indistinguishable. Although there were numerous workshops in Rome producing sepulchral reliefs, urns, and altars for slaves and the newly freed, the artists strove for a communal image, deliberately banishing personal flourishes from their work.

Just as these slaves relinquished the names of their parents and grandparents and took on the new names of their Roman patrons, the art that they commissioned in Rome did not look Greek or Syrian or Gallic or Germanic. It looked Roman. This is fascinating because the artists were themselves slaves or former slaves from the same ethnic backgrounds as their patrons.

While these non-elite patrons had diverse social and ethnic backgrounds and held religious beliefs that diverged from the Roman state religion, once they were settled in Rome they wanted the personal record that they left to posterity to present them as Romans. What made them think this way is interesting to contemplate but it is likely to have been a combination of such factors as accepting the reality of their situation, and respect for and perhaps even fear of their new Roman patrons. Foremost in their minds, however, was the belief that their children's futures were brighter than their own. What made this expectation possible was the upward mobility of Roman society. The Romans encouraged their slaves to earn their freedom by hard work and frugality. That the Roman aristocracy considered only the military, politics, and owning and running an estate appropriate professions for a Roman noble, left slaves with a panoply of opportunities for lucrative employment. They immediately took advantage of it.

Once these slaves secured their own freedom, the future of their children was assured since children of two freed people were considered freeborn. The more assimilated you were and the more Roman you looked the better. These former slaves were proud of their climb out of servitude and optimistic about their children's futures, and they exhibited this pride by displaying their new Roman names prominently on their tombstones and embracing the aristocratic Roman right to portraiture. Roman law allowed only Roman nobles to display ancestral portraits in their homes. These were showcased in special cupboards in the wings of an elite Roman's house. Since this privilege was denied slaves and freedmen in the domestic context, they embraced it with enthusiasm on their tombs. Family portraits of slaves and freedmen were aligned in a row as if they were in a household shrine. An example is the relief of Lucius Septimius and Hirtuleia of 75-50 BC, now in the Museo Nazionale Romano (**106**), where portraits of all three family members are presented in pedimented niches.

Furthermore, the baker Eurysaces is depicted like a Roman magistrate in a *toga* and his wife wears the *palla* and *stola* of a virtuous and respected Roman matron. The baking scenes in the frieze on the baker's tomb are the visual equivalent of Augustus' *Res Gestae*, a list of the patron's proudest accomplishments. Another freedman, probably from Rome's port city of Ostia, also proudly presented his achievements for posterity in a marble relief from a tomb, now in the Vatican Museums (**107**). Dating approximately to AD 130, the relief depicts the deceased, a *dominus factionis* or circus official, presiding over a chariot race in Rome's Circus Maximus. While the lively chariot scene effectively duplicates the exuberant activity of the race and the flavour of Rome's best known Circus,

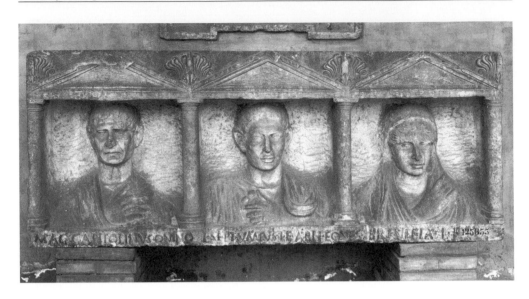

106 Funerary relief of L. Septumius and Hirtuleia. From Rome, Via Praenestina. Ht 63cm.
Rome, Museo Nazionale delle Terme 125655. Photo Gabinetto Fotografico Nazionale
N F11849

it is the portrayal of the *toga*-clad official and his loving wife that sears itself into the
memory of the spectator. The official is represented larger than his wife, identifying him
as the primary honoree. His spouse is not only smaller than he is but so diminutive in
stature that she needs to stand on a pedestal to reach him. That base serves not only to
elevate her but also to identify her as a statue rather than a living woman, signifying that
she predeceased her husband. And yet, even though she died first, the loving pair joins
hands in the Roman *dextrarum iunctio*, the ritual linking of the right hands. This gesture
refers not only to the most important act in the Roman marriage ceremony but also to the
fact that the bonds the pair forged in life were not terminated by death.

Portrait and professional reliefs such as these were inserted into the fabric of Roman
tombs, usually on the façade of the monument. Epitaphs normally accompanied these
pictorial scenes. These inscriptions named the deceased, identified his profession, and
described his familial relationships. Such reliefs embellished the tombs of slaves and
freedmen in the late Republic and continued into the second century. Nonetheless, by the
early second century, these reliefs began to diminish in popularity, overshadowed by the
growing interest in two new kinds of funerary memorials, the altar and the sarcophagus,
which more or less followed one another in a chronological sequence.

The manufacture of Roman altars flourished especially between AD 70 and 140. Like
the reliefs, they appear to have been commissioned solely by slaves and freedmen and
freedwomen. For this reason, they provide valuable evidence about the hopes and dreams
and artistic predilections of this stratum of Roman society. In addition, many altars were
put up in honour of a woman by her family or commissioned by a woman and therefore
provide information about the status and lives of Roman women.

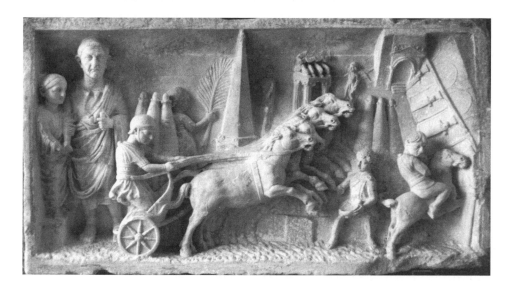

107 Funerary relief of a circus official. Second century AD. Ht 50cm. Vatican Museums, ex
Lateran Museum (9556). Photo R.J. Ling 54/7A

Most of the Roman funerary altars with known provenance were found along the major sepulchral roads of Rome. Many of these were set up in family plots surrounded by funerary gardens with pools and dining areas where repasts on the anniversary of the deceased could be enjoyed.

While some Roman funerary altars were custom-made for patrons who requested personalized mythological or professional scenes, others were prepared in advance in a workshop and completed upon purchase. Examples of custom-made altars include those of Quintus Gavius Musicus in the Vatican Museums and Quintus Sulpicius Maximus in the Palazzo dei Conservatori. Subsidiary scenes on the short sides of the Altar of Musicus (AD 95-110) (**108**), which depict the music teacher with his students and slaves, were clearly personally requested. The altar of the 11-year-old Maximus (AD 94-100) (**109**) is inscribed with a personalized Latin epitaph and includes Greek epigrams and the text of a Greek poem recited by the youth in a musical contest for which he was awarded honourable mention. One of the epigrams mentions that Sulpicius' death had been caused by an illness brought on by overwork. Poignantly, the very achievements celebrated in the boy's funerary memorial also brought Sulpicius Maximus to a premature death.

The production of funerary altars began to wane in the second century with the growing popularity and production of sarcophagi, literally flesh-eaters. The new sarcophagi shared with altars a repertory of sepulchral motifs, professional scenes, and mythological allusions. The change in Roman burial practice from cremation to inhumation, due in large part to the Roman adoption of a widespread eastern custom, led to the commissioning of stone receptacles for the bodies of the dead. The large size of these containers also made them attractive because they could accommodate more ambitious narrative, biographical, and mythological scenes.

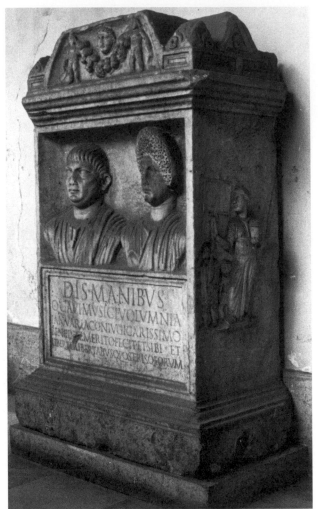

*108 Altar of Q. Gavius Musicus
(AD 95-110). Ht 1.35m.
Rome, Vatican Museums,
Cortile del Belvedere (1038).*
Photo D.E.E. Kleiner and
F.S. Kleiner

These coffins became so popular (about 5000 are preserved today) that a large-scale industry rapidly developed, with Rome, Athens, and Asia Minor the major centres of production. Popular scenes were sketched out on the marble and the coffins were then shipped to other major urban locales. The faces of the main protagonists and the epitaph plaques were left blank, to be filled in locally. While the taste of the day dictated whether the most favoured scenes cast the deceased in the role of a legendary hero, mythological being, Roman general, or businessman, the shop would have offered a variety of options. Wives burying their soldier-husbands, husbands laying virtuous wives to rest, and parents saying goodbye to beloved infants all needed to be accommodated.

Those sarcophagi made in Rome were carved on only three sides because they were placed against the rear walls or in niches inside Roman tombs. These 'western sarcophagi' were rectangular in shape with flat or slightly sloping lids framed by heads or masks. 'Eastern sarcophagi', made in Athens and Asia Minor, had gabled roofs and were carved on all sides so that they could be viewed in the round.

*109 Altar of Q. Sulpicius
 Maximus (AD 94-100)
 Found under Porta Salaria,
 Rome. Ht 1.61m. Rome,
 Palazzo dei Conservatori
 1102.* Photo D.E.E.
 Kleiner and F.S. Kleiner

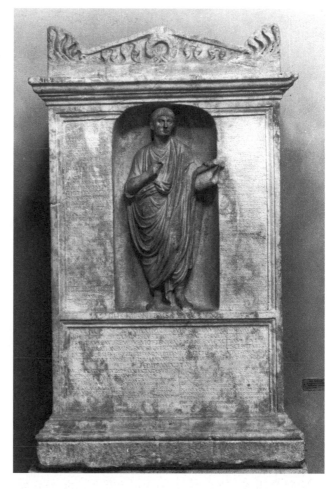

Most of the surviving coffins are decorated with hanging garlands. Large numbers of mythological sarcophagi are also preserved. The latter appear to have been favoured by wealthy patrons who had a penchant for Greek culture and wanted to present themselves as educated and cultivated. While some of the mythological scenes on these sarcophagi seem very appropriate for funerary contexts, the meanings of others are difficult to comprehend today. A sarcophagus from a tomb near the Porta Viminalis (AD 132-134), now in the Vatican Museums, for example, depicts the murder of Clytaemnestra and her lover Aegisthus; and the later Achilles and Penthesilea sarcophagus (second quarter of the third century AD), also in the Vatican Museums, portrays a husband killing his wife. Was the woman buried in the latter really murdered by her husband, an act that was sometimes sanctioned in Roman law? Or is the sarcophagus' message that this woman suffered some other kind of unexpected and tragic death?

While personal histories were intertwined with myth in such coffins, others were more straightforward narrations of personal history. Biographical sarcophagi related the proudest moments of the grandest general and the non-elite cobbler. Generals were usually depicted in the midst of battle. While such battle sarcophagi were at first presented

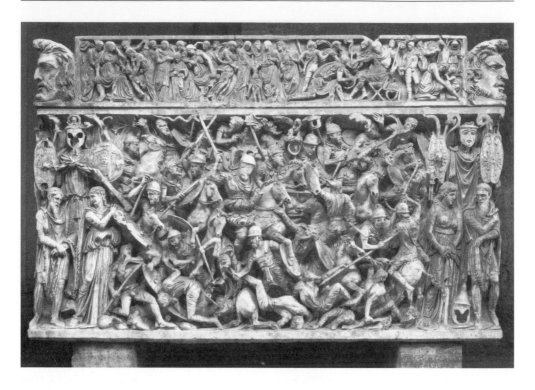

110 Battle sarcophagus from Portonaccio (cAD 180-190). Length 2.39m. Rome, Museo Nazionale delle Terme 112327. Photo German Archaeological Institute Rome 61.1399

as mythological or legendary conflicts, they soon began to reflect contemporary Roman military history. In the mid-second century, Roman generals were laid to rest in coffins with scenes that depicted battles between Greeks and Amazons or Greeks and Gauls. It was not until the late second century, when Rome itself was embroiled in foreign wars, known for their brutality and for the threat that they posed to the well-being of the empire, that contemporary battle scenes, noteworthy for their tumult and gore, began to be represented on Roman sarcophagi. Most of these must have been purchased to house the remains of military commanders or soldiers whose charge it was to pacify the northern provinces.

One of the justifiably best known of these is the sarcophagus from Portonaccio, now in the Museo Nazionale delle Terme in Rome (**110**). The general is depicted in the very centre of the fray, amidst the interwoven bodies and lances of the Romans and their sworn German and Sarmatian enemies. The face of the general is unfinished, either because the sarcophagus was a workshop piece that was never completed or because the burial was so hurried that there was no time to have the face completed by a special portrait artist. The subsidiary scenes on the lid describe the highpoints of the deceased's life and career — the granting of clemency to a barbarian foe, marriage, and the birth of a child. There too the faces of the main protagonists were never carved.

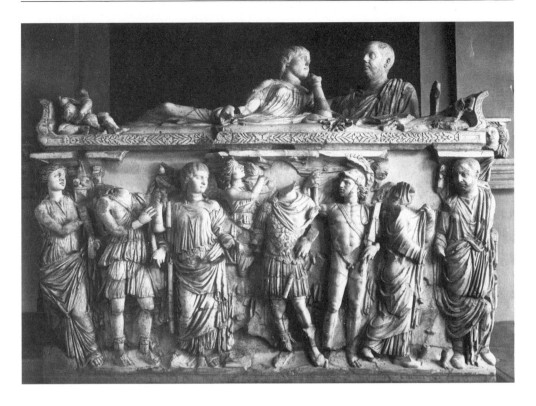

*111 Sarcophagus of the emperor Balbinus (AD 238), from Via Appia. Length 2.32m. Rome,
Catacomb of Praetextatus.* Photo German Archaeological Institute Rome 38.666

While Roman emperors and other members of the imperial family were cremated in
the first and second centuries, the transition to inhumation in the third century elevated
the imperial sarcophagus to the status of a major work of Roman art. The impressive
marble sarcophagus of the emperor Balbinus in the Catacomb of Praetextatus in Rome,
for example, was carved in AD 238 (**111**). Effigies of husband and wife rest on a funerary
bed that serves as the lid of the coffin. The scenes below depict the couple's marriage and
a sacrifice. Additional scenes portray the three Graces and several dancing figures,
appropriate subjects for the empress, whose remains were also apparently intended for this
sarcophagus.

While the Balbinus sarcophagus commemorated Rome's most elite first family in the
third decade of the third century, former slaves were even more motivated to commission
showy funerary memorials. While the elegantly-carved name of Augustus and his
staggering record of accomplishment were enough to preserve his memory forever, the
first-century attorney or second-century innkeeper needed to craft a more explicit
memorial. It is therefore not surprising that, although Augustus' tomb established the
normative sepulchral model and his *Res Gestae* became the ultimate list of attainments,
former slaves were immediately inspired to find a way to make their own unique mark on
posterity. The above-mentioned memorials demonstrate that they did just that.

Bibliography

Altmann, W. (1905) *Die römischen Grabaltäre der Kaiserzeit*, Berlin: Weidmann.

Boschung, D. (1987) *Antike Grabaltäre aus den Nekropolen Roms*, Bern: Stämpfli & Cie.

Ciancio Rossetto, P. (1973) *Il sepolcro del fornaio Marco Virgilio Eurisace a Porta Maggiore*, Rome: Istituto di Studi Romani.

Eisner, M. (1986) *Zur Typologie der Grabbauten im Suburbium Roms*, Mainz: Philipp von Zabern.

Frenz, H.G. (1977) *Untersuchungen zu den frühen römischen Grabreliefs*, dissertation, Frankfurt am Main.

Frenz, H.G. (1985) *Römische Grabreliefs in Mittel- und Süditalien*, Rome: G. Bretschneider.

Kleiner, D.E.E. (1977) *Roman Group Portraiture. The Funerary Reliefs of the Late Republic and Early Empire*, New York and London: Garland Publishing.

Kleiner, D.E.E. (1987) *Roman Imperial Funerary Altars with Portraits*, Rome: G. Bretschneider.

Koch, G. and Sichtermann, H. (1982) *Römische Sarkophage*, Munich: C.H. Beck.

Koch, G. (1988) *Roman Funerary Sculpture. Catalogue of the Collections*, Malibu: J. Paul Getty Museum.

Kockel, V. (1983) *Die Grabbauten vor dem Herculaner Tor in Pompeji*, Mainz: Philipp von Zabern.

McCann, A.M. (1978) *Roman Sarcophagi in the Metropolitan Museum of Art*, New York: Metropolitan Museum of Art.

Morris, I. (1992) *Death-Ritual and Social Structure in Classical Antiquity*, Cambridge: University Press.

Sichtermann, H. (1975) *Griechische Mythen auf römischen Sarkophagen*, Tübingen: Ernst Wasmuth.

Toynbee, J.M.C. (1971) *Death and Burial in the Roman World*, London: Thames and Hudson.

Zimmer, G. (1982) *Römische Berufsdarstellungen*, Berlin: Mann.

13 Macedonian tomb painting

Roger Ling and John Prag

Introduction

Most of the achievements of Greek painting are irrevocably lost to us. We know from literary accounts that many of the pictorial devices that we take for granted — perspective, foreshortening, modelling by light and shade, the naturalistic representation of the human form — were first developed by Greek painters of the fifth and fourth centuries BC. Pliny, Pausanias and other writers tell us about artists such as Polygnotus, Agatharchus, Zeuxis, Parrhasius, Nicias, Apelles and Protogenes who gradually progressed towards a mastery of illusionism. But the great works of these artists — the 'old masters' of the classical world — were mostly executed on wooden panels and have long since been destroyed. At best we can see reflections of their achievements in contemporary vase paintings and, from the end of the fourth century, in mosaic panels set in pavements.

The one medium which gives us a closer idea of the effect of Greek 'old masters' is wall-painting on plaster. Here for the last two or more centuries we have been able to sense something of the achievements of Greek painters from the painted tombs of Etruria and southern Italy and from the houses of the cities buried by the eruption of Mount Vesuvius in AD 79 (chapter 14). However, the tomb-paintings of Etruria are, at best, provincial works of modest pretensions, and the wall-paintings of Pompeii and the other buried cities, whilst they contain pictures derived from Greek archetypes, tell us more about the tastes and aspirations of the Roman householders who commissioned them than about the achievements of the great artists of the fourth and fifth centuries BC.

It is thus that the recent discoveries of wall-paintings in the tombs of Macedonia have transformed our knowledge of classical painting. Though works designed for the dead rather than for the living, and carried out in a different technique from the masterpieces recorded in ancient literature, these paintings are much closer in time and date to those masterpieces than are the wall-paintings of Italy. The earliest examples, dated to *c*350-300 BC, are contemporary with the activity of some of the most illustrious artists — personalities such as Nicias, Pamphilus, Euphranor, Pausias, Apelles and Protogenes. Moreover, they belong to a period when Macedonia, earlier a peripheral kingdom, had become the leading power of the Greek world and had extended that world to embrace the whole of Asia Minor, Egypt and the Near East. Most important of all, they were commissioned for prominent members of the Macedonian nobility and probably, in the case of the tombs at Vergina, for members of the royal family itself. Such paintings, whatever their intrinsic merits, and whoever the artists, are clearly documents of some importance.

Lefkadia

The earliest tomb paintings to be discovered were those of Lefkadia, near Naoussa. Here at least four of the numerous tombs which have been excavated have paintings of interest, but by far the most important is the so-called Great Tomb, excavated by Photios M. Petsas in 1954 (Petsas 1966).

The standard Macedonian tomb is constructed of ashlar masonry and consists of a barrel-vaulted chamber, with or without a shallow anteroom, entered by a single doorway in the façade. The whole is buried within an earthen *tumulus*, but access was obtained, at least while the tomb remained in use, via a passageway or *dromos*. The Great Tomb conforms to this standard type but exceeds the other tombs both in size and in the elaboration of its façade. It is the façade (**112**) that carries the paintings and thus concerns us here. Its articulation is based on the familiar motifs of classical architecture, albeit used in unaccustomed roles and combinations. The walls flanking the doorway are divided by Doric semi-columns into four bays, each of which is decorated with a high screen-wall of ashlar masonry, surmounted by a shallow recess containing a single painted figure. Above this comes a traditional Doric entablature, consisting of a plain architrave surmounted by a red fillet (*taenia*), a frieze of blue triglyphs alternating with metopes painted with duels of centaurs and Lapiths, and a cornice and *sima* picked out with ornament in red and blue. Resting directly on this, and almost as high as the whole Doric entablature, is a continuous frieze of Ionic type showing a battle between Greeks and Amazons (or possibly Persians) in painted stucco relief. Finally there is a small-scale Ionic order of Asiatic type (with dentils in lieu of a frieze) each of whose intercolumniations is occupied by a decorative motif in the form of an imitation door. This upper order was originally surmounted by a triangular pediment.

Of the three surviving sets of figures within the scheme two — the Greeks and Amazons (or Greeks and Persians) of the Ionic frieze, and the centaurs and Lapiths of the Doric metopes — are envisaged as representations of architectural sculptures (**colour plate 20**). In the case of the Ionic frieze they reproduce the physical characteristics of such sculptures, being worked in relief and painted in naturalistic colours against a blue background much like the carved friezes on temples and other monumental buildings. The way in which the battle is spread along the surface of the frieze, with a tendency to a division into duelling figures, in twos or threes, reflects the standard formula of classical battle friezes. Indeed, some of the individual types, such as the rearing horseman, and a pair of figures in which one leans or falls backwards as the other lunges forward, are closely related to comparable types in the Amazon friezes from the temple of Apollo at Bassae (late fifth century BC) and the Mausoleum at Halicarnassus (mid-fourth century BC).

The metopes are more interesting because they reproduce sculptures illusionistically. The pairs of duelling centaurs and Lapiths again conform to standard types such as are found on the south metopes of the Parthenon (chapter 8), but they are here painted on a flat surface with the effect of relief achieved by the use of shading. What is particularly interesting is that the figures are painted in a kind of *grisaille* technique, predominantly in tones of brown and grey, yet with hints of flesh tones in a broader range of yellows and

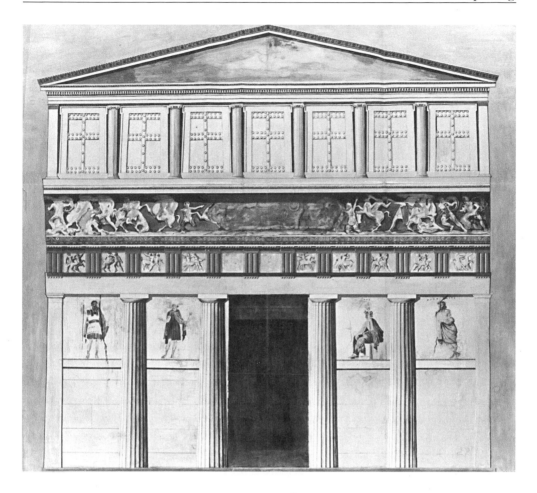

112 Lefkadia, façade of the Great Tomb (late fourth or early third century BC): reconstruction. Ht approx 8.20m. After P.M. Petsas, Ho taphos ton Leukadion (1966), pl. A (painting by Chr. Lephakis)

browns. There seems to have been a deliberate attempt to suggest the effect of carved stone metopes which were once fully painted but whose colours had faded through years of exposure to weathering (Bruno 1981). An unexpected feature is that the background is rendered in a uniform greyish white, implying that the background of the carved metopes which the painter has reproduced was left unpainted rather than, as usually claimed for the metopes of classical temples, coloured red or blue.

The remaining set of figures — the four represented in the intercolumniations of the lower order — lays no claim to being part of the architectural decoration. Each is naturalistically coloured and stands, or sits, in the space above the screen walls that link the columns. Whether they were intended to represent painted statues or real figures installed on the upper surface of the simulated screen wall, or whether they were conceived simply as paintings decorating the rear wall of a shallow recess, is impossible to

determine and of small importance. The four figures are larger than the rest, they are further distinguished by their isolation, and the fact that they do not fulfil an obvious architectural role like those in the frieze and metopes gives them an immediacy which all those other figures lack. The first from the left (**colour plate 21**) is a soldier wearing a military tunic, who stands with his weight supported on his left leg, a spear in his right hand, a shield in his left. Next to him, to the left of the doorway, is Hermes Psychopompus, the conductor of souls, recognizable from his winged hat and the herald's wand in his left hand; he turns his head in three-quarter view towards the soldier and holds out his right arm in a gesture of welcome. On the right of the doorway, identifiable from labels painted above their heads, are two of the judges of the dead who decide the fate of new arrivals in the Underworld. Aeacus is seated in profile to the left, a sceptre in his left hand, while Rhadamanthys (**113**), wrapped only in a cloak, stands more or less frontally leaning on a stick, but again turns to look towards the viewer's left.

113 Lefkadia, figure of Rhadamanthys, judge of the dead: façade of the Great Tomb (late fourth or early third century BC). Ht approx 1.10m. Photo Getty Research Library, Wim Swaan collection, 96.P. 21

The meaning of the figures is clear. The soldier is the dead man, presumably the Macedonian noble who owns the tomb, and Hermes is inviting him to enter the realm of the dead where the two judges are waiting. Though apparently a little hesitant, the dead man shows by the direction of his gaze that he is conscious of where he is about to go; Hermes' gesture and movement establish a link with him and reinforce the idea of the soldier's imminent entrance to the nether realms; and the gaze of the two judges, who seem to look across the doorway towards Hermes and the soldier, shows that they are conscious of his coming. The tomb's doorway, placed between the soldier and his guide on the one hand, and the denizens of Hades on the other, can be seen as a symbolic entrance to the world of the dead, a threshold across which Hermes is about to lead the

tomb's owner. The whole scene and the psychological relationships between the figures are carefully planned and skilfully executed. Detailed examination of the brushwork reveals great fluency in the handling of form and colour. This was the product of artists of no mean ability; for the first time, the finding of the Lefkadia tomb enabled modern viewers to judge at first hand what painters of the last years of the fourth century were capable of doing.

Vergina, the Tomb of Persephone

A further major discovery came in 1977-8 at Vergina, on the southern edge of the Macedonian plain, when excavation of the Great Tumulus by Manolis Andronikos revealed three royal tombs (Andronikos 1977, 1984).

The smallest tomb, in contrast to the standard monumental type, was merely a rectangular cist measuring 3.05m by 2.09m internally and 3m high; there was no entrance, so the bodies were lowered into the tomb before the roofing slabs were put in place. For all its unassuming character, however, this tomb has preserved magnificent frescoes which have completely changed our perception of Greek 'free' painting (Andronikos 1994).

The paintings cover three sides of the tomb. The lowest 1.5m of the wall is coated with dark 'Pompeian' red, above which is a frieze 19-22cm high depicting pairs of griffins facing one another across a flower, all on a blue background.

On the southern wall, the least well-preserved, are three seated female figures. The central and right-hand ones are both older, cloaked women with sorrowful expressions. The figure on the left, the youngest of the three, survives in outline; she sits facing to the right, her left hand raised before her in a gesture of concern, her right resting on the rock beside her; she wears bracelets and a necklace, and a cloak is bunched across her lap. Andronikos rightly compares her detached calmness with the figures on Athenian white grave *lekythoi* of the later fifth century BC and suggests that the three women are the three Fates — an appropriate subject for a tomb.

The short eastern wall (**114**) carries a single figure, a woman swathed in a *himation* (cloak) that envelops her arms and head, seated in an attitude of sorrow on a rock. She gazes sadly across at the rape of Persephone painted on the long north wall: she must be the goddess Demeter, mourning the loss of her daughter. Just as with the Fates, little colour remains, but the sense of depth and of emotion conveyed by the surviving drawing is impressive.

The north wall, measuring 3.5m by 1m, survives best: only a portion in the centre is damaged. It is much the most dramatic, in terms of theme, composition and colour. The focus is on Pluto, god of the Underworld, carrying off Persephone in his chariot. On the left he is preceded by Hermes, while behind the chariot crouches one of Persephone's companions.

Each element of the scene is rendered in vigorous movement. Hermes, his purple cloak billowing behind him, is running to the left, looking back over his shoulder at Pluto's chariot-horses which he leads by the reins. The horses, all white, follow at the gallop, drawing the red chariot, whose four-spoked wheels are skilfully shown in three-

114 Vergina, Tomb of Persephone: figure of seated Demeter above a frieze of griffins. Second half of fourth century BC. Ht of figure approx 65cm. Photo A. Barbet

quarter view. Pluto himself (**colour plate 22**), his lower body swathed in a pale purple cloak that comes up over his shoulder, is springing back into the chariot after seizing his victim; his right hand grips reins and sceptre, his left foot is just leaving the ground. He is bearded, and his wild, unruly brown hair shakes with the violence of his actions. Persephone, firmly held in the god's left arm, twists round towards the spectator in mute appeal as she tries to fling herself, arms extended and hair streaming in the wind, back towards her crouching friend. Her body crosses with that of Pluto in the classic Greek 'conflict' motif, just as her near-nakedness (her purple cloak has fallen away to reveal almost her whole body) is a further symbol of the helplessness of a rape victim. Her companion, crouching on one knee, her yellow and purple clothing in disarray, looks back and up at the chariot wide-eyed and with her right hand raised in horror.

Because the paintings are done in fresco technique it is still possible to see the first sketches made in the wet plaster (which the final version does not always follow), and also the artist's 'second thoughts' as he developed these ideas. Since he was working almost in the dark, with only small oil lamps to give him light, one has to assume that he made some preliminary drawings, but nonetheless it is clear from the confidence of the overall design and the detailed drawing, and from the skilful, restrained use of colour and shading that he was well used to working in the medium. Andronikos and Schefold suggest that this tomb was painted by Nicomachus of Thebes, one of the great painters of the mid-fourth century BC, or at least by his workshop (Andronikos 1984: 91; 1994: 126-30): Nicomachus was renowned for the speed with which he worked (essential in fresco-painting) and for a Rape of Persephone formerly in Rome (Pliny, *NH* 35.108-9).

115 Vergina, façade of the Tomb of Philip. Second half of fourth century BC. Ht approx 6m. Photo M. Andronikos

Vergina, the Tomb of Philip

The second tomb, a little to the north-west of the Tomb of Persephone, was a true Macedonian tomb, with a vaulted burial chamber and a Doric façade. This tomb is of exceptional interest because of the evidence from the skeletal remains and fabulous burial goods that it may have been the burial place of King Philip II, the father of Alexander the Great (Green 1982; Prag, Musgrave and Neave 1984; Prag 1990; Prag and Neave 1997; but for an opposing view see Borza 1990; Palagia 1998).

Here the pictorial interest is on the façade, above the applied Doric order that frames the doorway: a painted frieze depicting a royal hunt in a forest, a theme that derives from the traditions of oriental cultures such as Persia (**115**). Though much detail is lost, the composition is still clear. Like the paintings in the Tomb of Persephone its discovery has shown us a side of Greek painting at which one could only guess before, but this one is conceived in a different mood. At least four different incidents from a hunt are spread across a wooded mountain landscape; the painter delights in linking them through the twisting bodies of both men and animals, often shown in adventurous three-quarter or frontal poses. His muted palette of browns, greys and greens gives an atmosphere of wintry hillside that is in complete contrast with the strong colours of the Rape of Persephone.

116 Vergina, detail of the hunting scenes on the façade of the Tomb of Philip. Second half of fourth century BC. Ht approx 1.20m. Photo A. Barbet

At the left end (**116**) two men hunt deer; one apparently kneels on a stag that has been brought down (the painting is badly damaged here), while the other, mounted on a prancing horse and with his back to the spectator, twists round to despatch it with his spear. In the rocks above them a wounded hind tries to escape. They are separated by a tree from the next pair who are about to finish off a boar beset by four hunting dogs. This incident takes place either in a formal Persian 'game park' or in a sacred grove, for in the background is a tall square pillar surmounted by three aniconic statuettes, while the tree is decorated with ribbons and a plaque.

Further to the right is the main episode: a lion has been brought to bay in front of a clump of trees by two youths, one with a spear and the other wielding an axe; three dogs worry at him as he turns to face a bearded rider who thrusts down at him with a spear. A young man in a purple tunic and with an olive wreath on his head gallops towards them from the left, spear at the ready; he is strategically placed at the centre of the composition, but marked off from the figures on either side by a pair of bare trees. His prominent position and idiosyncratic bulging eyes have led Andronikos to identify him as Alexander the Great, who possibly commissioned the painting, and thus the bearded rider with an equally characteristic profile as Philip II, the presumed occupant of the tomb. The other huntsmen, all beardless, may then be identified as royal 'pages', sons of Macedonian nobles enlisted in the king's service whose duties included accompanying the king in the chase. Similarities with the Alexander mosaic from Pompeii, notably in the pose and features of Alexander himself, and in the placing of a bare tree behind him, have been noticed by several scholars. The painting on which the mosaic was based was probably

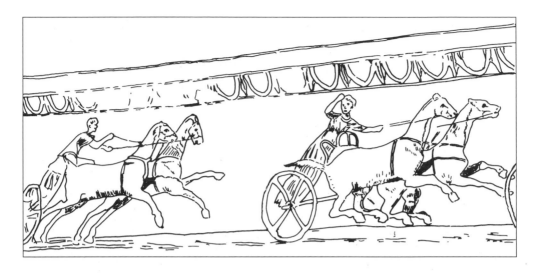

117 *Vergina, the Prince's Tomb, detail of chariot frieze. Second half of fourth century BC. Ht 24cm.* Drawing L.A. Ling, after M. Andronikos, *Vergina. The Royal Tombs and the Ancient City* (1984), fig 168

created around 320 BC, and has been ascribed to Philoxenus of Eretria, a pupil of the Nicomachus to whom the paintings in the Tomb of Persephone are attributed. Schefold and Andronikos argue that the Vergina frieze with its closely related but slightly less adventurous composition may be an earlier work from his hand (Andronikos 1984: 118).

Vergina, the Prince's Tomb

The third tomb was a simpler, conventional, version of the Tomb of Philip. The architectural elements of the exterior were picked out in red, blue and white, and there may have been a frieze painted on a detachable wooden panel above the door. The only surviving paintings are in the main chamber: a frieze of twenty-one racing chariots on a deep blue ground runs round the upper wall (**117**).

Meaning and importance

The subjects of the paintings of the Macedonian tombs seem to have been relatively uncomplicated in their meaning. They refer primarily to the departure of the dead from this life, or to the interests and activities which had occupied the dead during their lifetimes. Where symbolism occurs, it is of a basic and universally accessible kind.

The Great Tomb at Lefkadia is the clearest representation of the passing of the dead man into the next world. He is escorted by Hermes and awaited by the judges who, by implication, will pass a favourable verdict on him and welcome him to the Elysian fields.

Such scenes are reminiscent of paintings on Athenian white-ground *lekythoi*, where Hermes again leads the deceased to the other world (though the frequent presence of Charon, the ferryman of Hades, presents a slightly austerer view of what awaits him there). In a painting on the façade of another tomb at Vergina (one of four in the so-called Bella Tumulus), the dead man is again the focus of interest, but this time he is simply shown being glorified for his lifetime achievements: a female figure perhaps personifying Arete (Virtue) offers him a wreath symbolic of success, while a seated figure with shield and spear, perhaps the war-god Ares, watches. The association of the dead man with divinities (their status indicated by their larger scale) emphasizes the fact of his departure from the mortal world and at the same time raises him to the status of a hero.

The principal business of the owners of these noble tombs was of course warfare. This is clearly stated in the two scenes just described, where the dead man is represented wearing armour and carrying a spear. In another tomb at Lefkadia, the so-called Kinch Tomb (Kinch 1920), a scene painted in the lunette of the burial chamber showed an armed horseman riding down a foe on foot; though the precise interpretation is uncertain, the duel clearly signifies the importance of warfare in the life of the tomb's occupant. Elsewhere the reference is far more explicit. Again at Lefkadia the lunettes of the tomb of Lyson and Callicles (Makaronas and Miller 1974; Miller 1993), the burial place of successive generations of a second-century family, contain representations of Macedonian arms rendered in documentary detail (**118**). There can be no clearer statement of these people's preoccupation with war.

Other interests of the Macedonian nobility were the manly sports of hunting and chariot-racing. The former is represented on the façade of the Tomb of Philip, the latter inside the Prince's Tomb. The chariot-race, a motif used earlier on one of the sculptured friezes of the Mausoleum at Halicarnassus, where other friezes showed the mythical combats of Greeks and Amazons and Lapiths and centaurs, could of course refer to games which took place at the funeral, or even to the most famous of funerary chariot-races, that conducted at the obsequies of Patroclus in the *Iliad*; but, given the general tenor of the other Macedonian tomb-paintings, it is more likely merely to express the dead man's lifetime passion. That this passion was felt by the Macedonians is shown by the importance which Philip II attached to his victory in the Olympic chariot-race of 359 BC.

In addition to sports, a favourite activity would have been the banquet or drinking party (*symposium*). The façade of a recently excavated tomb at Agios Athanasios, on the outskirts of Thessaloniki, carries a finely painted frieze depicting horsemen and foot-soldiers converging on a group of garlanded drinkers reclining on couches (Tsimbidou-Avloniti 1994: 235, pls 9-10). Here again there could be a reference to a funerary event (a banquet at the tomb), but it is equally possible that the scene commemorates moments from the dead man's life.

Symbolic representations, as stated, were of a basic kind. Pluto's abduction of Persephone, the principal subject of the Tomb of Persephone, was a favourite motif of Hellenistic funerary art, found also in painted tombs in the Crimea (Tinkoff-Utechin 1979); it remained popular in the funerary art of Roman times, especially in the eastern Mediterranean. It has been suggested, albeit on flimsy grounds, that Pluto and Persephone were also depicted on the façade of the so-called Palmette Tomb at Lefkadia (late third or

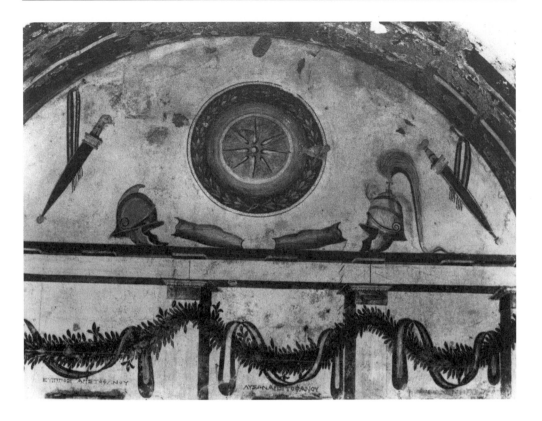

118 Lefkadia, Tomb of Lyson and Callicles: lunette containing Macedonian arms. Diam approx 3m. Photo S. Miller

early second century). The allegorical value of such representations is obvious. The seizure of Persephone signified death, but death in more hopeful terms. Persephone's mother Demeter tracked her down and negotiated a deal whereby her daughter was granted a six-month lease of life each year. The surviving relatives of the dead in the Macedonian tombs could have taken some comfort from this myth which presented death in a less unremitting form.

To return, finally, to the importance of the Macedonian tomb-paintings. Before the discovery of the Great Tomb at Lefkadia and, more especially, of the Royal Tumulus at Vergina, we had very little concept of the achievements of Greek painters beyond the hyperbolic descriptions of ancient writers. The figured frescoes of these tombs have for the first time shown the facility with which such painters could use quick brush-strokes to suggest texture, movement and modelling. They have also shown the range of colours which they used — predominantly warm tones such as purples, pinks, reds, yellows and browns rather than the colder blues and greens (thus confirming Cicero's and Pliny's reports of a restricted palette being employed by some of the most famous painters of the fifth and fourth centuries). In the hunting frieze of the Tomb of Philip we have a work which clearly rendered space and naturalistic detail with consummate skill. In this frieze

we see the same daring foreshortening of horses that is reflected in the Alexander Mosaic. More important, it shows an importance given to the role of landscape that we would never have anticipated from the evidence of vase-paintings and mosaics. The scale of the figures is reduced in relation to the trees and the rocks to the point that the setting becomes integral to the action — something which had previously been known from paintings in one or two Etruscan tombs but which had never been attested in mainstream Greek art. The bold use of foreshortening, moreover, activates the background by suggesting that the horsemen are moving in and out of the trees. Theories that landscape played only a minor part in painting before the late Hellenistic period have had to be radically revised. The paintings of the Macedonian tombs have let an important chink of light into what was a very dark area in our understanding of Greek art.

Bibliography and references

Andronikos, M. (1977) 'Vergina. The royal graves in the Great Tumulus', *Athens Annals of Archaeology* 10: 1-72.

Andronikos, M. (1984) *Vergina. The Royal Tombs and the Ancient City*, Athens, Ekdotike Athenon.

Andronikos, M. (1994) *Vergina* II. *The 'Tomb of Persephone'* (Bibliotheke tes en Athenais Archaiologikes Hetaireias 142), Athens.

Borza, E.N. (1990) *In the Shadow of Olympus. The Emergence of Macedon* (Princeton, University Press): 256-66.

Bruno, V.J. (1981) 'The painted metopes at Lefkadia and the problem of color in Doric sculptured metopes', *American Journal of Archaeology* 85: 3-11.

Green, P. (1982) 'The Royal Tombs of Vergina: a historical analysis', in W.L. Adams and E.N. Borza (eds), *Philip II, Alexander the Great and the Macedonian Heritage* (Washington, University Press of America): 129-51.

Kinch, K.F. (1920) 'Le tombeau de Niausta. Tombeau macédonien', *D. Kgl. Danske Vidensk. Selsk. Skrifter* 7th ser. *Historisk og Filosofisk Afd.* 4.3: 283-8.

Makaronas, C.I., and Miller, S.G. (1974) 'The Tomb of Lyson and Kallikles: a painted Hellenistic tomb', *Archaeology* 27: 248-59.

Miller, S.G. (1993) *The Tomb of Lyson and Kallikles: a Painted Macedonian Tomb*, Mainz, Philipp von Zabern.

Miller, S.G. (1999), 'Macedonian painting: discovery and research', in *Alexander the Great from Macedonia to the Oikoumene, Veria 27-31/5/1998* (Veria): 75-88.

Palagia, O. (1998) 'Alexander the Great as lion hunter. The fresco of Vergina Tomb II and the marble frieze of Messene in the Louvre', *Minerva* 9.4: 25-8.

Petsas, P. M. (1966) *Ho taphos ton Leukadion* (Bibliotheke tes en Athenais Archaiologikes Hetaireias 57), Athens: Archaiologike Hetaireia.

Prag, A.J.N.W. (1990) 'Reconstructing King Philip II: the "nice" version', *American Journal of Archaeology* 94: 237-47.

Prag, A.J.N.W., Musgrave, J.H., and Neave, R.A.H. (1984) 'The skull from Tomb II at Vergina: King Philip II of Macedon', *Journal of Hellenic Studies* 104: 60-78.

Prag, A.J.N.W., and Neave, R.A.H. (1997) *Making Faces using Forensic and Archaeological Evidence*, London, British Museum Press.

Tinkoff-Utechin, T.A.S. (1979) 'Ancient painting from south Russia: the rape of Persephone at Kerch', *Bulletin of the Institute of Classical Studies* 26: 13-26.

Tsimbidou-Avloniti, M. (1994) 'Ag. Athanasios 1994. To chroniko mias apokalupses', *To Archaiologiko Ergo ste Makedonia kai Thrake* 8: 231-40.

Vokotopoulou, I. (1990) *I Ioi taphikoi tymvoi tes Aineias* (Demosieumata tou Archaiologikou Deltiou 41), Athens: Tameio Archaiologikou Poron kai Apallotrioseon.

14 Pompeian painting

Roger Ling

Introduction

Pompeian painting has assumed an importance out of proportion to its true merit because of the accident of its survival. Buried by the eruption of Mount Vesuvius in AD 79, the city of Pompeii was preserved in a kind of time-capsule. As a result, its wall-paintings, together with those of the other towns destroyed in the same eruption (notably Herculaneum and Stabiae), have come down to us in a miraculously complete condition. They are our principal source of information on the painting of the ancient world.

In Greek times the most prestigious paintings, the 'old masters' of the ancient world, were executed on wooden panels (*see* chapters 3 and 13). These works, which were portable and could thus change hands, came to acquire commercial value and formed the basis of a flourishing art market. All now lost, they are known only from the accounts of writers such as Pliny the Elder (AD 23-79). In Roman times there is evidence that, while panel-pictures continued to be prized, the major effort of contemporary painters was devoted to wall-decorations. Pliny, writing shortly before his death (*NH* 35.118), specifically deplores the switch in fashion from painting panels to painting walls. Some of the surviving remains of wall-paintings, especially from the imperial palaces in Rome, are of the highest quality and testify to the attention lavished on this kind of decoration.

The paintings of Pompeii come mainly from the private houses of a medium-sized market town 200km south of Rome. They are thus intrinsically not works of the first rank. Their importance lies in two factors. On the one hand, through their general quality and their imitation of famous prototypes, they give us a glimpse, if only an indirect one, of the standards that must have been achieved by the great painters of the time. On the other, they reflect the tastes and aspirations of ordinary people in a period of crucial importance to the history of the western world.

The four Pompeian styles

The history of Pompeian painting can be traced back to the second century BC. Its formal evolution is today conventionally divided into four successive manners or 'styles'. Although both the validity and the chronological basis of the sequence have frequently been questioned, this classification finds support, at least as far as the first three styles are concerned, in Vitruvius' account of Roman wall-painting down to his time (the 20s BC): he clearly characterizes each phase and signposts the transitions (Vitruvius 7.5.1-3).

Further chronological reference points are offered by parallel decorations in dated buildings in the capital, such as the House of Augustus on the Palatine or Nero's palace (the Golden House) on the Esquiline.

The first Pompeian style was a variant of a form of decoration developed in the Greek world during the fourth and third centuries BC. Rather than simply painting on a flat surface, it consisted of plasterwork raised in relief to produce the effect of monumental ashlar masonry, or perhaps of marble wall-veneer such as Vitruvius (2.8.10) describes in the palace of King Mausolus (died 353 BC) at Halicarnassus (modern Bodrum, Turkey). The blocks were painted in bright colours and often variegated to suggest the veins of marble or alabaster. Good examples are preserved in aristocratic mansions such as the so-called Houses of Sallust (**colour plate 23**) and of the Faun.

In the second style, which came into fashion during the first decades of the first century BC, a true architectural illusion was achieved by pictorial means upon flat plaster (**colour plate 24**). The coloured blockwork of the first style was retained, but the impression of relief was supplied by painted shadows and highlights. In the foreground there were screens of columns standing on a projecting podium and supporting an entablature. The *trompe l'oeil* effects, exploiting a combination of shading and perspective, became increasingly elaborate, with three or more planes of architecture and exotic motifs such as broken pediments, arches carried by columns, and jutting entablatures; and the upper part of the wall was opened to reveal a colonnaded courtyard, sometimes with a rotunda in the middle. Such luxurious schemes, in which columns were frequently rendered in coloured stone with gilded and jewel-encrusted enrichments, were designed to evoke the imagined splendour of Hellenistic palaces and may reflect the delusions of grandeur enjoyed by the Roman elite. There may also have been some influence from painted scenery used in the theatre. Theatrical masks were often hung or otherwise disposed within the architectural framework, and Vitruvius (7.5.2) tells us that paintings 'in open spaces such as *exedrae*' reproduced 'stage-fronts in the tragic, comic, or satyric manner'. Examples of such theatrical allusions appear in a villa at Boscoreale, just north of Pompeii, and in a grand villa at Oplontis to the west.

In the last years of the second style, the architectural elements became less solid and the element of fantasy more prominent. Columns sprouted vegetal forms or were replaced by candelabra; pediments gave way to winged heads; half-plant and half-animal forms (the first 'grotesques') or figures seated on plants now populated the wall. Most important was the introduction of a framed picture in the central position. Initially taller than it was wide, this was set within a columnar pavilion which emphasized its importance; it showed mythological or other scenes set within buildings or a natural landscape, and in many cases reflected compositions derived from famous panel paintings of Greek times.

The third style, which superseded the second during the last two decades of the first century BC, emphasized the central picture still further by reducing the architectural elements to bean-pole columns and delicate bands of polychrome ornament within broad expanses of flat colour (**119**). The favoured colours were not only red, long favoured in the second style, but also black, light blue, and eventually green. Overall the illusionistic piercing of the wall was replaced by a respect for the surface, now solid and impenetrable;

119 *Third-style wall-decoration from a villa at Boscotrecase, north of Pompeii. North wall of the 'red room'. Naples, Archaeological Museum 147501. Ht 3.30m. End of first century BC.* Photo German Archaeological Institute Rome 59.1972

even the mythological and landscape paintings which dominated the schemes had a non-spatial quality, with figures ranged parallel to the surface plane, their forms delineated in clear, hard colours without highlights, and the background reduced to a more or less neutral foil.

The fourth style, which emerged around the middle of the first century AD, swung the pendulum back towards architectural illusionism, but instead of the solid, believable structures of the second style painters retained the spindly proportions and fantasy forms of the third, now rendered in warm golden colours and stacked up in breathtaking visions of infinite space and recession. Central pictures continued to be a feature, though the panels were generally reduced in size, acquired a square format, and tended to appear as if hung upon great coloured tapestries (for which yellow and red were now the preferred colours) rather than framed by pavilions. A favourite scheme offered a rhythmic alternation of these picture-bearing 'tapestries' and visual openings containing perspectival

120 *Fourth-style decoration in the House of Pinarius Cerialis, Pompeii (III.4.4). Orestes and Pylades among the Taurians. Between AD 62 and 79.* Photo Alinari 43179

architecture upon a white ground. Alternatively the entire wall was opened up to create a framework of architecture in which groups of figures played out scenes from well-known myths, like actors in some kind of baroque stage-set (**120**).

The fourth style was still in full swing at the time of the destruction of Pompeii. The subsequent history of decorative schemes in Roman wall painting has to be traced from scattered material at Rome and elsewhere, and does not concern us here (the paintings of the synagogue at Dura-Europus, examined in chapter 15, are a case apart from the main development). Suffice it to say that, with the end of the fourth style in the last years of the first century AD, the most innovative period of Roman painting came to an end. Thereafter painters tended to go back to formulae explored in earlier phases, often putting them together in less clear and coherent ways.

Figure paintings

What is chiefly remarkable about Pompeii is the ubiquity of its wall-paintings. Apart from kitchens, latrines, store-rooms and the like, more or less every room had some form of painted *décor*. Even kitchens often contained murals depicting images of the household

gods. Given that the paintings were executed on the spot by skilled craftsmen, this represents an enormous investment of time and resources. In no other society known to us has so much effort been bestowed on the embellishment of ordinary living spaces.

The elaboration of the paintings naturally varied. The sequence of four styles described above, with schemes based on architectural frameworks, relates to the better-quality decorations. Even within these there was a hierarchy. Polychrome decorations with mythological picture-panels were at the top of the scale, appearing in the more luxurious houses, or in the more important rooms of second-rank houses. Below them came a range of possibilities: polychrome schemes with landscape panels or still lifes, white-ground schemes with landscapes or still lifes, white-ground schemes with isolated birds or animals, and so on. At the bottom, hardly classifiable within the four-style system, were white walls with simple ornaments and fields outlined by coloured borders. These variations hint at the existence of a sliding scale of prices based on the degree of expertise and the cost of the materials needed for each décor. Simple decorations were normally relegated to subsidiary rooms; only in very modest dwellings whose owners could afford no more did they acquire a higher status.

In chronological terms there seems to have been an increasing 'democratization' of wall-paintings. There is some evidence that, in the period of the second style, the social diffusion of the expensive decorations was more restricted: they were exclusive to the grand houses and villas of a wealthy few. But by the time of the fourth style a process of imitation and emulation had led to the widespread use of polychrome schemes and even of mythological pictures. This spread of luxury down the social scale inevitably brought in its train a decline in standards. While more affluent patrons such as the freedman brothers Vettii could afford extraordinarily rich and delicate paintings in a large proportion of the rooms of their house, many lesser fry were content with crude and hasty work. The desirability of pretentious wall-paintings had created a demand which in turn engendered a kind of mass production available even to comparatively modest householders.

It is naturally the elaborate decorations that, from the artistic viewpoint, are of greatest interest. Especially interesting are the figure-subjects which began to appear in the time of the second style. At first these figures played an integral part in the painted architecture: they were shown standing in doorways or arranged along a shallow podium in front of the fictive veneer. Most famous is the pageant of figures which gives its name to the Villa of the Mysteries, just outside Pompeii; here 28 figures, two-thirds life-size, act out a continuous series of scenes from Bacchic myth and ritual against a backdrop of brilliant red slabs (**colour plate 25**). Similar paintings occur in another villa at Boscoreale, a short distance to the north of Pompeii; here, rather than a continuous series, the figures are individuals and pairs set in the spaces between monumental columns. The subject-matter is thought to embody Hellenistic political symbolism and may well have been inspired by a well-known cycle commissioned by one of the monarchs of Macedonia or Egypt. Whether such figures were conceived as living and breathing, or as works of art (statues or paintings) displayed within the architectural setting, it is impossible to know. Other figure-paintings of the time were certainly intended to be interpreted as pictures: they take the form of panels resting on a cornice or continuous friezes in the upper part of the architecture. The subjects include the Trojan battles which are named by Vitruvius (along

with the 'wanderings of Odysseus in landscape settings', examples of which are found in a contemporary house in Rome) as favourites of the late second style.

These forms of figure-painting eventually lost ground to the central pictures which came to dominate the wall from the end of the second style onwards. Some of the first examples may have involved the notion of a window opening to a world beyond the wall, but this rapidly gave way to the idea of a framed panel exhibited in a pavilion. These pictures were clearly the showpieces of Pompeian painting, by means of which householders gave their rooms an appearance of being picture-galleries hung with well-known masterpieces.

The most desirable pictures were mythological. Scenes such as Narcissus admiring his reflection in the pool, Perseus rescuing Andromeda from the sea-monster (**121**), the love-affair of Mars and Venus, Bacchus' discovery of Ariadne on the island of Naxos, the punishment of Dirce, the judgement of Paris, the death of Actaeon — these are the themes which appear time and again. Almost all are Greek in origin and reflect the overwhelming popularity of the Greek myths in Latin poetry, notably that of Ovid. Hardly any subjects derive from Roman legend: one painting depicting the origins of Rome, another representing the wounding of Aeneas described in Virgil's *Aeneid*, a couple of representations of Dido abandoned, and that is just about all.

Much effort has been bestowed on the task of identifying lost Greek masterpieces copied or reflected by these Pompeian pictures. It is clear that the iconography of particular subjects conforms to certain basic stereotypes and that these go back to famous originals. A scene in which Agamemnon hides his face in his cloak rather than witness the sacrifice of his daughter Iphigenia recalls Pliny's description of a painting by Timanthes, active in the early fourth century BC. Two closely related pictures showing respectively Io guarded by Argos and Andromeda rescued by Perseus (**121**) have been connected with paintings of Io and Andromeda juxtaposed in Pliny's list of the works of the Athenian master Nicias; their style conforms with what we know of the pictorial art in the mid-fourth century BC, to which Nicias belonged, and they amply confirm Pliny's statement (NH 35.131) that Nicias 'took great care to make figures stand out from the panels'.

But, whatever their origins, Pompeian versions of 'old masters' seem rarely to have been faithful replicas. Where two or more versions of the same original occur, there are regularly variations in the treatment. Gestures and postures are subtly changed, figures are differently positioned in relation to one another, extra figures are added, some figure-types are even appropriated for different personalities. Above all, the colour-schemes and backgrounds are constantly altered. A particularly common device, associated mainly with the third style, was to reduce the figures in scale and distribute them within vast landscapes of trees, rocks and water; sometimes in such cases successive episodes of a myth were incorporated in the same panel, with protagonists appearing more than once, so that the viewer could read them as a narrative.

Such variations imply that these paintings were reproductions of 'old masters' in only the loosest sense. A stock of compositional types which may go back to famous originals certainly existed, and it may have been transmitted via pattern-books which contained annotated sketches; but the Pompeian painters clearly operated with freedom, now relying on imperfect memory, now deliberately ringing the changes. What is interesting to

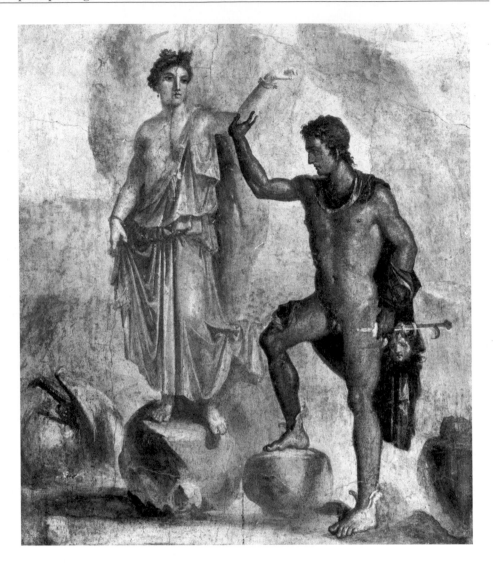

121 Perseus liberating Andromeda. Picture (after Nicias) from the House of the Dioscuri, Pompeii (VI.9.6). Third quarter of first century AD. Ht 1.22m. Naples, Archaeological Museum 8998. Photo Anderson 23464

consider is why changes were allowable. Here we can give no firm answers, but an important factor was the architectural and decorative context: pictures were enlarged or diminished according to the scale of a room, while the numbers of figures, the nature of the background setting, and the choice of colours were adapted to harmonize different pictures with one another. Chronological factors were also important: taste changed from period to period. The pictures of the third style, besides favouring landscape settings, tended to include supernumerary figures; those of the fourth style reduced scenes to their bare essentials and played down the importance of the backdrop.

An issue which has been much discussed in recent years is why particular subjects were combined. Each room contained two or three, sometimes four, dominant pictures; and it has been argued, most notably by the Swiss scholar Karl Schefold, that they were selected, along with much of the subsidiary ornament, to embody coherent moral or religious programmes. Thus some decorations represent 'hymns' to the deities of love and fertility, Venus and Bacchus; others contrast the punishment of a sinner with the achievements of a god-favoured hero. But, if such programmes had been widely current, one would expect to find more uniformity in the combinations that occurred. Of the hundreds of decorative schemes known at Pompeii and Herculaneum, hardly any repeat the same combinations of subjects. Statistically, therefore, the evidence points to a more complex set of criteria for choices. Some patrons may, certainly, have sought to combine subjects in meaningful programmes of a moral or religious nature (as the figure frieze in the Villa of the Mysteries had done in the period of the second style). Others chose subjects that were clearly linked, but at a superficial level: three episodes from the sack of Troy, for instance, or three scenes relating to the legends of Crete (Theseus' killing of the Minotaur, his subsequent desertion of Ariadne, and the flight of Daedalus from Crete to Sicily). Most choices, however, seem to have been random compilations. A patron may have picked scenes which reminded him of certain favourite stories or passages from literature, scenes which evoked the romance of the past or the mystery of the East, or simply those subjects that were available in the decorators' pattern-books.

Other paintings

To concentrate on the figure-scenes does scant justice to Pompeian painting. Some of the more attractive components within the schemes are predominantly non-figural. Such, for example, are the inanimate objects, birds and animals which first appear as isolated motifs distributed in the painted architecture of the second style, but which later tend to be grouped in still-life assemblages within panels. Among them are virtuoso representations of glass bowls containing fruit (**122**) that call to mind Pliny's hyperbolic stories about Greek paintings of grapes, horses and the like which could be mistaken for the real thing. Equally attractive are the landscape paintings that emerged as a separate genre in the late second style. They include evocative pictures of Arcadian landscapes with rustic shrines and shepherds tending their flocks, and scenes of contemporary seaside villas with odd people strolling about or fishing (**123**). In the latest examples these are rendered with quick brush-strokes and strong contrasts of light and dark colours remarkably prescient of nineteenth-century Impressionism. Such landscapes, along with paintings of lions, bears, leopards and other beasts in the wild, were often enlarged, especially in the final years of the city, to fill whole walls. Used in gardens, they gave the householder the sense of being transported to worlds of bucolic idyll and luxury, or to the wild game parks of Hellenistic kings. Another theme was the painted orchard. Chosen particularly for enclosed rooms, this transformed the walls into a magic forest laden with the fruit and flowers of different seasons and inhabited by birds of various species. At a more down-to-earth level there were what can be termed 'genre' paintings: actors performing scenes from well-known

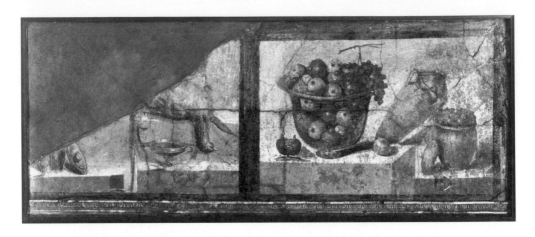

*122 Still life paintings showing (a) metal vessels and dead game, (b) bowls of fruit and a wine-jar,
from the Property of Julia Felix, Pompeii (II.4.3). Third quarter of first century AD. Ht
74cm. Naples, Archaeological Museum 8611.* Photo Archaeological Superintendency
Naples A 13509

stage-plays, pictures from daily life, couples indulging in sexual acts in more or less
improbable poses. And halfway between myth and reality came the subtle parodies of
human activity in which Cupids acted out the parts of people engaged in crafts, trades,
sports and festivities.

More characteristic still is the subsidiary ornament which provided the counterpoint
to the principal themes. The richness and variety of the motifs — vegetal, animal, or
inanimate — which make up the borders and fill the minor fields and intervals within the
designs are so great as to defy description. Particularly fine are the borders of the third
style, with their miniaturist lyres, vases, cornucopiae, birds, animals, palmettes and volutes
rendered in greens, golds, blues and purples (**colour plate 26**). These gave way in the
fourth style to single-coloured stencil-like borders with repetitive patterns, generally
yellow on a red ground, or white on yellow. Most influential for the future, however, were
the half-plant and half-animal forms which made a first appearance in the late second style
(to Vitruvius' disgust) and became a standard feature of the fourth. Typical are birds or
griffins with their tails or hindquarters dissolved into volutes, facing each other across a
wine-bowl. First rediscovered at the end of the fifteenth century in the buried ruins, or
grottoes, of Nero's Golden House, these inspired the 'grotesques' of the Renaissance.

The influence of Pompeian painting

The first excavations at Pompeii and the other buried cities, carried out under the auspices
of the Bourbon kings of Naples during the eighteenth century, created a sensation among
European antiquaries and connoisseurs. Publicized first by the letters of Winckelmann
and by the volumes of engravings sponsored by the Bourbons, the paintings came to

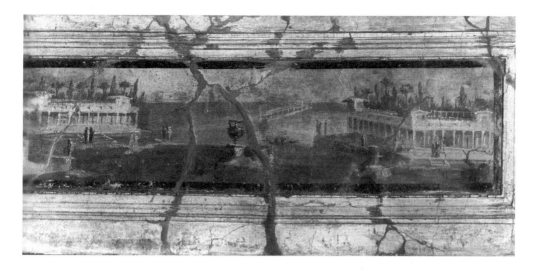

123 Landscape with seaside or lakeside villas, from the House of the Cithara Player, Pompeii (I.4.5). Ht of frieze 26cm. Third quarter of first century AD. Naples, Archaeological Museum 9496 (right half). Photo German Archaeological Institute Rome 60.472

exercise great influence on the decorative arts. Individual paintings, such as the Cupid seller from Stabiae, were reproduced in various media, while interior decorations in the Pompeian manner graced the mansions of potentates such as Napoleon's brother Jérôme, who had a Pompeian house constructed in Paris, and Ludwig I of Bavaria, who built a replica of the House of the Dioscuri at Aschaffenburg near Frankfurt. Even in the present day there are reproductions of Pompeian paintings, such as those in a house in Sydney, Australia, where the owner commissioned copies from the Villa of the Mysteries and the House of the Vettii.

General public interest has been increased by a series of recent exhibitions on Pompeii in which wall-paintings have played a major part: *Pompeii, Life and Death in the Cities of Vesuvius* at Essen in 1973, *Pompeii AD 79* in London in 1976, *Rediscovering Pompeii* in New York in 1990, and *Living under Vesuvius* at Ferrara in 1996. People have flocked to these exhibitions and have never ceased to be amazed by the sheer abundance and richness of the decorations with which Pompeian householders surrounded themselves. In the meantime new discoveries continue to emerge, both within the city and in the surrounding area. The House of the Wedding of Alexander, one of a number of finely decorated houses spilling over the city's western walls, has yielded garden paintings which rival the famous ones from the villa of the empress Livia at Primaporta, just north of Rome. A dining room in the so-called House of the Chaste Lovers contains three new pictures of banquets, each taking place at a different season of the year (**colour plate 27**). Pompeian painting still has many surprises to reveal, and it will continue to be a source of fascination for generations to come.

Bibliography

General
Cerulli Irelli, G., Aoyagi, M., De Caro, S., and Pappalardo, U. (1990) *Pompejanische Malerei*, Stuttgart and Zürich: Belser.

Pompei: pitture e mosaici I-IX (1989-99), Rome: Istituto della Enciclopedia Italiana.

The four styles
Beyen, H.G. (1938 and 1960) *Die pompejanische Wanddekoration vom zweiten bis zum vierten Stil* I and II.1, The Hague: M. Mijhoff.

Barbet, A. (1985) *La peinture murale romaine: les styles décoratifs pompéiens*, Paris: Picard.

Laidlaw, A. (1985) *The First Style at Pompeii: Painting and Architecture*, Rome: G. Bretschneider.

Bastet, F.L., and De Vos, M. (1979) *Proposta per una classificazione del terzo stile pompeiano*, The Hague: Staatsgeverij.

Ehrhardt, W. (1987) *Stilgeschichtliche Untersuchungen an römischen Wandmalereien von der späten Republik bis zur Zeit Neros*, Mainz: Von Zabern.

Tybout, R. (1989) *Aedificiorum figurae. Untersuchungen zu den Architekturdarstellungen des frühen zweiten Stils*, Amsterdam: J.C. Gieben.

Iconography and meaning
Schefold, K. (1952) *Pompejanische Malerei. Sinn und Ideengeschichte*, Basel: Schwabe. Translated into French (1972) as *La peinture pompéienne. Essai sur l'évolution de sa signification* (Collection Latomus 106), Brussels: Latomus.

Schefold, K. (1962) *Vergessenes Pompeji*, Bern and Munich: Francke.

Fröhlich, T. (1991) *Lararien- und Fassadenbilder in den Vesuvstädten* (*Mitteilungen des Deutschen Archäologischen Instituts, Römische Abteilung*, Ergänzungsheft 32), Mainz: Von Zabern.

15 The wall-paintings of Dura-Europus

Priscilla Henderson

Introduction

From time to time, in the history of art and archaeology, chance events lead to the preservation and subsequent recovery of a monument, the significance of which challenges prevailing ideas and modes of thought. Such was the case with the wall-paintings of Dura-Europus. Buried as a result of one war and discovered some 1700 years later during the course of another, the extensive cycles of paintings called for a complete re-evaluation of many accepted views of ancient history, art and religion.

In April 1920 a detachment of British soldiers was deployed against Bedouin tribesmen in the Syrian desert, north-west of Baghdad. While digging defences within the ruins of an ancient fortress they uncovered a section of wall painted with human figures. A brief assessment of the site was carried out by Professor James Henry Breasted, Director of the Oriental Institute of the University of Chicago, who happened to be in Baghdad at the time. The complete excavation of the city took a number of years. The early work was carried out by Franz Cumont in 1922 and 1923 under the aegis of the French Académie des Inscriptions et Belles Lettres. Following this, a series of 10 campaigns, beginning in 1928 and carried out jointly by the French and Yale University, succeeded in clearing and surveying the site.

The excavations yielded documents on parchment and papyrus, textiles, leather, wooden artefacts and sculptures. Numbers of wall-paintings were found in houses, baths and temples, and in the baptistery of a Christian house-church. All were painted between the second half of the first century AD and the mid-third century; all were significant and exciting. But the discovery during the fifth season of a Jewish synagogue, dated to AD 245 and decorated from floor to ceiling with an elaborate series of figure paintings, was startling. No parallels were known.

Such a monumental cycle in a synagogue appeared directly to contravene the second commandment regarding representation of the human form. It demanded a re-evaluation of 'normative rabbinic Judaism' and its supposed adherence to rigid iconoclasm. It also raised questions as to patronage. The isolated location of Dura did not seem to indicate a major art centre, with patrons and collectors of art, and highly trained painters, and the murals, although striking, were for the most part of poor quality and crude execution. Stylistically, they comprised an eclectic mix and adaptation of foreign influences. What, then, was the nature of this city and its population?

Dura-Europus and its people

According to the chronicle of the geographical writer Isidorus of Charax, Dura was founded by Nicanor, a general of Seleucus I, who later became governor of Syria. The city, named Europus after the birthplace of Seleucus, was founded around 300 BC: about 113 BC, it was conquered by the Parthians. Apart from a brief period of Roman occupation under Trajan in AD 115, Dura remained under Parthian control for almost three centuries.

Dura was a natural fortress, strategically placed high on a promontory overlooking the Euphrates river. It commanded the military and commercial routes from the East, across to Palmyra and the Mediterranean, and south to Charax and the Persian Gulf. The walled city was originally planned with an open *agora* in the middle but, as time passed, the face of Dura changed. The *agora* was built over, to become more like an oriental bazaar: a crowded agglomeration of merchants' houses and shops, separated only by narrow, winding streets. Architecture was orientalized and the functions of buildings changed. The Hellenistic fortress was gradually transformed into an eastern commercial centre.

In AD 165 the Romans recaptured Dura, remaining in power for some eighty years. During this time further alterations were made to the city. Old buildings were remodelled, new ones were built. Temples, the Christian house-church and the synagogue were enlarged and redecorated. But this evident prosperity was short-lived. In 256 the Sassanians laid siege to the city, undermining the western wall and towers. The Durenes responded by building embankments against the inside of the walls to reinforce them. In the process they partially demolished a number of buildings along the western wall, filling the street beside it, and the adjacent building sites, with earth and rubble. This act was instrumental in preserving the wall-paintings in this area. Despite these precautions the Sassanians broke through and the city fell for the last time. The fate of the citizens remains a mystery: the Sassanians did not occupy Dura themselves and the city was never again inhabited. Within a few years it was in ruins.

The changing fortunes of Dura-Europus were reflected in its population. From the evidence of documents and inscriptions found on the site, most of the inhabitants must have been the Aramaic-speaking people of the region, governed by a Greco-Macedonian aristocracy. The Parthian invasion brought Iranian names and influences; the Roman army introduced other ethnic groups. The records show that intermarriage was common. In addition, the location of Dura, its position on the caravan routes and the documented presence of Palmyrene merchants in the city, point to a cosmopolitan, but essentially provincial, centre.

This cultural diversity was reflected in the religious and artistic life of the city. No fewer than 16 religious buildings were uncovered and numerous votive artefacts were found during the excavations. Religion was syncretistic: Semitic gods had Greek names; Greek gods were depicted in Parthian dress. The Roman army built temples to Mithras and Jupiter Dolichenus and there were sufficient numbers of Christians and Jews to warrant their own, sizeable places of worship. Of these, the most interesting, and significant, was the synagogue.

124 *Plan of the Dura Europus synagogue complex.* After C. Kraeling, *The Excavations at Dura-Europus, Final Report* VIII, pt.1. *The Synagogue,* New Haven: Yale University Press 1956), Plan VI

The Dura synagogue

The synagogue is as important for its architecture (**124**) as it is for its painted decoration, although the murals have always received more attention. Originally a house, it was modified for use as a synagogue some time between AD 165 and 200. In 244-5 an adjoining house was incorporated into the complex and the building was completely remodelled. The interior walls of the original synagogue were removed and the area converted into one very large assembly room.

The result was a building that challenged established theories of synagogue architecture. The Dura synagogue was not freestanding, nor was it on the highest site in the town as required by Talmudic injunction. It had previously been thought that early synagogues were basilical in form but the Dura building was wide rather than long with its entrances on one long wall, the Torah niche on the other and benches all around the sides. It had no women's gallery nor, apparently, any separate area for the women at all. Even the location of the Torah niche on the Jerusalem-oriented wall appeared to contradict what was known of contemporary Jewish liturgy.

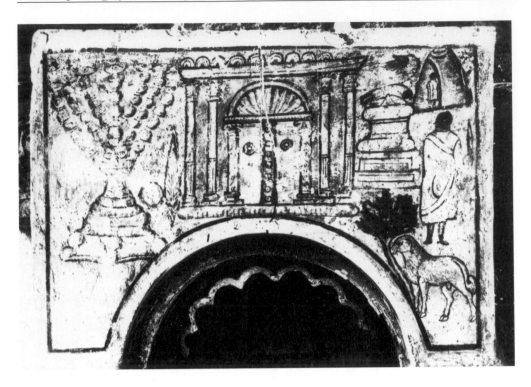

125　*Dura-Europus synagogue, paintings above the Torah niche.* Photo Yale University Art Gallery

The discovery of other synagogues which do not conform to the standard classifications has established that the Dura building was not unique. The complex is, in fact, typical of Durene temples which had their architectural origins in the broad-room temples of Mesopotamia. All were built amongst private houses; all had a large, walled court, entered by a relatively inconspicuous doorway from the street and surrounded by small rooms. The sanctuary or *naos* was broad rather than long, with its entrance on one long side. Perhaps more importantly, instead of a large cult statue such as those of the Greco-Roman temples, the deity was honoured either with a relief sculpture set within a niche or with wall-paintings. The decoration of both the Christian baptistery and the synagogue followed a similar pattern. But rather than being an echo of the past, the synagogue, in particular, heralded the dawn of Byzantine art.

The synagogue paintings: iconography

The decoration of the early synagogue was conservative and unremarkable. The walls were divided into three registers: a marbled dado, a series of incrustation panels above and plain white paintwork at the top. The ceiling was painted in imitation of coffers with gilded rosettes.

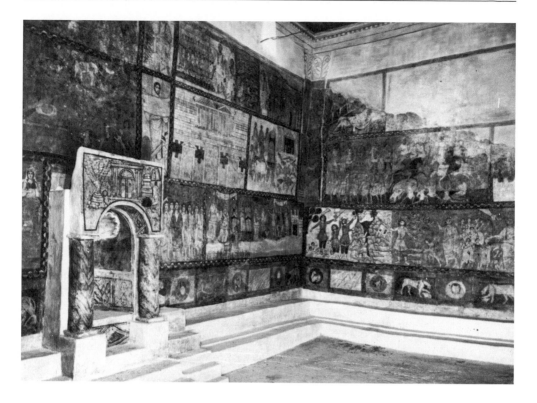

126 *Overall view of the paintings of the Dura-Europus synagogue, as reconstructed in Damascus Museum.* Photo Yale University Art Gallery

The focus was the Torah shrine in the middle of the west wall. This comprised a columned niche, painted to resemble marble, with an arched top surmounted by a rectangular panel. This panel (**125**) was decorated with three distinct themes. To the left were the symbolic elements of Judaism — the menorah or seven-branched candlestick, the *ethrog* or citrus fruit and the *lullab* or palm branch. In the centre was a representation of the Temple and, to the right, the scene of the sacrifice of Isaac, the Akedah.

A large vine occupied the wall above the niche. This was flanked on the left by a golden, cushioned throne with a footstool in front. To the right of the vine was a table. This early decoration was symbolic and essentially aniconic, the only figures, those of Abraham and Isaac, being shown with their backs to the viewer. Three more figures were later added to the central panel. An enthroned man, generally identified as the Messiah, was painted into the upper central section of the vine. Two men in togas, whose identity has not been firmly established, were added on either side and below him, with a lion beneath.

The paintings of the later building (**126**) were considerably more ambitious in scale and concept. A dado simulating marble panels, some of which were embellished with pictures of animals or theatrical masks, ran around the lowest part of the walls immediately above the benches. Above this, the walls were divided into three registers

221

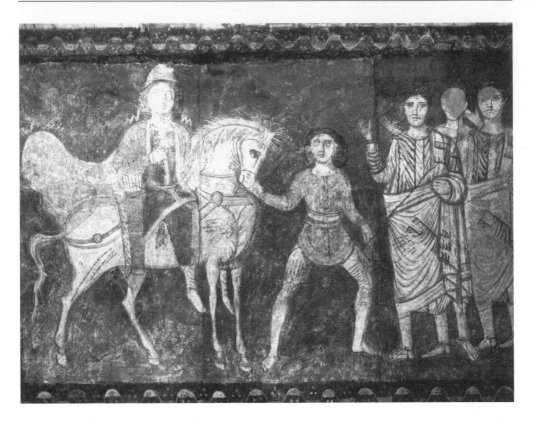

127 *The triumph of Mordecai: Dura-Europus synagogue, Panel WC 2.* Photo Yale University
Art Gallery

which were further divided into panels of irregular size. Simulated columns with heavy
Corinthian capitals were painted in the corners of the room and the ceiling was lined with
tiles painted with masks, fruit, flowers, animals and representations of the Evil Eye.

The Torah niche remained the point of focus from the entrance, with the new painted
narratives converging on the shrine where the scrolls were kept. The vine-panel above the
niche was overpainted with scenes of the ingathering of the tribes in the upper section,
David with his harp in the upper left corner, Jacob blessing Ephraim and Manasseh and
Jacob blessing all his sons below.

Over the years, scholars have disagreed as to the identification of some of the scenes
on the walls. The scheme given here is that of Weitzmann, based on comparisons with
manuscript illumination (Weitzmann and Kessler 1990). In the lower register, beginning
on the south wall and running round to the left of the Torah niche, are five episodes from
the life of Elijah. The cycle includes Elijah with King Ahab, with the widow of Zaraphath,
and with the prophets of Ba'al. Next, he is shown on Mount Carmel (**colour plate 28**)
and, on the west wall, reviving the widow's son. Next to the Torah niche is the Triumph
of Mordecai (**127**). The panels to the right of the niche show the Anointing of David, then
the Infancy of Moses and, on the north wall, a condensed narrative of Ezekiel in the Valley

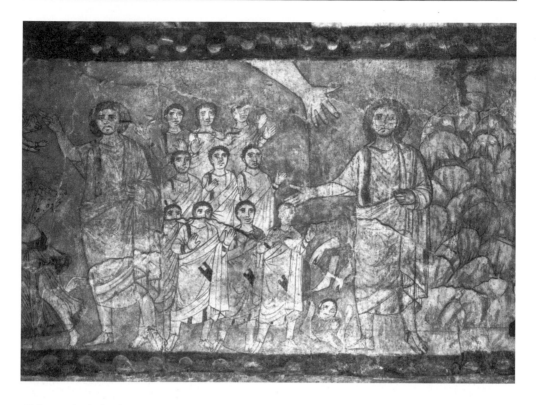

128 Ezekiel, the destruction and restoration of national life: Dura-Europus synagogue, Panel NC 1, section B (scenes 3-4). Photo Yale University Art Gallery

of Dry Bones merging into that of Mattathias and the Idolators. Little remains of the east or back wall, except for David and Saul in the Wilderness of Ziph in the lowest register on one side of the door. The panel on the other side probably shows Belshazzar's Feast.

The theme of the middle register is the Ark of the Covenant. The only panel to survive on the south wall is the Transport of the Ark to Jerusalem. On the west wall appear scenes of the Well of Be'er, the Consecration of the Tabernacle, Jacob's blessings, with portraits of Isaiah and Jeremiah on either side, the Temple of Jerusalem and the Ark at the Temple of Dagon. On the north wall are the scenes of the Battle of Eben-Ezer and Samuel at Shiloh.

The upper register was largely destroyed by the demolition of the building. Nothing survives of the south wall paintings and only half of one panel on the north wall is left. Enough of the western wall survives to enable identification of the scenes which are, from the left, the Anointing of Solomon and Solomon with the Queen of Sheba; in the centre, David as the King of Israel, to the right, the Exodus panel showing the Crossing of the Red Sea (**129**). On either side of the central panel and above the prophets, are two depictions of Moses, one receiving the Tablets of the Law and the other with the Burning Bush.

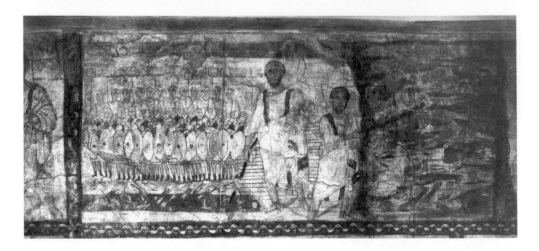

129 *The exodus and the crossing of the Red Sea: Dura-Europus synagogue Panel WA 3.* Photo
Yale University Art Gallery

The meaning of the paintings

Clear understanding of the meaning of the paintings has been hampered by the fact that
only about half of the original panels survive. This has led to confusion as to the
interpretation of individual panels and the order in which they should be read. What is
clear is that the 30 surviving scenes illustrate stories from the Pentateuch, the Historical
Books of the Old Testament and the Prophets, with details added from Midrashic and
Rabbinic texts. But the scenes do not always appear in their narrative sequences. For
example, the stories of David and Saul and the Anointing of David, in the lowest register,
are combined with the episode of Ezekiel in the Valley of Dry Bones. This event, while it
relates to David, is reported in another book. The sequence is interrupted by the unrelated
Infancy of Moses, while the other elements of the Moses story are placed in the upper row
beside scenes of the Kingship of Solomon and David. These disjunctions of narrative led,
in earlier years, to the belief that the synagogue panels had not been conceived as a unified
programme, but had been commissioned at different times by individual patrons as they
could afford it.

It is now generally recognized that the apparently disorganized scenes were intended
to convey a coherent message. The overriding themes are concerned with God's
protection of his chosen people and the messianic hope for the restoration of Israel. This
is expressed in the emphasis on the kingship of David, from whose line the Messiah was
prophesied to come; on the events from the life of Moses, who had led the Jews from
Egypt to the Promised Land; and on the giving of the Law, the building of the Ark of the
Covenant, its capture by the Philistines, and its return to Israel.

Such themes of restoration and return would have been of particular importance to
Jews of the Diaspora for whom the hope of a return to the Promised Land must have been
paramount. It has also been argued that many of the biblical passages illustrated in the

Dura paintings represented issues central to both Jewish and Christian polemic in the second and third centuries (Weitzmann and Kessler 1990: 178-9). This may be the case although, at a literal level, the subject matter of the paintings embodies the basic elements of Jewish faith, much as scenes from the life of Christ provide the basis for later Christian church decoration. At the same time, Gutmann's suggestion that the disjunctive sequence of the narratives may relate to liturgical function cannot be discounted (Gutmann 1973, 1992: 145ff). Liturgy is implicit in the iconography of Christian cycles such as those at Santa Maria Maggiore in Rome, and San Vitale in Ravenna.

Technique and style

The Dura paintings are not frescoes in the true sense although they are frequently referred to as such. They were painted by a tempera method onto a dry plaster base. The binding agent for the colour is not known although it was probably either egg-white or gum. The method employed was the same as that used in Byzantine murals. The registers and panels were defined in charcoal or with thin painted lines. Then, beginning at the top and working down, the figures and other details of the composition were outlined in the same way. When the composition was completed, the outlines were confirmed in colour. The forms were painted in their basic colour, after which details were superimposed in darker or contrasting shades. Finally, accents and highlights were applied in black or white.

The main characteristics of Durene art are its frontality and flatness. The figures are types, shown in rigid, frontal posture: for example, riders on horseback sit astride the profile horse, but with body twisted so as to face forward (**127**). There is little attempt at modelling. Garment folds are schematized and show little relationship to the body beneath; gestures and postures are stereotyped.

The faces are expressionless, with large, staring eyes accentuated by the frontal posture. They bear some resemblance to second-century Egypto-Roman mummy portraits but show none of the naturalism or individualization of these. Facial features are shown in outline and painted to a formula; the only indications of age are occasional wrinkles and grey hair; hairstyles and beards are schematized.

There is little attempt at illusionism in the strictly two-dimensional compositions. Figures bear no spatial relationship either to their surroundings or to the other figures. They are fitted into the available space with the most important protagonists in the scene being the biggest (**128**). There is no perspective: distance is indicated by placing the figure higher in the composition and reducing its size. Crowds are shown in straight rows or symmetrical groups, and at times, as in the Exodus panel (**129**), the number of heads does not match the number of feet. Architecture and landscape are used to identify the scene rather than to enhance the composition. In contrast, animals are much more naturalistically rendered.

Stylistically, Durene art is Asian; iconographically, it is eclectic. Some protagonists wear Parthian dress — breeches and long tunics for the men; ankle-length full skirts, long-sleeved tops and veils for the women. Others wear the Greek *chlamys* (short riding cape) and *himation* (cloak). Architectural styles derive from Greek sources, with gable roofs,

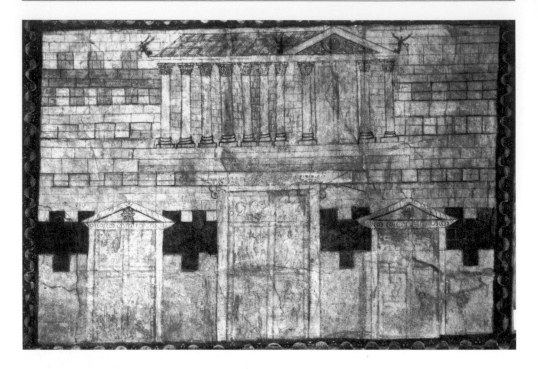

130 Jerusalem and the temple of Solomon: Dura-Europus synagogue, Panel WB 3. Photo Yale
University Art Gallery

acroteria and Corinthian columns (**130**). Roman motifs are reflected in odd details of
composition, rather than in any significant elements.

The most striking aspect of the synagogue paintings is their similarity to Byzantine art.
The ubiquitous frontality and staring eyes of the figures, their static poses and, particularly
in the case of the prophets (**131**), their slender, elongated figures and stern, spiritualized
appearance, bear little relationship to the illusionistic art of Rome or Pompeii. Some
aspects of this style appeared in Roman sculpture, most notably on the column of Marcus
Aurelius, but the figures are heavier and coarser. In Roman painting it has no parallels.

The sources of the synagogue paintings

Since their discovery, the synagogue paintings have evoked scholarly controversy as to
their origins and antecedents. Goodenough hypothesized that a 'philosopher', not
necessarily himself a painter, planned the programme which was then executed by local
artists. Kraeling argued that painted synagogues of upper Mesopotamia or eastern Syria
provided the model. Weitzmann maintains that the origins of the Dura programmes lie in
manuscript illumination.

There are problems associated with all these theories. The concept of an iconographic
designer not only presupposes the uniqueness of the Dura synagogue, but that a scholar

with extensive textual knowledge and design ability was available in a border garrison. The argument for lost prototypes in painted synagogues is more feasible. There is literary and archaeological evidence for decoration of synagogues in the third and fourth centuries although nothing contemporary with the Dura building is known. Nevertheless, it is quite possible that such buildings existed and have not survived.

The other possibility is Weitzmann's hypothesis that the origins of the cycle lie in manuscript illumination. There is much to suggest that he is correct, but the issue is not straightforward. The two monuments — San Marco in Venice and St Julien at Tours — where the decoration has been shown to originate from manuscripts postdate the Dura synagogue by several centuries, as do the manuscripts which apparently provided the models. Furthermore, the Dura paintings could not have been adapted from a single manuscript: they draw on a variety of textual material including maps. No contemporary manuscript has survived that might shed light on the matter. Paradoxically, Weitzmann has suggested elsewhere (1977: 39) that a miniature artist could have been influenced by a monumental composition.

Mural programmes may well have originated from manuscript cycles but the selection and modification necessary to adapt small-scale illuminations to monumental use is not straightforward. It

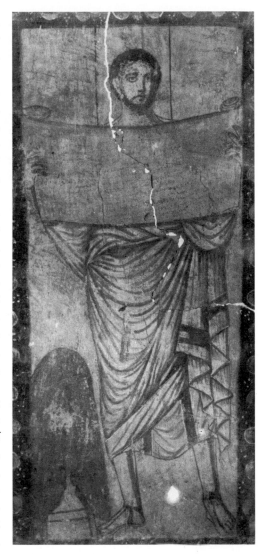

131 Prophet reading from a scroll: Dura-Europus synagogue, Wing Panel III.
Photo Yale University Art Gallery

is doubtful whether Dura would have had the resources to undertake such a task and it also seems unlikely that the donors would have required it. There is nothing to indicate that they were anything other than ordinary citizens, Jewish merchants in a caravan city. Inscriptions record that the synagogue was rebuilt by the Elder, the Treasurer and another member of the congregation. The inscriptions on mosaic pavements of later synagogues also demonstrate a practice of group patronage. It seems likely that the Jewish community of Dura, or part of it, would have banded together to commission the work.

The registers of murals in the other temples of Dura indicate a convention of painted cult buildings which is linked to the programmes of decoration found later in Byzantine churches. This is not to say that the Dura synagogue itself played a direct role in the development of Byzantine art, nor that Jewish art was the antecedent of Christian art. The Christian baptistery, though considerably less elaborate than the synagogue, provides evidence of programmatic decoration in the same period. Painted decoration in buildings has a long history: narrative and ritual cycles survive from the temples and tombs of ancient Egypt, the palaces of Minoan Crete and the houses of Pompeii and Rome. It is probably best to see the Dura paintings as belonging to the tradition from which Jewish and Christian religious decoration both developed, rather than seeing one as a derivative of the other.

Pattern books are usually assumed as the means by which traditional imagery was transmitted from place to place across time, but the form that they took remains controversial. Sketch books, cartoons and large-scale paintings on cloth have all been suggested but the answer remains as obscure as the items themselves. Little is known of ancient workshop practice and procedure. It is believed that the Dura paintings were executed by local workshops. Inscriptions in one of the houses name two artists and at least two hands seem to have worked on the Christian Baptistery. The number of painters who decorated the synagogue has not been established but, given the size of the room and the scale of the work, as well as observed differences in style and method of execution, it is reasonable to assume that several people may have worked on the project in one capacity or another.

The importance of the Dura synagogue paintings for the history of art cannot be underestimated. They are a unique legacy from a period in which little other material has survived. By their accidental preservation they provide evidence of a tradition of Jewish pictorial and representative art, which had previously been thought not to exist. They herald the emergence of the Byzantine style at a date much earlier than had been recognized. They also disproved earlier theories that Byzantine art was merely a debased derivative of Greco-Roman traditions. They exemplify a sophisticated system of programmatic religious decoration executed in the essentially oriental style which was to develop into the graceful, hieratic and stern art of Byzantine Christianity. Above all, they demonstrate a stage of development in a continuing tradition.

Bibliography and references

Goodenough, E. R. (1964) *Jewish Symbols in the Greco-Roman Period* 9-11. *Symbolism in the Dura Synagogue*, New York: Bollingen Series 37.

Gutmann, J. (ed) (1973) *The Dura-Europos Synagogue: a Reevaluation (1932-1972)* (Religion and the Arts 1), Missoula, Montana: American Academy of Religion, Society of Biblical Literature.

Gutmann, J. (ed) (1992) *The Dura-Europos Synagogue: a Reevaluation (1932-1992)* (South Florida Studies in the History of Judaism 25), Atlanta: Scholars Press.

Kraeling, C.H. (1956) *The Excavations at Dura-Europus, Final Report* VIII, pt.1. *The Synagogue*, New Haven: Yale University Press (reprinted 1979, New York: Ktav Publishing House).

Perkins, A. (1973) *The Art of Dura-Europos*, Oxford: Clarendon Press.

Weitzmann, K. (1977) *Late Antique and Early Christian Book Illumination*, London: Chatto and Windus.

Weitzmann, M., and Kessler, H.L. (1990) *The Frescoes of the Dura Synagogue and Christian Art*, Washington DC: Dumbarton Oaks Studies 28.

16 The Hunting and Seasons mosaic
from the Constantinian Villa at Antioch

Roger Ling

Any one of hundreds of examples could be chosen to illustrate the mosaic pavements of antiquity. We have picked the Hunting and Seasons mosaic from the so-called Constantinian Villa at Antioch (south-eastern Turkey) because it makes a particularly interesting case study, both in terms of its original context and meaning and in the light of the way that it has been treated since its discovery.

Antioch, the capital of Roman Syria, and one of the major cities of the eastern Mediterranean, especially in late antiquity, was an important centre of mosaic production. Almost every private house that has been excavated, as well as many public buildings, was provided with mosaic pavements, at least in the more prestigious rooms. While the types of decoration varied according to the function and importance of the rooms, the overwhelming majority were polychrome with elaborate pictorial scenes employing illusionistic effects; moreover, such non-figurative elements as were present, for example in frames, were again brightly coloured and favoured motifs such as undulating ribbons and blocks in *trompe l'oeil*. This conforms with the standard Eastern style found in Syria, eastern Anatolia and neighbouring regions through much of the Imperial period; it contrasts with the black and white geometric patterns and more simple figure-scenes popular in the West.

Our pavement was discovered in 1935, during excavations conducted by Princeton University, in what was evidently a luxurious private villa in the suburb of Daphne (**132**). It occupied a huge room, 12.5m long by 8.3m wide, enclosed by corridors on the south and east sides, if not also on the north and west (where no excavation was carried out). These corridors too were paved with mosaics, but only fragments remained. The other rooms of the villa were not explored.

The decoration of the pavement was in two sections, a larger square area at the east, and a shallow rectangular area at the west (**133**). The square part contained an octagonal stone water-basin at the centre, and the decorative scheme radiated outwards from this. Along the diagonals ran broad wedge-shaped fields containing full-length female personifications of the four Seasons, each growing from a rich cup of acanthus leaves; these were linked from corner to corner by four friezes of acanthus scrolls converging on heads, one at the centre of each side; and the interspaces were occupied by trapezoidal panels with scenes of hunting. Finally, round the outside came a border of geometric pattern (a meander or Greek key rendered in colours suggesting perspective) enclosing panels with figure subjects: rural scenes alternating with pairs of birds and plants at the sides, and busts personifying abstract ideas at the corners.

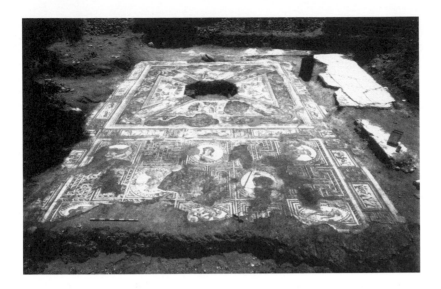

132 *Hunting and Seasons mosaic from Antioch: photograph at the time of excavation, from the west. Mid-fourth century AD.* Photo Princeton University, Department of Art and Archaeology, Antioch Archive

The smaller rectangular part was decorated with a meander pattern enclosing a total of five roundels with busts and three ellipses with standing or reclining figures. Dionysus and Heracles occupied the central positions, satyrs and bacchantes (the customary companions of Dionysus) the side panels. A surrounding border contained panels with groups of Cupids (on the long sides) and birds and flowers (on the short sides).

All this scheme was rendered in a broad gamut of colours, achieved with the aid of tesserae (normally 5 or 6mm square, but only 3mm for some details) of marble, limestone and glass paste. The predominant tones were browns, reds, yellows and greens. The backgrounds were either black or white: black was used to emphasize the four Seasons in the diagonal ribs and the acanthus friezes along the sides, while all the other figure scenes and motifs were on a white ground. The perspectival meander was in white with shading in pink, grey and yellow.

For the dating we have a convenient clue: a pair of coins found embedded in the mortar in which the pavement was set (Campbell 1984). These are identical issues of Constantius II, minted in the early part of his reign (between AD 337 and 347). Since coins often remained in circulation for long periods, it is theoretically possible that the mosaic was laid many years later; but it is also possible that the coins were put there as a kind of ritual foundation deposit, in which case there may have been no great lapse of time. The fact that the coins were identical issues might seem to favour the second alternative. A date round the middle or in the third quarter of the fourth century would thus accord best with the evidence.

Unfortunately, the pavement can no longer be appreciated in its original state. Already at the time of excavation it had been damaged by the growth of tree roots and by the effects

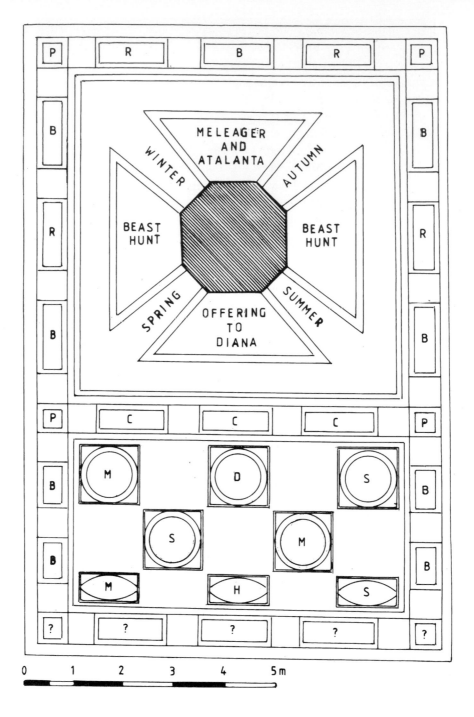

133 *Hunting and Seasons mosaic from Antioch: diagram of the scheme (west at the bottom):* B = *birds;* C = *Cupids;* D = *Dionysus;* H = *Heracles;* M = *maenad (bacchante);* P = *personification;* R = *rural scene;* S = *satyr or Silenus.* Drawing R.J. Ling, after F. Baratte, Mosaïques romaines et paléochrétiennes du musée du Louvre (1978), fig 97

of agricultural operations (**132**). The rectangular western part was badly affected, and there were also major gaps in the square eastern part. As a result, when (as usually happened at Antioch) the mosaic came to be lifted, some areas were abandoned. The bulk of the eastern part, except for the acanthus scrolls along the front and back, was salvaged and presented to the Louvre (in 1939), where it is now displayed with some details restored and with the missing parts replaced by plain mortar. Of the western part only isolated pieces were lifted: four panels are now in American museums, and two small fragments of the border are in the Louvre stores.

It is important to remember that a mosaic pavement such as this was designed for a living space and that people would have walked on it, seeing it first from a doorway, then establishing different relationships with it as they moved round the room. The present situation of the section exhibited in the Louvre (**colour plate 29**) is false. Not only is it incomplete and partially restored, it is also shown in isolation, at the centre of a top-lit gallery, the Cour du Sphinx. It can be viewed from upstairs windows on one side or from a low stairway opposite, at the entrance to the gallery; otherwise the museum visitor can inspect it from close quarters, but only from the outside. So far from being walked on, it is slightly raised and set in a frame, becoming a decontextualized and sterilized object. Moreover, the fact that it is seen from the exterior means that the original relationship between viewer and images has been reversed. In recognition of this fact, the borders on the north, east and west sides have actually been turned round to face outwards — a neat indication of the kind of compromises that result from the needs of modern museum display.

In antiquity, unless there was a gallery round the room, or inward-looking windows at an upper level, the viewer would have had only a low vantage point. He or she would have entered from the west, across the rectangular part, which formed a kind of antechamber, then proceeded to the square inner part, which was emphasized not just by its greater size but also by its richer and more ambitious decoration. Throughout the scheme, as normally in pavements which distributed figures over different parts of the surface, the scenes were oriented in various directions to accommodate the changing viewpoints of spectators. In the square part the scenes of the central area were oriented towards a viewer on the margins of the mosaic, but the panels of the enclosing border were oriented towards a viewer at the centre. In the rectangular 'antechamber', the orientation of the busts in the medallions involved abrupt switches of direction — those at the left and right were oriented for a viewer at the middle, those in the middle were oriented partly to face the front (entrance), partly to face the back (interior) of the room. The arrangement was clearly designed to present each motif from the angle from which it was most likely to be seen. But one senses that the problem of orientation vexed ancient mosaicists and that they were not always satisfied with the results.

The layout of the front part of the floor, with its rhythmic alternation of geometric motifs and roundels constructed on an underlying grid of squares, followed a common format; but that of the square rear part — the piece now exhibited in the Louvre — is more unusual. It seems, like a number of other mosaic pavements, to have drawn inspiration from a decorated ceiling. The strong emphasis on the diagonals recalls the structure of a groined cross-vault; and the egg-and-tongue enrichments framing the

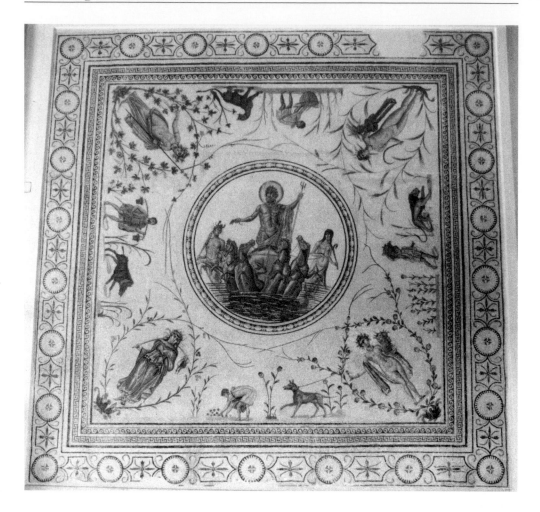

134 Neptune and Seasons mosaic from La Chebba, Tunisia. Second century AD. Tunis, Bardo Museum A 292. Photo R.J. Ling 90/11

triangular fields and the enclosing friezes are a favourite ornament in vault decorations made of stucco relief. The way in which these enrichments are modelled by shading reinforces the effect of relief, and also implies, by a form of optical illusion, that the triangular fields are slightly recessed, as they might have been on a vault. It is possible that the scheme may have reflected an actual ceiling decoration above the mosaic, but there is no way of telling. If the presence of a central basin in the floor indicates a corresponding opening in the roof, this would be structurally difficult to reconcile with a cross-vault of the type implied; and, even though the design could in theory have been painted or modelled on a barrel vault or a flat soffit, it is more likely that the pavement was intended to reproduce a ceiling merely as a general decorative device. Many other pavements betray the influence of ceiling-decorations. A second-century example from La Chebba in Tunisia, for example (**134**), again has figures on the diagonals and there is a central

medallion framed by a bead-and-reel, another enrichment suggestive of stucco relief. The motif of the imitated ceiling is even more explicit in a number of pavements, including a specimen from Trier in Germany, where four figures in the angles seem to bear the weight of a large central roundel; here the design makes sense only in terms of a dome with the supporting figures represented in pendentives.

We may pass on to a closer examination of the figure subjects, concentrating upon the square part of the pavement.

First, the four Seasons. These are shown, as often in ancient art, in the form of female figures identified by distinguishing attributes. Here, unusually, they are winged, a characteristic confined mainly to the art of the Roman East and to the third and fourth centuries AD (Abad Casal 1910: 522, 536). The sequence runs anticlockwise. At the front left is Spring, wearing a diaphanous white dress and holding a yellow cloth filled with flowers in front of her; her head is adorned with a wreath of flowers, and further flowers (roses and lilies?) grow beside her legs, while olive(?) branches rise above her head. At the front right is Summer, who wears a pale yellow dress and a hat to protect her from the sun; in front of her she holds a cloth containing a wheatsheaf. Stalks of grain grow beside her legs, and olive(?) branches above her head. In the back corners of the room are Autumn and Winter. Autumn (**colour plate 30**) wears a white dress like Spring's but fastened at both shoulders rather than just one; she has an olive wreath on her head, and holds a cloth containing fruit (including a pomegranate and grapes); olives grow beside her, and an olive and a vine appear behind her head. Finally, Winter is wrapped in a long black tunic with a yellow cloak drawn like a shawl over her head and shoulders, and bound round the head by a wreath of reeds; a lacuna across the middle of her body means that whatever seasonal attribute she was holding (perhaps, by analogy with other mosaics, dead ducks) is missing, but thick reeds grow beside her and above her head.

The Seasons are a familiar subject in Roman painting and mosaic, often occurring as here at the corners of ceilings or pavements. In the above-mentioned mosaic from La Chebba in Tunisia (**134**), the Seasons are once again represented by full-length female figures on the diagonals, standing above acanthus *calyces* and accompanied by plant-forms (here delicate tendrils); in this case, however, additional assistance in defining the figures is given by scenes of seasonal activities in the side fields: a man with baskets of grapes on a pole, for example, signifies autumn, and a boar winter. Full-length figures are found mainly at an earlier date: normally by the fourth century they had been replaced by just busts or heads; and in this respect, as in their wearing of wings, the Antioch Seasons are unusual. It is also unusual for Summer to be depicted fully clothed rather than nude or semi-nude, but here we may be witnessing a late-antique reaction, perhaps influenced by the moral strictures of Christianity. In their attributes, however, the Antioch Seasons conform to the standard types, with flowers (often roses) for Spring, wheat for Summer, fruit for Autumn, and dead branches or reeds for Winter. These plants, regularly worn in the hair or round the head, are common to the whole empire, while other attributes may vary from region to region; in Britain, for instance, Autumn carries a rake, and Spring has a swallow on her shoulder.

Secondly, the hunting scenes. The first to be encountered shows preparations for the chase — one huntsman offers a propitiatory gift of a hare at a rural shrine of Diana

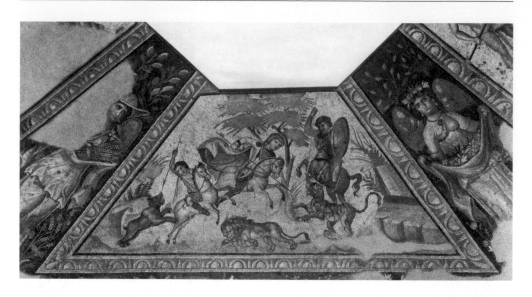

135 *Hunting and Seasons mosaic from Antioch: huntsmen spearing a bear and a tiger, with a wounded lion in the foreground. Mid-fourth century AD. Paris, Louvre Ma 3444.* Photo Bildarchiv Foto Marburg 180628

(Artemis), the patron goddess of hunting, while two more stand waiting with hunting spears in their hands; a fourth man fastens his boot in the left corner with a dog in attendance; and a servant, only partly preserved, is running off to the right, carrying a package of provisions on a pole over his shoulder. The panels at the sides of the pavement show encounters between mounted huntsmen and wild beasts in a landscape of rocks and trees. At the right (**135**) one huntsman is spearing a bear, while two others converge on a tigress; a wounded lion sinks to the ground below. At the left a huntsman spears a leopard in a composition almost identical to that of the bear group opposite, while a second rides at a lion with his spear poised ready to throw; a dead bear lies on the ground below. The last scene, at the rear of the room, represents a mythical hunt, with figures on a larger scale than the others. Meleager, in heroic nudity apart from a cloak hanging behind his back, strides forward and levels his spear at the Calydonian boar, while Atalanta, or possibly Diana, prepares to fire an arrow at a lion, the twin of the lion in the scene just described. A sacred column denotes a rural shrine in the background.

Hunting scenes are very popular in late Roman paintings and mosaics, especially in the villas of the aristocracy (Lavin 1963). A good parallel is furnished by a villa at Lillebonne in northern Gaul (**136**), where four scenes along the sides of a pavement (here facing inwards rather than outwards) depict respectively a preliminary sacrifice to Diana, the departure for the hunt, a group of huntsmen riding with hounds, and the actual hunt (in which a decoy is used to lure the quarry). At Lillebonne, however, the hunt is for deer, whereas at Antioch it is for big game. This type of wild beast hunt was a sport of Persian kings which was taken over by Alexander the Great and his successors and perpetuated in the game-parks and amphitheatres of the Roman world. The representation of hunts

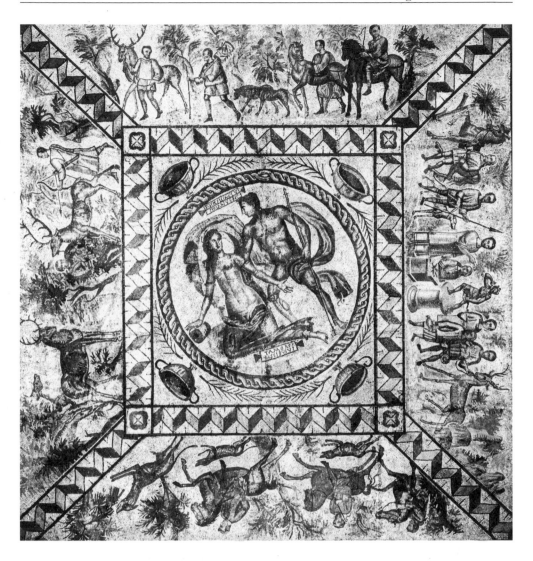

136 *Hunting mosaic from Lillebonne in northern France. The central scene, which probably shows Neptune seizing the nymph Amymone, carries the signature of a mosaicist from Puteoli (Pozzuoli) in Italy, who was assisted by a local apprentice named Amor. First half of fourth century AD. 5.73 x 5.92m. Rouen, Musée Départemental des Antiquités.* Photo Lauros-Giraudon

begins in the age of Alexander, and the figure-types of the Antioch pavement, notably the horseman advancing from the left with spear poised to drive at the prey, or the horseman turning in his saddle to strike down at an animal attacking from the rear, can be traced back to stereotypes in Hellenistic art (**colour plate 31**). In the period of the Antioch mosaic they appear in many of the hunt-mosaics of North Africa and Sicily.

Thirdly, the personifications of virtues and other abstract ideas. There were originally

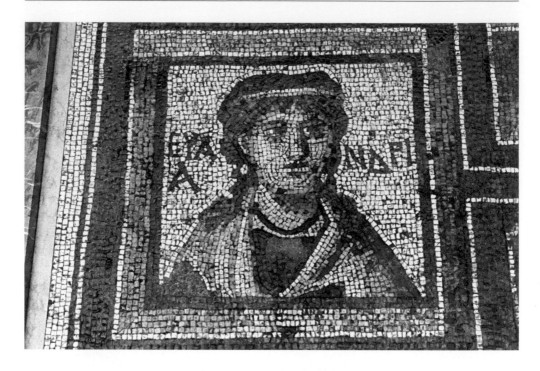

137 Hunting and Seasons mosaic from Antioch: bust of Euandria (Manliness). Mid fourth century AD. Paris, Louvre Ma 3444. Photo R.J. Ling 120/31

six of these, but the two at the corners of the forepart of the mosaic are lost, leaving only the four in the main scheme. All are female busts identified by labels: Euandria (Manliness) (**137**), Dynamis (Strength, Creative Power), Ktisis (Foundation, Possession, Enjoyment), and Ananeosis (Renewal). All were virtues or desirable conditions extolled by the popular schools of philosophy: the Greeks and Romans tended to view abstract ideas in more concrete terms than we do, and there are many examples of their being embodied in religious cults or represented in art, most famously in the form of the love-god Eros/Cupid and the goddess of chance, Tyche/Fortuna, but also in depictions of concepts such as Peace, Wealth, Opportunity, Hope, Honour and Virtue. Such personifications, increasingly obscure and for that reason almost invariably labelled, became particularly popular in the Roman mosaics of Asia Minor and the eastern Mediterranean, notably at Antioch itself and in other centres of Syria.

Fourthly, the scenes of Cupids (which survive in the border between the square and rectangular parts of the pavement). These children of the love-goddess Venus (Aphrodite) are shown, as normally in Roman art, as playful cherubs: dancing in a meadow to the music of pan-pipes, taking part in an open-air banquet, and picking flowers to be woven into garlands (which would be worn at the banquet). Cupids are favourite subjects in the Roman decorative arts, where they are often used to make subtle fun of human activities and human self-importance: flower-picking and banqueting Cupids appear, for example, in wall-paintings at Pompeii.

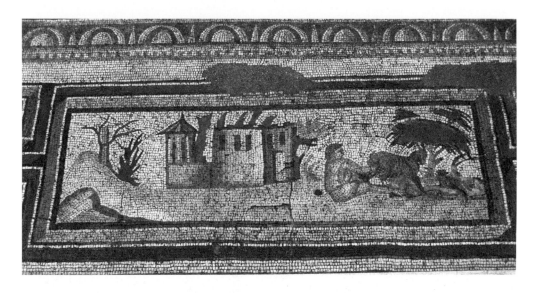

138 Hunting and Seasons mosaic from Antioch: rustic scene with farm building and herd milking goat. Mid-fourth century AD. Paris, Louvre Ma 3444. Photo R.J. Ling 120/12

Fifthly, the pastoral scenes (which are on the three remaining sides of the square part of the pavement, arranged in alternation with the panels containing birds and flowers). They depict respectively: a farm building and a peasant milking a goat (**138**); a shepherd leaving home to tend his flocks; another herd holding a basket and blowing a horn among his flocks; and a girl weaving garlands with a youth in attendance. Such pastoral scenes occur in countless reliefs, paintings and mosaic pavements from the Augustan period onwards, and are especially popular in the mosaics of North Africa, often with farm-buildings prominently displayed.

Finally, the birds and flowers. These panels are primarily decorative and their contents are clearly subsidiary to the other subjects. The birds, which include ducks, peacocks and partridges, are mostly in what can be described as heraldic pairs, though there are subtle variations to relieve the symmetry: for instance, one duck is pecking water-weed while the other looks up (**139**). The motif of paired birds is again a great favourite in Roman art and can be traced back at least to the first century BC, where it appears, *inter alia*, in the lunettes of vaulted tombs.

Why were these particular subjects chosen? Used in combination, what did they all mean, both to the patron who commissioned them and to the ancient visitor who looked at them?

We do not know the intended function of the room. It was probably not a conventional dining room because there was no plain surround on which the dining couches could be set. On the other hand, its size and central position, along with the richness of the decoration, suggest that it was a showpiece, used for entertainments, and thus that the images of the pavement were designed to convey certain messages to the guests who congregated there.

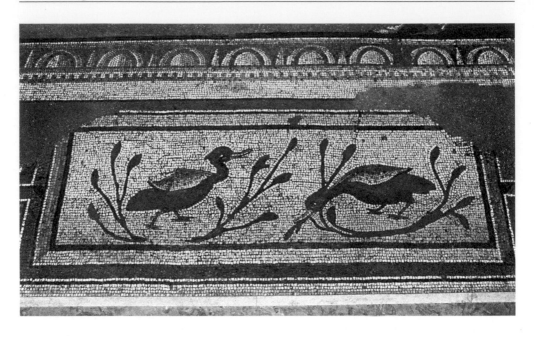

139 Hunting and Seasons mosaic from Antioch: pair of ducks and plants. Mid-fourth century AD. Paris, Louvre Ma 3444. Photo R.J. Ling 120/24

It has been fashionable in recent years to interpret Roman mosaics and wall-decorations in terms of unified religious, philosophical or intellectual programmes. In this particular case one could argue plausibly for a programme glorifying the world of nature under the aegis of the god Dionysus, god of fertility and of the forces of nature as well as of wine. There were actual Dionysiac busts, including one of the god himself, in the forepart of the pavement. Cupids, as love-deities, are frequently associated with Dionysus. The Seasons symbolise the cycle of the year and nature's different seasonal gifts. The acanthus scrolls along the sides of the pavement, each apparently varied in form and colour to reflect the passage of the seasons, symbolize growth and fruitfulness. Hunting and rural activities can easily be accommodated within this general theme. One of the personifications at least, Ananeosis, fits with the idea of the rebirth of nature in the Spring.

Alternatively one could argue for a less profound and systematic reading. Hunting scenes and pastoral scenes are favourites in the mosaics of the late Roman Empire, particularly in villas, the country residences of the elite, and may merely reflect popular or characteristic activities of the owners (or a romanticized view of such activities — the youth and the girl weaving garlands are resonant of an idyll rather than of real life). The Seasons are popular subjects for the corners of pavements (and of ceilings) simply because they are four in number, and so ideally suited for this position. Dionysiac motifs are common in all forms of interior decoration, and need not always have had a religious meaning: they may have been used, as they were in Renaissance and post-Renaissance art, in a purely conventional antiquarian manner. At the most, they may have acquired the character of good-luck charms, protecting the house and guaranteeing fruitfulness on the

estate. Three of the four personifications (Euandria, Dynamis and Ktisis) are not particularly appropriate to a Dionysiac theme anyway.

If there is any dominant theme, it is perhaps the glorification of the owner and of his estate. His hunting exploits, ostensibly involving lions, tigers and bears rather than the conventional deer and wild boar, were further enhanced by association with Meleager's legendary killing of the Calydonian boar. The Seasons carry flowers, corn, fruit, and perhaps ducks, alluding to the fruitfulness of his estate. The Cupids dancing, banqueting and weaving garlands were metaphors of the blissful life of the countryside, as were the shepherds with their flocks, all evocative of the world described in the bucolic poetry of writers such as Virgil. The personifications represented virtues and ideal states to which the villa-owner laid claim and to which his guests should aspire.

But the repertory of the mosaic is clearly broader than this. The presence of Heracles and Dionysiac figures evoke the world of myth and religion, serving at the very least as statements of classical culture. One can, in short, interpret the mosaic in various ways, and at various levels, and it is impossible to know if any one reading is 'correct'. We should in any case think not only of intention but also of reception. Whatever the owner had in mind when he commissioned the mosaic, different viewers would have imposed different readings according to their own experience and to the mood of the moment. Like most of the grander house-decorations of Roman times, this pavement would have had many resonances, ranging from the banal to the deeply meaningful. It is this which makes it such a fascinating case study for the role of mosaic pavements in Roman art and society.

Bibliography and references

Abad Casal, L. (1990), 'Horae', *Lexicon iconographicum mythologiae classicae* 5: 510-38.

Baratte, F. (1978) *Catalogue des mosaïques romaines et paléochrétiennes du musée du Louvre*, Paris (Éditions de la Réunion des musées nationaux), 99-118.

Campbell, S.D. (1984) 'Antioch and the corpus of mosaics in southern Turkey', in R. Farioli Campanati (ed.), *III Colloquio internazionale sul mosaico antico Ravenna 6-10 settembre 1980*: 143-8.

Lavin, I. (1963) 'The hunting mosaics of Antioch and their sources', *Dumbarton Oaks Papers* 17: 179-286.

Levi, D. (1947) *Antioch Mosaic Pavements* (Princeton: University Press), 226-56.

Epilogue:
the influence of classical art

Some of the effects of classical art upon succeeding ages have been mentioned above in the appropriate chapters. In regard to production processes, little changed before the advent of new materials and power-driven machinery in modern times. In stone-carving, for example, craftsmen continued to rely upon the old hand-tools — mallet, point and various kinds of chisel, supplemented by the bow-drill — right down to the nineteenth century. Many prefer to do so even today. In bronze-casting the lost-wax method of antiquity was revived by artists of the Renaissance and has again, with certain refinements, remained the standard mode of production for large statues. In wall-painting the fresco and tempera techniques brought to maturity in classical times have continued in use, despite the periodic introduction of new pigments and frequent experiments with new additives or new manners of applying the pigment to secure particular effects.

General artistic influence has varied in intensity. In certain periods there has been conscious revival and imitation on a massive scale. The first great wave of influence happened in the Renaissance, when the emergence of humanism in Rome, especially during the fifteenth century, led to a passion for collecting and copying ancient art. At the time the most numerous and accessible remains were of Roman statuary. Some statues, such as the bronze figure of Marcus Aurelius, spared from the iconoclasm of the Dark Ages because it was mistakenly thought to represent the first Christian emperor Constantine, had remained visible since antiquity; it now became the model for equestrian statues of contemporary rulers. Other statues came to light in the course of rebuilding operations. Such were three influential marbles found in the first years of the sixteenth century: the Apollo Belvedere, which became a touchstone for ancient artistic beauty, the Laocoon group, and the Belvedere torso. All were widely copied and adapted by contemporary artists. The Laocoon was particularly influential. In addition to being reproduced in marble statues and bronze statuettes, it was parodied in a drawing by Titian; and its coloristic theatrical style, which fired the enthusiasm of the young Michelangelo, played an important part in the shaping of Mannerism.

The revival of ancient sculpture had further consequences for artistic fashion. It reintroduced the concept of the life-size nude statue, the first example of which was Donatello's bronze David, cast in Florence about 1430. Further, together with the new interest in classical literature, it popularized the use of the myths and legends of Greece and Rome as a source of subject matter for contemporary art. In marble sculpture, the accident that the surviving ancient statues had lost their colouring instituted one of the hallmarks of Renaissance and post-Renaissance work — its unrelieved and startling whiteness. Finally, the revival was not long confined to Rome and Italy. Plaster casts were

employed to disseminate copies of the newly discovered Roman statues to other parts of Europe, just as the ancient Romans themselves had once used casts to reproduce Greek statues for their villas in Italy. In this way François I of France assembled a collection of replicas and newly commissioned works in the classical manner for his palace at Fontainebleau, south-east of Paris.

Scarcely less important than the influence of ancient sculpture was that of wall-painting. Here the first major surge of interest came in the last two decades of the fifteenth century, with the discovery and exploration of Nero's Golden House in Rome. The well-preserved wall- and ceiling-paintings of this palace, buried under the remains of the Baths of Trajan, had an enormous impact on contemporary artists, who spent days in the underground rooms, copying motifs in their sketchbooks. The distinctive ornamental style which they found, based on half-animal and half-vegetal forms, and christened 'grotesques' after the cave-like context, was imitated by painters of Raphael's school in the decorations of the Vatican Loggias, the Villa Madama, and the papal apartments in Castel Sant'Angelo. One of Raphael's pupils, Giovanni da Udine, tried to recreate the formula of the ancient stucco reliefs with which the paintings were interspersed. Outside Rome, Pinturicchio used the most spectacular vault decoration, the so-called Volta Dorata ('gilded vault'), as a model for a couple of vaults at Siena.

A further wave of influence came with the systematic excavation of the western wing of the Golden House in the eighteenth century; it was at this time that British architects such as Robert Adam and Charles Cameron saw the paintings and exploited them as inspiration for the decorations of the houses that they designed in England and Russia. Still more dramatic was the beginning of excavation in the buried cities of Pompeii, Herculaneum and Stabiae. Here was an almost inexhaustible treasure of paintings preserved by the volcanic deposits of Vesuvius. Extensively quarried from the 1740s onwards by the Bourbon kings of Naples, who had the best pieces cut out for the royal collections at Portici, these paintings were publicized in monumental volumes of engravings and lithographs. More spectacular finds and easier access to the site of Pompeii in the nineteenth century led to widespread imitation. Pompeian rooms became fashionable in the houses of European grandees, and individual pictures were copied by contemporary artists in more than one medium — the picture from Stabiae of a woman selling Cupids, for example, inspired not only numerous drawings, paintings and engravings, but also a painted fan, a marble relief, gem engravings, and a group of porcelain figurines. A telling example of more subtle influence was the borrowing by Ingres of a figure in a well-known mythological painting for his portrait of Mme Moitessier now in the National Gallery in London; her seated posture and the gesture of two fingers resting against her cheek are clearly inspired by the figure of Arcadia or Demeter in the picture of Heracles and Telephus from the so-called Basilica at Herculaneum. More surprising perhaps is the quotation of the same two-finger motif a century later in an early drawing by Picasso. Even the archetypal modern artist had his experience coloured, directly or indirectly, by the anonymous decorators of the first century AD.

Mosaic has been less influential than painting, but discoveries in the eighteenth century, and especially that of the panel representing Sosus' doves on a bowl, along with

243

other fine pictorial *emblemata*, in Hadrian's Villa at Tivoli, inspired a rash of imitation. Artists were particularly impressed by the way in which minute tesserae could be fitted together to produce the effect of a painted picture. There developed a fashion for new works in this technique, the so-called 'micromosaics', many of which were used as a kind of exquisite inlay for the decoration of table tops. Whether or not intended to deceive, these panels sometimes came to be regarded as genuine antiquities and found their way into museum collections. Recent developments in mosaic production, such as the adoption of the 'reverse' technique (in which the composition is prepared face down on a cartoon before being lifted into position on the wall or floor) and the use of heterogeneous modern materials such as plastic, have moved the medium away from its Greco-Roman roots; but even today the work of an artist such as Elaine Goodwin at Exeter (England) contains frequent references to figures and motifs in ancient mosaics.

Ancient vase painting, like mosaic, has had a relatively limited impact on the art of recent centuries, but an exception was the wave of interest that occurred at the end of the eighteenth century following the acquisition by the British Museum of Sir William Hamilton's first vase collection. Assembled in Italy while Hamilton was British ambassador at Naples, this collection of mainly red-figure vessels was published in four sumptuous volumes of lithographs by the adventurer Pierre d'Hancarville and inspired Josiah Wedgwood to make his imitations. Since the vases were then thought to be of Etruscan rather than Greek manufacture, Wedgwood's products were called Etruscan and his factory, just north of Stoke-on-Trent, came to be known as Etruria. The vase-collection of the British Museum, like those of numerous other national museums, was enlarged by subsequent gifts and purchases throughout the nineteenth century, and it continued to provide inspiration for philhellene artists, such as Frederic Leighton, who reproduced (or adapted) specific pots for the *bric-à-brac* in his romantic paintings of scenes from ancient Greek myth and life.

Perhaps the most influential event in the saga of the modern reception of ancient art was the opening of Greece to western visitors in the eighteenth and early nineteenth centuries. This began with the mission of Stuart and Revett, whose measured drawings of Athenian buildings, published between 1762 and 1830, launched the Greek revival in English architecture; but the real turning point was the arrival in London of Lord Elgin's marbles. These sculptures, removed from the Parthenon and other buildings in Athens between 1801 and 1803, were bought by the British Museum and put on public display in 1816. In the face of received practice, they were not restored but were preserved in the mutilated state in which Elgin had found them, thus inaugurating a new phase in the history of the museum display of classical sculpture. Widely disseminated by plaster casts, they became standard test-pieces for art students developing their drawing skills, and few nineteenth-century galleries and studios in Britain were without a selection of copies.

Within a few years of Elgin's activities in Athens a team of international investigators retrieved the internal frieze of the temple of Apollo at Bassae in southern Greece and the pedimental statues from the temple of Aphaea on the island of Aegina. The Bassae frieze, with its depictions of battles between centaurs and Lapiths and Greeks and Amazons, was again acquired by the British Museum (actually two years before the Elgin Marbles), and contributed further to the 'Grecian' fashion in England. It was replicated round the

entrance-hall of the Ashmolean Museum at Oxford, a building designed by one of the excavators of Bassae, Charles Cockerell. The Aegina statues, which showed battles between Greeks and Trojans, went to Munich (a representative from the British Museum failed to secure them because of a mix-up over where the auction was being held) and exerted the same sort of influence on Bavarian taste in the nineteenth century as the Elgin marbles did in Britain. Unlike the Elgin marbles, however, the 'Aeginetans' underwent restoration at the hands of a neo-classical sculptor, Berthel Thorvaldsen. As a result they were modified to the taste of the time rather than remaining unsullied specimens of true Greek art. In the 1960s, however, they were again stripped of the heads and limbs added by Thorvaldsen, and are now to be seen in their original incomplete form. A proposal that casts of the neo-classical versions should be displayed alongside them — thus providing a unique double exhibit of the same works in two different cultural manifestations — has not been acted upon.

These few comments illustrate the importance of classical art in the artistic tradition of recent centuries. Even if the twentieth century has seen a strong reaction against classical influence, with many artists preferring abstraction and simplification (much as artists of the medieval period reacted against the naturalism and illusionism of the original classical world by substituting a more formalized and simplifed kind of art), there has remained a convention that art students should be trained in the classical style before going on to other things. In the earlier part of the century artists whose outlook was decisively 'modern' (Picasso has been mentioned and De Chirico can be added) incorporated allusions to classical art in their works. Plaster casts of antique sculptures were retained in many galleries and art schools until comparatively recently, and some have subsequently regretted their decision to get rid of them. The pendulum may have swung against classical art, but some day it will certainly swing back.

Glossary

acrolithic	form of figure sculpture in which the flesh parts are made of marble, the drapery of wood
acroterium (-ia)	crowning sculpture or ornament at the apex and angles of a pediment
agora	open space at the centre of a Greek city, serving as a market place, administrative centre and social centre
Amazonomachy	battle between Greeks and Amazons
amphora (-ae)	tall two-handled storage jar, generally used for wine, with a neck much narrower than its body
aniconic	lacking human form (used of religious and other images)
apotropaic	designed to ward off evil
arete	virtue, excellence
arriccio	coarse coat of plaster preceding the fine surface plaster (*intonaco*) designed to carry a wall painting
asaroton	literally 'unswept'; applied to a mosaic floor design showing the scattered remains of foodstuffs discarded from the table
bacchante	one of the female devotees of the god Bacchus (Dionysus)
bucchero	type of grey pottery, produced particularly in Etruria
centaur	mythical creature, part man, part horse
centauromachy	battle between Lapiths and centaurs
chiastic	shaped like the Greek letter *chi*, applied to a pair of duelling figures in cross-shaped formation
chryselephantine	form of figure sculpture in which the flesh parts are made of ivory and the drapery of gold
columbarium (-ia)	large chamber-tomb, its walls lined with niches for funerary urns
crater (krater)	large two-handled wide necked bowl for mixing wine and water
dentils	tooth-like blocks on the underside of an Ionic cornice
Doric	one of the two main orders of Greek columnar architecture, associated especially with the Dorian states of southern Greece and the colonies of Sicily and southern Italy
emblema (-ata)	inserted panel, especially one in fine mosaic at the centre of a pavement
encaustic	painting technique where colours are 'burnt in' to the ground by mixing the pigments with hot wax
entablature	horizontal elements forming the superstructure in a columnar order
exedra (-ae)	open-fronted room or recess, often situated at the rear of a portico

fresco	technique of painting on damp plaster (*a fresco*) without the use of an organic medium; the colours are fixed by a chemical reaction between the lime in the drying plaster and carbon dioxide in the air
frieze	middle part of the entablature (superstructure) in columnar architecture, divided into triglyphs and metopes in the Doric order, continuous in Ionic
gigantomachy	battle between gods and giants
giornata (-e) di lavoro	'day's work'; the area of fresh plaster laid for a session of fresco painting
gorgon	mythical female creature whose gaze turned viewers to stone
grisaille	monochrome painting in grey or greyish colour
herm	pillar of stone, surmounted by a sculptured head or torso
impasto	painting technique in which the pigments are applied thickly to exploit textural effects
Ionic	one of the two main orders of Greek columnar architecture, developed initially in the Ionian states of the eastern Aegean and Asia Minor
kalokagathia	ideal union of beauty and goodness; being of noble and honourable character
kleos	fame, glory
kouros (-oi)	nude standing male statue of the Archaic period
kylix (-kes)	shallow two-handled cup for drinking wine
lekythos (-oi)	small flask with a narrow neck, generally used for oil or perfume
loutrophoros (-oi)	tall vase with high neck and flaring mouth used in Athenian wedding ritual
maenad	*see* **bacchante**
meander	decorative motif like a labyrinth, created by lines turning in and out at right angles and crossing one another
metope	square slab, often sculptured but more commonly plain, which alternated with triglyphs in a Doric frieze
musivum (opus)	wall mosaic
opus	'work', used by modern writers with various adjectives to signify craftwork techniques
pentimento (-i)	alteration in a drawing or painting showing a change of intention by the artist
pithos (-oi)	large storage jar, generally set in the ground
pontata (-e) di lavoro	horizontal stage in the application of plaster for fresco painting, corresponding to a level of scaffolding
predella	narrow frieze, decorated with figures or ornaments, beneath the main zone of a painted or relief decoration
prothesis	literally 'placing out', used of the public laying out of a body before a funeral

satyr	one of the male inhabitants of the wild who formed part of the company of the god Dionysus
secco	technique of wall-painting on dry plaster (*a secco*), using an organic medium or lime water to bind the pigments to the surface
sectile (opus)	surface decoration employing pieces of stone cut to geometric or natural shapes
sima (-ae)	continuous channel or gutter along the edge of a roof
sinopia (-e)	underdrawing or preparatory sketch in red ochre
smalto (-i)	glass tessera used in mosaic work
sphyrelaton	technique of metal working where parts of a statue are made separately from hammered sheet metal and attached to one another with rivets, or where costly materials, such as gold foil, are hammered onto a surface of cheaper material
stele (-ae)	gravestone or other free-standing commemorative slab
syncretism	'growing together', used especially of the merging of different religions or philosophies
tempera	technique of painting using an organic medium, notably size or egg-yolk, to bind the pigments to the surface
tessellatum (opus)	standard form of tessera mosaic used for floor decoration
tessera (-ae)	one of the small cubes of stone or glass which are used to make up a mosaic
triglyph	oblong slab, usually twice as high as wide, carved into three vertical fillets, which alternated with the metopes in a Doric frieze
trompe l'oeil	form of artistic representation which produces an illusion of reality so as to 'deceive the eye'
symposium (-ia)	drinking party
vermiculatum (opus)	form of mosaic made with minute tesserae, normally used for inset pictures (*emblemata*)
votive	small object or model of a larger one presented to a god, often in supplication for a favour or in thanks for one received

For mythological and historic personages, and for ancient place-names, see *Oxford Classical Dictionary*, 3rd edn (1996).

Index

Figures in **bold** indicate illustrations